The Temptation

Edgar Tolson

and the

Genesis of

Twentieth-Century

Folk Art

Julia S. Ardery

The Temptation

The University of North Carolina Press Chapel Hill & London

The paper in this book meets the guidelines for
permanence and durability of the Committee on
Production Guidelines for Book Longevity of the
Council on Library Resources.
Library of Congress
Cataloging-in-Publication Data
Ardery, Julia S., 1953–
The temptation: Edgar Tolson and the genesis
of twentieth-century folk art / Julia S. Ardery.
 p. cm.
Includes bibliographical references and index.
ISBN 0-8078-2397-X (cloth: alk. paper). —
ISBN 0-8078-4700-3 (pbk.: alk. paper)
1. Tolson, Edgar, 1904–1984. 2. Wood-carvers—
Kentucky—Biography. 3. Folk artists—Kentucky—
Biography. 4. Folk art—United States—History—
20th century. 5. Folk art—United States—
Marketing. I. Title.
NK9798.T65A93 1998
736'.4'092—dc21
[B] 97-23897
 CIP
02 01 00 99 98 5 4 3 2 1

Portions of this book originally
appeared in the following articles.
The author gratefully acknowledges
these journals for permission to reprint
the material herein.
"How Edgar Tolson Made It: Oral Sources
and Folk Art's Success." *Oral History Review*
23, no. 2 (Winter 1997): 1–18.
"'Loser Wins': Outsider Art the Salvaging
of Disinterestedness." *Poetics* 24, no. 5
(February 1997): 329–46.

Page vi: *Edgar Tolson, 1969.*
(Photograph, Rick Bell)

Pages xii–xiii: *Edgar Tolson at the 1973*
Smithsonian Festival of American Folklife,
Washington, D.C. (Smithsonian Institution
Photo No. 78-2592-#10)

With love "mixt of all stuffes,"

for Bill Bishop

CONTENTS

ACKNOWLEDGMENTS

Before it was a book, this project looked like other things: curiosity, talk, muckraking, reading, introspection, scholarship, job. With each phase I needed and received great help.

I have Larry Hackley especially to thank. Larry first introduced me to Edgar Tolson in 1983 and through miles of conversation pulled me forward better to understand visual art and the people who make it. His difficult balance of patience, compassion, pragmatism, and aesthetic intelligence sets the highest of standards. I am grateful also to Skip Taylor for his kindness and to members of the Tolson family for their invaluable help: Donny Tolson, Monnie Profitt, Flossie Watts, Mary Tolson, Wanda Abercrombie, Elvin Tolson, and Sally Tolson.

This book would not have been possible without the generous cooperation and aid of Michael Hall, who spent three afternoons hooked to a tape recorder in Columbus, Ohio, and another two days answering questions at his home in Michigan. Hall made available to me an extensive personal archive of letters, papers, clippings, and photographs, as well as several taped interviews with Edgar Tolson. I thank him for passing on his hard-earned insights and these many materials into which he poured more than a decade of thought and energy.

Julie Hall, Miriam and John Tuska, Rick Bell, and all those who agreed to be interviewed gave this work what substance and verve it may claim. Although I can offer here only abbreviated versions of their accounts, I hope to have served them all well. My sincere appreciation goes to Minnie and Garland Adkins, Richard Ahlborn, Richard Bellando, Gary and Sharron Bickel, Russell Bowman, Judy Broadus, James Broadus, Marian "Mike" Broadus, Roger Brown, Monna Cable, Priscilla Colt, Gene Conti, Nancy Druckman, Mary Dunn, Ken Fadeley, Carl Fox, Estelle Friedman, Anne Glenn, Werner and Karen Gundersheimer, Dwight Haddix, Carl Hammer, Travis Hemlepp, Herbert W. Hemphill Jr., David Holwerk, Elinor Horwitz, Alan Jabbour, Caroline Kerrigan, Flo and Jules Laffal, George López, Paul and Patricia Maddox, Carl McKenzie, Guy Mendes, Clay Morrison, Leslie Muth, John Ollman, Savinita Ortiz, Earnest Patton, Margaret Magrath Reuss, George Reynolds,

Ralph Rinzler, Chuck and Jan Rosenak, Mike Royce, Sal Scalora, Fern Sheffel, Colin Smith, Adrian Swain, Graydon Taulbee, and Roberta Williams.

Conversations with the following scholars, authors, and arts administrators have expanded and clarified my thinking. Thanks to Betsy Adler, Dwight Billings, Bob Cantwell, Andrew Connors, Gary Alan Fine, Archie Green, Lynda Roscoe Hartigan, Loyal Jones, Liza Kirwin, Gene Metcalf, Gurney Norman, Tom Patterson, Irwin Pickett, Betty-Carol Sellen, John Michael Vlach, and Nancy Coleman Wolsk.

I appreciate the work and confidence of my doctoral program advisers, a committee gloriously "mixt of all stuffes": Ron Bruzina, Roz Harris, Chris Havice, Pat Mooney, and Gerry Slatin. I am most indebted to the committee's chair, Kathy Blee, a brilliant scholar and resilient guide; her breadth, integrity, and good humor kept me moving through the labyrinth.

The research and initial writing were generously supported by a Dissertation Year Fellowship from the University of Kentucky Graduate School and two grants from the Kentucky Oral History Commission. Thank you, Kim Lady Smith. At the University of Kentucky Oral History Program, I am grateful to Terry Birdwhistell and, hugely, to Jeff Suchanek for promptness and patient hours of help. At University of North Carolina Press, many thanks to my editor David Perry, to Pam Upton, Grace Buonocore, and Rich Hendel.

Adding immensely to this book have been many skilled and smart photographers, some of whom tunneled back to the 1960s looking for negatives. Bless you, Rick Bell! Special thanks also to Charles Bertram, Ken Fadeley, Michael Hall, Guy Mendes, Skip Taylor, and Melissa Lebus Watt for shedding light on the story. In my work at museums, newspapers, and libraries, the following people were especially helpful: Judy Throm (Archives of American Art), Rachel Sadinsky (University of Kentucky Art Museum), Judith Palmese (Milwaukee Art Museum), Lee Kogan (Museum of American Folk Art), Silvio Lim (National Endowment for the Arts), Pat Lynnah (National Museum of American Art), Billie Adams and Josephine Hollon (Wolfe County Library), Shannon Wilson (Berea College), and Ron Garrison (*Lexington Herald-Leader*). Thanks also to two transcribing wizards, Lisa Lizer and Anneen Boyd.

Through this project I've had the unfailing support of my family, Anne and Phil Ardery, Joe, Anne, Cecilia, and Phil ("Red Pen") Ardery, and Tom and Helen Bishop. Special thanks belong to the friends who weathered everything with me, especially Cyndy Clark, Anne Mason, Catherine Rubin, Carolyn Courtney Zysk, Kathy Schiflett, Dan and Pat Stiles, Al and Martha Helen Smith, Ben Ardery, Lillian Hicks, and Jenny Ruffin.

And to Bill. You made a way.

The fate of our times is characterized by rationalization and intellectualization and, above all, by the "disenchantment of the world." Precisely the ultimate and most sublime values have retreated from public life either into the transcendental realm of mystic life or into the brotherliness of direct and personal human relations. It is not accidental that our greatest art is intimate and not monumental, nor is it accidental that today only within the smallest and intimate circles, in personal human situations, in *pianissimo*, that something is pulsating that corresponds to the prophetic *pneuma*, which in former times swept through the great communities like a firebrand, welding them together.
—MAX WEBER, "Science as a Vocation"

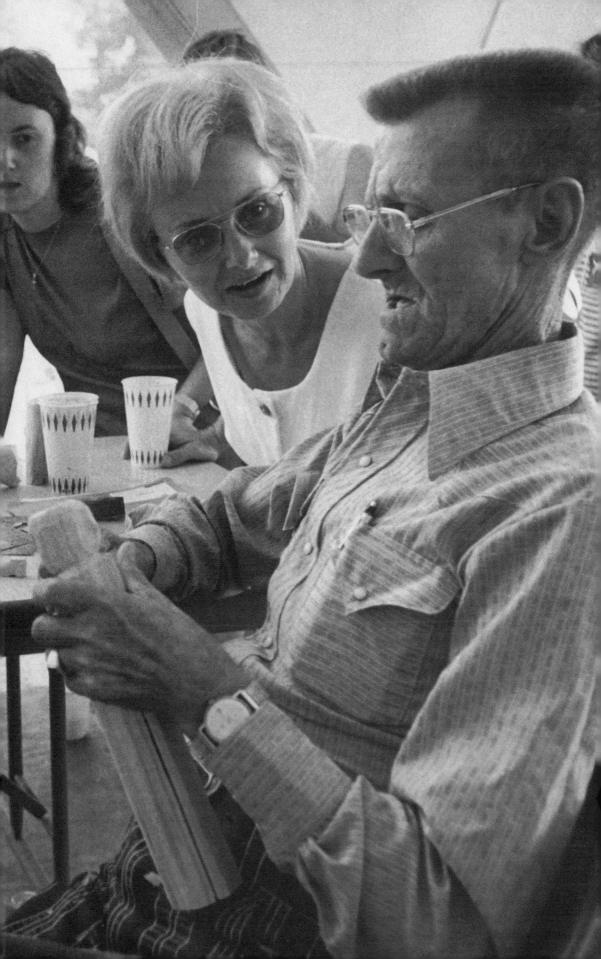

Standing
Woman
(detail), 1967.
Collection of
John Tuska and
the estate of
Miriam Tuska.
(Photograph,
University of
Kentucky Art
Museum)

INTRODUCTION

tanding twelve inches high, with whittled hands the size of my thumbnail, the carved figures of Edgar Tolson are poplar embodiments of the "intimate art" with which Max Weber characterized our time. Tolson himself called them "dolls"—personal, diminutive, fit for a child's grasp—yet children, at least Tolson's own fourteen surviving daughters and sons, were not to touch the man in overalls he made, his unicorn, or Eve. More risqué pieces Tolson hid even from the family's sight. Instead his woodcarvings were to become "twentieth-century folk art," the cherished possessions of trained artists and museum directors, the cultural authorities according to whose favor they have since been interpreted, sold, owned, enshrined.

What would induce the arbiters of a nation's prestigious cultural institutions to treasure wooden dolls, Bill Traylor's paintings on shirt cardboard, and the twining root ice-house proprietor Miles Carpenter fashioned as a dragon? Oddly, such intimate artworks owe their success to the seemingly inimical forces of rationality, mass mediation, and commerce; hallmarks of modernity, they have driven human enthusiasm—whether erotic, aesthetic, or religious—to society's backstages, searching for some unpremeditated act, some object fashioned for its own sake. Where old pressure lines of region, race, ethnicity, and class have cracked, searchers for authenticity go looking, in hollows of Appalachia, expanses of the Navajo reservation, slums of Miami and Chicago. These have come to seem the most culturally fertile locales of all, glades where bureaucratic rule and calculation have not yet scorched the earth. The very harshness of such places has vouched for the creative works made within them—here, one might fantasize, is art pure, without the dulling nurturance of training or the complicity of an intention. This widespread dream gave rise to twentieth-century folk art.

Such idealism, as will be seen, had its roots in certain historical conditions, changes in government, race relations, the art market, and education—the very social structures that brought woodcarver Edgar Tolson and his patrons acclaim. These same forces meanwhile made it possible to build an art

historical edifice around Tolson and his admirers: the field of twentieth-century folk art, which has since contained and conveyed them.

This book describes the coalescence of contemporary folk art as a field of action, interest, and meaning over roughly two decades, 1965–85. It gauges the impact of large-scale institutional and economic changes on a wood-carver and his works during those years and, in so doing, explains how social forces trespass on creativity and attraction. This is also the story of many frail and skilled individuals who through collaboration and strife enabled Tolson's carvings to gain that multifarious capacity and limitation we summarize as "art."

Not just folk art but all art depends on a condition of distance, some estranging display: the difference between a tiger and "The Tyger," between death on the battlefield and the *Fallen Warrior* of Aegina, decorously braced on his marble shield. According to this rule, folk art would seem to offer a kind of aesthetic shortcut, since its very designation is in fact based on an apprehension of social distinctions. "We make art, they make folk art," or, conversely, as I have heard some contemporary carvers say, "They make art, we just make folk art." In either case, it is this acknowledgment of distance that both names folk art and makes an immediate provision for its appeal. Like the antique, folk art purports an aesthetic claim straightaway, based not on how it looks but what it is. Yet unlike antiques, distanced in time, folk art is immediately aesthetic owing to *social* distance. It is strange because the people who made it are strangers.

Or are they? The story of Edgar Tolson and the history of twentieth-century American folk art suggest that this sense of estrangement evolved, paradoxically, from egalitarian ideals, particularly those of white liberalism and its cultural and governmental manifestations in the late 1960s. It was under a political aegis that Tolson's woodcarvings were first promoted and in the name of social equality that his works first sold outside his native Wolfe County. Initially marketed by a local cooperative as Appalachian crafts, his carvings, like the quilts and bonnets sold alongside them, were to be valued as material survivals of country life but also as embodiments of widely shared standards—industriousness, self-determination, and workmanship—standards held both inside and outside the mountains.

As this crafts organization and the political movement behind it dwindled, Tolson simultaneously met another set of admirers, Miriam and John Tuska, Michael Hall, his wife, Julie, and their protégés within the studio art department of the University of Kentucky. Trained both as an ethnographer and a fine art sculptor, Michael Hall befriended Tolson and struggled to define him in two ways: as a fellow artist toiling in the nation's cultural hinterlands and, increasingly, as a contemporary folk artist, proof that the nation's ver-

nacular genius had not vanished with modernity. In his effort to tie Tolson to nineteenth-century crafts traditions and to the avant-garde as well, Hall's advocacy situated Tolson at two vanishing points of a long historical curve: like traditional folk artists, Tolson was bearing forward a regional crafts legacy centuries old; at the same time Tolson's alienation and symbolic depth might set him among contemporary heirs to modernism, as an innovator. Thus, doubly appealing to tastes outside the Appalachian region, to old guard folk art collectors and to students of the U.S. university counterculture, Hall's argument incited the aspirations and tastes of a broad and disaffected middle-class audience. With Tolson's consent, he and his works were made "strange," divorced from the present and the local social movement with which he had been tentatively allied. His dolls and biblical tableaux came to serve as emblems of aesthetic virtue in a larger project: during an era of dubiousness and commercial speculation, to make American art intelligible, affordable, and credible.

During the 1970s folk art seemed immune from the contagions of normalcy then threatening the arts: a runaway market, the expansion of arts education, stylistic pluralism, and government patronage. While fine artists strove for corporate commissions, folk artists appeared naive—at least they were still poor. While urban artists plied their résumés, working up the line of reputable galleries, folk artists like Tolson had no telephones, lived on rocky hillsides, at the ends of mountain roads. As master of fine arts programs and new art journals proliferated throughout the 1970s, rural folk artists appeared ever more exceptional in their noncompliance with an increasingly dense cultural system.

Joining forces with collector Herbert W. Hemphill Jr., a founder of the Museum of American Folk Art in New York, Michael and Julie Hall directed attention to self-taught artists of the South and Midwest, collecting all the way. They challenged the Northeast's monopoly on "heritage" and argued with increasing conviction that folk art was indeed alive in the twentieth century. From 1970 through 1985, the Halls and Hemphill incorporated Tolson's woodcarvings into large personal collections of paintings, trade signs, and pottery made by other nonacademic artists, and as their collections toured to museums across the United States, they built an art world reputation for Tolson and his unschooled art contemporaries, legitimating twentieth-century folk art as whole.[1] Now there are some 135 U.S. galleries specializing in current-day folk and outsider art, with more opening each season.[2] The bulk of Hemphill's collection, including several Tolson carvings, was acquired by the National Museum of American Art in Washington in 1986. The Hall Collection, with its twenty astonishing examples of Tolson's work, belongs today to the Milwaukee Art Museum.[3] Poplar woodcarvings Tolson once gave away

"by the truckload" now sell for thousands of dollars from the auction block at Sotheby's. Before his death in 1984, Tolson had garnered two of the nation's highest public honors in the visual arts, earning a place in the Whitney Museum's 1973 Biennial Exhibition and winning a National Endowment for the Arts Fellowship in 1981. Marked initially by its "specialness," folk art in the 1990s has been incorporated like so many rarities before into established cultural institutions—museums, galleries, universities—reflecting both the extent of those institutions' embrace and the difficulty of sustaining alternate foundations for artistic understanding and regeneration.

Although the idea of "folk art" marks cultural differences, beyond this, it involves (if seldom acknowledges) gradations of power, too. Robert Cantwell, analyzing the more inclusive term "folklife," explains that it "stands at the cultural frontier between self and other, particularly where self directs its gaze socially outward or downward."[4] Thus a Navajo rug or Appalachian quilt, considered weaving or sewing—or art—on the reservation, in the mountain hollow, is "folk art" in the eyes of an Anglo patron or a customer from Chicago. As a cultural construct steeped in power, folk art would seem an inviting topic for social scientists, but few have turned their attention to it. Those who have addressed folk art have done so almost incidentally, as an element in classificatory systems that juxtapose a range of human creative productions and tastes, reading them as signposts and consequences of stratification.[5] Overwhelmingly, despite their important insights into folk art's function as a marker of solidarity and status, sociological studies have ignored the historical context and symbolic content of folk art and instead used artworks to ratify core concepts of the discipline—especially class and collective action. In the process, sociology has evaded the more potent questions of how art succeeds and fails to communicate across social divisions and whether such communication erodes or fortifies boundaries.

In contrast, microlevel studies of folk art have been undertaken by folklorists and anthropologists.[6] These works, conventionally grounded in field research, portray the folk artist as a tradition bearer, in some or many respects resisting the secular, commercial, individualizing, and homogenizing forces of modernity. The nonfolk audience for folk art, if considered at all, is typically cast as an offstage villain whose fascination and ability to buy threaten to deplete the folk community through theft and distortion of its symbols.[7]

Like-minded scholars from art history and American studies have offered analyses of folk art's role in sustaining ongoing systems of domination.[8] Their works, most influentially the writings of Kenneth Ames and Eugene Metcalf, have generally eschewed case studies of individual artists in favor of broad-brush critiques of collecting and connoisseurship. Metcalf in particular has endeavored to understand the historical contingency of folk art's ap-

peal, both as a nostalgic fetish, evoking a simpler time, and as a palliative for uneasy middle-class agnostics.

The present study of twentieth-century folk art in the United States is indebted to all these authors and offers a synthesis of their approaches. From the sociological perspective, it considers folk art as a marker of social distinction. Drawing on the work of Pierre Bourdieu, this book examines the ascendancy of a cultural field during the 1970s and 1980s, when interest in, and a market for, the creative works of poor and nonacademic artists exploded. This development is considered in light of larger transformations in U.S. culture, particularly the decentralization in U.S. arts brought about by increased government subsidy and expanding educational opportunities during the 1970s. In this same period a new highly barbed and critical discourse arose around the whole subject of folk art as, at academic symposia, anthropologists and folklorists squared off against connoisseurs and dealers, all vying for definitional rights. Such conflict, rather than eroding public interest in folk art, of course electrified its appeal. Debate and acrimony, which for the most part have lapsed into mere performances of opposition, were vital in making folk art pieces meaningful stakes within U.S. culture.

Analysis of large demographic and political trends is coupled with a thoroughgoing study of Wolfe County, Kentucky, woodcarver Edgar Tolson. In contrast with conventional folklore research, however, this book does not attempt to celebrate Tolson as a tradition bearer, subjected to the corrosive elements of commercialism and popular culture, but endeavors to portray him as a complex, talented man, who, for a variety of reasons, perpetuated, changed, and betrayed the local culture into which he was born and found a place he could not entirely choose or enjoy in a larger, national culture as well. I hope to unravel the myriad influences on his work, some of them traditional but many more derived from popular and elite sources. In this respect, Tolson may be seen as a successful artist much like any other: charming, self-absorbed, visually heedful, a person who seized many of the aesthetic and commercial opportunities available to him.

While earlier folklore studies may have too narrowly limited investigation to the lives of folk artists and the circulation of their works within small communities, cultivating a romantic and insular sense of tradition, more ideological approaches to folk art, by neglecting the lives of folk artists and local understanding of their works, have attributed too much authority to collectors and art dealers. Such critiques typically begin the story of folk art with the artist's "discovery" by affluent admirers and then decry this process as colonialist. Yet such accounts actually play into the very hegemony they intend to criticize by failing to allow artists and their works any kind of existence outside that framed by "discoverers."[9] Further, such an approach succumbs to a

temptation Jessica Benjamin has explored, a tendency "to idealize the op-pressed, as if their politics and culture were untouched by the system of dom-ination, as if people did not participate in their own submission."[10] This book reveals how Tolson and other folk artists, too, have contributed, not as gullible marks but canny and enthusiastic participants, in the creation of con-temporary folk art as a cultural phenomenon. I hope to engage the ideologi-cal questions raised by Ames, Metcalf, and other critical voices in the folk art arena yet, in contrast with their work, to show Edgar Tolson as a participant in as well as an object of domination and desire. To this end, Tolson's life prior to his "discovery" by collectors must be chronicled, lest his artistry ap-pear the ghostly invention of more powerful interests.

Future art historians may weigh the formal qualities of Tolson's pieces and trace more thoroughly the evolution of his oeuvre. Such matters, interesting as they are, will not be settled here. Rather, this book endeavors to locate Tol-son and his woodcarvings within a season of cultural history and to explore that moment. As an imaginative act, this more sociological perspective teeters between two risks. One demeans a life, turning the edges of experi-ence under to form an "example." So Edgar Tolson might dissolve behind some stereotype: Appalachian or outsider. Another temptation is to incise for him too keen a profile, setting him off so discretely that the ground of both his experience and his reception vanishes—a kind of portrait on black velvet. Endeavoring to avoid these extremes, the work at hand is grounded in biogra-phy but moves beyond it, to examine the circuit of Edgar Tolson's talent and its meaning, to know it as a gift honed, spent, salvaged in the rhythm of so-cial history.

Finally, I hope to probe the ramifications of art's demands—demands per-ceptible in the lives and words of artists and their contemporaries—and thereby to raise a disturbing charge against U.S. culture and society. In the fortunes of contemporary folk art, we may see how sustaining the old values of Western aesthetics, particularly its requisite disinterestedness, has perpet-uated forms of deprivation, self-destruction, even cruelty many would refuse. Our culture seems to demand that artists be both more and less than ordinary people, that they enact the part of our society's losers and for that effort earn an abstract form of love, more abstract even than money: publicity. These terms are not the vices of a few greedy collectors or exploitative art dealers but the fulfillment of art conventions two centuries old. For a multiplicity of rea-sons, these conventions and the roles they permit remain temptations for both contemporary artists and their audiences.

Rather than positing the motives and attitudes of Tolson's publics, I in-clude folk art's appreciators through their own accounts, drawing substan-tially on interviews with participants from many quarters: Tolson's family and

neighbors; Wolfe County patrons who enjoyed his woodcarvings prior to their national exposure; former poverty workers who took part in regional crafts marketing initiatives; Lexington acquaintances, especially the university associates who understood, displayed, discussed, and traded his carvings as art; folk art collectors in New York, Santa Fe, and Chicago; gallery, museum, and auction house officials who have handled his pieces in more recent years; and other woodcarvers whose works both inspired and were influenced by Tolson's career.

In representing these sources, I have, of course, acted strategically, selecting those quotations that serve my own historical and rhetorical purposes while leaving hundreds of pages of interview transcript aside. Here most overtly I have taken the kind of authorial liberty challenged by contemporary critics of ethnography.[11] My own work may appear especially egregious in this respect, since, at odds with the conventions of social science, I have recommended to informants neither confidentiality nor anonymity. Instead, I asked each of them to consent to be quoted by name, and in nearly all cases, I was granted that privilege.[12] This approach may manifest a habit formed over several years of small-town journalism, in which even sources who refused to "go on the record" were popularly identifiable. Still, while they satisfy personal inclination, the steps to record and name informants were taken in good faith. By making publicly available the conversations from which these quotes were drawn, I invite other authors to interpret the same sources, and my own mode of questioning, for themselves.[13] I also credit the women and men who helped me by contributing the feeling, eloquence, insight, and experience that are, in fact, their own.

As a consequence of these informants' thought and candor, as well as an analysis of larger social forces at work, the present story of contemporary folk art's ratification perhaps may render more than a righteous clash of heroes and villains. Instead, it may reveal how all individuals and groups strive for security and excitement, dignity and playfulness, commitment and freedom, despite the binding and anomic forces of modern life. The glory of folk art, in fact, lies chiefly in its visible suggestion that such balances are possible. Its failure to make these possibilities real measures both the perversity of our aesthetic heritage and the persistence of inequalities too deep for a doll to rectify.

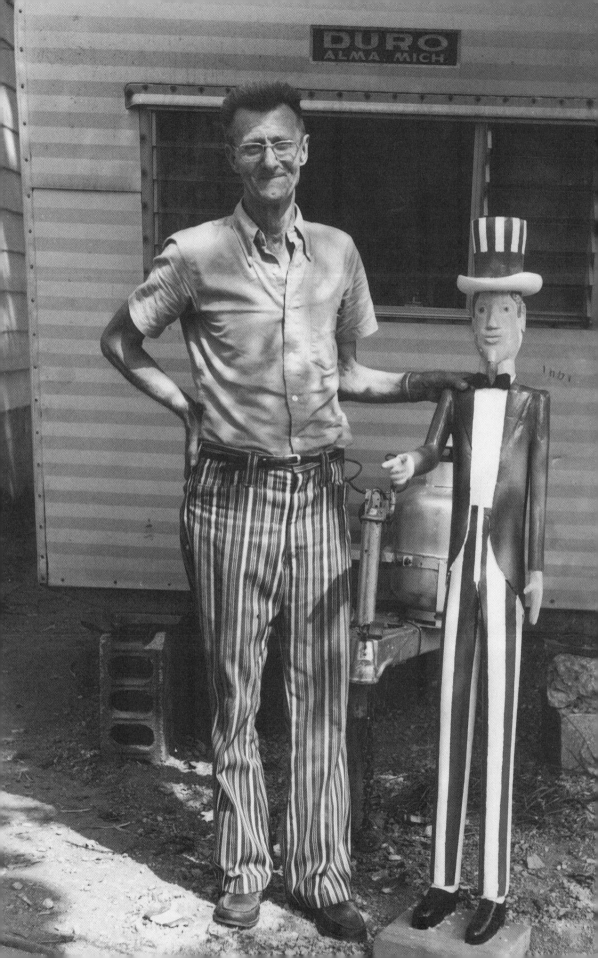

I STRIPED PANTS

hy did Edgar Tolson wear striped pants?

Looking for him—in clippings, pictures, carvings, court documents, remembrances, any strand long enough to have been saved—here's one thread that wouldn't weave in. It is a chronicler's temptation to disregard details like this one, facts that refuse to lie down in history's fabric, yet often it is just these details that, by their very coarseness, scratch against the mind and irritably prevail, the overriding memory of a man.

Posing for photographer Guy Mendes, next to a five-foot carving of Uncle Sam, whose pants were striped, too, Tolson looks especially relaxed and savvy. Tolson's daughter Monnie Profitt said Edgar's first wife used to mock him with a song about "striped pants"; in 1941 she brought him up on charges of desertion, and a Breathitt County jury sent him to the state penitentiary, to wear a convict's uniform. Tolson carved and painted striped or "pied" snakes to crawl up fireplace posts in a house he built entirely by hand. He made zebras, tigers, and a piebald horse that now stands saddled in the Milwaukee Art Museum. But why did he wear striped pants, often clashing with shirts of another stripe?

Tolson wore striped pants the one day I met him, in the spring of 1981. He was both more ancient and more playful than seventy-six years would suggest. His face, skin taut across the cheekbones, caved in with wrinkles around a toothless mouth. Sitting on a couch next to Larry Hackley, our mutual friend, Tolson coughed and smoothed his slender fingers over the hump of a wooden dromedary, a carving in progress. As the tape spools turned, he answered questions for the hundredth, or was it thousandth, time. How many children do you have, Mr. Tolson? "Well, I had six in the first litter. . . ."

Because I met Tolson only once, an afternoon more than a decade ago, I cannot make much progress toward the psychic merger many folklorists and anthropologists dramatize, with testimony "I was there." Nor, hanging out a pair of striped pants, do I intend to make perplexity a virtue. It is just a fact. Met through his neighbors and children, his many admirers, protectors, and portraitists, and through his own art, he is difficult to champion or judge.

Edgar Tolson, Campton (detail), 1976. (Photograph, Guy Mendes, from Light at Hand)

Rather, he remains deeply contradictory, one who wore his conflicts brazenly. Tolson's stripes, suggestive and vital, tell his height, wiriness, and jesting. They are devilish designs and dress up his guilt. I show you Edgar Tolson's striped pants because he chose them, instead of something drab or utilitarian, and because I cannot fit them entirely to my own account. They are overt and annoying, a chafing trail in the mind. If he were alive, he might explain them, or probably not. With humor, they restrain me from an author's temptation: to sum up a man. They are the clearest question I can offer you.

Edgar Tolson was born June 24, 1904, the fourth of eleven children born to James Perry Tolson and Rebecca Maddox.[1] Maddox's parents came from Wise, Virginia (her mother, a Roseberry), in the nineteenth century, but the Tolsons, of Scotch-Irish and German ancestry, had settled in Kentucky a century before. Several branches of the family remained in Harlan and Letcher Counties, near Blackey, but James Perry chose to raise his children in far eastern Wolfe County, its hills carved by tributaries of the Red River. In these narrow valleys James Tolson and his wife worked as tenants, owning only "an old horse and a cow, a bunch of chickens."[2] By 1912, they were sharecropping Willy Hart's farm at Trent Fork. James Perry, popularly called "Uncle Dick" Tolson, and his eldest son, Floyd, built a two-room house that year out of boards they rived with froes from local timber. "You could look up through it and see the sky," Edgar's brother Elvin Tolson remembered. 'Becca Tolson, according to her last surviving son, "couldn't count a dozen eggs, I don't suspect, twice. She was high tempered. She done all the whipping of us kids." James Tolson, strict and religious, punished the children otherwise, with scorn.

Although nearby counties overlie rich seams of bituminous coal, Wolfe has fewer mineral deposits. The majority of its inhabitants until recently survived by subsistence farming. In this respect the Tolsons were typical Wolfe Countians, and Edgar was, in most ways, a typical farm boy. He did show, however, an early facility with woodcarving, by his own account undertaking his first major effort "when I was about nine year old." "It's a big old chestnut log laid right in front of the house where we lived. And I took an ax and went over there and flattened the top of 'em off, cut me a table on there, a round tabletop. By God, I carved a set of dishes. I carved bowls, plates, spoons, forks, knives, coffee pots, coffee mills, and every damn thing I could think of."[3] Edgar followed his chestnut tablesetting with a "locomotive engine. . . . I was about 13, 14, I guess,"[4] and fascinated by the trains that then ran up Trent Fork to Lee City. By 1903, the O&K Railroad had pushed a narrow-gauge line through eastern Wolfe County and freighted coal and lumber out of the region for the next thirty years, stimulating a number of small sawmills and the most commerce that Lee City has ever seen.

Tolson attended several one-room schools in the southeastern end of the

county: Greenbriar, Trent Fork, Rose Fork, and Gilmore's Creek, where "one teacher taught about 80 or 90 kids."[5] Nearly eighteen years old, he finished the equivalent of sixth grade, which at that time qualified him to teach in Wolfe County.[6] Instead, like most teenage sons of farming families, he began to work alongside his father and brothers, making implements, tending crops. Tolson recounted, "I worked every summer at home, and then I'd go out in the fall and go up the river, coal mine or worked somewheres around home in a mine. I always had a job."[7] It was also about this time, 1918, that Tolson tried his hand at instrument making; though unmusical himself, he fashioned what Elvin Tolson called "a 'tater bug mandolin," its backside rounded and striped.

Artists of the sort that Tolson grew to be have incited "term warfare" among art historians, folklorists, and connoisseurs.[8] Recently, "self-taught" seems to have gained a kind of neutralizing acceptance, yet in Tolson's case, clearly it was through the obligations of farmwork—his occupation by dint of family, age, region, class, tradition, gender—that he learned the rudiments of woodcarving. Asked who had taught him to handle a knife, Tolson responded: "I never even thought about carving. I didn't know what I done. I was just whittling, that was all, but I always wanted to make something, you see. And I'd get out and make sleds when I was a small boy and carve out a locomotive train or something, you know, whittle it out and set it up. I thought it, well, it was fun to me but I never thought, well, I never heard carving named then."[9]

Although woodcarving had not been "named," at least in Tolson's community, the more practical chores of making tools, sleds, and yokes, of building barns and repairing wagons constituted daily occupations (his earliest dolls, especially the female figures in their long A-line dresses, are ax and hammer handles personified). These trades taught him use of the hatchet, ax, froe, and pocketknife. In the meantime, he grew familiar with wood itself, learning the grain, weight, density, and durability of the many varieties that abound in Wolfe County: the strength of oak, softness of poplar and buckeye, pungency of red cedar. Not Edgar only but all his brothers learned the qualities of wood and the tools for working it. Both Edgar and Elvin have contended that the youngest of their family, Shirley, was the greatest virtuoso of all with a knife. He, too, "always wanted to make something," though none of his carvings are known to have survived; Shirley contracted tuberculosis and died at age eighteen. The shared experience of the Tolson brothers suggests that visual skills, a feel for tools and materials, and even the desire to "make something" are not so much self-taught as learned through on-the-job necessities and sharpened through family rivalry.

Edgar and Elvin Tolson both have portrayed the settlement at Trent Fork and nearby Lee City with a combination of relish and dread. In their youth,

"There were damn rattlesnakes in there as big as your leg," Edgar claimed.[10] Elvin Tolson called Lee City in the 1920s, its heyday, the "meanest place in the country. There was 21 men that was killed in there." One notorious gunfight broke out after a jealous man objected to another's advances on his sister at a local pie supper.

> Centers told him, said "I'll give you what's in my gun" and they broke it up and went on. Wasn't no more said about it. And they was hauling tanning bark down Red River to the tie yard down there, and they met there. Rob Huff was one of them; that was the old man. He was shooting a 32 by 20. He shot Centers. Centers hung to a post over here. And he shot Centers three times with a 32 by 20, before Centers ever pulled his gun. Centers pulled his gun and one shot killed Huff, and he went pitched over one side of the steps and Centers on the other.

An informant in Eugene Conti's penetrating study of Wolfe County offered a similar view of the boom years. "Lee City used to be pretty bad to fight and scratch; you've heard it mentioned—killing." She recounted another incident: "Lykins had a store; shot at somebody else but killed an Arnett. Troy Patrick's bootleg joint used to be a place of trouble. . . . Lee City used to be awful; they done everything here."[11] According to Elvin Tolson, "They had a six-gun law." In nearby Jackson, the end of the O&K line, there was, he claimed, a killing "every week. You'd go up there on Saturday and Sunday and take your hand and rake the pistol shells up."

In the midst of this turbulence James Perry Tolson's was a stentorian voice for order, a voice amplified through the authority of the pulpit. In six decades of lay ministry he never led an established congregation but was routinely summoned to pray for the sick or departed and renowned for his abilities to preach and heal by faith. Elvin Tolson, his wife, Sally, and Edgar's son Donny all recounted how "Uncle Dick" cured toothaches by the laying on of hands and made warts disappear. Edgar once claimed, "Hell, he's cured cancer."[12]

In rural Wolfe County, especially through the first half of this century, denominational creeds held less sway than these acts of faith; rather than standing at the base of a steeple, "the church" was constantly re-created, enacted within groups of believers who met each Sunday to sing hymns and "listen to a local, non-ordained preacher speak on the word of God as shown through the Bible."[13] James Perry Tolson, serving the eastern end of Wolfe County, was just such a minister. Elvin Tolson said his father belonged to "The Church of God," and, in fact, this denomination was the county's largest by the 1970s, but Uncle Dick Tolson took part in Baptist church services too, according to Edgar, and in all likelihood preached for Methodist and Holiness gatherings also. It may be most accurate to consider James Perry Tolson a "called preach-

er" of Christian fundamentalism. He disapproved of short dresses, forbade music and dancing in the house, and shunned strong drink and tobacco. According to son Elvin, "He never said a smutty word in his life." The elder Tolson led by a stern example and indoctrinated, one might almost say "inoculated," his children with continual quotation from the King James translation of the Bible.

Despite his father's religious firmness—or perhaps because of it—teenaged Edgar Tolson was a prankster and relished revisiting these escapades in storytelling for the next sixty years; most of the tales recount how Edgar and his pals disrupted a sacred service. In one, Tolson and his friend Harv loosened a plank in the church house so that when "Uncle George," a particularly long winded, foot-stomping neighbor, began to testify, he smashed straight through the floor. In another, Edgar and Harv sat in on a house church meeting. As it was summertime, the heating stove and stovepipe had been removed, leaving a hole in the wall. Harv found a long milkweed vine, poked it from out-of-doors through the stovepipe hole, and imperceptibly gathered a twist of Uncle George's straggly hair. When the old man's turn came to witness, all he could do was fume, his scalp knotted tight to the wall. "Oh we had a time out of them people," Tolson remembered.[14]

Of all his unholy adventures, one was particularly intriguing to later chroniclers and visitors, who asked him to relate it again and again. Here is a 1971 account Tolson gave to Ellsworth "Skip" Taylor.

Taylor: Didn't you tell me once that when you were a boy, or something, you put some dynamite under a church?

Tolson: Me and some more boys did. We didn't put it under it. We put it down beside of it, blew the side of it out. Broke the windows all out of it. Blowed an old dog away.

Taylor: Well, you went inside, didn't you?

Tolson: I went in after we threw the dynamite down. Ran a big long fuse on it, and I went in and sat down. It went off. Son, my head run up over my head. I imagine if we'd a'gotten that under that floor we'd have blown that thing clear. It'd have killed everything in there, and it was full.

Taylor: How old were you when you did that?

Tolson: I was about 18.

Taylor: Just crazy, huh?

Tolson: Just a bunch of crazy boys. We didn't like the church, the way they was carrying on. We thought we'd have us some fun and would have died having it too. We could have killed 'em. If we'd have gotten that under that floor, it would have blowed that thing away.

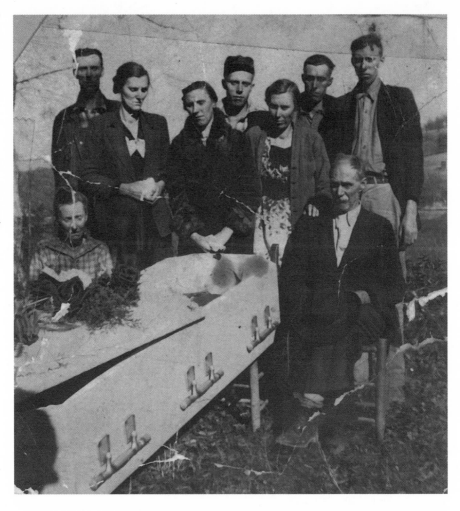

Funeral of Shirley Tolson, ca. 1940. Standing (left to right), Floyd, Haley, Dovey, Sam, Mag, Logan, Elvin. Seated, Rebecca and James Perry Tolson. (Photograph courtesy of Mary Tolson)

The story of the church explosion is important because of its repetition and embellishment in future writings about Tolson, its incorporation over time into the discourse of personal legend. One author portrayed the prank as derring-do, the "existential exploit" of an "18 year old ecumenical Che Guevara."[15] For others, the tale vivified Tolson's religious conviction and purpose, a jeremiad. "He was troubled by what he saw in the world, and one Sunday in 1935 or 1936 he put a stick of dynamite under his church and blew it off its foundation [no one was hurt]. 'Bunch of hypocrites,' he is said to have yelled, 'they can't live it [the word of the Lord].'"[16] While these interpreters gauged Tolson's action as politically or morally motivated (especially the latter account, in which a thirty-year-old man, rather than a teenager, lights the fuse), in fact, this and the similar incidents Tolson recounted through the years were the escapades of adolescent boys. Commentators and folk art collectors have read a noble message into the church explosion, an interpretation that evidently pleased the woodcarver, since he never refuted it outright; however,

Tolson did concede in one early interview, "That was before I was ever a Christian."[17] In light of Tolson's youthful circumstances, a preacher's son who quit school and fell in with a rough crowd, these stories portray a young man threading his way between the rowdy influence of the nearby railroad boomtown and the piety of his farming family.

Such antics were curtailed in the winter of 1922. Then eighteen years old, Tolson was working on a small-time logging operation, hauling timber to a sawmill outside Lee City with a wagon and team. When he and his partner, waiting their turn at the mill, noticed they'd lost a breast chain, Edgar mounted one of the mules and retraced their way through the woods. After finding the chain, he remounted and was headed back to the mill when the animal reared. Tolson was thrown into the snow, and the mule fell too, directly onto his leg. "I laid about five or six or eight hours and froze to death. I don't know why—people traveled that road but nobody decided to help me. And I just laid there and hollered till I give out."[18]

Eventually, a passerby heading to Jackson, Viceroy Lykins, heard Tolson's groans and carried him to the closest house. From there he was transported by wagon into the tiny Lee City hospital, where he stayed the night, his father at his bedside. The next morning Edgar was loaded onto an O&K train and taken to the larger facility in Jackson, where doctors tried to realign the broken bones in his thigh.

> Doctor set it. Instead of putting splinters on it he just put some tape down my leg and put a weight from my foot up over a pulley at the bed to hold the bones apart, and that's the way he let it knit. And that night some of the nurses slipped in. I was giving them a lot of trouble I guess. They'd take me down in the bed and then they'd have to come let me back up. And I reckon they got tired of fooling with it and come tied the damn weight up. And while they done that, my leg limped. Doctor never paid no attention to it till it knitted. When he went to put the cast on it, he found out it was an inch and a half shorter. He wanted to break it and I told him hell no, that I'd live with it the way it was.[19]

Tolson walked with an obvious limp the rest of his life.

Released from the hospital, Edgar required many more weeks of care. "They brought him home and he was spoiled. Worse spoiled man I ever saw," according to his brother Elvin. Edgar would spit tobacco juice from his sickbed straight into his brother's face, "And I'd squall like a wildcat. Man, he was mean." As his brother claimed, and he himself admitted, Edgar was their mother's favorite child, coddled perhaps because he was frailer than his brothers, perhaps too because, as his medical records from the 1950s show, he suffered from epileptic seizures.

In the early 1920s Tolson met Lillie Smith at a church gathering. During these same years he began to preach, initially alongside his father at meetings in Wolfe and Breathitt Counties.[20] He and Lillie, daughter of farmers Tom and Dorie Smith, married on March 17, 1925, settling first along Trent Fork in Wolfe County and then moving into Breathitt, nearer Lillie's family, on Clear Fork. The couple would have six children, delivered by midwife Linda Taulbee: Harold; Herschel, who died of dysentery as an infant; Minnie Lou; Thomas; Monnie; and a stillborn son.[21]

To support the family Tolson worked intermittently in local mines and sawmills, at railroad jobs, carpentry and timbering, but his identity remained bound to farming. "I farmed every year but I'd work through the fall and winter off something for my neighbors and do something, build or, well, just anything that come along to make a dollar. I had to."[22] Though Eastern Kentucky is commonly considered a mining region, farmwork was typical of all but the elites within the "Highland Rim."[23]

The collapse of the coal market in 1927, anticipating the nationwide crash of 1929, had devastating effects on Appalachian Kentucky. The O&K railroad, which had spurred commerce in Wolfe and Breathitt through the teens and twenties, would cease operating by 1933.[24] Tourists from the Bluegrass could no longer afford weekend or summer-month retreats in Wolfe County; the El Park Hotel at Torrent, with its lush mountain setting and performances by the Cincinnati orchestra, closed in 1928.[25] For families like the Tolsons, the 1930 drought and two dry years that followed brought near starvation. Further burdening the local economy, family members who had migrated north were fired from factories and returned to the mountains.[26]

Kentucky's mountaineers, with a two-year head start on the nationwide depression, flocked into Roosevelt's Works Progress Administration (WPA) and Civilian Conservation Corps; by 1935 approximately a third of Wolfe County's labor force was employed in one or more of the new federal relief programs.[27] Edgar Tolson was part of that workforce. Through the WPA he was hired to help build several of the area's first consolidated schools: Stone Fork in Breathitt County, Rowdy in Perry County, and Talcum in Knott County.[28]

The Tolsons had shuttled among tenant houses north of Jackson, but by 1938 they were settled on eight acres at Clear Fork, land Edgar had prepared for a corn patch and garden with help from his brother Elvin. During the thirties Edgar, like so many others who could no longer find day jobs to supplement their crops, turned to handcrafts, making chairs to sell on the streets of Jackson and at the nearby Taulbee Grocery for fifty cents apiece.[29] According to daughter Monnie Profitt, he fashioned his own turning lathe with a foot pedal and bicycle wheel, shaping and smoothing the legs, posts, and rounds, bending the posts back for comfort, weaving seats out of hickory bark. He

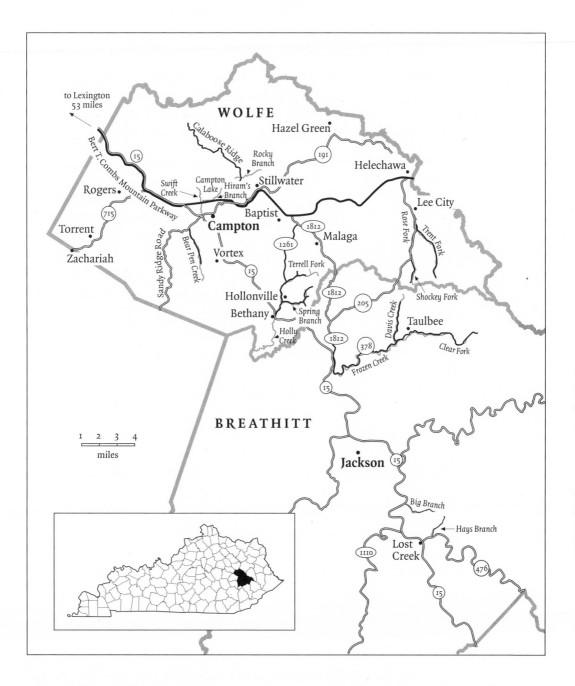

Wolfe and Breathitt Counties, Kentucky

made not just sitting chairs but also, by his own account, "rocking chairs, everything in the world. I made porch swings, piano stools."[30] Profitt remembered her father's tying four chairs on each flank of his horse and then riding from Clear Fork to the county seat on market days. While they lived at Clear Fork Tolson also set up a blacksmith shop, making axes, auger bits, hammers, and chains.

It was during the 1930s that Tolson began to preach more earnestly. Daughter Monnie Profitt and others remembered hearing him preach at

house services, funerals, and revivals as late as the mid-1950s. Monnie recalled her father's agitated delivery: "Daddy would jump up and down. His little top knot would just shake." A lifelong student of the Bible, Tolson claimed to have preached for "twenty-five or thirty years," until "I got too rotten."[31] He told Roderick Moore and Michael Hall that during his preaching years he did no woodcarving.

Although Profitt said her father belonged to the Church of God, he ordinarily called himself a Baptist. As was true of "Uncle Dick," Edgar Tolson seems to have been more concerned with his own private Bible study and with "carrying the word" than adherence to any one denominational doctrine. "You'd preach with the Methodists, Presbyterians, and all them," he explained. "They all just mixed together and had a meeting. Go on. Maybe the next they'd start one place first Sunday, next place the second Sunday. It'd be church the third Sunday at a different place. You just went anywhere you wanted. And you preached in either one of them you wanted to."[32]

Preaching revivals wasn't all that drew Tolson away from home. Edgar had begun to disappear during drinking binges and to wander into relations with other women. As his absence became a pattern, he asked his younger brother Elvin to watch after Lillie and the four children once they moved to Davis Creek. "I stayed over there and worked for him," Elvin said. "He'd have a field of corn or something like that. He'd go off and stay a week or two and I'd stay there and cut wood for Lillie, done the milking and helped her."

By 1940, according to Monnie Profitt, her father had become involved with a Wolfe County woman. Lillie, backed by her parents and even some of Edgar's siblings, brought charges against Tolson for desertion. "Swain Profitt, Daddy's brother-in-law, said that the judge asked him, 'If we don't send you to the pen,' said, 'will you support your children?' He asked him that twice. And he said, 'I'll do like I've been doing.'" On February 26, 1941, Tolson was sentenced to two years in the state penitentiary at La Grange.

In later years, once he became well known as a carver, with visitors routinely asking for his life story, Tolson rarely mentioned his prison term. When he did allude to serving time, Edgar distorted the past, suggesting the charge against him had been either innocuous or actually due to his own heroism. A friend from childhood, later Tolson's welfare caseworker, Graydon Taulbee said he'd always assumed Tolson was imprisoned for moonshining. Rick Bell, who as a student photographer befriended Edgar in the 1970s, remarked, "Have you ever heard the story that Edgar did time for killing a deputy sheriff? Yeah, he did some time in prison. The story I always heard, and I think I've heard it from him, was that he spent a couple of years in jail for shooting or killing a Harlan County deputy sheriff back in the labor days."[33] Michael Hall, meeting Tolson in the spring of 1968, recorded in de-

tailed field notes of their first conversation Tolson's saying the locals "know I mean what I say. You know I did eight years in jail for shooting this feller and they know I'd do it again." When asked what his occupation used to be, Tolson replied, "I guess you'd say I was sort of a gangster."[34]

Later commentators, scholars, and collectors have been accused of romanticizing folk artists, but Tolson also molded a personal mythology. As the ultimate authority on himself, Tolson's accounts of his own past carried singular power and gravity. That he would obfuscate some facts, embellishing and inventing others, does not make him even strange, for all of us distinguish the life lived from the life told. Significant here is the particular event that Tolson wanted so radically to transform. The one year he served at La Grange expanded to eight. His own failed marriage became a sermon against divorce, a club he wielded against his own daughter Wanda in later years. The philanderer and drunk was costumed as a "gangster." The shirking of domestic obligation became a shoot-out against mine company gun thugs.

These efforts to hide the facts of his imprisonment, to trump them up into violent, manly, vengeful crimes, suggest the depth of Tolson's humiliation. Onto his shame, James Perry Tolson had heaped Old Testament condemnation. According to Elvin, "My daddy got on him I don't know how many times. He told him, he says, 'The Bible says he that took hold of the plow handles and looked back is not fit for the kingdom of God,' and said, 'He's a dog turned again to his own vomit.' And [Edgar] just sat there and took it. He had to. He was telling the truth."

While Tolson continued intermittently to preach, even until the 1950s, it appears the dissolution of his marriage to Lillie Smith and his year in prison tarnished both Edgar's conviction and his reputation as a lay minister. Though he would imply to the art buyers and curiosity seekers who came to know him later that he had turned away from preaching because of his own "rottenness," Tolson managed to frame this story with heroic scrollwork. Unable to bear hypocrisy either within his own conscience or in the lives of the churchgoers around him, according to Tolson's version, he painfully set his calling aside, and in fact, his own son Donny recounted Edgar's falling away in these noble terms. At this suggestion Elvin Tolson, also present at the time, laughed and said, "He just quit."

"Whiskey, women, cares of the world," his brother summarized. "He loved the world, the cares of it, better than he did the word of God." A gentler appraisal came in 1980 from Fred Rogers, Presbyterian minister and host of a popular children's program on educational television, who devoted an hour of his series on American families to Edgar Tolson and his second wife, Hulda. "Mr. Rogers" construed in Tolson's conversation and his woodcarving traces of the minister father yet noted that these remain traces, stray passages

from Scripture, shards of conviction that Tolson, despite all his wit and craft, never managed entirely to absorb into a life. Piercing toward the heart of the matter at the program's conclusion, Rogers wondered, "Somehow, his wooden pieces seem to be carving him."[35]

In July 1941, Lillie Smith Tolson sought and was granted a divorce and by the following January had remarried. At Tolson's first parole hearing that October, Beacher Fugate and Willie Hatton agreed they would hire Edgar to dig coal. The January pre-parole investigation solicited several letters from Breathitt and Wolfe County citizens, writing on the inmate's behalf. Circuit judge Bach described Tolson as "an irresponsible fellow," and Beech Strong, former jailer in Jackson, wrote, "He goes about the country picking banjo and has several other women." "He is not a vicious man," wrote Ollie James Cockrell, "but he just left his family for another woman."[36]

On February 26, 1942, after serving one year of his sentence, Tolson was released to Kenny Carpenter of Taulbee, Kentucky, on Clear Fork. According to parole reports he worked on various farms in Breathitt and eastern Wolfe Counties, earning a dollar a day and, as ordered by the court, turning a portion of those wages over to his former wife for child support.

Soon after Tolson's release, his children learned he was back in Breathitt County, living in the next hollow on Richard Rudd's farm at Clear Fork. Monnie and Minnie Lou stole away one Sunday and surprised their father, welcoming him back. The two girls and their brother Tom resolved to escape their stepfather's beatings by moving in with Edgar, and though Lillie initially forbade them to leave, she eventually relented.

Tolson took the children back to Wolfe County that summer, living for a month with his sister Mahalia (Haley) and brother-in-law, Stewart Profitt, along Spring Branch. Monthly church services were soon organized in the next settlement, and the Tolsons attended. Edgar and two of the children—Monnie and Tom—moved in with his brother Sam there, at a community along the creek called Holly. Sam's wife, Elizabeth, introduced Edgar to her sister Hulda, a seventeen-year-old girl, and soon Monnie and Tom were "packing messages" over the hill between the two sweethearts. Tolson described the young Hulda Patton as "just a stripling. I had to learn her to cook, to patch."[37] They lied on the marriage license, claiming Hulda was eighteen, and married at Christ Church, Hollonville, on August 27, 1942. O. H. Miller, the landowner who was then Edgar's employer, and Hulda's sister Elizabeth signed as witnesses.

After their wedding the couple moved briefly west to the Bluegrass region, Clark County, where they harvested tobacco. According to Elvin and Donny Tolson, while in Clark County Edgar also carved and pieced together a guitar.[38] During this same period Edgar and Hulda befriended an African Amer-

ican couple, fellow tenants and fieldhands on the farm.[39] Since there were few black families in Wolfe County, just one tiny settlement near Helechawa, Edgar and Hulda's Clark County stretch was likely their most significant exposure to African American culture. Clark County, especially its western edge, is horse country; thus it is possible that Tolson's later woodcarving, now titled *Man with a Pony*, may have been inspired by this period in the early 1940s. This large carving may even be a portrait of one of the farmhands Tolson met at this time.

Edgar and Hulda returned in 1943 to Holly Creek, where Edgar resumed farming for O. H. Miller, earning six dollars per week.[40] Tolson said the 1940s were some of his most strenuous years: "I was a'working just like a brute, son. I was carpentering, farming and trying to get by, jack of all trades."[41] With his brother Sam, Edgar built "about sixteen or eighteen barns over there on Holly."[42] He set up a small blacksmithing operation and, for a short time in 1944, according to Monnie Profitt, resorted to making chairs again. A measles epidemic that year nearly killed him.

With wartime's acceleration of industrial manufacturing, Tolson, like many other Appalachians, migrated north for a factory job.[43] Once his crops were in, he followed his sister Mahalia and brother-in-law, Stewart Profitt, to Dayton and hired on at Masters Electric Company until the end of World War II. Hulda stayed behind. In fact, Edgar was working in Ohio when Blanche, their first child, was born in September, 1944. Hulda had already borne a son, Bill. With Edgar she would have fourteen more children, six girls and eight boys, over a span of twenty-two years.[44]

In January 1945 Edgar and Hulda bought twenty-one acres on Terrell Fork of Holly Creek from Goff and Maud Brewer, the first recorded property that Tolson ever owned. The family stayed here eight years. According to Monnie, her father "made a crop for John Stones" at Holly, continued in carpentry work, and meantime built the family a one-room log house, with a sleeping loft for the children. The acreage included a number of large stone boulders and outcroppings, natural features that fired Tolson's imagination; he would soon apply himself to making them over into markers of his property. Returning home each evening, Tolson worked into the night on his building project, a second house constructed of milled boards. His daughter Flossie remembered being wakened late one night. "They packed us out of our beds in that old big log house, just across the yard to where he'd built the other house. And we woke up and here we was in the new house. That stands out, really. And I thought after I got older how proud Dad was. He wanted to surprise us."

"The plank house," as Monnie refers to it, completed in about 1949, was an important undertaking, one that both unleashed and confirmed Tolson's cre-

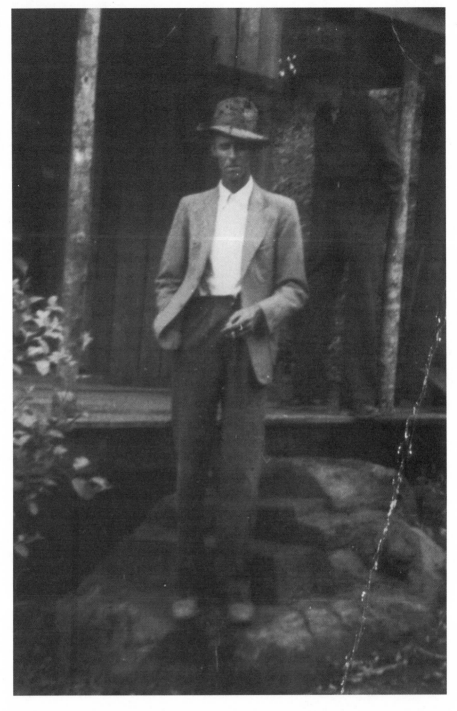

ative gift: "He bought some second hand lumber, used lumber, and fixed the inside. I mean, he saved every little piece and stuck it in like a puzzle." He strove to put an individual mark on this his first piece of property, to celebrate his far happier second marriage, and to provide for a growing family, making the house not just a dwelling but a statement of his proprietorship, belief, and

craftsman's pride, by building in several strange and original features. At the tops of the house's porch posts were the sanded stubs of limbs, as if Edgar had wanted to emphasize just how he had hewn his home out of the surrounding woods. He dug a large basement to use for a smokehouse and built furniture, not bark-bottomed chairs like those he'd made for sale, but a rough dining table and benches.

Tolson had situated the plank house on top of a series of stone outcroppings and then carved the extant rock into front steps. Further driving his own mark onto the landscape, Tolson carved the native stone into several forms: a sleeping dog out of one boulder and, nearby, on the low side of the step, a cat in the act of making its escape. These carvings have been broken or worn away, and the Holly house itself is gone also. One piece of the plank house has been preserved, however: a fireplace post with a striped snake winding upward toward the mantel. Sculptor Michael Hall acquired this decorative carving in the early 1970s, when Tolson's sons Don and Wilgus retrieved the piece from the yard of a house at Swift Creek, where the family lived in later years. Tolson evidently had thought enough of the object to salvage it from the house at Holly.[45]

The plank house, with its fancy fireplace, animated steps, and expert piecing of scrap lumber, was a local attraction. Monnie Profitt said that the front porch posts especially, with their bobbed off limbs, were "what sold the house. I mean everybody come to see the posts, and they'd talk and talk and talk." Through the virtuoso dwelling, Tolson bestowed a present on his young family—Flossie's story of being carried while sleeping into the new house to awaken there shows that the endeavor, though it had required months of labor in plain sight of the children, was nonetheless intended as a "surprise" and gift. Among Tolson's neighbors, the house also demonstrated his superior carpentry skills, his ability to turn a commonplace, utilitarian craft into imaginative expression, and declared Tolson's ownership of these acres he had wrenched from a wilderness of rock boulders and mountainous woods.

The Tolsons' own property did not include an allotment for raising tobacco, though Edgar would hire out to nearby landlords who raised it. On Hulda and Edgar's own farm, there was just enough level ground for corn and potato patches and the garden. Tolson worked a team of mules and Hulda tended the milk cow. With a few chickens and a hog, this was the extent of their family farm. They traded for all other supplies with the grocer in nearby Bethany.

From boulders he found scattered on the land, Tolson carved several pieces during the 1940s: by his own account, "a lion, three or four dogs. Then I carved two or three squirrels, big squirrels. And I carved out an Indian out of rock."[46] A few of these works have survived (Plate 1). According to Flossie Watts, Tolson made a number of gravestones (and built caskets also) "as a

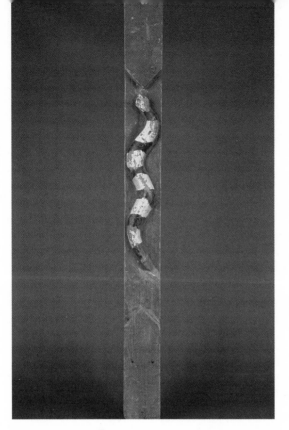

Fireplace Post, ca. 1948, detail of the "Plank House." Private collection. (Photograph courtesy of Michael D. Hall)

favor" for departed relatives, friends, and neighbors; he had learned stone-masonry on the job, notably during the ambitious school-building projects financed by the WPA.[47] Yet in his stone animals and Indians, one sees Tolson again expanding the circuit of indigenous and utilitarian crafts in order to make something figurative and expressive. In the decorative elements of his plank house at Holly and the objects he chiseled out in the adjoining yard, Tolson evidenced a febrile energy for making things, even after long days of physical exertion, plowing, hammering, loading. Typically, he walked twelve miles to Campton to work, twelve miles home, and then handled the daily chores of the farm. As art historian Kenneth Ames has noted, "Handwork does not necessarily make labor more enjoyable. It is a matter of wanting to make objects or having to."[48] At Holly, Edgar Tolson was evidently exploring for his own pleasure the aesthetic properties of wood and stone, animating the natural elements of the hollow, the materials of his everyday work, into watchdogs to stand guard over his land, snakes to bless the hearth.[49]

Hulda, between preparing meals and washing diapers in the creek, also hoed the garden and managed the livestock. According to Flossie, "Mom knew what time of day it would be by where the sun was on the porch. She'd be out working in the fields. The older ones would be left there to take care of the babies and watch the little ones. She'd tell one of the older ones, one of us would have to come where she was working when the sun got to a certain

spot on the porch. Then she'd come in and cook our dinner. We'd eat and she'd go back to the fields." With her daughters' help, Hulda canned garden produce at the end of the growing season—beans, berries, sulfured apples, kraut, and pickled corn. She sewed her daughters dresses from feed sacks.

Subsistence farming and supporting a large family, with some lay preaching on the side, meant Tolson had little time for the whittling that would later bring him acclaim. In 1947, Edgar also bought a cobbler shop in Campton, where he mended shoes for fifty cents a pair, selling the business and its machinery to his son Harold three years later.[50]

The family's reliance on a primitive water supply, the lack of medical attention, and an uncertain diet subject to the vagaries of each farming season all lowered the Tolsons' resistance to disease. They survived the measles epidemic in 1945, but the next year Hulda, and many others at Holly, contracted whooping cough. The Tolsons' third child, Carl Edward, caught the infection and lived just two weeks.

Nor could they hold on to their mountain farm for long. Between 1946 and 1960 Edgar and Hulda sold and repurchased the Holly property some five times, finally passing the deed for one dollar to Edgar and Lillie's son Tom. This continual shifting indicates both the family's financial uncertainty and Edgar's affinity for trading. Donny Tolson said his father relished market days in Campton, where, swapping knives or sizing up horses, he would usually come out ahead. Still, the hand-to-hand history of the Holly deed indicates the Tolsons' constant straining for money and, despite his architectural and sculptural claims to proprietorship, Edgar's difficulty holding on to anything of his own. Profitt remembered her father's routinely shopping on credit at the local grocery: "Then he'd go sell this crop and then he'd go pay off his store debt and turn around and do the same thing, over and over."

In 1949 Edgar qualified for a welfare check under the Aid to Dependent Children program. An early fieldworker for the state Department of Economic Security, Graydon Taulbee had known Tolson as a chair maker in Breathitt County. He contacted the family while they still lived at Holly and ascertained their eligibility, based on size, income, and housing and in further consideration of Edgar's crippled leg and epilepsy. According to Taulbee, the Tolsons were "one of the larger families" in his field area. He remembered allocations of twenty-one dollars per month in the early days of the program, followed by strict limitations on eligibility in later years: "If they were able to turn a light switch on and off they were disqualified."

In 1952 the Tolsons moved nearer to Campton, first to the Bill Horton hollow outside the community called Baptist, then to a house owned by Herbert Miller north of the county seat. They settled on property owned by Leonard Tolson, a distant relative, along Hiram's Branch. It was here in 1955 that

Edgar and Hulda lost their second child, a daughter named Linda, to spinal meningitis. The rest of the children were forced out of school and quarantined, two of them placed by the court in temporary guardianship. According to Flossie Watts, "That just was a real sad time in our life." Linda was the first to be buried on the hill at Hiram's Branch, what has since become the family cemetery, where Edgar, Hulda, their son Wilgus, and three of their grandchildren have been buried also.

Studies of Wolfe and surrounding counties at midcentury suggest how typical the Tolsons were by local standards. Like many other rural mountaineers, through the 1940s and 1950s they relied less and less on farming and, from necessity, turned to wage work in town.[51] Edgar's employment by the mid-1950s appears to have been divided between farming, carpentry, and construction. In the fall of 1956 he broke a leg while handling a cow; the next year, he was helping to build Campton's new cinder-block IGA supermarket.[52]

On September 25, 1957, according to his physician's records, Tolson had "been serving on jury, getting along pretty good; got up this morning and went to milk his cows (and) suddenly got numb in his right leg."[53] Several of the children found him collapsed and lying on the hillside in the sun. He was transported to the medical clinic in town, where Dr. Paul Maddox, after an examination, decided Tolson had suffered a stroke.

Edgar was "bedfast about eighteen months," barely able to move his right arm or leg.[54] According to Flossie Watts, "He was just paralyzed. And I can remember seeing his hand. That hand looked so funny, and it got to it looked so soft. There was no muscle tissue." Meanwhile, there were eight children in the house to feed, from thirteen-year-old Blanche to the baby, Charles, seventeen months old. Neighbors helped bring in Tolson's fall crop, and the landlord suspended the rent. "We all got sick that winter with the flu," Watts said. "Lot of people died with it. And they couldn't drive to where we lived, it was such a winter." Even so, store owners Omer and Virgie Catterns managed to fill net onion bags with groceries and venture overland, "the rock cliff way," to deliver food.

On the point of this injury, Tolson's relation to the world began grindingly to rotate. He had always managed a pinched but, for his locale, commonplace living through hard physical work and the self-sufficiency wrought from diverse manual skills: smithing, farming, masonry, implement making, mining, chair making, cobbling. Now a man of fifty-three, his right hand strangely softening, Tolson dangled over a new and immense uncertainty as a door dropped open in his life.

Among nonacademic artists, often it is just such a trauma that launches their commitment to creative self-expression. Folklorist Roger Manley has

observed, "The loss of a job through illness, injury or retirement; the death of a spouse or elderly parent; religious doubt; social ostracism, imprisonment. These events precipitate their transformation from 'ordinary' farmers, loggers or textile workers into artists." Manley noted also that many such late-blooming creators were accustomed to "jobs in which they are able to see a tangible, very physical product or result at the end of each day's labor."[55] Losing these palpable achievements "casts them into a cultural shadow felt as a spiritual vacuum. They see the isolation opening up around them and feel a strong urge to plant seeds to fill the emptiness with their own creativity."[56] This psychological profile certainly matches Edgar Tolson's experience.

Six months after the stroke, Tolson had slipped into a severe depression; his doctor recommend he be committed to a mental hospital for observation, but Edgar refused to leave home. Instead, he picked up his pocketknife and began, clumsily at first, to whittle.

"After I got so I could move, really move any part about me, I began forcing myself to everything I could take. I finally got to where I could go on crutches and I'd take a rubber ball and squeeze all I could with my hand, and I got some strength in it. And then I'd be sitting around there and I wanted to do something, so I whittled out I don't know how many walking canes. . . . I carved out a lot of Masonic emblems, different things. I bet I gave two truckloads of it away."[57]

In the three years following Tolson's stroke, his family grew increasing reliant on Dr. and Mrs. Maddox; Tolson's welfare caseworker, Graydon Taulbee; and several neighbors. Not surprisingly, these friends were the recipients of Tolson's early carvings. Tolson made Martha Spencer a cane and later a pair of crutches, a Masonic compass insignia for Paul Maddox, and assorted pieces for Graydon Taulbee. "It started like that," said Tolson's daughter Flossie. "Dad had made several little pieces and things and give to people, and I'm sure it was probably to someone that had helped him."

By 1960, though Tolson was beginning to regain mobility and strength on his right side, the family was beset with other difficulties. Their daughter Mary, born prematurely in March, was taken to the orphanage in Bethany for the first three months of her life: "They fed me with an eyedropper. Mommy said they give me three drops of milk at a time out of the eyedropper. I fit in a shoebox I was so little. I only weighed two and a half pounds. When they brung me home, [Hulda] would pin me to a pillow so I wouldn't get lost."

That spring Edgar collapsed on the street in Campton. In July he was arrested for public intoxication and, as directed by Dr. Maddox, admitted for twelve days to Eastern State Psychiatric Hospital in Lexington. Maddox's September report to the welfare office spelled out Tolson's chronic health problems: his shortened leg and residual spinal injuries, "nervousness," some

paralysis caused by the stroke, ulcers. In addition, Maddox reported that Tolson "has some type of seizures either epilepsy or cerebral vascular spasm which occur 3 or 4 times a month during which he may be in coma or semi-coma for a period of several hours."[58] From 1957 until his death in 1984, Tolson was steadily medicated with phenobarbital.

Although the first piece Tolson carved during this period of rehabilitation is unknown, by 1959 he had clearly begun to whittle regularly and to give his works away. In medical records of August 1959, Paul Maddox wrote, "This man is very intelligent and is highly skilled in the art of carving." The doctor's September 1960 report to the Division of Public Assistance noted, "This man is skilled with a knife, can carve most anything he desires, canes, ash trays, picture frames and the like, is very good at this type past [sic] time."

The family physician, as well as Campton's esteemed community leader, Paul Maddox received many of Tolson's early carving efforts. Flossie Tolson Watts recounted:

Doc Maddox, he doctored us and he doctored Dad when Dad had the stroke, and he didn't charge us. I mean, he'd taken care of us but for no money. And Dad out of thanking him when he got to he could use his hand, and he started forming into stuff, I can remember when Dad made a little yoke of ox. He fixed a little board and he carved these little heads out of these steers or whatever he put on this little board, and then he made the yoke that goes around their neck and had little chains on 'em. . . . He gave the doctor this, which the doctor still has.

Michael and Julie Hall acquired a similar plaque from the Taulbee family, the heads, shoulders, and forelegs of a yoked ox team. Other versions of this subject at one time were given to Lor Ray Rice and two of Tolson's daughters—Monnie and Wanda.

Although the origin and circulation of this image in wood is not known, the ox plaque and the subject of yoked oxen more generally have been popular themes for carvers since at least the nineteenth century. Robert Bishop's *American Folk Sculpture* includes several such pieces from the Midwest, all anonymous and dated tentatively to a span from 1850 to 1920.[59] A religious image of oxen comes from the Hispanic "santos" carving tradition of New Mexico, in renderings of San Isidore, patron saint of farmers.[60]

Allen Eaton's *Handicrafts of the Southern Highlands*, published in 1937 after he surveyed Appalachia's material culture for the Russell Sage Foundation, included several examples: a reference to the covered wagons with yokes of oxen available from Tryon (North Carolina) Toy-Makers; a prairie schooner with team by Joe Burkett of Boone; and an ox-drawn logging sled by Floyd Laney of the John C. Campbell Folk School.[61] Eaton wrote, "No attempt can

be made here to measure the influence of the whittling done at the Campbell Folk School outside the community, but it is very noticeable." He cited a carving by Ross Corn of Berea, "who seeing a friend from the Campbell Folk School whittling out a goose, thought he would like to try his hand at another bird."[62] Eaton curated an exhibit of objects from the early Southern Highlands Handicraft Guild that circulated from 1933 until 1935, and in 1937 he organized a Rural Arts Exhibition for the U.S. Department of Agriculture including at least two pieces on this theme.[63]

It is doubtful that in 1959 Tolson had visited the crafts enterprises at Berea College, some sixty miles away, and even less likely that he would have seen Allen Eaton's exhibitions, yet these many examples of carved oxen suggest the wide circulation of this image throughout Appalachia by the 1950s. Evan Decker of Wayne County, Kentucky, had produced two steer head plaques in the late 1940s, and several other anonymous examples survive at John Rice

Irwin's Museum of Appalachia.[64] "Remembrances," a 1986 exhibition of Kentucky folk art, showed "logging activities and draft animals working at various tasks" as recurring themes.[65] Curator Larry Hackley singled out this "classic memory image: a wagon, containing a log straddled by a man, which is being drawn by two powerful oxen," a rustic subject repeated in the paintings and carvings of many contemporary folk artists.[66]

This manifold tradition of Appalachian ox-driving imagery suggests that Tolson drew from many sources, both folk and popular. A more interesting problem, since Tolson reported he carved "a lot of just ox heads with the yoke on 'em and a chain," is what this image meant to him.[67] Why was it among the first subjects he attempted? Was it simply the reiteration of a popular motif, or did it bear particular significance for him?

Surely, these pieces recollect "bygone days" with fondness. The subject suggests an ode to farming, the occupation with which Tolson always identified himself but that, in fact, he like many others in the region had been forced to abandon for carpentry, shoemaking, and odd day jobs. In both these senses, the ox plaques are nostalgia pieces, records of the past and tributes to a proud, if untenable, livelihood. Further, by making the oxen into a plaque, a composition borrowed from taxidermy, Tolson presented the ox team as trophies or relics. With this device he memorialized perhaps not just the old methods of farming but his own working years, which with the stroke in 1957 had abruptly ended.

Scholars Eugene Metcalf and Kenneth Ames have criticized the nostalgic dimension of folk art, especially inasmuch as it answers the yearnings and appetites of collectors: "As the masters of a seemingly fragmented, alienating, and overcivilized world where many of the traditional foundations of identity and status in work, the family, religion and community no longer seem fixed and secure, modern elites search the world for non-modern people, places, experiences, and artifacts with which to have 'natural' and 'authentic' relationships that give substance and meaning to their lives."[68] Metcalf and others have suggested that such "rusticophilia" masks the resolution of elites to maintain social dominance.[69]

Yet Tolson's carving history indicates that it is not elites only who cherish emblems of a pastoral past. Tolson and many other Kentucky carvers—notably Evan Decker, Earnest Patton, and Noah Kinney—have repeatedly chosen to render symbols of preindustrial agrarian life in wood, though for reasons of health and economics all ultimately abandoned farming.[70] In families that claim little in the way of material legacy, such artifacts may honor one's forebears, those who in fact did clear the logwoods with oxen, and memorialize at once the passing away of regional trades and the waning of one's own physical strength. If this imagery has consoled elites, it has also proved a

comfort to many less powerful Americans, who likewise experienced the fragmenting, alienating effects of modernity and who also, as in Tolson's case, had strayed from the confines, norms, and assurances of traditional family and religious life.

On most of his oxen pieces, Tolson whittled to hang between the animal heads a chain and hook carved from one piece of wood. This detail alone links Tolson to colonial carvers and to an ongoing folk tradition.[71] As folklorist Simon Bronner has sensitively examined, chain carving's technical difficulty marks the virtuoso and supplies a kind of craftsman's riddle, but its puzzling aspect offers merely a leaping-off point, into deeper questions of masculinity and aging. Similar to Roger Manley's work on creative patterns among folk artists, Bronner has offered a profile of chain carvers: "Elderly, usually retired, and originally from the country, each tells of passing time by carving chains and other objects. They typically never sold their chains, but rather gave them to friends and relatives. They learned how to carve chains in childhood from a neighbor, uncle, father, or grandfather but picked it up again only after retirement or in old age. At some point they spent most of their time carving."[72] Although we do not know who taught him the trick of chain carving, Edgar Tolson is clearly part of this brotherhood. By 1959 he was prematurely "elderly" as a result of his stroke and, returning to the pastime of his youth, had begun giving his woodcarvings away.

Tolson's son Donny remembered several local chain carvers, in addition to his father: "I'd seen some old timers down there in town. They used to sit around and whittle on cedar and make little things like that, and then Toonis Bryant I think it was, down there at Natural Bridge, one time, he had a shop down there and he was showing me some chains he'd made like that. . . . I might have been twelve or thirteen."[73] The younger Tolson recalled also Rile Tom Harris's carving in downtown Campton and Grady Bush of Zachariah, Kentucky, who, having carved a chain, displayed it in his country store. Leaving aside the question of their local origin or traditionality, woodcarving and chain carving in particular were, at least by the 1960s, familiar hobby crafts among Wolfe County men.

Edgar Tolson would feature chain carving again in the unicorn pieces for which he became well known in the 1970s. His first version, carved at the suggestion of Marian "Mike" Broadus, is simple and somewhat crude, described by the late J. M. Broadus as "a cow with a horn on it." After finishing this rather homely piece, Edgar received an inspiring postcard from admirer Sarah Asher, a detail from the seventh tapestry in the renowned *Hunt for the Unicorn* group, acquired by the Metropolitan Museum of Art in 1937 and housed at the Cloisters. In contrast with Tolson's mulish interpretation, here a delicate creature lies down with a reverential upward gaze, its hooves gath-

ered and poised, its tail rising in a spume of white. Tolson used this image as a model, making fence pales of popsicle sticks and a handcarved chain binding the mythical animal to a tree.

Edgar decided in his advanced age to carve a unicorn piece for his son Edmond, one of the very few works that Tolson and his son Donny completed together. Donny explained that he contributed the fence, the animal's horn, and "goatee," as well as the chain. "At the time . . . I'd never made a chain. His was kind of square links, you know, and I made mine more round."[74] Tolson's unicorn carving, a much requested, oft repeated piece during the 1970s, suggests how braided traditional, popular, and elite arts have been in the development of contemporary folk art. The Cloisters tapestry, debatably a piece of folk art itself, was communicated to Tolson through the popular medium of a color postcard purchased at the nation's most prestigious fine art institution. The image, in turn, stimulated Tolson to practice again the local folk craft of chain carving and to pass the technique on to his son Don. Edgar was, in the folk spirit, making a gift for another son, Edmond, but Edmond had requested the unicorn piece only after seeing the many versions that his father had already made and sold to art collectors. As well, while Donny Tolson acknowledged the chain-carving society in which he grew, he stressed how his chains were exceptional, different even from his father's, signifying the premium he placed on originality, ordinarily considered a virtue of elite or even avant-garde art.

It has been suggested that Tolson's early figurative carvings were toys, and, without access to manufactured dolls or animal miniatures, it seems reasonable that Tolson would have exercised his whittling talents to amuse his many children. Yet the sons and daughters interviewed for this study alleged that only rarely did Edgar give his woodcarvings to them, and most of these gifts were not playthings for children but objects received after they were grown, after Tolson had achieved some notoriety. Monnie Profitt remembered that Tolson gave her sister Minnie "dolls and things," but added, "We even carved our own little dolls when we was kids." Monnie also remembered Edgar's giving his son Wilgus a squirrel carving, a yellow bird with black wings, and, to pacify his crying once, a lion head mounted like a trophy, all in the late 1950s. Donny, Wanda, Flossie, and Mary said they never were given hand-carved pieces as toys. According to Wanda, her father began making dolls only after 1965, after she had moved away. Mary, recalling her earliest memories of her father's carvings, said, "I always liked 'em. To me, I thought it was a toy." But she added, "We didn't play with them. Daddy wouldn't let us." Flossie Watts agreed: "He would carve out on pieces of wood like the doll, the formation of the dolls. When he was just getting them started we would play around with them, and the littler ones that was small, hauling around or just learning to

*Unicorn,
ca. 1970.
Collection
of Marian
Broadus.
(Photograph,
Charles Bertram)*

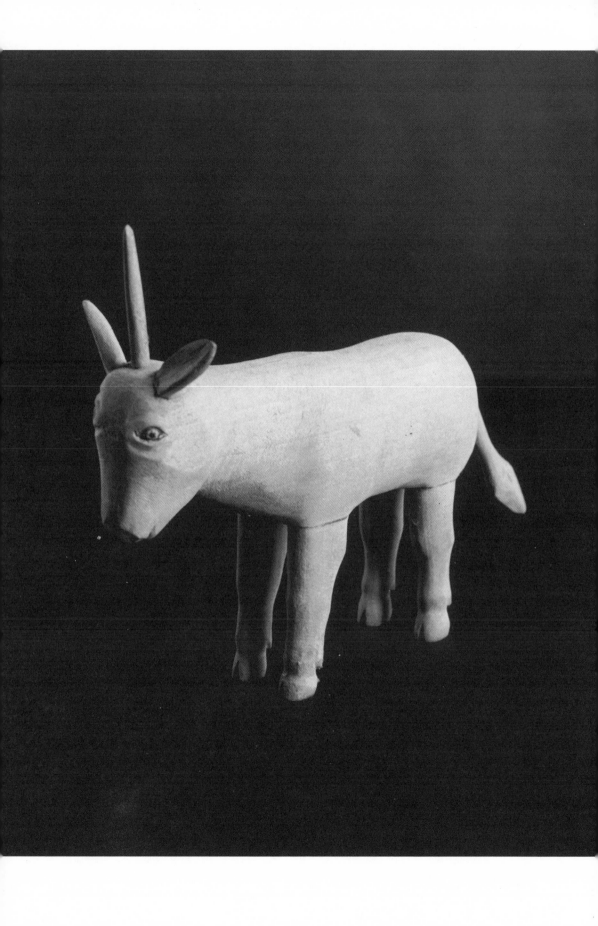

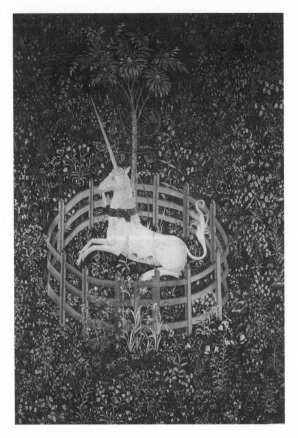

The Hunt of
the Unicorn:
VII: The
Unicorn in
Captivity.
*(The Metropoli-
tan Museum of
Art, the Cloisters
Collection,
gift of John D.
Rockefeller Jr.,
1937)*

Unicorn in
Captivity,
*1973. Collection
of Ellsworth
and Ann Taylor.
(Photograph,
Ellsworth
Taylor)*

walk, they would play with them. But now when he started carving their ears
and the little things out on 'em, like putting their arms on and their legs, then
we wouldn't be allowed to play with them." Tolson in later years gave his
daughters Monnie Profitt and Wanda Abercrombie ox team plaques. Profitt
received a snake cane and Uncle Sam figure, and Flossie Watts once owned a
larger tableau, an Adam and Eve piece. As previously mentioned, Edmond re-
ceived a unicorn in captivity in his father's waning years, but all these gifts
were made to adults, not children. No one recalled Tolson's making anything
for his wife Hulda.

Instead, Tolson gave most of his early carvings to friends, especially the
more prominent people of Campton. He presented Dr. Paul Maddox with a
Masonic plaque, ox team, and miniature spinning wheel (another obvious
memory piece) in the early years of his carving. By the early 1970s, the Mad-
doxes were displaying Tolson's woodcarvings, along with pieces by other
local craftspeople, at the busy Campton Medical Clinic; in subsequent years,
especially when he had nothing to sell, Tolson turned to the doctor's office as
a museum, touring out-of-town visitors there to view some of his work. For
his welfare caseworker Graydon Taulbee he whittled out four oxen tied to a
two-wheeled cart as a birthday gift, a piece Taulbee displayed in the Wolfe

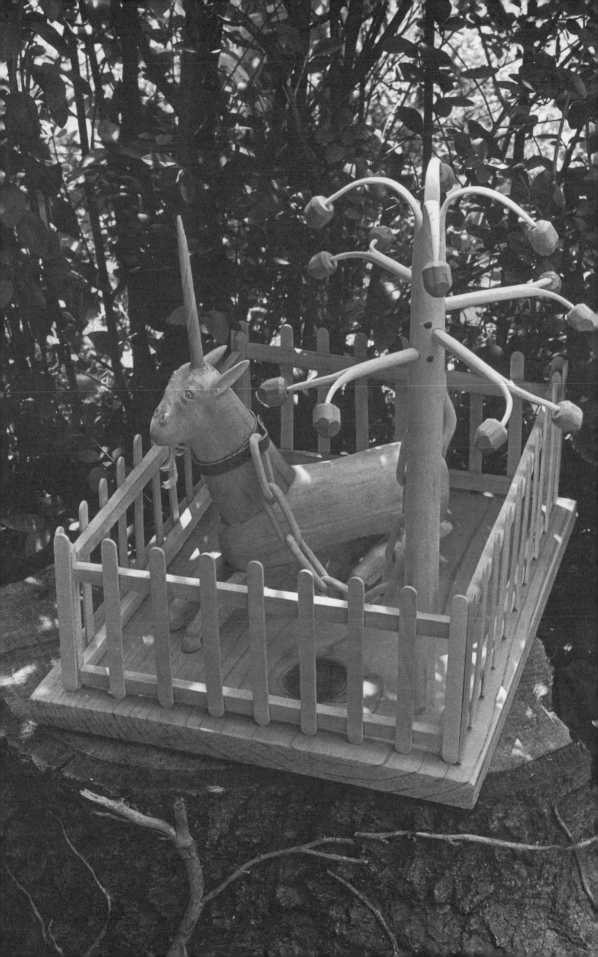

County welfare office. He also gave Taulbee a whittled squirrel eating nuts, a wooden ashtray shaped as the open palm of a hand, and the relief carving of a horse. Somewhat later Tolson carved the figure of a man in overalls and presented it to the head of Campton's Farmers and Traders Bank, where the piece was subsequently set out on display.

The most ambitious of these extant early works is *Man with a Pony* (Plate 2), made in 1962, while Tolson built the family yet another house, at Swift Creek.[75] Standing almost three feet tall, this piece depicts an African American man patting the flank of a saddled horse and holding the reins to its bridle. The man is dressed in black pants, a white shirt, a smart polka-dotted black necktie, and red boots. Originally, the figure wore a cap also, until Tolson's son Wilgus, aiming at a bird, "shot the bill of the hat off with a .22 rifle."[76]

The source of this image is unknown. One stimulus is very likely to have been the standard concrete jockey boy, a piece of similar scale and a fixture in yards all across central Kentucky at the time.[77] These lawn ornaments typically feature a black jockey in white shirt, black pants, boots, and cap, extending his right arm and clenching a metal ring, where one might tether a horse. The dapper costume of Tolson's figure, especially with its original cap, further suggests that the carving represents a jockey rather than a groom or farmhand. Also, the horse has been fitted with a lightweight saddle, the proper tack for racing. The animal's exaggerated legs, very long and slender, also indicate Tolson may have been rendering a thoroughbred horse, though the animal bears the marking of a pinto "pony." While employed in Clark County, Edgar would have seen many of these jockey yard decorations; the farm on which he was working tobacco may also have been a horse-breeding or -training operation.[78] In any case, he appears to have seized on this popular Bluegrass icon and made it his own, emphasizing the relation between horse and rider. Another indication that Tolson may have been emulating mass-produced lawn statues is that earlier, during the family's years at Holly, he had carved several yard flamingos for his son Tom.[79]

The recipient of *Man with a Pony* was again a prominent acquaintance, Forest Cable, a former Wolfe County schoolteacher and caseworker at the local welfare office. Cable and his wife, Monna, kept the piece in their house for several years, but after Mr. Cable died in 1965, his widow moved the woodcarving out onto a porch, where it remained for almost four years. Thus, whether Tolson intended to make a yard ornament or a museum piece, he in fact made both: the work is now part of the Milwaukee Art Museum's permanent collection.

Edgar himself used a cane, and had intermittently since his mule-driving accident at age eighteen. Once he turned to carving, he produced canes in

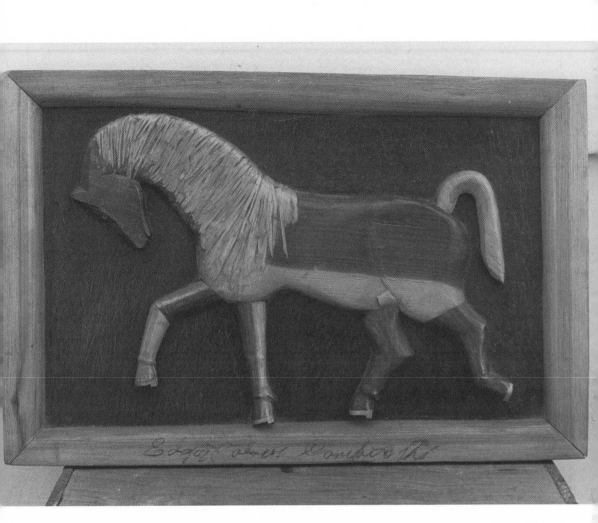

Early relief carving, ca. 1962. Collection of Graydon Taulbee. (Photograph, Ellsworth Taylor)

considerable numbers, simple, utilitarian ones to sell through Campton druggist Eddie Yeager's store and more elaborately decorated walking sticks for friends, family, and dignitaries. For his old friend B. F. Taulbee, Tolson carved a cane encircled by two snakes and incised with a bell, eagle, and the word "LIBERTY." This piece, the only known one of its type by Tolson, was made in the early 1960s.[80] Most of Tolson's decorated canes are plainer, carved with only one twining serpent, sometimes two. Among his first decorated sticks were gifts to Dr. Maddox, the local mortician Lewis Porter, and Edgar's brothers Elvin and Logan.[81] Tolson also presented canes to Kentucky governors Bert T. Combs and Edward T. Breathitt and later to Senator Wendell Ford. It may be significant that Combs, himself an Appalachian, who led the movement to fund construction of the Mountain Parkway through Campton, also officially restored Tolson's civil rights December 2, 1960. When Governor Breathitt came to Wolfe County in April 1967 to commemorate the opening of Wolfe County's first library, Paul Maddox introduced Tolson, who presented the governor with one of his trademark canes.[82]

Simon Bronner has written, "Going beyond the bounds of the utilitarian cane with a design all his own, the elderly carver tells himself and others that he is not to be lumped with a stereotypical group of oldsters but is an individual brandishing the power to create."[83] Just so, Tolson's snake canes, suitable for their stricken maker to lean on, were also fit accessories for doctors, professional men, politicians. Through these works, as through his other carvings, Tolson asserted his rightful place. Incapacitated from former livelihoods, beleaguered by poverty and ill health, burdened with a large family, Tolson's cane carving and cane giving permitted him, if not power itself, then at least contact with the powerful; through the personal sculpture of a walking stick he might address a United States senator man to man.

In his persuasive study, Bronner finds that chain carving—seemingly an innocuous pastime—expresses deep, contradictory attitudes toward the world. On the one hand it is a distracted, inward gesture, a way for elderly men to engross themselves within the solitude that often becomes their lot; more willfully, they may find in whittling the means for escaping a world where they no longer find much comfort. Yet the whittled chain is also a mark of pride, offering the satisfaction of a job completed (a job not just everyone can do) and a badge of virtuosity, an object to show. In chain carving, and I would submit, in all carving, introspection is transformed into exhibitionism. This mixture of impulses seems also to have moved Tolson to take up his carving knife.

When he was still a young man, Edgar appears to have been singled out by his family. His brother Elvin contends, "My mother spoiled him," keeping him aside while the rest of the children were expected to work. After Edgar's accident at age eighteen he began to preach with "Uncle Dick" Tolson at revivals and local church meetings, stepping into his father's respected calling. His lay ministry grew shadowy in the late 1930s, however, when Tolson drifted from home—perhaps on the pretext of preaching—and took up with another woman. According to Elvin Tolson, their father expressed his disdain for Edgar's behavior: "He didn't do like my dad and my dad got on to him. [Edgar] was a preacher, he'd preach the truth, but the cares of the world drawed him away . . . women and whiskey."

After Tolson served his year in the penitentiary, was divorced from Lillie Smith, and married Hulda in 1942, he continued to preach, though sporadically. According to Monnie Profitt, "He gave it up and then he took it back up and then he'd give it up and take it back up again." She remembered her father's leaving to preach a revival with Herbert Hollon the night her half sister Wanda was born, in August 1948: "[Hulda] was in labor, and Daddy left and he went on his way and got the midwife which was Mrs. Golden, and he went on to church, to hold church." In the late 1950s, Profitt said, Edgar made sev-

eral trips with Herbert Hollon to Powell County, where Elvin Tolson lived, to preach for Baptist gatherings. These services were the last days of Edgar's lay ministry that Profitt remembered.

Rarely, if ever, did Tolson's family accompany him or have the opportunity to hear him preach. The children grew excited with the preparations as Hulda would "wash and iron his white shirts."[84] Watts said, "They'd have revivals and he would be getting ready to go somewheres and we thought that was special, you know, somebody going somewheres. . . . I can remember him going to preach, but I don't remember ever seeing him preach." In this role, one that dignified and distinguished Tolson in the larger community, he utterly withdrew from his family. Since Tolson never owned a car or was able to drive, bringing such a large group with him to church would have been complicated; still, the family's absence from his ministry was so absolute as to constitute a kind of statement.

It is a statement Tolson reiterated in his practice of carving. As previously discussed, his early pieces were all gifts to prominent people, most of them men around Campton, rather than presents to family. In fact, Edgar neglected to keep pieces even for his own enjoyment, preferring to expend his talents in cultivating or sustaining social relations with Campton's elite. Furthermore, Tolson consistently maintained a retreat from his wife and children, despite the financial burden of keeping a second residence. In the late 1950s he opened a workshop in town, "where he repaired furniture, filed saws and worked on guns, and carved in his spare time."[85] In 1961 he built and moved into a shop on property he had purchased at Swift Creek, where he carved *Man with a Pony*, while the rest of the family remained at Bear Pen. In the late 1960s he rented a separate house that overlooked Campton, and in the 1970s he retired to a small blue trailer that Michael Hall purchased with proceeds from sales of his woodcarvings. Like the chain carvers Bronner met and studied, Tolson associated whittling with refuge and typically carved at a distance from his wife and children.

Despite the scores of visitors who have written and spoken confidently about Tolson the man, his own children continue to find him enigmatic. Wanda Abercrombie said, "He was the type of person that didn't sit down with us and talk about anything. He just didn't do that . . . Maybe that's the only way he knew. We only do things the way that we know. I think you can just express your love the only way you know, the way you've been raised. And maybe that's as much as he could give. I'm sure he loved Mom or he wouldn't have stayed with her all them years. I really don't know that much about my father, as a person."

Flossie Watts agreed: "Daddy was a private person. He was a person that didn't express himself. And like I say, if something was going on and you

wanted to know something about it, you wouldn't hear it from him. I mean, he wouldn't just come in, sit down and tell you about it. If you wanted to know something about something, you had to specifically ask him . . . He'd just answer your question and that'd be the end of the discussion."

For a man of his locality, social class, and generation, Tolson's detachment was not strange, yet he did strain extraordinarily the bonds of family by subjugating himself to two implacable masters: a fundamentalist faith he could neither share nor sustain, and alcoholism. According to Elvin Tolson, drinking "snared" Edgar during his first marriage, estranging him not only from his wife Lillie but from his minister father also. When by 1960 it became clear Tolson would never regain enough strength to farm or carry on the heavy trades that had always sustained him, he wheeled downward. By spring 1960, his doctor concluded that despite Tolson's intelligence and willpower, "with his present educational level and with his present training and in his present condition, I don't believe he can earn a living by working." His medical records portray a man "despondent because he cannot work and disgusted with himself." Two months after this entry in the medical log, Tolson in a drunken spree opened fire on his neighborhood and was headed for the state psychiatric hospital.

According to Mary Tolson, "People thought he was a tough person, heartless or whatever, but Daddy was just a real gentle person. Daddy was a scared person really." His daughter Wanda described him as "a mixture of two people. For years he'd read the Bible. He'd come in from work, he'd set with the Bible, he'd read till dark. He didn't drink then. I think that's when he was preaching. I'm not sure. And then all of a sudden, he doesn't read the Bible no more, and he drinks. But still, if you got into a conversation with him, he'd always bring up the Bible, always referred to that Bible, so I don't really know. It was like two people, fighting with each other on the inside of him."

Tolson revisited his alcoholic demons periodically over the next five years, 1961–66, landing once in jail and several times at the Campton Medical Clinic. Beginning in 1966 the clinic visits increased; Tolson was, according to the medical record, "already hooked" on phenobarbital and would routinely appear to refill his prescription or to dry out in one of the monitored beds. Increased drinking through the 1960s, complicated by his advancing years, brought on anorexia and anxiety. A notation from January 1970 stated, "He looks like he is deteriorating and if he doesn't get in a hospital and stay off the booze for awhile, he is going to die."

Tolson was repeatedly admitted to detoxify in Lexington hospitals—in 1970 and 1971 and each year in 1973–76—visiting the Campton doctor regularly throughout these years for ailments due to drinking. Rick Bell, who befriended Tolson during this period, conceded, "The alcoholism sort of over-

rode everything. It was like the great reality."[86] Bell remembered finding Tolson in Campton at the end of a binge in 1970: "He'd been on a long drunk, really bad drunk, and I went in. He was staying with one of the kids and was literally on a cot. I thought he was dying, right on the spot. And I said, you know, 'We've got to get him to a hospital. We've got to dry him out.'" Bell drove Tolson to his own apartment in Lexington "and had one of the most dreadful nights in my entire life, with Edgar. Unfortunately, I only had two beers in the house. Sunday night in Lexington there's no beer, of course. And I stayed up with him all night trying to just keep him together enough to take him to the med center the next morning. . . . At one point I remember him pulling me down to his face and saying, 'Your face is prettier than Jesus.'"[87]

After an episode in December 1974, Tolson's physician wrote, "Looks like he has been pretty close to the Cross." His nervous condition, never specified, worsened, and in the last decade of his life physicians routinely prescribed Valium and Librium. Increasingly desperate, Tolson attempted suicide in 1978 and again in 1983, the year before his death.

As James Clifford has insisted, every ethnography is "always caught up in the invention, not the representation, of cultures."[88] Such inventions are made admissible, in fact made possible, he has argued, through the licensing and legitimizing forces of political inequality and social convention. Yet

this particular ethnographic study, trained now upon one man's life, is peculiarly skewed owing to the very character of those documents he left behind: documents of human extremity, they embody either the most concerted self-fashioning or abject helplessness.

Tolson knew that his woodcarvings, his art, would speak in his absence. Interviewed for the federal Archives of American Art, he said, "I'm really proud that people think that much of my work because it's something that makes a record for you, and it's something that you're going to leave behind one of these days. And it'll be here when you're gone. There ain't too many fellows left anything here as they went out, that you could see." Through desire and skill, Tolson measured in a portrait of himself as he carved, a calculation that does not particularly distinguish him in cunning, since such is the effort of every artist. Yet to comprehend a person through his or her art is to capture less a life than a performance, one in which a person enacts his best perfected self. As documentary evidence "that you could see," a work of art stands vividly for its maker, but not completely. Psychological studies have, of course, been made of artworks, a burrowing effort to expose the person "behind" the work, when, actually, in a piece of art the best exerted stratagems of will, the most convincing capacities of craftsmanship fall most richly between the artist and the viewer. Though an artwork, mustering all its formal and expressive rhetorical capacities, may say, "Here I am," it is always primarily an idealized version of the self, the most decorous of introductions: "This is what I would have you know of me."

Tolson left a sumptuous legacy of this idealized sort, but he also left records of a very different stripe. These are the documents that, in the culture of the late-twentieth-century United States, impoverished people typically leave behind—relief office memos, medical logs, prison files.[89] They differ immensely in kind from records left by elites: personal letters, school transcripts, photographs, wills, furniture, libraries, ticket stubs, and party invitations. Even in the more neutral medium of a tape-recorded interview, upper-class informants hold an advantage if only because they are more accustomed to recounting their past experiences, thoughts, and opinions; they are better rehearsed, more artful.

The written records of uneducated people typically inscribe their very vulnerability, just as those of (or, to be more accurate, "by") the rich evidence powers of self-description, leisure, and inviolateness. Rather than offering the composed self-presentation an artwork makes possible, the artist interpolating a persona between self and audience, these administratively gathered documents conduct, in Michel Foucault's terms, an "examination" of the subject. Even the artist, in this case, is laid open for a kind of scrutiny over which he can exert little or no control. Rather than the guiding author of our

impression, he becomes the impaled and desperate object of voyeurism. Both these tools, in effect, are distorting lenses, one magnifying Tolson's coherence and power, the other his derangement and frailty.

From these documentary extremes, the chapters that follow endeavor to realize Edgar Tolson the man and the artist more fairly and, in doing so, to answer larger questions his life and reputation suggest about how symbolic meaning is marbled with social power. To this end I have striven to find—and through interviews, to create—other sorts of documents, sources neither as idealized as sculpture nor as subjugating as medical charts. I have sought a methodological middle ground, between the interpretative realm of literary hermeneutics, valorizing meaning, and the empirical domain of mute but stubborn facts. Clifford Geertz has written, "It is not whether phenomena are empirically common that is critical in science—else why should Becquerel have been so interested in the peculiar behavior of uranium?—but whether they can be made to reveal the enduring natural processes that underlie them."[90] Thus from the singular, striped, and contradictory history of a man and his creations may come, if not a theory of culture, an illumination of those social forms that art, in its familiar strangeness, engenders and endangers.

 olson's carving began as child's play. Practiced fifty years in trades of carpentry and implement making, it became a skill. During the years at Holly, Tolson turned carving to more personal and expressive uses in the plank house, with its animated stone steps, and the several guardian statues made to mark his property. After the stroke in 1957, he carved as therapy, to rehabilitate his left hand and distract him from worry. "It helps me forget my sickness. Now just setting around and doing nothing, you get wore out," he said in later years. "It's pastime for me. . . . You've got something to occupy your mind."[1] As adjustment to his disability, Tolson's refuge in carving also became a form of saving face; no longer able to earn a wage, he offered whittled gifts to his doctor, welfare caseworker, and banker. In 1967, however, his woodcarvings were enlisted in several larger cultural programs and, through these movements, reached new publics. As a consequence, Tolson's dolls evolved to absorb, bespeak, and repulse several ideologies—of political activism, regional pride, and economic development—that attended the nation's rediscovery of Appalachia.

Barbara Ehrenreich, to understand the social revelations of the 1960s, asked, "If the poor and the working class had to be discovered, from whose vantage point were they once hidden?"[2] Her answer, of course, is the middle and upper classes, who, through the flush 1950s, had grown to assume postwar affluence as a general condition. While many forces converged to shake this complacency, it was the civil rights movement that most brazenly exposed injustice in America and brought impoverished people into coalition. The Montgomery bus boycott, Greensboro sits-in of 1960, Freedom Rides of the following year, Birmingham riots, and 1963 March on Washington, where Dr. Martin Luther King delivered his "I Have a Dream" speech, not only exposed the facts of American poverty and racism, realities long familiar to many, but through an expanding mass media culture, these events broadcast the success of African Americans in building and sustaining political strength.

Whites in the movement, many of them young, college-educated leftists, had been galvanized by the civil rights cause. Tom Hayden, soon to be presi-

dent of Students for a Democratic Society (SDS), wrote in the fall of 1961, "Those Negroes are down there digging in, and in more danger than nearly any student in this American generation has faced. . . . When do we begin to see it all not as remote but as breathing urgency into our beings and meaning into our ideals?"[3]

In the 1963 Mississippi Summer Project 300 volunteers, 250 of them white, were to serve as a shield against southern police violence, but by summer's end there had been six civil rights murders and scores more shootings, beatings, and church bombings. Sociologist and former SDS member Todd Gitlin recounted, "While many Negroes were grateful for the help of whites—in voter registration, freedom schools, and many another summer project— many others were enraged that killings, beatings, and jailings were worthy of the ministrations of the media, the FBI and the Justice Department only when whites were in jeopardy." Black organizers both suspected and in many cases found that "white students would swamp the local Negro leadership, over-whelm them with skills and arrogance, then leave the movement disrupted when the autumn came and college called."[4]

In August 1963 Stokely Carmichael of the Student Nonviolent Coordinat-ing Committee (SNCC) proposed that blacks and whites organize separately. The following August 1964, Lyndon Johnson issued the Gulf of Tonkin Reso-lution, escalating the war in Vietnam. That same month the Democratic con-vention in Atlantic City failed to recognize the Mississippi Freedom Demo-crats, representing 80,000 African Americans who had registered to displace the state's all-white delegation. Atlantic City, disclosing an armored Demo-cratic Party machine, undermined the hopes for any real coalition among its racial, generational, and political factions. Carmichael concluded, "The major moral . . . was not merely that the national conscience was generally unreliable but that, very specifically, black people in Mississippi and through-out this country could not rely on their so-called allies. . . . Black people would have to organize and obtain their own power base before they could begin to think of coalition with others."[5]

As both the political and cultural dimensions of the black power move-ment gained momentum, white leftists, rebuffed, turned their energies in-creasingly against the war. At the same time, their politics assumed an increasingly expressive hue. Accommodating political action to cultural ex-pression, whites, too, focused on "the perfecting and proliferating of identi-ties, . . . the idea of 'liberation,' the movement as a culture, a way of life apart."[6] To these ends, many white liberals and leftists realized they might carry on the fight for civil rights in Appalachia, this time among whites, in a land of strong cultural traditions and a region seemingly distinct from bour-geois America. Don West, founder of the Appalachian South Folklife Center

Coal Miner,
1969.
(Photograph,
Rick Bell)

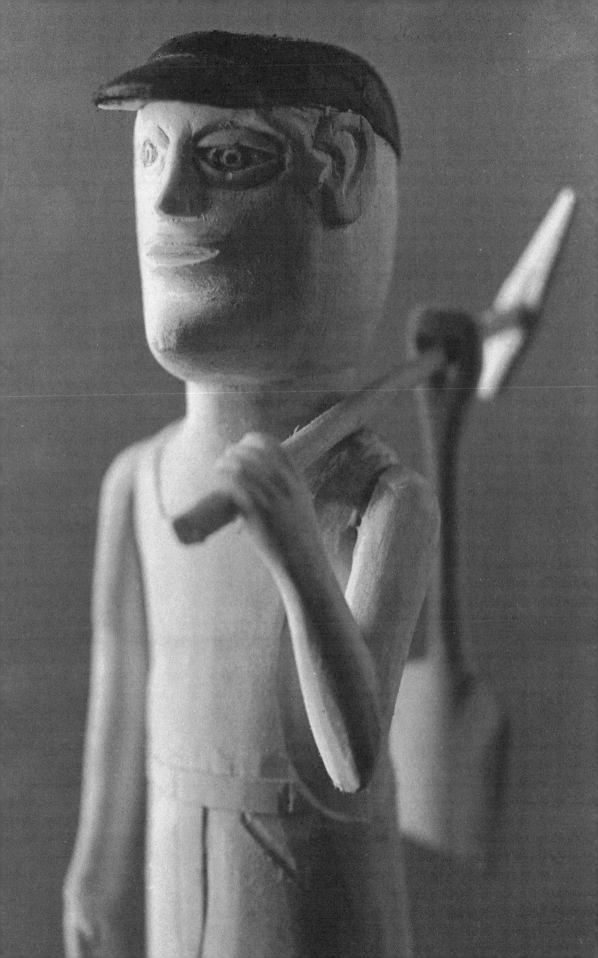

at Pipestem, West Virginia, put it bluntly: "Since the black militants kicked the whites out, suggesting they go organize their own kind, the next most romantic thing seems to be the Appalachian South."[7]

The allure of Appalachia, and its political consequences, have been examined by many insightful authors and artists.[8] These commentators, who differ in important ways, all have described Appalachia as a kind of stage where outsiders periodically enact American dreams: of rapacious capitalism, missionary uplift, individualism, racial purity, fundamentalist faith, traditionality, adventure, and Protestant industriousness. Comprehending the region as an "invented" rather than a natural or geographic entity, Allen Batteau wrote, "The important context for the making of Appalachia was not in the region. . . . Rather, as a mobilizing of moral resources in preparation for confrontation with other groups — immigrant-criminal-anarchists in the 1890s, freebooting capitalists in the 1930s, and southern rednecks in the 1960s — it existed in national arenas. By creating a domestic preserve of pure Anglo-Saxonism and rugged patriotism, these groups could augment their moral stock for more important battles."[9]

This assessment, despite its perceptiveness, takes an overly strategic view of human interaction. To see Appalachia as a kind of moral arsenal ignores the complexity of the romantic tradition, belittles the ties between insiders and outsiders, and exaggerates the degree to which cultural interchange may be dominated by one group or another. Furthermore, perhaps out of embarrassment, many who have deconstructed the romance of Appalachia neglect that their own fascination or allegiance in part springs from that same suspect source. They rush to identify themselves with mountaineers, as natives, allies, or advocates, maintaining the long, angry perspectives that a film camera or college campus window permits. Many such defenders too have instrumentalized Appalachia and obfuscated how their own secure academic or artistic careers were established on the basis of public rage. The purpose here is not to demean such efforts or to dismiss them with familiar labels but to elucidate how this tradition was revived and transformed at a particular time in American history, in a particular place — Wolfe County, Kentucky — and to understand how a doll carved out of poplar could gather so many forces of that tradition behind it.

Antonio Gramsci, contemplating the possibility of a national literature in the fragmented Italy of his own day, wrote, "Among its other meanings romanticism has assumed that of a special relationship or bond between intellectuals and the people, the nation."[10] Todd Gitlin, himself an SDS organizer of Appalachian "exiles" in the ghettos of Chicago and Cleveland during the mid-1960s, alluded to his own part in this ongoing relationship, seeing the work of SDS as an outcome, in part, of aesthetic precedents. Reaching back to

James Agee and Walker Evans, and further to Leo Tolstoy, Paul Gauguin, and Henry David Thoreau, he wrote, "A strain of radical intellectuals has insisted not only that simple people, especially peasants, are entitled to justice but that they are unspoiled repositories of wisdom, insulated from the corruptions of modern urban commercial life; that despite the injuries meted out to them, or perhaps because of those injuries, they remember something about living which the prosperous have forgotten."[11] In Appalachia, the "bond between intellectuals and the people" would after 1964 be forged along two axes — politically, through continuing work to democratize power and wealth, and culturally or expressively, through efforts to construe, retrieve, and record the region's collective memory. Both movements would involve Edgar Tolson.

To political purpose, attention on Appalachia was intensified by several publications, especially two books: Michael Harrington's *The Other America*, published in 1962, and Harry Caudill's *Night Comes to the Cumberlands*, which appeared the following year. In the oft told story, these works, reviewed in the national press, caught President John Kennedy's attention and steadied his resolve to develop Appalachia's economy. The Kennedy administration, after meetings with the Conference of Appalachian Governors, came to describe poverty through Appalachian problems. One planner of Kennedy's poverty program conceded that the administration in 1963 was less focused on black ghettos than mountain hollows, writing of the burgeoning War on Poverty, "Color it Appalachian if you are going to color it anything at all."[12] Homer Bigart's front-page exposé of Letcher County in the *New York Times* that fall described "pinched faces of the hungry children, the filth and squalor of cabins," and provoked a rush of editorials.[13] Caudill's book included a foreword by Kennedy's secretary of the interior, Stewart Udall, and praise from Peace Corps director Sargent Shriver. Through the combined impact of these woeful stories and accolades, "Kennedy realized that there might be political gold up in the mountains of misery."[14]

Miserable they were. Wolfe County, according to the 1960 census, was the nation's second poorest county, its median family income only $1,455 (as compared with the Kentucky median of $4,051, $5,660 nationally). Of Wolfe County families more than 80 percent had annual incomes of less than $3,000. None recorded incomes over $10,000. County residents were poorly educated too, with median school attainment of 7.9 years (the 1960 national median for schooling, 10.6 years). Housing conditions were particularly disastrous. In 1960 76 percent of households had no refrigeration; 88 percent had outhouse toilet facilities or none at all; 89 percent of Wolfe County houses had no bathtub or shower.

Although fertility rates stayed high, Wolfe County showed a startling decrease in population; owing to outmigration Wolfe's population dropped 14

percent from 1950 to 1960.[15] With only small deposits of high-sulfur coal, Wolfe County has always relied more on agriculture than its neighbors, but agricultural employment, too, had begun to decline.[16] The county's population was aging, and its economy had grown increasingly reliant on government transfer payments in the forms of Aid to Dependent Children and the allied Unemployed Parents or "happy pappy" program.

While the national media portrayed tumbledown shacks, wispy-haired grandmothers, and barefoot children, images driven home in Charles Kurault's CBS documentary "Christmas in Appalachia," which aired in December 1964, eastern Kentuckians had not been meekly waiting for a Christmas miracle. An organization of coal miners centered in Perry County had instigated wildcat strikes beginning in late summer of 1962, after the United Mine Workers (UMW) announced its plan to revoke the health benefits of some four thousand miners in Appalachia. The union claimed it was forced to renege on the members' "hospital cards" because mine operators had failed to pay coal royalties into the union's health care fund, as stipulated in the UMW's contract. In the fall of 1962 the union went further, announcing its plan to sell or close four regional hospitals.[17] "Roving Pickets" worked through several eastern Kentucky counties closing down mines that autumn and through the following year. Coal tipples and railroad bridges were set afire in protest.

By 1963 Berman Gibson, a muscle-bound, charismatic miner who had been thrown out of work, emerged as the group's spokesman, and, as news accounts of the Roving Pickets appeared in the national press, Gibson was invited to New York City, courted by a group of liberal and radical whites who hoped to leap aboard the miners' cause. The Committee for Miners was formed under the direction of Paul Wagner, brother of New York's liberal mayor. A flier announcing a benefit concert of folk music described the committee as "a group of economists, trade unionists, city planners, students and activists," and its task: to provide "technical assistance through its skilled field and research staff" and raise funds for financing "the efforts in Hazard."[18]

Kentucky miners took their protest to Washington in early January 1964, meeting with Kentucky senator John Sherman Cooper and demonstrating in front of the White House. Granted an interview with George Reedy of Johnson's staff, they were told the president planned a generous Appalachian relief program requiring "maximum feasible participation of the poor." The miners were encouraged to return to the mountains and to focus their mental and organizational energies on planning how promised federal support could best serve their localities. That same evening, January 8, in his State of the Union Address President Johnson declared "war on poverty." In light of the miners' organized protest, their powerful northeast sympathizers, and

the violence that had inflamed eastern Kentucky for more than a year, Johnson's War on Poverty in Appalachia begins to appear less an act of national conscience or benevolence than a desperate attempt at peacekeeping.[19]

In March, the newly formed Appalachian Committee for Full Employment, organized by the Perry County–based miners group, arranged a meeting jointly with SDS. At this "symposium" on conditions in the mountains, held at the Allais Union Hall in Hazard, March 28, 1964, Gibson held forth before a crowd of nearly two hundred, half local people and half students, both black and white, from across the Midwest. Novelist Gurney Norman, then a reporter for the *Hazard Herald*, remembered being cautioned by one wary citizen, "Be careful, honey, a lot of them are art majors."[20]

In fact, there was a strong cultural dimension to this assembly of union activists and campus radicals, in addition to its overt political purpose. The Committee for Miners arranged for a group of the era's most popular folk singers, including Carolyn Hester, Phil Ochs, Tom Paxton, and Eric Anderson, to "see the situation first-hand."[21] Paxton was inspired to write "The High Sheriff of Hazard." As late as 1968, the New York committee was continuing to raise contributions through its New York offices and to enlist folk singers for benefit performances, among them Judy Collins, Mississippi John Hurt, Dave Van Ronk, and Hedy West.

The pattern of urbane American artists aligning themselves with Appalachia's poor was already well established.[22] In Kentucky specifically, the regionalist revival of the 1930s, flowering in literature, music, and handicrafts, had been politicized. Novelist Theodore Dreiser came to Bell County during the violent strikes of 1931 with an investigative team of journalists, posing for the newspapers with Bell County songwriter and activist Aunt Molly Jackson; Pete Seeger soon thereafter befriended Jackson's half brother, miner and musician Jim Garland.[23] Banjo-picking fund-raisers staged by the Committee for Miners in the 1960s were, in part, an effort to refasten this legitimating tie between East Coast radicals and resistant mountaineers.

The Area Redevelopment Administration had been inaugurated during the Kennedy years; however, it was with Johnson's presidency that money began to flow into Appalachia through multiple federal projects. Significantly, Johnson's poverty program for the mountains split a large-scale, public works agenda from more microfocused, community action projects, assigning the former to the Appalachian Regional Commission (ARC), the latter to the Office of Economic Opportunity (OEO).[24] Emphasis on human development and infrastructural improvements rather than social and economic change largely characterized the Johnson poverty program and, in the analysis of David Whisnant and others, partly explains why its impact was shallow. Likewise, by the time Johnson visited the mountains in April 1964, it was clear the

credo of "maximum feasible participation of the poor" had been abandoned. Federal moneys were not to be administered by local organizations like the Appalachian Committee for Full Employment but piped through existing state, county, and municipal lines, lines long clogged by political corruption.

Of all the War on Poverty programs, those that registered the greatest impact in Wolfe County were three administered by the OEO: the Community Action Program (CAP), the Volunteers in Service to America (VISTA), and the Appalachian Volunteers (AVs). Formed by the Economic Opportunity Act of 1964, the Community Action Program funneled federal antipoverty moneys to state and local nonprofits; the Head Start program for preschool children living below the poverty line was CAP's most notable success. VISTA, designed as a domestic Peace Corps, recruited its volunteers initially from college campuses for one-year placements, charging them rather vaguely to "alleviate human need."[25]

Appalachia had been crisscrossed for a century by curious students, arriving with every kind of agenda—touristic, scholarly, evangelical, radical. Thus were the War on Poverty's Appalachian Volunteers, in Whisnant's words, "born of a tradition that had both conservative and radical strains, and their efforts eventually partook of both."[26] Originally, the AVs were an offshoot of the Council of the Southern Mountains, an interdenominational consortium of mountain missionaries and community workers with a fifty-year history in the region. A member of Kennedy's special projects staff proposed in 1963 that the council recruit college students from within Appalachia to spend weekends working in local communities, winterizing homes and schools. In 1964, with the influx of OEO funds after passage of Johnson's poverty bill, the council expanded this pilot project, hiring additional staff, recruiting local nonstudent volunteers, and arranging for VISTA workers to be assigned as Appalachian Volunteers in the region; by summer 1965, 150 VISTA volunteers were working in the AV program.

In Wolfe County, the first AVs were weekend recruits from the University of Kentucky (UK). David Holwerk of Lexington began AV work in the fall of 1965 for social reasons. "In my freshman English class there was a girl I thought was real cute and she had started going to eastern Kentucky with the Appalachian Volunteers on Saturday to work on a one-room school house in Wolfe County, and I thought, well, I don't have anything to do on Saturdays so I sought out the Appalachian Volunteers too." Holwerk, his friend Mary Kay Stolz, and as many as ten others would meet Saturday mornings in the basement of the university's student center, at the AVs' campus office, and drive the hour and a half to one of Wolfe County's one-room schools. The Mountain Parkway, a four-lane road leading from Interstate 64 east of Lexington through Tolson's town of Campton, had been completed that year.

The college students spent most Saturdays painting school buildings, organizing games, or reading with local children; AV files of 1965 recorded that the University of Kentucky volunteers took part in neighborhood cleanup projects, dug garbage pits, planted flowers, and set up a basketball goal. Holwerk remembered a disjointed and largely ineffectual program:

> Lots of times when we'd get there, there wasn't anybody there and we had to go around and scrounge them up. One day we were going to lay a new floor in a school but we got there and nobody had any tools and so we didn't manage to do anything except get one guy's hand cut open pretty good with a knife. We spent an entire day one time trying to find some pumpkins in Wolfe County because it was about Halloween. There are not any pumpkins or were not any pumpkins in Wolfe County in that particular year and we tried to make jack-o-lanterns out of cushaws.

That same fall the AV leadership proposed that the OEO fund training for "community action interns," local people who, under AV supervision, would establish work-study centers in their own localities. According to Whisnant, the AVs had by late 1965 begun shifting philosophically from a self-help approach, a legacy of the Council of the Southern Mountains, to a more activist program of community organizing; as Whisnant wrote, "The irony of acting responsibly in one's own behalf under someone else's direction did not become clear until later."[27]

As a result of these philosophical differences (and the Appalachian Volunteers' success in attracting favorable publicity), the AVs broke with the Council of the Southern Mountains in April 1966, swiftly incorporated, and petitioned the OEO for its own budget. The Office of Economic Opportunity did recognize the newly autonomous AVs and funded the largest summer project ever in 1966, involving some five hundred VISTA college recruits and increasing the ranks of local volunteers as well.

Wolfe Countian Mary Dunn was recruited in 1966 by two VISTA women from Louisville. Mrs. Dunn and her husband, Darley, had purchased and farmed a hilly thirty acres at Sandy Ridge since 1940, using a heifer calf as down payment and "working out" the rest to their landlord over time. Dunn joined the AV-VISTAs eagerly and was a paid staff member for three years. She remembered that when the recruiters first described a "war on poverty," she told them, "'I've been fighting that all my life.' I was really happy to do whatever I could to help."

Sandy Ridge applied for an AV summer program, listing among its goals "tutoring in arithmetic," "pot luck suppers (community meetings)," "wood work," and "trips to airport, horse farm, Frankfort, Natural Bridge." The Dunns and two other couples further agreed to house student volunteers

throughout the summer. One of them was Gene Conti, a nineteen-year-old VISTA-AV from Pittsburgh, who moved in with the Dunns. Conti would return to Sandy Ridge in 1974, as a graduate student in anthropology from Duke University.[28]

Wolfe and neighboring Breathitt County were overseen by fieldman Mike Kline, an Appalachian Volunteer from suburban Virginia. To head the 1966 Wolfe County summer project Kline hired Stanford University graduate Michael Royce, son of Wisconsin's liberal congressman Henry Reuss.[29] In all, Royce directed some fifty AVs that summer in Wolfe, Breathitt, and Owsley Counties.[30]

At the orientation for summer AVs, held at East Tennessee State University, leftist rhetoric competed with the "general do gooder talk," according to David Holwerk. He remembered that soon thereafter some two hundred Kentucky AVs traveled to an abandoned coal camp at Royalton, in Magoffin County, for additional training: "That's where things got intensely political." Mike Kline had brought in a number of speakers, students from Oberlin, Harvard, and Berkeley, and Alan McSurely, a friend who had been politically burnished through work in the juvenile courts and poverty programs of Washington, D.C. McSurely advocated organizing not community kitchens but a full-scale political revolution; his ideas astounded many of the AVs present. Michael Royce had traveled to the meeting with Ray Fugate of Barwick. "I was a nineteen-year-old kid, idealistic but fairly naive," he reflected. "They were all talking Marx and Lenin, and we were kind of blown away by the experience." Holwerk said in retrospect, "It seemed to me that the McSurleys were essentially out of it, that they were talking about a world that existed somewhere other than the world in which we were living. I couldn't imagine how you were going to make this sort of neo-Maoist socialist workers' vision of the world apply in Wolfe County, where as near as I could tell the populous was more conservative than they were in the suburbs of Lexington."

Although much of the summer program did focus on children's educational and recreational activities, the hiring of local VISTAs like the Dunns and the AV leadership's new commitment to a Saul Alinsky style of community organizing meant that by summer's end AV projects had begun to address more volatile and adult problems and to envision longer-term solutions. Increasingly through 1966 the AVs, especially in West Virginia, mounted attacks on CAP programs that had fallen into the hands of political bosses, pointing up their failure to attempt, much less achieve, maximum feasible participation of the poor.

The Wolfe-Breathitt AV program, though not so confrontational as those in the Cumberland Valley, was noticeably strengthened with the addition of two more local workers: Breck Fugate of Upper Big Branch and Nancy Cole of

Barwick, both in Breathitt County. In the fall of 1966 the Grassroots Citizens Committee for Action had been formed; the OEO claimed that an AV-VISTA volunteer began the group, but Whisnant's account has credited an unnamed "young native eastern-Kentucky father" determined to organize Breathitt Countians around hunger, roads, and jobs.[31] As of November 1966 the Grassroots Citizens Committee, by this time dominated by AV and VISTA volunteers, had begun its own newspaper, the *Grassroots Gossip*, with Breck Fugate as editor.[32]

Gene Conti and another Appalachian Volunteer, John Lewis, meanwhile had taken note of a local seasonal industry: the making of pine wreaths and roping. Conti found that several of Wolfe County's poorest families produced these Christmas garlands annually, selling to a few distributors who, in turn, profited from huge markups in price. While the county's producers might earn five hundred to one thousand dollars all told for an autumn's work, distributors typically made four thousand to ten thousand dollars.[33]

The AVs attempted to organize this family-based industry into a cooperative that fall, Conti and others traveling as far as Detroit to make contracts with Christmas retailers. The AVs managed to more than double prices for pine roping and wreaths this first year and reported that "jobbers [were] already quarreling" over arrangements for the following season.[34] A notice in the Grassroots newsletter recounted, "A man was making wreaths for us for $3.00 and a jobber offered him $4.50. He asked me what he should do, and I told him, hell, sell to the man who pays the highest price, and he did. We got someone else to make the wreaths." As this story indicates, from its inception Grassroots' first aim was to increase income, even at the expense of its own organization; the news story concluded, "Maybe next year prices will be so high that the Grassroots won't have to get involved." This approach would have repercussions later, when Edgar Tolson's woodcarvings, too, were plucked out of the crafts cooperative by determined collectors.

In the course of their efforts to sell Christmas greens, Conti and Ron Hyde were invited to a Pittsburgh antipoverty conference and asked to "bring samples of Eastern Kentucky handiwork" with them. So they did, transporting north a collection of "quilts, rugs, weavings, and other assorted crafts."[35] Although the trip failed to net any contracts for pine decorations, Conti wrote that he and Hyde had "made some contacts which may be helpful in the future. Most everybody was interested in Grassroots and the idea of poor people trying to help themselves."[36]

Ten days after Hyde and Conti returned from Pennsylvania, thirty people met at Hays Branch in Breathitt County to discuss "ways to make a quilting co-op work."[37] Michael Royce and others were especially encouraged to try such an enterprise by his mother, Margaret Reuss, who visited Kentucky that

Thanksgiving. "She was very interested in primitive crafts, especially in quilts," said Anne Glenn, then an Appalachian Volunteer. Royce had taken his mother to Nancy Cole's house in Barwick, where they looked at quilts Cole had collected from around the community. According to Glenn, Mrs. Reuss "was absolutely flabbergasted with the stitchwork."

Cole was a forceful woman. A consulting economist from outside the region described her as "a coal miner's widow who has raised eight children, almost solely on welfare payments of $100–$150 a month for many years."[38] She was chosen to represent the quilters, and hers was the first quilt to be sold, for $34.20, to a "Mrs. Moore of Philadelphia." As well, according to Anne Glenn, Mrs. Reuss bought several quilts and took them back to Washington, where "people were wildly excited about them. And they sold some that way." Royce, Cole, Glenn, and several other AVs, considering these small successes, concluded, "Well, hey, maybe this will really work."[39]

Efforts of the AVs in Wolfe and Breathitt shifted quickly then, from expanding pine roping sales to establishing a cottage industry of local quilters. The change may have been partly attributable to the collapse of a market for Christmas garlands after mid-December, but, more significantly, the quilting program also revived a long-standing Appalachian self-help strategy and coincided with an emerging national taste for objects homey, countrified, and handmade. A quilt co-op seemed the ideal vehicle for combining the AVs' political and economic ends.

According to Royce the Grassroots Craftsmen's aims involved community building, crafts revival, economic development, and empowerment. The co-op represented, he said, "a very logical development of the idea of drawing people together to build more power and controlling their lives." In the United States this crafts-cultural approach to political organizing dates at least from the mid-1890s, when urban settlement houses used crafts to foster community pride and cooperation.[40] The model was later adapted, with limited success, to more narrowly economic ends by Kentucky's rural settlement schools at Hindman and Pine Mountain and at Berea College.[41] The Grassroots Craftsmen were, in effect, resuscitating a seventy-year-old development strategy.

David Whisnant's *All That Is Native and Fine*, examining the Hindman Settlement School, Campbell Folk School, and White Top Folk Festival, and more recently Jane Becker's work on the commodification of Southern Appalachian culture during the 1930s have offered stringent analyses of the relationships among producers, promoters, and consumers of mountain arts and crafts. Whisnant's study decries a pattern of "systematic cultural intervention" dating from the turn of the century, the efforts of a number of reformers to mold mountain culture according to their own aesthetics and mores;

Whisnant vilifies these efforts, both for their intrinsic arrogance and for their evasion of the economic realities that had already gripped and were steering Appalachian society.

Becker examined how mountain crafts during the 1930s were transformed into metropolitan decorations through such managerial and marketing apparatuses as the Southern Highlands Handicraft Guild and the National Parks Service. She recounted a short-lived effort to reconceptualize mountain craft work as poorly paid industrial labor and to reorient mountain crafts enterprises toward improving both working conditions and pay. This attempt was, she found, superseded by the commercial potential of "selling tradition."[42]

"Consumable yet non-commercial, southern mountain crafts were marketed as possessing virtues otherwise unattainable in modern products," Becker wrote.[43] Thus mountain handicrafts were advertised as "traditional," even though coverlet designs and quilt colors were actually selected to meet middle-class tastes. Furthermore, Becker argued that, though the marketing of authenticity required linking the handmade object to an Appalachian maker, the drudgery of actual working conditions was consistently hidden. Instead, mountain artisans themselves became invisible, as "Americans replaced the mountaineers' specific histories with a vague, persistent past devoid of conflicts and differences."[44]

Organizing the Grassroots Craftsmen in the fall of 1966, the Appalachian Volunteers also took part in selling tradition, and they were not alone. Crafts enterprises at the Kentucky settlement schools, Red Bird Mission, and Berea College were ongoing; other smaller groups like the Hound Dog Hookers and the Jackson County Quilters had sprung up by 1967.[45] Distinguishing the Grassroots Craftsmen, however, was its underlying political agenda. As an offshoot of the Appalachian Volunteers, the Grassroots Craftsmen of the Appalachian Mountains intended to seize the familiar strategy of crafts marketing and deploy it as a means of social activism. Even so, the idea of organizing around crafts reflected a distinctly cultural turn from the earlier Citizens Committee's focus on roads and hunger.

By all accounts, the crafts initiative was stimulated by VISTA workers from outside the mountains, as a consequence of the Pittsburgh meeting Conti had attended and Mrs. Reuss's enthusiasm. Asked whether she would sell her quilts, Mary Dunn, for example, explained to the other VISTAs that she had never been able to command prices high enough to make sales worthwhile. Once assured she would receive a fair price for her needlework, she was eager to participate. Dunn and her two sisters had learned to quilt by watching and imitating their mother, Nettie Hollon Taulbee, piecing and quilting the log cabin, flying geese, and bow tie patterns. For the Taulbee family, like most other mountaineers, quilts were functional. "We didn't have enough material

to make anything just to look at. We just made them for our beds to keep us warm. . . . Of course we looked at them, but you know, they weren't nothing fancy."[46]

During the 1930s and 1940s, the Taulbee sisters and their mother also quilted tops other women had pieced, charging three dollars for a job that typically required forty hours of sewing. They did not sell their own pieced and quilted spreads because, according to Dunn, "Nobody wouldn't pay you for them. . . . They didn't have no money to buy them with." From these experiences and without previous access to buyers outside the mountains, Wolfe and Breathitt County quilters would not likely have conceived of quilting as a reliable source of income. The idea of crafts marketing was instead developed according to the aesthetics and buying power of the incoming VISTA workers and their contacts outside the region, those who perceived quilts as a rarity and possessed enough disposable income to afford the labor time they require. Where a needleworker on Pine Ridge had priced her quilts at only twenty-five dollars apiece, quilts for which Mrs. Reuss and her Washington friends would soon pay a hundred dollars and more, the VISTA workers recognized potential. They began discussing the fundamentals of a crafts cooperative.

According to Dunn, the student VISTAs were responsible for bringing local quilters together, and this first gathering of women, November 18, 1966, itself marked an important development. Mary Dunn, representing Wolfe County, was introduced to Nancy Cole. Maude Rose, the retired postmistress of Malaga near the Wolfe/Breathitt line, was also involved, as were Media Barnett of Owsley County and Mildred Faulkner of Lee County. Each of these women recruited quilters in her respective county, involving personal acquaintances at first and then inquiring door to door, expanding the project to include more women.

By 1967 Mary Dunn and several of the VISTA women had arranged a quilt-training program for Sandy Ridge girls at Dunn's house. "All of them would come in two days a week, I believe it was, and I had a quilt up and we'd let them quilt, learn how to quilt, and piece too." As for the VISTA women from outside the mountains, like Anne Glenn, Dunn said, "They didn't know much how to quilt but they'd help."

In the processes of building the cooperative, Mary Dunn and others gained experience in community organizing and reporting. According to one AV worker, it was Edgar Tolson himself who "upon hearing that Appalachian Volunteers were helping some mountain women learn how to drive [said], 'Why, now you've started something really radical!'"[47] With both VISTA wages and quilt revenues, these women were generating independent income for the first time in their lives. According to Anne Glenn, "That was sort of touchy too. . . . When the men still didn't have a job and were on some happy-

pappy program or totally unemployed, it did create some social tension in the community."

Doing business as the Grassroots Quilting Co-op, the group decided to retain 10 percent of the sales price of all items, applying that money to costs of mailing and promotion. By December 1966 VISTAs were buying materials in bulk, and by January 1, 1967, "the first big batch" of quilts, priced from twenty to forty dollars, had been offered for sale.[48] Grassroots asked five dollars per year in membership dues, though initially nonmember quilters were welcome to sell through the organization too. Eventually, the co-op involved, by Dunn's estimation, fifty quilters across four counties, Lee, Owsley, Breathitt, and Wolfe.

Returning to Washington, D.C., with several Kentucky coverlets, Margaret Reuss showed the Grassroots Co-op's quilts to staff at the Smithsonian Institution and received an enthusiastic response, especially for a white-on-white christening quilt made by Mary Dunn's sister.[49] Mrs. Reuss also copied a quilt pattern from the Smithsonian's collection, an eagle against a background of stars, and mailed the pattern back to Kentucky.[50] By the spring of 1967 the Grassroots quilters had added this design to their repertoire.

This episode in the quilt co-op's development conforms to the pattern of cultural intervention that Becker, Batteau, and Whisnant have described, in which Appalachians are enlisted to act out a palatable and prefabricated version of traditionality. In this case, through the agency of an influential woman, the wife of a U.S. congressman, the quilters were introduced to a national history museum and subsequently invited to revive a particular aspect of that history, an aggressive and patriotic one, applying their craftsmanship to such an emblem. The Grassroots quilters eagerly complied. To publicize the co-op, the same quilters in 1969 presented another prominent woman, Pat Nixon, wife of a politically conservative president, with their reproduction of the historical quilt.

Here, as will also be seen in the development of Tolson's woodcarving, when an extant craft tradition meets an expanded market, it typically becomes traditionalized through a kind of cultural feedback. The episode of Margaret Reuss and the eagle quilt provides vivid illustration. The concept of tradition yokes together two related dynamics, of preservation and persistence. Although both imply continuity over time, these dimensions of tradition emphasize differing characteristics of culture and of the people and societies through which it endures. The preservationist face of tradition stresses a preexisting cultural form or practice that both needs and warrants keeping. A backward-looking, defensive attitude, it conceives of a lifeworld as imperiled but valuable; it further tends to enforce a rather static fondness for cultural forms, gauging authenticity by comparison to earlier models.

The three Taulbee sisters (left to right), Maude Gilbert, Martha Combs, and Mary Dunn, members of the Grassroots Quilting Co-op, presented First Lady Pat Nixon with an eagle quilt at an exhibition of Cooperative Crafts, U.S. Department of Agriculture, 1969. (Photograph courtesy of Mary Dunn)

The notion of persistence is keyed to another aspect of tradition and comprehends culture as a chain of human adjustments to changing life conditions. Through this lens, cultural forms will alter, quickly or gradually, according to deeper rules, impulses, or structures for survival. From this perspective, tradition is measured not against forms of the past but according to practices borne forward into the present. Here tradition is not so much what warrants keeping but how a people keep on. The story of Mrs. Reuss and the eagle quilt shows these two dimensions of tradition in subtle articulation. In the 1960s many women of Wolfe and surrounding counties knew how to make quilts, which served as warm bedcoverings. Requiring considerable labor but a minimum of capital outlay, quilting had persisted as a practical—and, for some women, pleasurable and artistic—craft tradition.[51] It was only, however, when reasonable prices for quilts were offered by buyers outside the region that the preservationist chord of this craft tradition grew dominant. In this case, as with Tolson's carving, preservation was keyed not to ongoing local forms but to accredited and fashionable national models of traditionality: first to a particular pattern enshrined at the Smithsonian Institution, and later to the standardized designs and color schemes sought after by decorators.

By as early as February 1967 the quilters had arranged to consult a local extension agent "to assist in selecting the color combinations." Mary Dunn wrote in the Grassroots newsletter, "It might be well to bring pencil and paper and take notes."[52] Breathitt Countian Dwight Haddix, who became a

fieldworker for Grassroots in 1970 and its director two years later, explained how local quilts were modified to meet national tastes:

> We would set up a workshop. We would bring people in if necessary or we would train them with the staff. Like I said, a lot of these people were making quilts earlier but they made them about big enough to fit the top of the bed and we wanted them larger. Like, our standard queen size bed quilt is 90 × 102. We realized that the customers wanted them big enough to drape down for bedspreads, like a fifteen-inch drop on either side, so we would talk to them in the meetings and get them to make them the size we wanted. We would do color training. Like if I had an order for a double wedding ring and they wanted it in blues, that when we mean blues we mean all just different shades of blues because a lot of the people, if we said, "Make me a double wedding ring in blues" and they had a piece of black and a piece of purple, they would incorporate this in the quilt and we would have to train them and tell them, "You're not to do this."

From a preservationist perspective, one would conclude that the quilts marketed through the Grassroots Craftsmen, impeccably crafted, highly standardized coverings, represented an abandonment of authentic quilting tradition to meet public demand: the commodification of a folk art form. Yet from the perspective of persistence, these new quilts represented instead an adaptation of traditional craft practice according to the preservationist aesthetics of newfound buyers. Haddix explained:

> Because people grew up with them, and they had to make their own quilts for their beds, they told me it didn't mean that much to them. I always wondered how a lady could put all these hours of stitches and quilting into a pretty quilt and put a price on it and sell it, cheap. And then I realize it's that they grew up with it. They're used to it and it doesn't mean anything to them and they need the money that they're getting from that product to send their children to school and to buy a washing machine when their washing machine tears up—that they need the money for more essential things than to have the beauty in their house, the piece of art, the way I look at it, or the beauty of a handmade quilt. It was extra money and they could stay home and make this product and not have to go out to a job, which there are no jobs in this area. And if they did have a job, you know, they had to have a vehicle, they had to have clothing to wear and maybe somebody to take care of their children. This way they could stay home with their husband. When it became time to fix a meal, they'd get up and fix it or take care of the children and they could work of the mornings, they could work of the nights on this quilt and stay in their homes.

In Haddix's view, the commodification of quilts is one part of a larger pattern of persistence, one that sustains the traditional craft of needlework, though in a more highly rationalized form, in order to perpetuate a larger lifeworld of family, gender roles, and home. Whether one considers this lifeworld one worth preserving raises, of course, other questions.

During the early 1960s the Tolsons had been living north of Campton, renting houses along Rocky Branch and in the vicinity known as the Calaboose. Edgar was visiting the health clinic approximately twice each month, checking in for refills of phenobarbital, complaining of stomach pains, and seeking treatment for other recurring ailments. Dr. Maddox's records document several head injuries and fractures Tolson attributed to "being beaten up by his family," incidents that coincide with his drinking sprees. In July 1965, still complaining of "nerves," Tolson was treated with Thorazine. By the summer of 1965 his mental and physical health seriously deteriorated, and, with family relations straining, Edgar moved off for three months, joining his brother Sam in Pierceton, Indiana, and hiring on at an industrial parts factory there. He had returned to Wolfe County by December of that year.

The separation appears to have calmed the family's strife, though Tolson's drinking persisted. In 1966 he was charged twice for public drunkenness and once, in July, for breach of the peace. Despite this personal instability, or perhaps because of it, Tolson in 1966 turned his attention increasingly to carving and to gaining recognition for his work. A Campton Medical Clinic record from January 1966 noted Tolson had "been doing a lot of whittling and has some evidence of this along with him." Also in 1966, according to Donny Tolson, Edgar was commissioned by neighbor Ralph Likens to make a coffee table and a set of end tables. His skill and ambitiousness increasing, Tolson decorated the furniture with inlaid squares of red and white cedar. "They were real pretty. One of them he even put his name in the inlaid part, 'made by Edgar Tolson.'"[53]

According to Mary Dunn, her husband, Darley, visited Edgar regularly and encouraged Tolson to sell his woodcarvings through Grassroots Craftsmen, but Anne Glenn remembered Mary herself proposed the idea of drawing men into the co-op at one of the group's early meetings. "I can remember Mary Dunn speaking up in her absolutely saintly little voice, 'Well, you know, maybe some of these wood-carving men would like to be involved in this, 'cause there's some men who sit around here and whittle, and they really make some nice stuff.' And we said, 'Who?' And Edgar Tolson of course came right to mind."

In January 1967 Ron Hyde announced through the Grassroots newsletter that boys were needed to operate a woodshop in Breathitt County, and by March, Hyde and several others were building quilt frames at Hays Branch.[54]

This notice marked the first direct recruitment of local men into the Grassroots crafts cooperative. Tolson was skeptical until Darley Dunn brought several of the young VISTA volunteers, including Mike Royce and Gene Conti, by to see his woodcarvings for themselves; their immediate enthusiasm caused Tolson to reconsider. It was during this winter season that he was drawn into the organization.

Royce described Tolson as "laconic" at their first encounter and remembered being "startled by the beauty of his work. . . . I don't think he really had sold things. It seemed like it was something he mainly did for himself." Even with encouragement from the fledgling co-op, his friends the Dunns, and a band of admiring VISTA volunteers, Tolson was slow to produce. "He didn't want to make stuff for people," said Mary Dunn. "Darley would have to keep going back and getting him to work on things. He wouldn't. I don't think he felt good or something." Tolson's frail health might, in fact, have accounted for his sluggish work pace, yet others who knew him and worked closely with him years later attested that Tolson was ever an unreliable producer. Much as he craved attention and could have used the added income, Tolson always carved according to an erratic inner prompting. Mrs. Dunn said, "He didn't think he could get anything for them at the start, but then after he got getting stuff for them he just didn't. I don't know why it was. They'd get him to make something and he'd say he would and they'd go back and he wouldn't have nothing done on it." Tolson admitted he was lackadaisical: "They offered me three hundred dollars a month to run the wood shop up at Grassroots but I said no. Not for me. I like doing what I'm doing and mostly I like doing as little as possible."[55]

Among Tolson's 1967 pieces Mary Dunn remembered carved animals and "dancing dolls," stout figures usually whittled from poplar. Tolson fixed brads on top of the dolls' heads and suspended each one from a thread that had been strung between two short posts, mounted on a base. When the string was jiggled, the doll's feet would tap and dance on the board below.

Puppets of many sorts, figures manipulated by threads and strings, date from ancient Egypt. Surveys of folk sculpture in the United States have found articulated dolls among American inventories from the late eighteenth century, many of them imported from Europe, elegantly dressed and known as "fashion dolls."[56] Doris Ulmann's photographs of the Ritchie children, taken in Knott County circa 1930, show several marionettes.[57] Charley Kinney of Lewis County, Kentucky, built and attached several articulated puppets to foot pedals, dancing the dolls to his fiddle playing.[58] The limberjack doll, moved not by strings but with a stick attached to the figure's back, is also well known in the Appalachian mountain region.[59]

Edgar Tolson's own predecessors in doll making are indistinct, since he

denied having learned carving from anyone. Questioned as to his sources in a 1981 interview, Tolson answered, "I never saw no carving done in my life. . . . I don't know whether anybody did any." When he was reminded of the many men who routinely sat together, sometimes with Tolson among them, whittling in the Wolfe County Courthouse yard, Tolson answered, "Oh I've seen that all my life. And I've done a little of that. But they never make anything. . . . All they make's a pile of shavings."[60]

Records of the Kentucky Guild of Artists and Craftsmen alone suggest otherwise, as do accounts given by Tolson's relatives. A correspondent from New Jersey wrote to the guild in 1969: "Approximately fifteen years ago, I purchased by mail a [sic] eleven inch wooden carving of a woman. . . . it was from some association such as yours and it was in Kentucky."[61] Guild sales from the 1967 state fair further document Berea woodworker Helen Shepherd, a "carver of animals and letter openers." Mary Rogers was carving and selling through Pine Mountain Settlement School in the early 1960s.[62] Closer to Tolson's home, the *Wolfe County News* featured Sam Cecil, who since 1963 had been carving and selling "small pitchers from solid pieces of cedar," as well as miniature animals and rail fence.[63] Cecil's "7 complete coffee sets" are reminiscent of the objects Tolson recounted first whittling, the outdoor place settings he had carved as a child.

Emma Weaver's *Artisans of the Appalachians* (1967) documented several carvers of North Carolina who would have been Tolson's contemporaries, most of them affiliated with the John C. Campbell Folk School. Although their chip-carving style differs from Tolson's and they tend to favor animal rather than human forms, there remain traces of influence. Most overt are Hardy Davidson's relief carvings of ducks, groupings usually of three birds in flight, fashioned in various sizes to simulate distance.[64] This popular image, mass produced in brass and plaster, became a popular wall decoration. According to Donny Tolson, Edgar, too, carved a flight of birds, "some geese like they were flying. And you hang them on your wall and they were like different sizes. One was smaller, medium and large, and made the one look like it's further away that was flying, like something you might see even on people's walls. He may have seen that on people's walls to get the idea to do it. They were like ducks and [he] painted them green and white or whatever the colors was, and he'd carved them out of wood."[65]

This set of plaques hung for a while on the wall at the Tolsons' house at Swift Creek. Tolson also gave a grouping, perhaps this same set, to his sister Maggie Cane of Mount Sterling.[66] These may have been Tolson's attempts to replicate the signature piece Davidson first made during the depression in wood, but just as likely they were, like the "yard birds" or flamingos he also produced, homemade versions of commercial decorations. Like the unicorn,

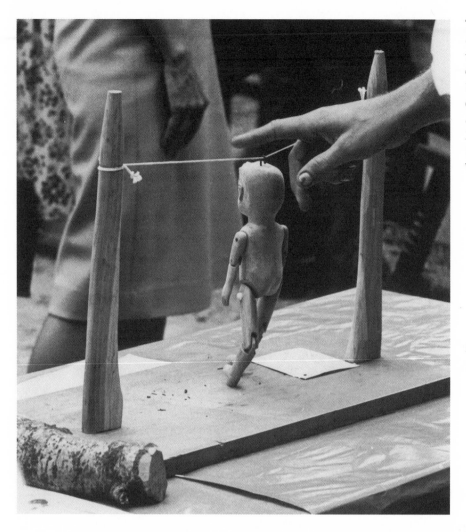

these birds in flight confound the distinctions among art categories: David-son's folk carving, it appears, became a popular commercial decoration at midcentury, one reappropriated by a traditional woodcarver, Edgar Tolson, thirty years later.

Folklorist Alan Jabbour, director of the Library of Congress American Folk-life Center and a scholar of old-time fiddle music, commented on Tolson's claim of uniqueness, explaining that many of his musician informants have similarly denied having learned their art from neighbors or elders:

You can go to a fiddler and very easily encounter this story: "Well, when I was a kid, my dad or my granddad had a fiddle in the house and he would-n't let me play it, but one day when he was gone, you know, I picked it up because I thought I could play that and sure enough I could. And then, when they were playing one day, I said, 'Can I do that?' And they said, 'Oh

you can't do that,' and so I said, 'Yes I can. Let me try,' and so I tried and they all said, 'Wow, he can play the violin!'" It's a great story, but then when you hear it about a hundred times you start saying, "Wait a minute. What's going on here?"

What's going on, according to Jabbour, is "a received mode" of artistic acquisition, "but the narrative that goes with it suggests that the person did it all by themselves. . . . You have to conclude that at some level, conscious or unconscious, there's some mass conspiracy here to perpetuate the fiddle through this device."

The fiddler's story Jabbour recounted stands as an archetype of art education within a folk setting. The tale involves some prohibition against using the artistic tool, the child's secret experimentation, and a public reckoning that the novice has, in fact, mastered the instrument: "Wow, he can play the violin!" Tolson never recounted such a tale about his own education in carving, but his son Donny did.

> I found this little cub scout knife laying beside this black pine which [was] one of the other boys', either Delmer's boy's or Wilgus's, I think it was. One of them had lost it up there, which I didn't know. I got it, and they was trying to make me give them the knife and I wouldn't and Dad wouldn't let them make me give it to them. So I can remember whittling on that. I'd sit down there by Dad then and was carving on just a piece of wood, just making shavings more or less.[67]

Donny also remembered from about age five (1964), "Dad was carving out some ax handles and hammer handles. I made hammer handles and stuff when I was younger but didn't do too good a job at them." In Donny Tolson's story, he was introduced to carving informally, by finding the knife his peers lost and beginning to whittle with it despite their objections; however, with the "cub scout" knife of his brother, which Edgar permitted him to use, he could "only make shavings" and failed to "do too good a job" at fashioning an ax handle.

A change occurred when he began "to sneak Dad's knife out behind the house and make a few things." As Donny told it, "Years later, like when I was seven or eight, I guess, or nine, I remember getting Dad's knife and going out behind the house and had me a piece of wood already blocked out or something and carving out like a dagger knife or something to play with." Like Jabbour's fiddlers who gain their musical facility by stealth, only by sneaking his father's knife "out behind the house" was Donny able to make "things." And intriguingly, the first "thing" he carved was "a dagger knife," a glorified image of the tool he had begun to master. As an adult, Donny returned to this

image, carving an elegant wooden sword from poplar as a gift for his girl-friend's son. His elaborate Daniel Boone piece, now at the Huntington Museum of Art, also captures the Kentucky pioneer wielding his knife against an attacking bear.

Edgar Tolson contended, "I never saw no carving done in my life," even though he had seen chain carving and idle whittling and grown up in a working world of hand-fashioned implements.[68] Jabbour added, "We know that whittling is a widespread folk custom throughout the rural south and that young boys especially learn to whittle and that when they whittle they sort of doodle around with shapes of things. So you might say the skill is clearly traditional and widespread."[69] Then why did Tolson deny his own sources and informal education?

The folk musician's contention that he or she was never taught but instead surreptitiously learned to play represents itself a kind of folk tale, the tale Donny Tolson has also told. Jabbour noted: "When somebody says, 'I never saw something like this before, I just made it up myself,' it may be true, but it also may be that that's a certain convention in conversation about art that the person had adopted, and what he means is he didn't specifically model each item on something else that he saw, because his alternative is direct copying."

As Jabbour has unfolded the ambiguities of "I never saw," he moves toward a conception of art: a creative act, not direct copying. Edgar Tolson clearly shared this conception. He told Skip Taylor: "Art is something that no one else can do, but yourself. Art comes from the heart and the mind of a man. And it's grown in him from the time he was born, that he can do that job and no one else can do it like he does. . . . It's not art as long as you can substitute."[70] This definition would explain why both strictly traditional folk art and strictly academic art are palpably weak: both are bound by preexisting models.

Jabbour's analysis points also to the problems of creativity and identity. Artists of all designations are pained to specify the springs of their work. Some have paid homage to the Muses; some allude to gifts inherited by blood. "The Kinneys were artists from beginning to end. It was all natural to us," said folk painter and puppeteer Charley Kinney.[71] Carver Savinita Ortiz of the López family, Córdova, New Mexico, described her carving similarly as a legacy of good luck: "I tell, you know, my grandkids, 'Keep on, you have to do it,' one after the other one, because it is a gift that my grandfather, after God's will, left to the family." Like Tolson, however, many nonacademic artists simply deny all influence, a contention (now also a convention) that has made the term "self-taught" credible.

This denial, a dimension of the fiddler's tale and its retelling by Donny Tolson, suggests a peculiar and inaccessible aspect of creativity: that it involves a

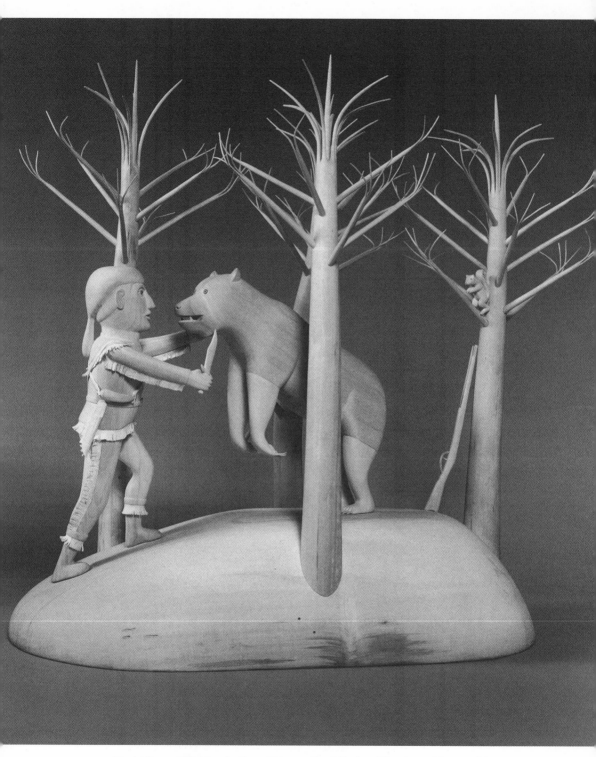

Daniel Boone Kilt a Bar, by Donny Tolson, 1984. Collection of Huntington Museum of Art, Huntington, West Virginia. (Photograph, Mary Rezny)

surrendering of will—to the qualities inherent in one's materials and to the capacities of one's audience. Because surrendering the will constitutes a kind of nonactivity, creativity is difficult to fathom. Just so, attributing it to gods or blood or luck are three ways of putting off the question, or at least putting it beyond the artist's obligation to explain. Edgar Tolson's denial and Donny's trope of "hiding" function in the same way.[72]

Edgar Tolson may, in fact, never have seen carved wooden figures before attempting his own, but there do exist notable woodcarving traditions in the Wolfe County vicinity. By 1930, in addition to Hindman Settlement School, established in 1902, a program called Homeplace had been initiated in Perry County at Ary, a threefold endeavor of crafts, agriculture, and social uplift. The Homeplace "experiment," with its goal of "finding in the region about, all those who have been engaged in handicraft work and urging them to make the most of their skills and abilities," prefigured the Grassroots Craftsmen.[73]

Allen Eaton's 1937 survey of Appalachian handicrafts made special note of a wooden doll-making tradition of this area: the "Kentucky poppets" carved by women of the Ritchie family of Perry County and sold through Homeplace.[74] A 1922 book of poetry by Ann Cobb, a teacher at Hindman, memorialized "The Poppet-Doll" in verse, suggesting that Hindman's Fireside Industries likewise had produced and sold these objects at least a decade earlier.[75] Such singularly local crafts were, according to Eaton, the very type that Homeplace sought to foster and to sell. "Mountain furniture, baskets, dulcimers, and the entirely indigenous Kentucky poppets made of buckeye wood . . . are among the best known handicrafts of the region."[76]

During this same period, the early 1930s, Edgar Tolson was employed by the Works Progress Administration to build several stone schoolhouses in the area, at Stone Fork in Breathitt County, Rowdy in Perry County, and Talcum in Knott County. It was Tolson's employment in these towns along Troublesome Creek, at the Perry and Knott County border, that very likely brought him into contact with the wooden dolls then available through the handicraft enterprises under way at Ary and Hindman.[77] If Eaton was accurate in describing the poppets as among this region's "best known handicrafts" in 1937, Tolson, a carver himself, should have been aware of these wooden dolls. Elvin Tolson claimed he, too, began making dolls from wood at this time, about 1933, picking up whittling from Edgar during the months he resided with Tolson and his first wife, Lillie, in Breathitt County.

Eaton described poppets as "whittled out of buckeye, a close, fine grained wood, very light in color."[78] Although Tolson's dolls are commonly of poplar, another close-grained and pale wood, he noted in a 1971 interview, "I'd rather have buckeye if I can get it but you can't get it around here."[79] As for the "poppets" themselves, Eaton called the Ritchies' carvings "the most primitive

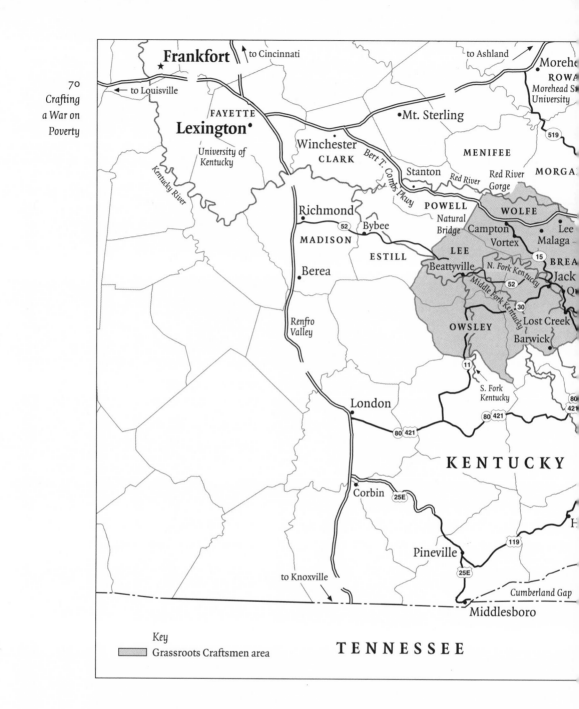

Key
Grassroots Craftsmen area

dolls of our mountain country. . . . One family, so far as is known, is the only one making them for market."[80] His *Handicrafts of the Southern Highlands* included a sepia-toned photograph Doris Ulmann made of Mrs. Orlenia Ritchie, seated with an egg basket on her lap, holding both her pocketknife and a wooden doll.

As described by Eaton, the poppets were usually dressed in homespun, their cheeks stained with pokeberry, their hair of wool or fur. Despite these

East-Central
Kentucky

decorative touches, the doll in Ulmann's photograph is similar to Tolson's earliest extant figures. The disproportionately large head and body appear to have been whittled from one piece of wood. Facial features are small and clustered together like Tolson's 1967 works *Man with Cap*, *Library Doll*, and *Dancing Doll*.[81] Nomenclature also links Tolson's figurative carvings to the Perry County "poppets," for while the Tolson children contended he never permitted them to play with the wooden figures he carved, Tolson routinely called these

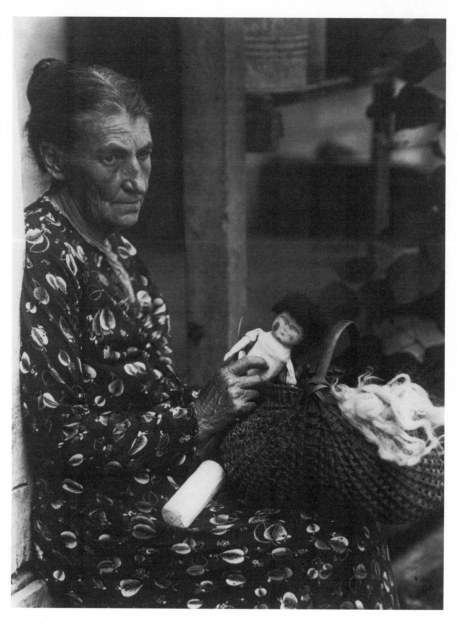

pieces "dolls," even after they had been exhibited as "carvings" and "folk sculpture."

Within Wolfe County there also existed a tradition of making wooden dolls. According to Mary Dunn, her uncle Porter Hollon, a chair and basket maker who lived at Bear Pen, used to whittle toys in his spare time, carving pop guns and the whirling noisemakers known as bull tongues. Hollon also made dancing dolls. Dunn first remembered seeing his figurative carvings in the late 1920s, when she was a girl of ten. Her uncle, also a musician, "would tie a string around his little finger and he'd play the banjo and his little doll

would dance." Hollon and Edgar Tolson were well acquainted; in fact, according to Mary Dunn, they were cousins. In all likelihood, their visits were most frequent from 1961 until 1963 when the Tolson family also lived at Bear Pen.

Whether Tolson first saw wooden dolls within the family, around the community, or through his traveling employment with the WPA, a number of local traditions existed for him to draw on. Still, it required the encouragement of outside admirers, the young poverty workers of VISTA and the Appalachian Volunteers, and the Grassroots Craftsmen's marketing project to coax him into anything like steady production. He had carved both utilitarian and presentation canes, but these carving efforts were more practical and manly than doll making. Even Mary Dunn, who broadened the Grassroots Craftsmen's scope to include men's handiwork—recommending Tolson's carvings in particular—mentioned the skepticism with which figurative woodcarving, even of Tolson's caliber, was locally received. Wolfe County people, she said, "didn't pay much attention to it. They just thought it was just foolishness. . . . I guess, they don't pay much attention to dolls or anything. Yeah, they think a grown man ought to do something besides, you know, 'piddling around,' they call it."

Tolson and his family voiced similar misgivings about carving, implying it was not an appropriate pastime for a man. Monnie Profitt explained that her father had "not been whittling all that many years, because he was too busy building barns and houses and digging basements. He didn't do too much whittling because he didn't have time." In a 1971 interview Tolson said, "I've had that in me ever since I was a boy. But I never would fool with it till I got knocked out of work."[82] Describing woodcarving as a last resort, Tolson's remarks suggest that sales dignified the child's play of fashioning animals and dolls:

> I was a carpenter, done a lot of building up here around town. And I couldn't do that no more. So when I had this stroke I had lost the use of my arm and leg and really went trying to whittle to get the strength back in my arm. I carved here a couple of years and just gave it away. There wasn't no sale for it. Finally some boys from Washington came in here and they got acquainted with me and they liked my work and they knew that it would sell. I didn't know it.[83]

The opportunity to sell carvings through the Grassroots Craftsmen engaged Tolson in two related ways. First and most obviously, it supplied him with some income while he was "knocked out of work." Locally, his pieces had not sold before primarily because Tolson himself had handled the carvings as gifts. As Patricia Maddox explained, "He just gave it to you because he liked you. . . . He didn't attach any particular monetary thing to it." Because

Tolson had routinely given carvings in thanks or to people in positions of prestige, he had never determined prices.[84] How, after treating the carvings as gifts, could he initiate local sales, especially since those with enough money to purchase works were, in all probability, those like Dr. and Mrs. Maddox, to whom Tolson was already deeply indebted? Wolfe County's median family income in 1960 was $1,455. There simply was no disposable cash for purchasing handicrafts or much else. According to Monnie Profitt, "At the time that he was doing the whittling nobody cared anything about [it]. There was nobody them days could have bought a piece of whittles." Tolson himself acknowledged, in 1981, "Twenty years ago you couldn't sell this stuff."[85]

Yet, in addition to income, sales brought Tolson a new kind of respect in Campton, both for himself and for the craft that had been considered "piddlin' around." Of response in his community, Tolson said in 1968, "At first they just stayed away, wouldn't talk to me. Now, since people have been coming to see my work, they think it's alright. They stop me on the street and ask how things are going."[86]

It was in 1967 that the Grassroots Citizens Committee shifted its economic development plan from contracts for pine roping to marketing quilts and carvings, to a focus on craftspeople. This same year also witnessed the inauguration of two ambitious and enduring crafts institutions: the Smithsonian's Festival of American Folklife and the Kentucky Guild of Artists and Craftsmen's Fair. Both events were to have enormous impact on both Tolson's career and the national appetite for folk art.

The Kentucky Guild was the brainchild of Virginia Minish, an enamelist and painter, the wife of a Louisville physician. Its original missions were educational and economic: to direct the production and design of Kentucky crafts and then find buyers for them. Like earlier crafts programs of the 1930s, the guild was founded on the premise that Kentucky's rural craftspeople were "needy" and that association with academically trained artists would both improve formal standards and open new markets.

From the guild's incorporation in 1960 until 1966, the group's activities were focused on maintaining and touring the Guild Train (two L&N baggage cars equipped as a mobile art gallery and demonstration space) and, with funds from the Kentucky Department of Economic Development's newly established Arts and Crafts Division, opening crafts centers throughout the state. During 1961 alone, twenty-three such centers grossed $230,000 in sales.[87]

In late 1966 the guild's board hired Richard Bellando, a potter, Berea College graduate, and son of a New Jersey cabinetmaker, as its full-time director. After its formation by a group of college art educators, the guild had virtually neglected its membership; thus, the board's first mandate to Bellando, arriv-

ing in January 1967, was to organize a major crafts fair in Berea by May, its primary aim to build interest and a sales venue. Any Kentucky craftsperson would be eligible to exhibit if his or her work could pass Bellando's ad hoc standards committee.

Through the Council of the Southern Mountains, Bellando learned of the Wolfe-Breathitt County co-op, and by mid-April the Grassroots Craftsmen had been juried into the fair. The objects Grassroots would offer for sale were an amalgamation of traditional Appalachian crafts, such as flower garden quilts, rag rugs, and split oak baskets, and "Appalachianesque" items clearly influenced by popular fashion—quilted pillows, granny dresses. Mary Dunn expressed Grassroots' ethos in an article for the co-op's newsletter; quilts, appliqué, and homemade aprons all signified "that our people are not lazy, rather that we are a working people."[88]

Some five thousand visitors attended the first guild fair, held May 18–20, 1967, at Indian Fort Theater outside Berea; sales topped six thousand dollars.[89] The event's success was due in part to Bellando's diligent promotions, in part to mounting fascination with things American and handmade. In April 1967 Georg Jensen, a retail store that combined the panache of a New York boutique with the volume of mail order marketing, had displayed works from the Southern Highlands Handicraft Guild, an exhibition reviewed in the *New York Times* under the headline "Spotlight on Appalachian Craftsmen."[90] The *Times* review underscored, "None of the 40 craftsmen represented in the show receive government assistance for their work," and proceeded to describe a Tennessee doll maker who "makes 30 cents an hour for her cornhusk dolls" and "refuses to put a higher price on her dolls because they are made from scraps." This article makes plain how conveniently a self-help ideology of handicraft production, as espoused by Mary Dunn and many others, could be accommodated to meet the interests of the affluent, catering to both the disdain for "government assistance" and the thirst for a bargain.

Among those who attended the first guild fair that spring was Georg Jensen vice president Charles Hubletts. Impressed with the Grassroots co-op's "Presidential quilt," the design Margaret Reuss had copied out of the Smithsonian registry, he ordered a number of them to be marketed as tablecloths: "just the thing for that little Fourth of July picnic."[91] Another visitor was the Smithsonian's Ralph Rinzler, then on the brink of the first Festival of American Folklife, scheduled for July in Washington, D.C. Rinzler shortly announced, "The Smithsonian has recently changed the policies of its shops. From now on, the shops, which sell to tourists, will feature authentic handmade crafts instead of reproductions made at the museum. I expect the demand for craft items made in [Appalachia] will jump dramatically when the museum's summer tourist season gets under way."[92]

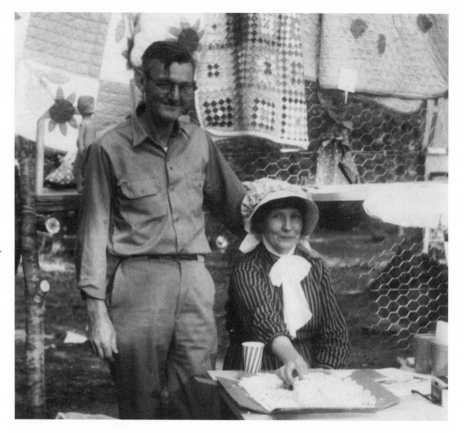

The Grassroots Craftsmen brought a large delegation to the guild fair, some thirty-two craftspeople, AVs and VISTA volunteers led by Nancy Cole, and, in Bellando's words, a "hippie-looking" Mike Royce. Edgar Tolson was with them. The co-op stationed its booth below a pair of the eagle quilts, with one of Tolson's articulated dolls displayed on a high shelf. Also featured were twig roosters, rugs, baskets, cinch belts, chairs, and a demonstration of shingle splitting.

The fair's forty-one exhibitors provide a wide-angled view of Kentucky arts and crafts circa 1967. Pine Mountain Settlement School and the Christian Appalachian Project set up booths, as did more recently established organizations like Kentucky Hills Industries and the short-lived Pennyrile Cornshuckers of Dawson Springs. Production-line objects from Bybee Pottery and Churchill Weavers were stationed next to works of painter Nancy Comstock of Louisville and photographer Warren Brunner. Many exhibitors were also college and university faculty: Emily Wolfson of Murray State, Charlie Whitaker of Alice Lloyd College, James Rhein of Eastern, and from the University of Kentucky painter James Foose and ceramic artist John Tuska. This mix of aesthetics, skills, and sensibilities fulfilled Bellando's hope for the guild fair. "It was such a cross-section. That was the most exciting and beau-

tiful thing about it to me. You had these very educated, schooled craftspeople right next to some of these traditional craftspeople—some people who never made anything in their life but who all of a sudden started to get excited about what they saw . . . and then these schooled craftspeople learning things about wood and materials from these people who knew it all the time."

The guild's federation of fine arts, folk arts, and crafts at Indian Fort would gradually splinter, a divergence that took place nationwide through the 1970s, as these dimensions of the plastic arts evolved into visual specializations, each with its own press, galleries, and professional associations. At the guild fair one may still hear the chugging of a steam-powered grinding mill or watch William McClure split oak shingles, but producers of "fine craft"— lapis and silver bracelets, porcelain bowls, silk scarves—predominate. The crazy confederation of the 1967 guild proved too volatile to hold.

In the story of Edgar Tolson's career lie clues to this dissolution. That same spring of 1967, Miriam Tuska accompanied her husband, John, to the fair with beads and pop-up dolls of her own to sell. Mrs. Tuska, visiting the Grass-roots Craftsmen's booth, remembered seeing "lots of little crafts, most of which I was not interested in. But they had a couple of dancing dolls that were fantastic. They were not flat, silhouette figures like most of the dancing dolls, but they were three dimensional people. They were little sculptures that were jointed and wiggled around, but it was the sculpture that just thrilled me." Initially, no one at the Grassroots booth seemed to know who had made the carvings.

Tuska's difficulty in learning Tolson's identity may in part have been due to the Grassroots Craftsmen's inexperience at selling (Bellando remembered the group as "very unorganized"). As well, with so many co-op members and guests attending the fair, representing four different counties, it is likely that whoever first spoke with Mrs. Tuska had never met Edgar Tolson himself. Tolson had joined the co-op only recently, and from reports in the Grassroots newsletter, though he occasionally attended its monthly social gatherings, he remained fairly aloof from the organization.

Confusion about the carvings further demonstrates the prevailing custom among groups like the Grassroots Craftsmen at this time. Larry Hackley's history of the Kentucky Guild noted that the many crafts centers involved in fairs over the years "usually sell the work of their members anonymously."[93] While never explicitly developed into co-op policy, the practice of selling anonymous objects reflected a collective, guildlike approach in which the value of an object stems from its traditionality, its embodiment of craft standards, not from its originality or authorship.[94] Groups like the Grassroots Craftsmen, however sloppily conceived, adopted the ethic of anonymity in part because it suited the AVs' larger programs of community organizing and

leadership training, as Royce put it, "drawing people together, building power and controlling our own lives." With such aims, reinforced through its cooperative structure, Grassroots addressed craft as a medium of social cohesion and an accessible, demonstrable source of community pride. Through efforts like the Malaga woodshop and the sewing circle at Sandy Ridge, the Grassroots Craftsmen employed crafts education to build social networks, not to stimulate virtuoso carvers and quilters.

Secondly, the potentials of individual makers were subsumed within a more general mission of economic development. Grassroots' approach to crafts marketing was lackadaisical at first. VISTA volunteer Carla Heffner of New York designed a mailer modeled on the Georg Jensen catalog: a pocket of fliers, each with a photograph and description of one item. According to Mary Dunn, these advertising sheaves were mailed one at a time, as the out-of-state VISTAs thought of friends and contacts who might make purchases. In the spring of 1967, however, with the hiring of economist Gary W. Bickel and a fifty-thousand-dollar OEO grant to the Grassroots Citizens Committee, the co-op's approach to sales became more strategic.

Conceptualizing crafts as a means for communitywide economic advancement, Grassroots turned from an aesthetic to an industrial perspective on objects. Bickel's report on the organization, circa 1968, boasted that the Grassroots officers "have worked out rational procedures for handling incoming orders, distributing these among co-op members, gathering finished items and sending them out, and distributing the income received," as well as maintaining "effective quality control."[95] This outlook tended to elide matters of crafting skill, originality, or visual impact in favor of calculable profits. Again, efforts to standardize and rationalize output were consistent with a practice of anonymity.

Third, the Grassroots Craftsmen's marketing approach—in selling both its projects to funders and its products to consumers—routinely resorted to the rhetoric of self-help and appeals to altruism. As Bickel wrote, "We've seen what is possible for very low-income Appalachian mountain people to accomplish, given a little aid and encouragement."[96] Nina Pogue, hired later as a manager and trainer for the organization, reported to a Kentucky newspaper that some of the Grassroots Craftsmen "live clear up at the heads of the hollows. These need help the most and have the most will to help themselves."[97] During the War on Poverty, crafts programs were pitched to government and philanthropic sources as promising strong economic return with a minimum of capital outlay. Furthermore, through the utter visibility of tiny stitches, crafts embodied a sound work ethic and thus symbolized a wholesome way to help the disadvantaged.

It might seem obvious that Grassroots would emphasize the poverty of its

members, for in fact they were poor, yet this approach has had long-standing, generally negative effects both on the pricing of Appalachian arts and crafts and on the direction of twentieth-century American folk art. Rather than demanding fair prices, based on even so crude a measure as the minimum hourly wage, Grassroots adopted a comparative approach: "For women who had sold handmade quilts for as little as $10, it was an exhilarating experience to now sell quilts for prices ranging up to $80," Bickel wrote.[98] According to a 1970 estimate offered by one Grassroots manager, a quilt represented "between 100 and 150 hours of work." Thus, an $80 price tag, however much improved over former prices, still exploited the quilter. In time, when it became evident that this form of "a little aid and encouragement" was in fact illegal, the co-op resorted to buying quilts outright and reselling them as property of the Grassroots Craftsmen to skirt wage and hour laws. By 1970 Grassroots' modest goal was "to pay all its producers $1.60 an hour," then the minimum wage.[99]

Rather than promoting individual makers for their talent, Grassroots routinely emphasized the industriousness of anonymous "mountain people," who had been undercompensated for "the thousands and thousands of tiny stitches they painstakingly put into each quilt."[100] Craft objects were marketed not as whole, beautiful, and worthwhile in themselves but as "a little piece of the heritage of Eastern Kentucky."[101] The implicit sales message was that in purchasing an object from the Grassroots Craftsmen, even at a nefariously low price, one was buying an emblem of one's own munificence. One was helping "the poor."

This marketing approach was, of course, not new, as revealed by Jane Becker's superb study of efforts to sell Appalachian crafts during the 1930s. Nor was it a sales strategy entirely imposed by out-of-state poverty workers. Mary Dunn herself had pointed to handicrafts as proof, "that our people are not lazy." In his early dolls Edgar Tolson, too, celebrated the industrious mountaineer, through figures of pick-toting coal miners and farmers in brogan shoes and coveralls.[102]

Tolson himself, as noted earlier, did not prefer this stereotypically rural attire. His daughter Monnie Profitt recalled an evening in 1952 when Edgar, on his way to a church service, swapped clothes with his son, exchanging his overalls for Tom's "dress pants." Coveralls were not for preaching. He later carved "a Farmer Jones, a man with a pair of overalls on," for an officer of Campton's Farmers and Traders Bank. Overalls were the uniform for farming, the life's work that had, until the late 1950s, undergirded all Tolson's other laboring occupations.

But overalls were not simply an elegiac, pastoral, occupational, or even regional emblem. Todd Gitlin explained, "In 1961 and 1962, the SNCC organiz-

ers who fanned out into the Black Belt were powerfully affected by the most impoverished and disenfranchised Negroes: what began as strategy became identity. SNCC organizers, mostly city-bred, picked up the back country look of Georgia and Mississippi: denim jackets, blue work shirts, bib overalls."[103] On Good Friday, April 1963, Martin Luther King led marchers in defiance of the city of Birmingham's ban on protest, and "photos showing an apprehensive-looking King, clad in his blue overalls and being led to the [police] wagon, were flashed around the world."[104] The rural work suit thus had become a national, even international, symbol of resistance.

Breck Fugate, editor of the *Grassroots Gossip*, translated this symbol into an Appalachian idiom in the co-op's February 1967 newsletter.

THE MAN IN OVERALLS

The man in overalls is a man that has been all his life accustomed to hardship of making a go of his worn-out hillsides. He arises at four o'clock in the morning, and doesn't stop his daily toil until the whip-poor-wills have begun to sing at night. He plows the furrows wide and deep, the grueling days work shows in the lines on his face. . . .

He is faced . . . with sickness in the family. He seldom has enough money for the doctors bills. Even though he would give his right arm to see his child well again. . . .

What will happen to the man in overalls? Will he just crumble under his hardship? Or will he keep trying, pushing ahead, and maybe sometime he will be able to fulfill his needs and be able to have the good life.

Tolson had made dancing dolls since childhood and carved the dapper *Man with a Pony* in the early 1960s, but there exists no record of his making standing figures such as these—men in overalls and their female counterparts in long dresses and rough laced shoes—until after associating with the Grassroots Craftsmen in 1967.[105] Fugate's verbal portrait of the aging mountaineer, with its many similarities to Tolson's own life history, may also have prompted him to carve such a stock image of mountain manhood. The editorial lacks the defiant spirit of King's march on the city hall of Birmingham, yet it too asserts a workingman's honor with the farmer's uniform.

Man with Cap,
1967. Collection
of John Tuska
and the estate of
Miriam Tuska.
(Photograph,
University of
Kentucky Art
Museum)

Most carvers favor local subjects and, typically, "rely on costume or environment to suggest identity." As E. J. Tangerman, author of many hobby books on woodcarving, has noted, "Western carvers do cowboys and Indians; Midwestern carvers do farmers, hunters or trappers; Eastern carvers make fishermen—all more recognizable by their garb and tools than by their faces."[106] True to this generality, Tolson, especially in his pieces from 1967 through 1969, favored figures in old-fashioned mountain costume or tradesmen, identifiable through miniature tools: *Bob at the Forge* shows a blacksmith

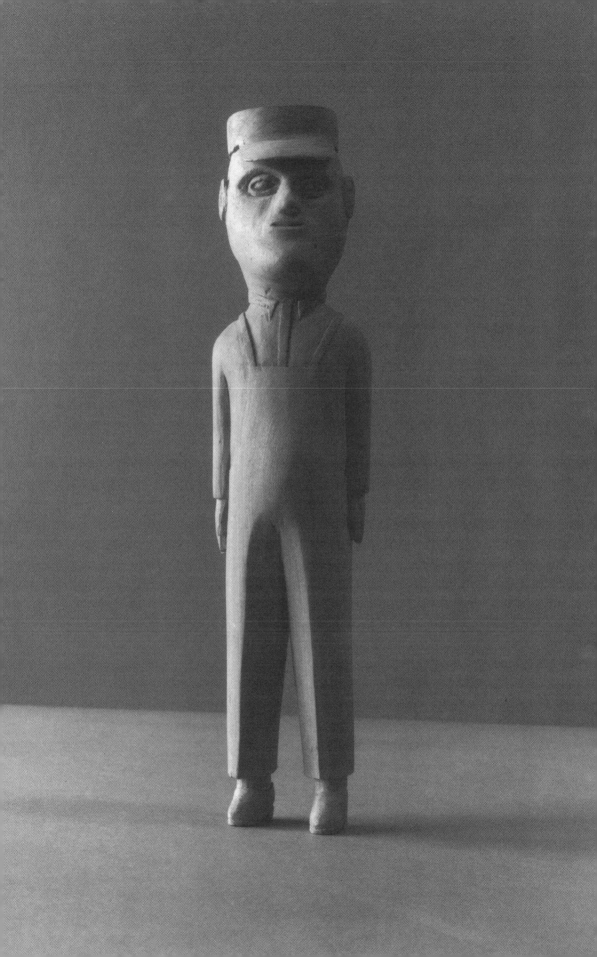

pounding on his anvil, and an early coal miner carving wears a cap and carries a pick and shovel.

Anthropologist Nelson Graburn has also examined this proclivity, noting its underlying message: "All nations, but especially those with a history of subjection to colonialism and oppression, seek to establish a recognizable image based on the most favorable and highly romanticized characteristics of their peoples."[107] Thus Tolson's men in overalls and women in long dresses can be seen as the Appalachian equivalents of Eskimo dolls garbed in rabbit fur or the wooden nesting dolls of Russia, painted in peasant costume: each partakes of cultural stereotype "to assert a new identity or reassert an old one." In Tolson's case, the man in overalls symbolized the honest laboring citizen, a figure opposed to a degraded and demoralized generation of "happy pappies."

Other indications exist that Tolson's carvings were not idle reminiscences but commentaries on present-day life. In the spring of 1968 he carved and painted the figure of a black man in a mustard yellow suit, a piece he gave to Appalachian Volunteer and Grassroots associate Anne Glenn. "Edgar always called him Carmichael. And I have no idea why except I think Stokely Carmichael was probably on the news at the time," Glenn surmised. In 1968, as chairman of the Student Non-Violent Coordinating Committee, Carmichael was, with the Black Panthers' Huey Newton and H. Rap Brown, the nation's most celebrated proponent of black power. Three years later Tolson began to produce "hippie" dolls, female figures carved in notched or fringed dresses.

In November 1967 Gary Bickel and his wife, Sharron, a VISTA volunteer also, accompanied Mary Dunn, Nancy Cole, and Maude Rose to Washington, D.C. in the hope of increasing the co-op's sales. The quilters visited and earned two sewing commissions from Mrs. John Sherman Cooper, wife of the Kentucky senator, and through arrangements Margaret Reuss had made, they appeared on a local television program, lighting up the station's switchboard with "twenty-five calls within ten minutes."[108]

The Grassroots Craftsmen delegation also visited the Smithsonian, meeting with Carl Fox, director of the museum shop. It was under Fox's leadership, from 1967 until 1969, that the Smithsonian's sales policy changed dramatically, from merchandising reproductions made at the museum itself to selling, in Ralph Rinzler's words, "authentic handmade crafts." Formerly with the Brooklyn Museum, Fox had come to know an international circle of folk art enthusiasts through the United Nations and, thanks to this network, turned his connoisseur's eye to objects from Holland to Indonesia. He brought to the Smithsonian a dedication "to the *original* folk arts and crafts of the world's . . . men and women. I loathed reproductions," Fox declared, "and

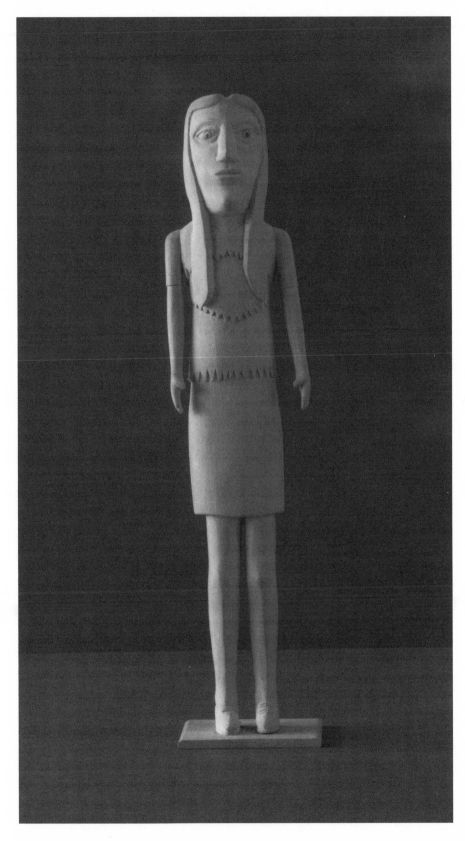

Hippie,
1971. Private
collection.
(Photograph,
University of
Kentucky Art
Museum)

hoped to influence children and adults in buying and living with original works of art."[109] Ralph Rinzler was cognizant and supportive of this change. He had collected and presented American handicrafts himself at the Newport Folk Festivals and incorporated craft demonstrations into the Festival of American Folklife also, from its inaugural gathering in July 1967.

Carl Fox took immediate and special interest in Edgar Tolson's woodcarvings, a group of dolls and animals the Grassroots entourage had brought. According to Sharron Bickel, the Smithsonian shop staff people were especially curious to know whether the figurative carvings bore any resemblance to Tolson himself. "Do they look like him?" asked one Smithsonian employee, noting that "primitive" carvers typically render features like their own. The museum shop bought several Tolson works outright, in addition to seven of the Grassroots Craftsmen's quilts.

In early December Carl Fox wrote to Tolson himself. "I consider your carvings to be just about as good as any woodcarvings I have seen in our country. . . . I would be pleased and grateful to you for the opportunity of mounting a large sales exhibition of your work at the Smithsonian."[110] Fox encouraged Tolson to visit Washington and promised him "a show that both of us will be proud of introducing to our innumerable visitors from all over the world."

As the crafts co-op's membership, funding, renown, and output all blossomed during 1967, Appalachian Volunteers elsewhere in Kentucky were enmeshed in far more volatile causes and by summer's end were feeling the heat. Alan McSurely, an AV hired in April 1967, soon circulated a vehement paper within the AV network advocating "taking national power." Subsequent to Bickel's criticisms, protests from such AV advisers as Harvard psychiatrist Robert Coles, and a "red-baiting editorial" in the Lexington newspaper, McSurely was fired.[111]

In Pike County, by late June forces opposed to coal strip mining, organized in part by Appalachian Volunteers, stood before bulldozers on the property of yet another "man in overalls," farmer Jink Ray. OEO director Sargent Shriver promptly drafted a memo forbidding "any activities that are contrary to law or partisan in nature." Shriver vowed to withhold OEO moneys from all agencies whose representatives engaged in "any activities which threaten public order in any community."[112]

On August 11 Pike County officials, under pressure from the coal operators association, arrested AVs Joe Mulloy and Alan and Margaret McSurely on charges of sedition. All were indicted, and though a federal court dismissed charges in September, Governor Breathitt petitioned OEO to withdraw funds for the Appalachian Volunteers in Kentucky. Mulloy was fired from the AVs in December, after making known his decision to refuse military induction; a group of influential AVs soon resigned to protest his dismissal.

Throughout 1967 AV field officers had also grown increasingly strident in their complaints that federally funded Community Action Programs had been usurped and corrupted by local politicians. Even in the relatively calm territory of the Grassroots Citizens Committee, Breck Fugate published repeated editorials questioning the use of OEO moneys through the Middle Kentucky River Area CAP. A spring *Grassroots Gossip* newsletter advertised sales of "Beat the Breathitt Bosses" sweatshirts.

In September a Canadian filmmaker was shot and killed in Letcher County, redoubling the suspicions of local citizens and the paranoia of AV and VISTA "outsiders." By late 1967, according to historian David Whisnant, the Appalachian Volunteers were fraught with "openly crossed purposes, confusion, and mutual distrust."[113] Internal fragmentation was matched by threats from without. The November election of Louie Nunn, a Republican, as Kentucky governor was followed by state senator Fred Bishop's resolution of January 1968 that all AVs and VISTAs be removed from the state.

Governor Nunn requested that OEO officials investigate the AVs' activities statewide; the ensuing report, made public in September 1968, found that the AVs had met opposition "from various county power structures who counted the outsiders as enemies bent on overthrow of the political system." Recommending that the poverty workers strive to improve relations with "officials, middle-class citizens, and community action agencies," the report concluded: "The worst that can be said against the AVs . . . is that certain volunteers apparently did, on occasion, advocate opposition to the Vietnam war."[114] Despite this largely positive evaluation, and an allocation of $116,000 for Kentucky AVs in the 1969 OEO budget, Nunn refused to approve the funding. By the summer of 1970, the Appalachian Volunteer program had ended.

Further national attention turned to the Kentucky mountains during these months when the Army Corps of Engineers proposed damming the Red River, which runs through portions of Powell and Wolfe Counties, as a flood control measure. Farmers and environmentalists organized in protest, drawing support from the Sierra Club. In November 1967 Supreme Court justice William O. Douglas, with six hundred more demonstrators and reporters, hiked the magnificent Red River Gorge to protest the dam project. In February 1968 Robert Kennedy and photographers visited the one-room school at Vortex, Kentucky, three miles south of Campton, where the presidential candidate met with Grassroots Craftswoman Nancy Cole. (In June 1968, four months later, the Vortex school closed permanently, the same month Kennedy was assassinated.)

To what extent was Tolson drawn into these events? Though he whittled out *Carmichael* and men in overalls and, through the years, would harp on the hypocrisy of politicians, Tolson's record with the Grassroots Craftsmen sug-

gests a shallow, apolitical involvement. When the Middle Kentucky River Area CAP developed its own crafts outlet, in competition with the Grassroots co-op, Tolson supplied carvings to both organizations, as well as to the Tuskas, who sought him out after the Kentucky Guild Fair.

In March 1968, Tolson himself went to the Smithsonian, meeting Carl Fox. Featured on television and in the *Washington Post*, Tolson was pictured with a half dozen dolls and a large carved horse. Journalist Phil Casey portrayed him as "lean, laconic . . . a tanned weather beaten man who is built like a knife."[115] The reporter made special mention of Tolson's "lovely carving of Adam and Eve" but no reference at all to the Grassroots Craftsmen co-op.

This feature story was neither a tale of vanishing crafts revived nor proof of how poor Appalachians had grasped the "hand up" proffered by VISTA. Rather, the *Post* story profiled an eccentric individual with a "splendid Kentucky drawl." Although several AVs from outside the region had met Tolson by 1967, enjoying and exporting his carvings to their family homes in Washington and New York, it was through his visit with Smithsonian officials and the *Post* article documenting that encounter (reprinted April 2 in the northern Kentucky *Post Times Star*), that Tolson's reputation spread beyond Wolfe County.

It is revealing to consider two newspaper accounts, of the visit Cole, Dunn, and Rose made to Washington in November 1967 and of Tolson's trip four months later, contrasting the contexts of these stories, the writers' emphases, and the ways in which the Kentucky subjects described themselves.[116] Differences between these accounts indicate the disintegration of the Grassroots crafts co-op and Tolson's free float away, later to land within the designative net "folk art."

Cole, Dunn, and Rose were interviewed at Mrs. John Sherman Cooper's "elegant Georgetown home." The senator's wife told the women, "Your products are very fashionable," calling one quilt "wildly smashing" and ordering one like it for her husband. In contrast, Tolson was interviewed at the Smithsonian Institution, museum official Carl Fox proclaiming, "This man has one of the greatest collections of woodcarvings I've ever seen." Fox expressed his determination to display, as well as sell, the carvings and announced, "He's going to do many more for us, of working groups, of people he knows and has known all his life."

The story of the Grassroots quilters, written by a woman, described a semi-private encounter in a domestic setting, noting in cozy detail how the quilters "ran their knowing hands" over a coverlet Mrs. Cooper had removed from her own bed. The Grassroots Craftsmen's quilts excited a highly subjective response from Mrs. Cooper ("wildly smashing") and prompted her to order a personal gift. Mrs. Cooper failed to ask who actually made the "smashing"

piece she selected and assumed that another might be made to order just like it; the quilt was, after all, a "product," though a "very fashionable" one. This encounter represents a bit of staged intimacy, the sort that politicians' wives frequently enact, but its staging *as* a private and domestic encounter signaled that quilts were certain kinds of objects: utilitarian, reproducible, anonymous, decorative, personal.

In contrast Casey's article has Tolson "showing the Smithsonian Institution some of his work." Fox, in his role as a museum official, praised Tolson's carving and announced the plan to exhibit his "work." Likewise, Fox's reference to Tolson's pieces as a "collection" of carvings implies that each piece is original and distinctive and that together they constitute a creative oeuvre. Rather than picking out one object that suited his personal fancy, Fox was determined to acquire "many more" on behalf on the museum. Staging here is quite different, as are the signals about Tolson's dolls. They are not utilitarian but aesthetic objects, suitable for "display." Tolson, in the article at least, was not asked to repeat any carvings but "to do many more, of working groups, of people he knows"; thus, his pieces are understood as nonreplicable, one of a kind. Neither are they anonymous works, but all bear the mark of "his pocket-knife" and style. They are represented not as personal objects but public ones, to be exhibited and sold through the Smithsonian.

Sue Ellis's article on the quilters dwelled on the inception of the Grassroots co-op, recounting the history of the organization with emphasis on "the help of VISTA volunteers and a $100 donation," and the "instrumental" work of Michael Royce and his mother. Furthermore, quotes from Dunn, Rose, and Cole all stress the collective nature of their enterprise ("We make quality things. . . . When it gets cold, we have to have something to do as a pastime") and their industriousness ("We've got enough work to keep us busy until after Christmas").

In contrast, Phil Casey's article never mentions VISTA, Bickel's November trip that introduced Carl Fox to Tolson's carving, or any other instrumentality that might have brought the woodcarver to the museum. Rather, Tolson is portrayed as an independent agent, not a member of a group needing "help." Lacking further context, this story implies that Tolson strolled into the Smithsonian for a man-to-man talk, his carvings requiring no introduction. In the same vein, the Casey piece has Tolson tell his own life story, relishing his dramatic and colloquial speech: "I had a stroke, still got a blood clot in my head, and hard arteries. I've had a mess of it, been misfortunate, I've given up to die." The portrait that emerges from these devices combines backwoods bravura ("I told them to hang up those insurance policies—I'm not going to die") with insouciance ("He has either 23 or 27 children, it isn't clear which, and he doesn't seem sure"). Whereas Dunn, Rose, and Cole are depicted as a

wholesome, industrious bunch (Ellis has them arriving in Washington "Mary Poppins style"), Tolson is a lone wolf, "weather-beaten," sexual, bemused.

This contrast is further borne out in accompanying photographs and headlines. "The women" of Grassroots Craftsmen are posed in a cluster, smiling into the lens. They hold before them a batch of quilts one or all or none of them made. Tolson is pictured alone beside an assembly of his wooden dolls, staring with them off into the distance, his veined hands clasped, holding a cigarette. The headline of Ellis's article reads, "Vanishing Grass Roots Crafts Return," as Cole, Dunn, and Rose indeed *have* vanished behind a story of altruism and crafts revival. Tolson and his virtuosity are, in contrast, pushed to the fore: "Kentuckian Produces Penknife Art."

These two newspaper stories, of course, did not bring about a schism within the crafts cooperative, nor did they initiate the distinction between crafts and what would soon become known as contemporary folk art. Still their differences in approach do mark a distinction that would be continually retraced: between traditional and original, collective and individual, repeatable and singular, diligence and heedlessness, need and sufficiency, compliance and defiance. As exemplified in these articles, this distinction also divided female handicrafts from manly art, the former suitable for personal gifts and domestic use, the latter for museum sales and public exhibition.

Lest this distinction be understood as merely the result of imposed social constructions—urban and national press bigotries against rural people or male hegemony—one must reckon with how the Wolfe and Breathitt County craftspeople described themselves, the objects they made, and their processes of making. In the "vanishing crafts" account, Dunn, Cole, and Rose all avoided personal reference and stressed instead how "we" go about quilting and selling. Nancy Cole in a later article remarked, "We know we're poor. The people don't want to be but there's nothing they can do about it."[117] Cole presented herself as a spokesperson for both the cooperative and "poor people" generally; president of the Grassroots Craftsmen and a paid AV-VISTA, she spoke in an official capacity, cognizant of her position and the political goals of the Grassroots project. Dunn and Rose, also co-op officers, were likewise salaried Appalachian Volunteers.

Tolson, on the other hand, was loosely bound to the organization. Involved through his friend Darley Dunn, Tolson was never hired by the AVs nor held office within the Grassroots Craftsmen; therefore, he was neither as informed about nor as invested in the co-op's viability as such. His self-absorption and self-promotion were in considerable part consequences of his far vaguer affiliation, a distance from the organization that was largely self-imposed. As Mary Dunn related, "[The AVs]'d get him to make something and he'd say he would and they'd go back and he wouldn't have nothing done

on it." Tolson, who had turned down the offer to run the co-op's woodshop, remarked, "I can sell all the dolls I make and that is enough for me."[118]

According to Anne Glenn, Tolson did attend a number of the co-op's monthly socials, though he remained only tenuously affiliated with the group. Gary Bickel referred to Tolson's "self-respect and stature" and contended that the woodcarver possessed the bearing of "an aristocrat. He really understood his own worth."[119] Such matters of temperament are indispensable for understanding the phenomenon of artistic reputation and its representations, for it is to some degree according to sensibility, as manifested both in artistic style and in the maker's self-presentation, that certain objects, laying claim to greater significance, come to be socially designated as art. By refusing to manage the Grassroots woodshop or rationalize even his own output, Tolson was doubtless answering his own inner promptings; at the same time, wittingly or not, he was cultivating an image not of a humble, laboring craftsman but of an isolated and recalcitrant eccentric.

The Grassroots Craftsmen handled most sales through mail orders, especially in the early years. Since Tolson could not be relied on either to repeat himself or to carve on schedule, his pieces were impractical for the co-op to market. Its 1967 sales brochure offered carved dolls for $6.98, made by Grassroots member Mary Cole but sold anonymously. The sales leaflet noted, alluding to Tolson, "Similar dolls by our craftsmen have been sold to the Smithsonian Institution."

Former Appalachian Volunteers have conceded that the co-op was neither practically nor conceptually equipped to handle Tolson's carvings. David Holwerk explained that the AVs' outlook on locally made objects was "sort of industrial. Can we use this to form an industry that will give people jobs, that will create an economy here that will make life better for people? There was not much interest in the items themselves." Holwerk said that on first seeing Tolson's carvings, "I remember thinking they were, in their execution, a whole different order of work from the things that I had seen, but it didn't seem like you were going to turn this into an industry or anything, so it didn't make any impression on me from that regard. It never occurred to me that I was looking at a famous folk artist's work." Mike Royce conceded also that Tolson's carvings "didn't fit within the traditional handicraft concept. It wasn't like a hickory broom, which you could sell for $6.95," yet Tolson's carvings had been comparably priced. Miriam Tuska bought his dancing dolls for "around five dollars" at the 1967 Berea fair, and a year later, even after winning Carl Fox's praise, the figures were selling through Grassroots Craftsmen for only $11.[120] According to Royce, no one in the co-op understood "the full value of primitive art as opposed to traditional handicraft. . . . None of us had a concept of them as works of art. They didn't fit our general

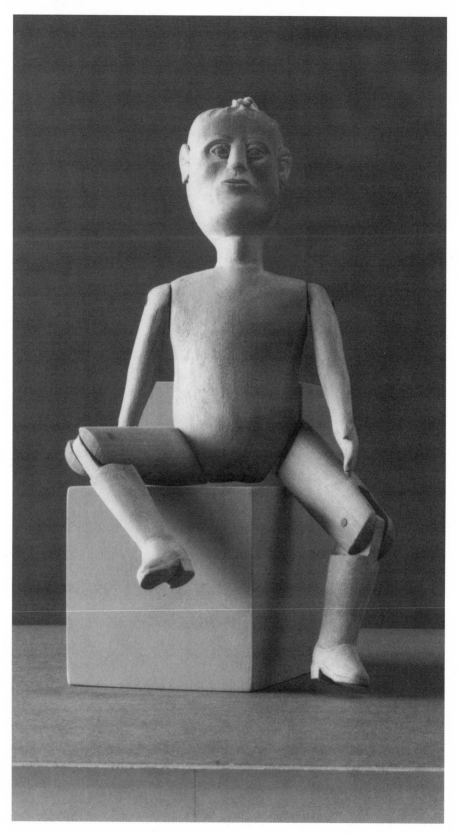

Dancing Doll,
1967. Collection
of John Tuska
and the estate of
Miriam Tuska.
(Photograph,
University of
Kentucky Art
Museum)

categories." Through his self-presentation, remoteness, output, and carving style, Tolson eluded the crafts categorization; in all these respects he resembled a fine artist.

By 1968 Tolson was developing a personal following, both mail correspondents and increasing numbers of visitors from Lexington. He no longer needed to rely on the Grassroots Craftsmen as a sales venue, though intermittently he sold pieces through both the co-op and its local competitor, Middle Kentucky River. A May 1969 flier from Grassroots, showing how Tolson had become an emeritus member, announced a "workshop on [Tolson's] front porch in Campton," where he would "share his secrets of successful carving. . . . Just this one day with Edgar might prove to be a start on a new life of carving, and Edgar will tell you it's a money making project."[121]

In October 1969 Mary Dunn and a contingent from Grassroots took a Tolson cane and one Adam and Eve carving to Washington, D.C., as part of a U.S. Department of Agriculture–sponsored exhibit of crafts cooperatives; Dunn and her sisters presented the presidential eagle quilt to first lady Pat Nixon on this trip. Just a week later, Monna Cable of Middle Kentucky River traveled to Washington for a similar convention, displaying yet another Tolson Adam and Eve tableau. By June 1970, when Dwight Haddix became the co-op's fieldworker, Grassroots Craftsmen handled only a few Tolson carvings. This was also the year sculptor Michael Hall assembled a one-man show for Tolson at the University of Kentucky and, subsequently, assisted in mounting a New York exhibition of twentieth-century folk art, featuring the carver's work. These university and museum exhibitions would further displace Tolson from both a "craftsman" designation and a cooperative marketing approach. Accordingly, Haddix, who continued to direct Grassroots as a private concern until his death in 1995, did not remember any Tolson carvings passing through the co-op after 1970.[122]

Why did the co-op not prove a lasting means for handling and selling Tolson's works? One must take into account that funding for the Appalachian Volunteers evaporated in 1969 when Governor Nunn refused the federal OEO allocation. AVs recruited from outside the region soon drifted off, most of them to graduate school, and the local Appalachian Volunteers were put out of work. According to Mary Dunn, who had been Grassroots' treasurer, a quilting teacher, and a key organizer since the group's inception, "My VISTA term ran out and I didn't get no more pay and I couldn't keep it a'going." Though not so embattled as the Pike County group, AVs in Wolfe and Breathitt Counties had met with local resistance too. Dunn remembered, "There's some people in Campton didn't like the VISTAs and they wouldn't sign up for the VISTAs to be in there. They said they was Communists." Monna Cable agreed that many of Wolfe County's elite resented the AVs: "I

guess they thought they was out of their place. I think they thought they was trying to run things."

The Grassroots Citizens Committee for Action did continue to receive OEO funding and in 1969, through the Grassroots Economic Development Corporation, initiated several new projects: a feeder pig cooperative, sawmill, pickle plant, and chair factory. Haddix contended, "After they got these other projects going they just let [Grassroots Craftsmen] die." In 1972, OEO funds disappeared entirely, just as the national handicrafts market began to boom. With the poverty programs that had sustained Grassroots Craftsmen enfeebled or gone, the cooperative was no match for alternative sales opportunities available to Tolson by 1969.

At the same time Grassroots, based on earlier settlement school models, had limited itself to a self-help ethos, a cottage industry approach, its cornerstones being, on the production side, an insistence on standards and, on the marketing side, an appeal to altruism. Though the co-op's founders could not have foreseen them as such, these principles narrowly restricted the group's aesthetic and economic fortunes.

In hindsight, Anne Glenn could describe the adverse effects of Grassroots' rationalized approach: "The first few quilts I saw were made out of feed sacks, not out of any kind of matching cloth. I mean, it amazed me the sense of design that women had even with the crummiest of resources. . . . And, in fact, I think, artistically some of the quilts made out of feed sacks were even prettier in some ways than ones that were later made out of polyester materials that were purchased in bulk and then distributed." In 1970 Grassroots was considering even more overtly industrial techniques, planning "woman community centers to do assembly line type quilt production so more quilts can be made."[123] Further, as Haddix explained, the co-op's training squelched individual piecing and stitching styles. From a crafts industry perspective, forbidding deviation from the model could be justified both as upholding standards and as meeting the customer's order, but from the perspective of fine art aesthetics, such standardization diminishes the quilt's potential worth as singular and experimental. In curbing the quilter's personal technique, such training might result in more widespread decorative appeal but not in the sort of original statement generally associated with works of art. These differing approaches, of course, have ramifications in pricing. Standardization tends to steady crafts prices but also to restrict them according to demonstrable investments of materials and labor, while art prices, which are much more volatile, typically reflect the demonstration of personal taste and the buying of individual authorship rather than labor time.[124]

The story of Dunn, Rose, and Cole's visit with Mrs. John Sherman Cooper—who took a quilt from her bed and then asked the women to "copy it for

me" — shows the Grassroots coverlets were assumed to be for household use rather than for display. In understanding and marketing quilts as utilitarian objects, it might first appear that Grassroots in no way distorted the indigenous quilting tradition, for in Wolfe County, too, people slept under homemade spreads rather than hanging them up like paintings. But, ironically, by marketing the quilts as bedding, Grassroots altered the needleworkers' quilting practices. Federal laws require that quilts intended for bedding that are marketed across state lines must be made only from new materials. In other words, by setting out to produce utilitarian quilts, Grassroots was not just induced to dispense new fabrics to control design and color choice (curbing community aesthetics to satisfy trends in suburban bedroom decor) but *forced* to do so by law. Thus, by maintaining a traditional conception of quilts as bedcoverings, Grassroots inadvertently distorted the traditional practices of quilters.

Grassroots' rationalized approach—subverting local quilting practices to suit popular taste—mirrored earlier incursions into Appalachian culture that Whisnant and Becker have so ably documented. As "cultural interventions," the Grassroots Craftsmen's efforts might be attacked with the same critical weaponry that has been aimed at the John C. Campbell Folk School and the Southern Highlands Handicraft Guild.[125] But what of the views held by the quilters themselves? "I thought it was great," said Mary Dunn, of sewing to specifications for both design and color. "They'd furnish the material to make the quilt, and then when you sold your quilt you'd go and pay the co-op for the material." For Dunn, Grassroots solved the primary problem of quilting, access to fabric, as well as boosting prices. Though her VISTA term ran out in 1970, she has continued to sew and sell her quilts both independently and through the privatized Grassroots Craftsmen.

What Grassroots members, including Haddix and Dunn, failed to see (and what Whisnant and Becker failed to consider in their analyses of cultural intervention) is that a higher economic gain could have been made by handling quilts as art, by translating the particularities of Wolfe and Breathitt County coverlets into aesthetic virtues. Instead, Grassroots chose to capitalize only on the craftsmanship of quilters and to efface both local and individual styles. In the past ten years, as even the Smithsonian has begun to market "Appalachian" quilts sewn in China, we see the consequences of this decision: sales fall to the lowest wage stitchery. Rather than inviting customers to dictate pattern and color or training quilters toward standardization, the Grassroots co-op could have benefited quilters more substantially with an alternative strategy, of authentication.[126] Since once standardized, patterns and color combinations can be mass-produced (by exploited women in the Far East, if U.S. needleworkers refuse the work), standardization is a shortsighted strat-

egy. Instead, Grassroots might have built a market for "authentic" quilts from Wolfe and Breathitt Counties, the "even prettier" ones sewn from feed sacks and those with "a piece of black and a piece of purple." Sold on the basis of their scarcity and uniqueness, these objects could have both commanded higher prices and afforded Kentucky quilters the chance to develop local techniques and individual styles.

Granted, manufacturers catch on quickly, and overseas seamstresses can produce feed sack quilts also. These realities only drive home that the greatest economic benefits to be gained from contemporary handmade objects will accrue to individuals or groups who succeed in preserving difficult skills or cultivating inimitable styles, especially those whose skills and styles continue to evolve and thus elude the copycat mass market. These are, in large measure, the same factors that both made Tolson's work more difficult for the Grassroots Craftsmen to market and account for its high prices today.

Grassroots' appeal to the altruism of potential buyers, emphasizing the poverty of its member-makers, was also ill advised: "One member's first quilt sale enabled her to buy new eyeglasses. Another was able to line her small home with wallboard."[127] This poster-child approach to crafts marketing undermined the Grassroots Craftsmen's avowed goal of "build[ing] human dignity."[128] It also rationalized low prices: treating a crafts purchase as charity masked the truth—that asking prices broke the minimum wage law.

The AVs' battles in Wolfe and Breathitt Counties, such as they were, tended to cast local elites—county politicians and CAP officials—as foes and to ally the poorest mountain people with the volunteers' wealthy families and powerful friends outside the region. The Grassroots co-op mailed sales fliers out piecemeal to personal associates and commissioned works as Christmas presents. The group also sought the favor of national political figures for publicity's sake. This tactic worked. Mary Dunn related that after presenting the eagle quilt to Mrs. Nixon, "I got all kinds of letters and things from people all around over the different states wanting to know about our quilts and ordering quilts. It kept us busy for a long time." But by casting local sheriffs and judges as enemies and forging ties, even if only symbolic and temporary ones, with federal politicians, the crafts co-op workers ignored the region's one-hundred-year exploitation by out-of-state interests and conveniently neglected how their own affluent families might be implicated in that same pattern of depredation.

David Whisnant has criticized Appalachian crafts enterprises in general, and Grassroots in particular, for "divert[ing] attention from the necessity for structural change."[129] He argued that crafts efforts in the mountains have depoliticized questions of culture and so neutralized possibilities for social change. "Interventions" such as the Hindman Settlement School, in Whis-

nant's analysis, misguidedly sought to combat the effects of systematic economic exploitation through private gestures of goodwill. Politically futile, these programs furthermore distorted even the local sense and potential of Appalachian culture: "Culture has become not the deeply textured expression of the totality of one's life situation—hopes, fears, values, beliefs, practices, ways of living and working, degrees of freedom and constraint—but a timeless, soft-focused, unidimensional refuge from the harsher aspects of reality."[130] Was Grassroots Craftsmen indeed guilty of this kind of cultural depletion and political evasiveness?

According to former AV-VISTA Anne Glenn, the crafts program "was expedient. And from my own point of view, and I think other VISTA volunteers felt this way too, we felt helpless to change anything politically." She and others found the crafts co-op satisfying "because it was something concrete." It should be remembered that the co-op's original agenda was only partly economic; Glenn, Bickel, and Royce all said they considered crafts a vehicle for leadership training and community organizing. As federally funded employees, however, all AVs and VISTA were restrained by the Hatch Act, forbidding any overtly political activity. Glenn stressed, "In training us they made that very clear, that we could not participate in politics, per se. Of course, now I look back at it and think, gee, the only way to make any change in eastern Kentucky would have been politically. So we sort of had our hands bound." With the arrests of AVs in Pike County and Joe Mulloy's dismissal, it became clear that the prohibition against political action was real. Political neutrality, in other words, had been built into the AVs through the group's dependence on the federal Office of Economic Opportunity.

Pulling back from overt political work, whether owing to the Hatch Act's prohibition or, as Whisnant claims, their own conservatism, the Grassroots co-op's artists still bespoke resistance and subversion through the symbolism of their crafts. Their carvings and quilts inscribed what author James Scott has called "the hidden transcript" of a political position too risky for official voicing.[131] In a *Wolfe County News* article appearing after Dunn and the other quilters visited Mrs. Cooper in Washington, local publisher Hazel Booth challenged Mary Dunn to explain the co-op's "Dove" quilt, asking if it contained a pacifist message. Booth wrote, "Mrs. Dunn explained that the dove quilt has nothing to do with the 'doves' in the context of the war in Vietnam, but the pattern comes from the Biblical story of Noah."[132]

As with the double meanings of African American spirituals, songs of rebellion communicated through the Israelites' escape from bondage, so there are good reasons to believe that Dunn and the other quilters used the Bible story to smuggle a protest of the war. An October 1967 memo to the AV leadership on the situation in Wolfe and Breathitt Counties expressed concern

that while OEO had disbursed a forty-thousand-dollar grant to the Grass-roots Citizens Committee, "the recent 'flap' in Pike County has stifled the full development of the Grassroots to handle this grant."[133] This remark suggests that the sedition cases and antiwar protests in more hostile Kentucky counties to the east were shaping the activities of the Grassroots Craftsmen. More directly, when asked to explain the origin of the dove design, Mary Dunn equivocated: "I don't know. Might some of the women had it. I don't know for sure. But that pattern, we kept certain patterns in the co-op that we just didn't give to people that didn't work for the co-op." This design, unlike flower basket or log cabin, was not part of the folk repertoire of Wolfe and Breathitt County needleworkers but "belonged to the co-op." Furthermore, by keeping this quilt pattern within the organization rather than making it available to everyone, Grassroots signaled the dove's special status, perhaps as a money-maker and a messenger both; special handling of this design suggests the members understood its antiwar message, realized that such a position was unpopular, to say the least, and refused to relinquish the motif to other quilters who might not share their views.

Booth's effort to interpret the dove quilt occurred just as Appalachian Volunteer Joe Mulloy had made public his intention to defy the Louisville draft board; in fact, the *Wolfe County News* article appeared only ten days before Mulloy was fired. The co-op's own newsletter account of the firing quoted Mulloy: "Poverty in Eastern Kentucky and the war in Viet Nam are the same issue. The advocates of war and the businesses that prosper from it are the same absentee landlords that have robbed Eastern Kentucky blind for years."[134] The same newsletter issue included a brief antiwar editorial also, published anonymously and trailed with a disclaimer—"The views that are printed here are not necessarily the views of the Kindling Wood"—added proof the Grassroots members felt restrained from open protest, even in their own publication.[135]

According to Donny Tolson, his father also opposed the war. "Dad thought they had no business over there in the first place."[136] To Tolson's own "hidden transcripts," the *Man in Overalls* and *Carmichael*, had been added by 1970 a full-scale poplar dove too. The first of these pieces was requested by photographer Rick Bell, who that year had sought and received military deferment as a conscientious objector, from the same West End Louisville draft board that heard the cases of Joe Mulloy and heavyweight boxing champion Cassius Clay/Muhammad Ali.

Whisnant's charge that cultural programs shirk political realities, or even that to "do good by stealth," which he criticizes, is somehow cowardly, ignores the threats that members of Grassroots Craftsmen faced. Whisnant acknowledged that local AVs and VISTAs, like Mary and Darley Dunn, "needed

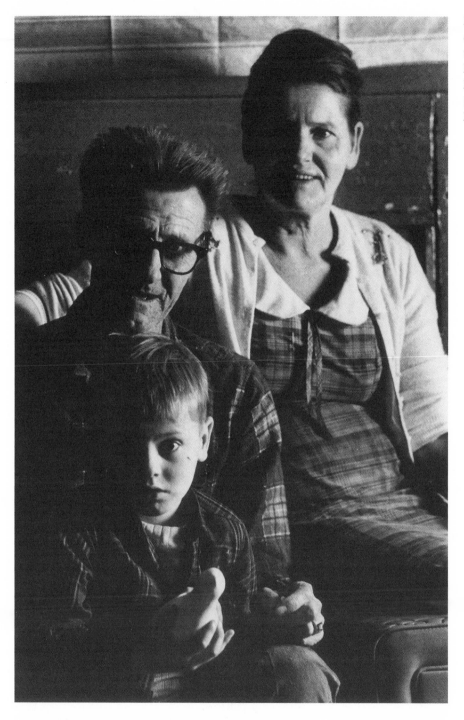

their AV jobs as many of the well-educated and well-connected fieldmen did not."[137] With these same jobs plainly in jeopardy, the Grassroots members were both clear and crafty to protest through expressive means: resistance takes artful form precisely when the penalties for resistance become most severe.

The Grassroots Craftsmen, during the era of the AVs, constituted an un-
likely alliance between affluent college students and dispossessed Kentucky
mountain farmers. Despite regional and class differences, they shared a
sense of powerlessness. The mountaineers had endured waves of intensive
development and abandonment, a century of resource exploitation. Locally,
these pressures were exercised and felt in the domination by local political
elites. Yet the college students who came to Wolfe and Breathitt, though priv-
ileged, were powerless too. As Anne Glenn remembered, "I just couldn't find
direction in college and that's when I became a VISTA volunteer." Reflecting
on her work in Appalachia, Glenn admitted, "I was a nineteen-year-old col-
lege student and I really had no skills. . . . When I look back on my years as a
VISTA volunteer I think, 'Oh my Lord, I was so naive and young and, almost
misdirected in a way.' I mean that in the sense that I really didn't know how to
impact any change there."

David Holwerk, a summer worker in 1966, recounted, "All the men were
worried that they might end up getting drafted when they got out. They had
worry about whether they would get into VISTA and not be drafted and sent to
Vietnam. These people had a whole lot on their minds, just getting through
the day." In addition to the threat of induction, Holwerk said, the student AVs
were menaced by local resentment.

> Lots of [the AVs] were subject to harassment by local people. People got
> their windows shot out and their tires slashed and that kind of stuff, and so
> the situation was a lot more fluid and had a lot more elements of just sort
> of confusion and inertia—all the things that you get if you take a bunch of
> twenty to twenty-four-year-old people and put them in a place where the
> future is completely obscure to them. Then if you put on top of it the whole
> uncertainty of the mid-sixties in this country, you get a pretty confusing
> environment.

This environment, rich in its potential for building unlikely coalitions, was
not conducive to sustaining them. When War on Poverty money flowed to
eastern Kentucky during Lyndon Johnson's administration, local elites proved
they could and would usurp control of the federal programs that had first re-
quired "maximum participation of the poor." And as it became evident the
majority of AVs would not stand behind Johnson's "dirty little war," funding
for the poverty program was snapped off. Student volunteers wandered away
to graduate school or jobs outside the mountains. Local VISTAs like Mary
Dunn, tossed out of work, returned to their rocky farms.

The same month Joe Mulloy was fired from the Appalachian Volunteers,
December 1967, Abbie Hoffman, Jerry Rubin, and a band of the New Left in-
augurated the Youth International Party. The Yippies represented "a blending

of pot and politics . . . a cross-fertilization of the hippie and New Left philosophies." In Todd Gitlin's analysis, the ascendancy of the Yippie marked a crucial shift of philosophy and strategy within the American Left. Most pointedly, political organizing was displaced by "a politics of display." This was not anonymous street theater. Instead Hoffman and Rubin brandished made-for-TV satires, burning cash on the floor of the New York Stock Exchange, wearing the flag—and, in turn, they became celebrities. In Gitlin's view, by playing to the media the Yippies became "trapped in a media loop, dependent on media standards, and goodwill. . . . They contributed to the very polarization of counterculture and radical politics which they claimed to overcome."[138]

A similar change would soon take place in the realm of folk art. Groups like the Grassroots Craftsmen had attempted to enlist material culture in a program of social change. Through community organizing, anonymity, and the symbolic freight of their creative works, the Grassroots Craftsmen had deployed handcrafts as a "weapon of the weak." Though the Wolfe and Breathitt County co-op could claim some success on these counts, its marketing approach was both economically ineffectual and politically skewed. As a consequence the organization withered once AV leaders were red-baited out of the region and OEO moneys withdrawn.[139]

By 1968 other visitors were venturing from Lexington to Wolfe County, and through them Edgar Tolson and his curious carvings would become enjoined in another kind of program: the building of artistic renown. Like the Yippie movement, it too would be based on sensation, celebrity, promotion. It too would shear politics and culture apart.

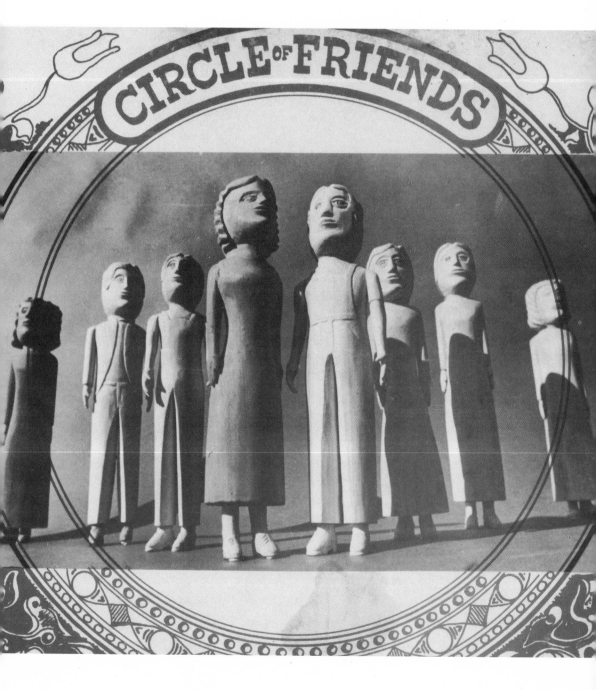

hrough the Grassroots Craftsmen cooperative, word of Edgar Tolson and his carvings had rippled over the Wolfe County line. His wooden dolls and animals had traveled north, east, and west with poverty workers, their sojourns in the mountains having come to an end. One former Appalachian Volunteer wrote Tolson in December 1967: "The dolls I brought back with me Thanksgiving have made so many people happy that there is a movement in New York to make you into Saint Edgar Tolson!"[1] Michael Royce gave a Tolson figure to his parents, Margaret Reuss and U.S. congressman Henry Reuss of Wisconsin; Anne Toepker Glenn purchased Tolson canes for her brother and father that Christmas. Yet these personal acquisitions and gifts, despite the prestige or delight of their recipients, would not significantly build Tolson's reputation or further an understanding of contemporary folk art. Rather, they were souvenirs, memorializing a period in the lives of these particular young people who, in most cases, quickly threaded back into professional schools, on their way to middle-class careers.

Journalist David Holwerk, a former AV, said of the Tolson carvings he still owns, "I don't have an interest in folk art per se. I liked having Edgar's stuff because I knew him and it reminded me of a time—when I was a freshman in college and was working in Wolfe County. Because of my connection through Appalachian Volunteers to Anne Glenn, to Colleen [now his wife], it has a meaning to me." Holwerk still views Tolson's carvings before the backdrop of personal reminiscence rather than within the history of art. The pieces have meaning for him not primarily because of their aesthetic merit, their traditionality, or their now considerable market value, but "because of my connection" to loved ones. In 1971 Holwerk would write a feature story about Tolson for the *Louisville Courier-Journal Magazine*. With his wife, Colleen Hattemer, he founded the mock-academic Tolson Institute and under its ensign traveled to early meetings of the Popular Culture Association to deliver papers on such species of American kitsch as the 1957 Chevy and White Castle hamburgers. Yet Holwerk's genuine but unsystematic admiration for Edgar Tolson, shared

"Circle of Friends," a 1970 anthology album of folk music produced by Michael Hall (Donerail Records no. 102), featuring J. D. Crowe and the Kentucky Mountain Boys, Annadeene Fraley, and others. (Cover photograph of Tolson dolls, Rick Bell; cover art, Michael D. Hall)

by others who worked in Wolfe County during the War on Poverty, would not cultivate Tolson's artistic career.

To understand why folk art "per se" gained popularity and prestige—and to see Edgar Tolson's place within that development—requires looking beyond both individual biography and localized projects like the Grassroots Craftsmen and Kentucky Guild. Folk art had long earned and warranted appreciation, both within and outside its originating folk communities, but in the United States it was not until the 1970s that folk art became commonly acknowledged as a category of *contemporary* art. Beginning in the late 1960s a confluence of social-structural developments—demographic, political, economic, educational—prepared a climate of receptivity for folk art, which over the next two decades was rationalized through systematic collection, marketing, and documentation. The fortunes of Edgar Tolson's "pen-knife art" vivify this shift from a local, folk-cultural orientation to an institutionalized folk art world.

His woodcarving had been rooted since childhood in eastern Kentucky traditions, occupational crafts like chair and ax-handle making and recreational ones like chain carving and the whittling of limberjack dolls. His work owed still another debt to commercial enterprises of the mountain mission schools and their offshoots, which abounded during the crafts revival of the 1930s, projects like the Southern Highlands Handicraft Guild and Homeplace at Ary, Kentucky. Still, it is accurate to say that Tolson did not, in fact, could not become a "folk artist" until he came to the attention of people outside his community, those who because of their age, social class, education, and regional heritage (as well as more immediate and sensate traits of diction, accent, dress) were struck by a sense of their own difference from him.

Eugene Metcalf, Henry Glassie, and others who have pried open the word "folk" have found that an assertion of such difference beats at the center of this unsettling term. Metcalf wrote, "It is a word hardly ever applied by a group of people to themselves or to the things they make and do. Instead, it is a word generally used by one group to describe the nature, activities or artifacts of others. . . . The word 'folk' designates a difference between the observer's art and that being described."[2] For Tolson to become a folk artist, then, required "observers" securely enough grounded in one notion of art to perceive and describe with confidence both the aesthetic value of his carvings and a contrast between objects he made and other works deemed "art." This apprehension of difference and the power to certify it marked preconditions for establishing a folk art world and for selecting the makers whom that world would admire.

It was, in fact, those institutionally authorized to make such distinctions, and those with the most pressing professional reasons for making them, who

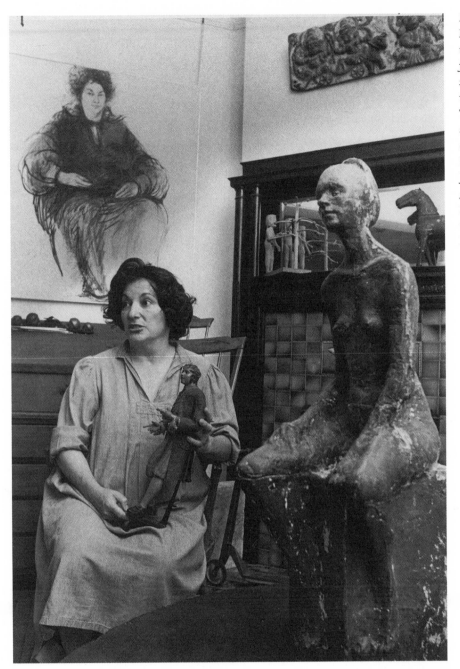

cultivated an appreciation of Edgar Tolson as folk artist: the faculty members and associates of the University of Kentucky art department. The first of the UK studio group to encounter carvings by Tolson, in early May 1967 at the Kentucky Guild fair in Berea, was Miriam Gittleman Tuska. A native of Newark, New Jersey, she had studied one year at Alfred University in New York and in 1956 married John Tuska, one of Alfred's outstanding students of ceramics. The Tuskas moved in 1960 to far western Kentucky, after John was

employed at Murray State University. Three years later, when he joined the faculty at the University of Kentucky, the Tuskas and their two sons relocated to Lexington.

At the 1967 guild fair, the Tuskas set up a booth of their own selling John's pottery as well as beads and dolls Miriam had made. Wandering about the grounds at Indian Fort, Miriam was enthralled by several unpainted articulated dolls she noticed at the Grassroots Craftsmen's table. She purchased all she could, two dolls for some five dollars apiece, but after making several inquiries about the carver, could learn only his last name and his hometown of Campton. "Well, I went home and I was absolutely on fire with these things," she remembered. "I wanted to see more of what this man did." Immediately she had conjured up an image of the unknown carver: "I pictured a certain kind of very romantic, primitive situation," Tuska said, laughingly. "I imagined him exactly the way I found him."

Phoning a Tolson residence at random through the Campton operator, Miriam failed to reach the woodcarver but learned that his pieces had recently been available through Yeager's Drug Store in town. The next day she invited a friend, Mimi Siegel, to accompany her on an exploratory drive to Campton. Tuska's venture led to the drug store, which no longer carried Tolson's pieces, to the bus depot, to an abandoned trailer outside town, "five or six places," she said, "and each person had some information that would take me to the next stop."

Eventually she was directed to a cabin north of town, a locale known as the Campground. From the roadside she called out to a figure up on the hill, "Edgar Tolson?" He waved and walked down to meet the two women, helping them across a deep dry creek bed, then up the slope to the log house. "It was so stereotyped," Tuska said. "There was this overstuffed, plush sofa on the front porch covered with chickens and whatever chickens do." Tolson's wife Hulda "motioned not to sit down," Tuska said. "She went in, got a broom, shooed off the chickens and brushed off the sofa, and then very graciously" invited the visitors to sit down. "She was just as charming as if she were greeting me at Buckingham Palace."

Hulda Tolson quietly scoffed at Miriam Tuska's enthusiasm for the carved dolls. "There was a lot of eye rolling. . . . The expression said, 'I can't believe these idiots are interested in this stuff.'" But Tolson himself, according to Tuska, was not surprised: "I think he liked what he did." He seemed also to enjoy entertaining the two Lexington guests. "He told us all of the Ed fables," Tuska said, how he'd whittled himself a set of dentures, how he'd served in the army, neither of which was true.

Tuska, however, was "basically interested in his work. . . . I asked him if he would make some pieces for us." Two weeks later she returned and acquired

two small standing figures, a man and woman, which the Tuskas refer to as "Mr. and Mrs. Tolson." According to John Tuska, "It's the spittin' image of himself and the other one is the spittin' image of his wife." Miriam called them "the best pieces, I think, he ever made in his life." The features of these figures are more naturalistic, finished, and delicate than the stylized, nearly archaic dolls Tolson would later make. On these early figures he carved with an understanding of facial structure, setting the eyes deeply into the dolls' wooden faces, and had taken great care in rendering the particulars of eyebrows, shoes, and galluses. "The soles of the shoes were defined," Miriam Tuska remarked, and she was pleased with this "refinement." "It isn't that that's a requirement, that there has to be all this itsy detail, but it was there, and it was thrilling."

After her second visit to Campton, Miriam Tuska mailed Tolson several preaddressed postcards; since the Tolsons then had no telephone (nor would they until 1981), she asked that Edgar send a card when he had more carvings to sell. She further encouraged Tolson in a letter after returning to Lexington with the astounding wooden pair: "We have some friends who would like some of your work but I did not say you would do it until I spoke to you. They all think your dolls are fine work and so do we. We have the new ones standing on the mantel and last night John and I just sat and looked at them. Their faces are so real we feel like they are going to speak."[3]

Tolson's local associates in the Appalachian Volunteers, Darley and Mary Dunn, had also recognized a market for his carvings, but sales through the Grassroots Craftsmen had been sporadic, the co-op training its energies primarily on quilts and an underlying goal of political organizing. It was the Tuskas' contact and enthusiasm, beginning in the late spring of 1967, that stepped the carver's productivity into a new register. Tolson recounted years later, "Mrs. Tuska bought some of my work and she came up to see me and ordered a bunch of dolls, one hundred. And I told her I didn't know whether I'd ever make that many or not. And I made her fifteen or twenty. I don't know how many."[4] The *Wolfe County News* reported the following year that Tolson realized his pieces "may be a source of income when he sold some items to a Mr. and Mrs. Tusky [sic] at the University of Kentucky for $3 each."[5] Assured that Mrs. Tuska would buy promptly all he could make, Tolson was moved to carve more diligently. Doubtless, he was also gratified to learn that a college professor and professional artist, her husband, John, valued his work.

On one of the Tuskas' visits Tolson produced a demonstration piece, a figure standing in prayer, for their son Stephan.[6] John Tuska remembered Tolson's "taking a square of poplar and beginning to break out, sharpen up edges, and if you've ever seen any even photographs of African tribes carving blocks of wood, he was going about it in exactly the same way." The art pro-

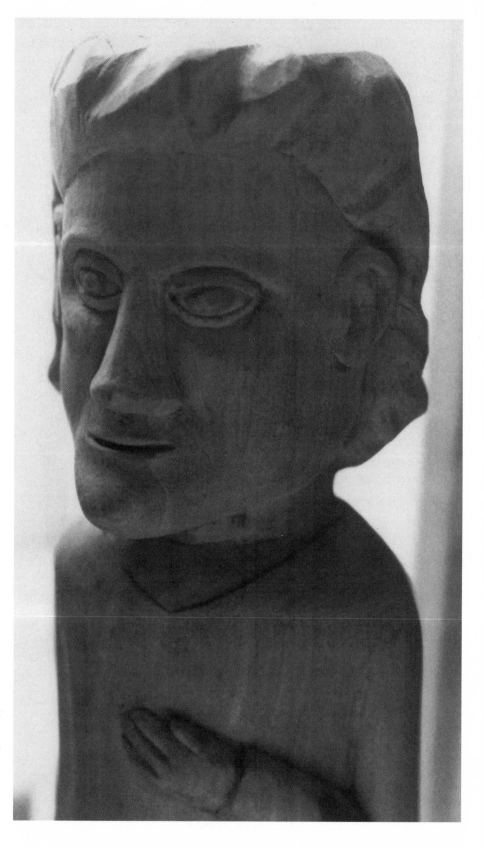

Standing
Woman, 1967
("Mrs. Tolson").
Collection of
John Tuska and
the estate of
Miriam Tuska.
(Photograph,
Melissa Lebus
Watt)

fessor was fascinated equally by Tolson's carvings and by his manner of work-ing, in accord with "some kind of an instinct." Miriam wondered, "What was this man seeing? Who are all these people he's doing? Each one was so differ-ent and we decided that they really looked like what we thought his friends would be like."

As their collection of carved dolls grew, John Tuska recounted, "I became curious if he could get beyond just that single figure that he was doing. They seemed to all be related to people around him in some way. And that's when I suggested that he try a more complex situation." Following his own impulse to teach, Tuska urged Tolson past the single "doll" and figures of local refer-ence, the men in overalls and women in ankle-length dresses. "I was the one," Tuska said, "who asked him to carve Adam and Eve."

Well versed in art history, Tuska recognized the theme as "very traditional subject matter for American carvings, in fact primitive carving. . . . I thought [Tolson] might have an interpretation that would be kind of interesting." Miriam Tuska knew Wilhelm Schimmel's nineteenth-century carving of Adam and Eve. John said he had seen early American folk sculptural depictions of the subject elsewhere: "I know the Brooklyn Museum had an Adam and Eve in their American wing collection. So did the Metropolitan. So did the Mod-ern Art museum." By requesting this set piece from the folk repertoire John Tuska was, without intention, teaching Tolson to become a "folk artist," to adopt its thematic conventions, just as in his university classes Tuska might have asked students to execute a still life drawing or sketch a live model. Tuska also held a personal interest in this highly visual myth. "I've always re-sponded to the tree, the snake. I am utterly enthralled by the Golden Legend. The descriptions, of course, that I read are that Seth planted the tree in Adam's head . . . the tree which ultimately becomes the tree of the crucifixion."[7]

The Tuskas have not described themselves as religious people, nor did they discuss religion at length with Tolson. Rather, they requested the primal scene of Adam and Eve to see Tolson tackle the formal problems of the nude figure. "The only thing I had ever seen of his was heads and hands and feet on some kind of a clothing," John Tuska said. "You don't ever get a sense of the body underneath. And I think that's what I was curious about. . . . I said to him, 'Edgar would you consider carving me Adam, Eve, tree, apple, snake?' and he said, 'Naked?' and I said, 'Yeah, naked.' And that was where he started."

Tolson gave much the same account: "What got me started on that story was the Tuskas from Lexington. She [Miriam Tuska] was up one time. And her husband John, he told her to ask me could I carve naked people, and I told her I didn't know, that I'd never tried. And that's what got me started on the Adam and Eve story. They were naked. And I made up my mind that I would

carve the Adam and Eve, in the Garden of Eden. And that's what started it all."[8] The point of discrepancy is whether Tolson chose Adam and Eve as an appropriate subject for rendering nudes, which the Tuskas had requested, or whether the Tuskas selected the biblical story for him. John and Miriam Tuska both said they recommended Adam and Eve after some thought. According to Miriam, "We both talked about it. I think we got to Adam and Eve because we wanted to see what Ed's concept of a nude figure would be and we didn't want to offend him."

The tableau was slow in coming, however. The first record of such a wood-carving does not appear until late March 1968, when, with representatives of the Grassroots Craftsmen, Tolson traveled to Washington and was introduced to Carl Fox of the Smithsonian. The *Washington Post*'s account noted, "[Tolson] has a lovely carving of Adam and Eve at the apple tree, with just enough of their primary and secondary sex characteristics to tell you who is who."[9] This first pair of figures were carved of yellow poplar, the tree of willow, with darker, marblelike apples whittled from cedar.

Ralph Rinzler intercepted the piece but shortly thereafter sold it to Joan Watkins, a filmmaker and potter and the wife of the Smithsonian's cultural historian Malcolm Watkins. As Tolson later explained, "Ralph Rinzler, he's one of the directors there, and somebody begged him out of it. They gave him about seventy-five dollars for the first one."[10] Also during this March trip Rinzler made preliminary plans for Tolson to take part in July's Festival of American Folklife; as postscript to a letter confirming Tolson's invitation to the festival, Rinzler wrote, "It was great to meet you. Please make more Adam and Eve pieces."[11] Tolson did. He brought four Adam and Eve tableaux with him to Washington that July, consigning them to sell for seventy dollars each through the Smithsonian museum shops; Tolson received fifty dollars apiece for them.[12]

Case of
"American Folk
Craft Survivals"
on view at the
Smithsonian's
"Hall of
Everyday Life,"
Museum of
American His-
tory, 1968–76.
The display,
assembled by
Joan Watkins,
featured works
by Tolson,
George López,
and several
anonymous
carvers.
(Smithsonian
Institution Photo
No. 68496)

While Carl Fox had enthusiastically accepted several smaller Tolson carvings for the Smithsonian Museum gift shop by December 1967, it was Mrs. Watkins who arranged to display Tolson's work, including this first Adam and Eve tableau, within the museum proper. From 1968 through 1976, two glass cases she prepared and labeled "American Folk Craft Survivals" stood in the Smithsonian's "Hall of Everyday Life," on the second floor at the northeast corner of what is now the Museum of American History, near the original "Star Spangled Banner."[13] Shown with Tolson's Adam and Eve were his rendering of a man milking a cow and a carved team of oxen painted red and white, as well as an Adam and Eve and Saint George and the Dragon by George López of Córdova, New Mexico, a wooden pig, and two carved chickens. The display would be viewed by thousands of museumgoers over the next eight years.[14]

After the *Washington Post* article appeared and was picked up by Covington's *Kentucky Post Times Star*, Tolson began to receive letters from around the country, a stream of mail that would swell through the 1970s and continue until his death in 1984.[15] Mail addressed simply to "Edgar Tolson, Campton, Kentucky" reached him; many correspondents directed their letters to Tolson, "the Woodcarver." According to Miriam Tuska, who in early 1968 was visiting Tolson regularly, the *Post* article was the turning point: "After that he got mail. And he wouldn't even open it. I said, 'Ed, why don't you answer your mail?' He said, 'It's never from anyone I know.'" After this exposure and the onset of the Tuskas' collecting efforts, demand for Tolson's carvings would

always exceed the supply. The *Wolfe County News* in the spring of 1968 quoted liberally from the *Post* story and noted, "[Tolson] has found markets at Winchester and Lexington for his carvings and now it appears that he will have an outlet for all the marketable items he can produce."[16]

Patterns of his early correspondence, 1968 through 1971, prove the impact of press coverage on Tolson's renown. The enormous variety of letters he received at this stage—the many types of carving requested and range of appeals, expressing every degree of sophistication and formality—also suggests that the field of folk art had not yet solidified. In the late 1960s Tolson was still a kind of cultural free agent, whose woodcarvings and biography struck a number of chords. A northern Kentucky woman, after seeing the Covington news article, wrote to request that Tolson carve a doll for her collection: "I want it to use in a doll museum I am planning on starting in four years when my youngest daughter is out of school." Enclosing a picture of several rubber baby dolls, she asked for a carving "on the order of dolls in picture."[17] Another correspondent with family ties to Kentucky sent wistful memories of the "narrow tunnel where the train plodded to Natural Bridge" and inquired after friends Tolson might have known; he also described an assortment of intriguing carvings he had encountered over the years: German peasant figurines holding detachable tools, a carved and shellacked piece of fungus that had been whittled into "an Indian on horse back spearing a Tiger, the most beautiful thing you ever saw."[18] A Berkeley professor of political science wrote, "The *Post* mentioned an Adam and Eve at the apple tree; that sounds interesting. Have you got a price list or something?"[19] Approached variously as an artisan for hire, an expert on carving, a fellow mountaineer, a mail-order artist, Tolson in 1968 could be many men to many admirers. As a character and creator he stirred intense interest.

Miriam Tuska intervened in Tolson's correspondence (as would others in later years, Monna Cable, Michael Hall, Ken Fadeley, and Larry Hackley). She urged him especially to raise the prices of his pieces, insisting, for example, that he charge the Berkeley professor seventy-five dollars for an Adam and Eve carving, though Tolson thought it should cost "considerably less." Like Mary Dunn, she grew annoyed at the carver's inconsistency. "I had the man send me the check because Ed was constantly drinking up the profits. I mean, his family never saw it. . . . He would make promises and then not fill them, so I was not giving him the check until I had the thing and then I shipped it. John and I paid for the shipping to California. . . . I never sold another piece for him."[20]

At the 1967 guild fair, Julie Friedman Hall had also noticed a Tolson woodcarving, a large wooden doll lying on its back in a box. She and her husband, UK sculpture professor Michael Hall, had driven from Lexington, "to look at

these people, our Third World, people who were left over from the American Great Society. A mixture of that plus an interest in aesthetics drove us."

Julie had grown up in Nashville, the daughter of stockbroker Jack Friedman and Estelle Friedman, an author of children's books and collector of African and contemporary art. Mrs. Friedman, like other well-to-do Nashvillians, had in the 1940s collected stone carvings from a local maker of grave markers and garden ornaments, William Edmondson, whose carvings are now routinely categorized under the rubric "twentieth-century folk art."[21] According to Friedman, "Nobody really in those days called them that. . . . They called it primitive art or naive art."

Her daughter Julie enrolled at University of Colorado in 1961. Majoring in art history, she met Michael Hall in 1965 while a student in his pottery class. They married later that year and moved to Lexington, Michael joining the University of Kentucky art department in the fall. The couple found a farmhouse in the country and gradually began to fill their home with pottery, American pots purchased at flea markets and antique stores — "production ware, big pots with blue writing that said 'Greensboro, Pennsylvania.'" In Julie Hall's estimation, their early interest in collecting American ceramics was linked to a kind of protopolitics. "We came from a craft base, which is a similar kind of interest in people of the grass roots, the earthy people, the people who live that mythical closeness to, what? Reality, I guess. That's what."

In an as yet inarticulate way the Halls, like many people of their generation, were trying to synthesize their liberal political hopes with more aesthetic proclivities. For them, as for many others at this time, shifting from an art mentality, with its overtones of stodginess, luxury, and elitism, to a focus on craft seemed a means of resolution.[22] As well, an antimodern sentiment of the late 1960s was taking shape through the idealization of handmade objects and "the simple life." Just as the century's earlier arts and crafts movement had been led by wealthy and bourgeois Americans, so too the 1960s crafts revival was carried on primarily by affluent and leisured young people, most of them college educated, who had grown restlessly ambivalent toward the comforts they had enjoyed.[23] By extension, whether in the role of altruistic VISTA workers, weekend antiquers, or "reality" seekers, college students of the Halls' generation sought to establish some contact with "people of the grass roots, the earthy people."

Like the Tuskas, the Halls found only sketchy information concerning the Grassroots Craftsmen's woodcarver. According to Julie Hall, "Somebody told me to go back to the potter at the University of Kentucky, that he knew who this person was." Asking John Tuska about the doll maker's identity, she said the trail went cold: "Like a lot of people who are very proud but also very pos-

sessive of their area's gold, he told me that it was an old woman that had carved that doll, and that she had died just recently. And so I kind of gave up."

In April 1968, the Tuskas hosted a dinner for California ceramic artist Peter Voulkos, who through Michael Hall's invitation had come to Lexington for a brief studio residency. According to John Tuska, the Tolson carvings he and Miriam had acquired sparked the interest of the art students and faculty members in attendance that night, especially the Halls. The following month both Julie Hall and faculty painter Jimmy Suzuki spotted several more wood-carvings at the second Kentucky Guild fair. Julie Hall remembered, "I grabbed Michael's arm and said, 'If she's dead she's carving from the grave. We've got to investigate this.'"

According to Michael Hall it was through OEO representatives in Frankfort that they learned Tolson's identity and then, with Suzuki and his wife, Emi Ozaki, undertook their own safari to Campton. Julie Hall recounted, "We pulled into some sort of little diner there, where there was this kind of a chunky type with an apron on and she said, 'What do you want to find him for? He carves naked people.' In other words he's not anybody in the town that we are proud of. And she said, 'But if you want him you'll probably find him,' she said very disdainfully, 'in the pool hall.'"

There the group from Lexington asked if anyone knew Tolson. "Everybody was a bit taken aback by our appearance," Michael Hall remembered. "I had long hair and bell-bottoms and Julie had a flowered dress on. We were the first hippies, I think, the town had seen in the flesh." They were directed to a man standing outside on the street leaning on "a wooden cane with a serpent carved around it. So we went over and asked him if he knew who Mr. Tolson was, and he said, 'Yep.' And we said, 'Could you tell us where we could find him?' And he said, 'Nope—but I'll take you to him.'" According to Michael Hall, "He started down the street and he turned the corner and went back behind the pool hall and down the alley. About twenty feet into the alley, he turned around with a big grin on his face and said, 'You're a-lookin' at him.' We had just met Edgar."[24]

This suspenseful story, frequently told by both the Halls, typically progresses through several salient subplots—the mystery of Tolson's identity, the setting out on an adventure, the Campton residents' disdain for Tolson's carvings, the young people's alienation, and finally Tolson's tricksterlike unmasking (as Michael Hall phrased it, "We had been slicked pretty good").[25] Not disputing the facts, it is worthwhile to examine the form of this story, since it served and continues to function as a kind of archetype, both to aggrandize and to authenticate contemporary American folk art.

Like Miriam Tuska's narrative, the Halls' tale of first encounter emphasizes the complexity of finding Tolson, involving a chain of local citizens as

Visiting Edgar Tolson in the summer of 1968 were Julie Hall, Emi Ozaki, Jimmy Suzuki, and Hiro Suzuki (foreground). (Photograph, Michael D. Hall)

clues. Similarly, both stories assert the sophisticates' ability to appreciate Tolson's dolls, which the people of Campton have ignored or dismissed; in Miriam Tuska's story it is Tolson's wife Hulda who "rolls her eyes," while for the Halls it is the waitress, offended by Tolson's "naked" figures. Unlike Mrs. Tuska's story, however, the Halls' discovery tale emphasizes their own feelings of self-consciousness on arriving in Campton and, crucially, Tolson's witty and private self-disclosure, which puts them at ease.

These narrative details first establish the difference between the Halls and the Camptonites and secondly cement their bond with Edgar Tolson through the joke he fondly plays on them in the privacy of the alley, beyond detection of the pool hall gang. The Halls' tale functions as a story of initiation; Michael Hall concluded one telling, "And that is the story of our meeting Edgar Tolson, and that was the beginning of the friendship. And, of course, the Tolson story is very central to our folk art odyssey."[26] This anecdote became a trope for his own understanding of folk art, envisioned as a journey and imbued with overtones of heroism. With scores of other stories like it, wherein educated seekers find and befriend folk artists in some out-of-the-way setting, a crucial dynamic of the field gains form: folk art is discovered by a legitimating outsider, some form of testing follows, and the folk artist reciprocates by accepting the discovering stranger.

Robert Cantwell, through subtle explication of moments at the Smithson-

ian Festival of American Folklife, explored this same dynamic: "In a context of unshakable dominance, the dominant offers himself up for a temporary and symbolic humiliation and defeat."[27] Such defeat and other rituals of festivity, Cantwell has contended, "temporarily relieve spectators of the burden that is most hateful, because it is the most difficult to throw off—that of their social privilege."[28] Likewise, in an effort to reconcile their liberal politics with the facts of their own advantage, the Halls set out to gain not only Tolson's woodcarvings but some sign of his validation also. In fact, their long association with him evolved as much from Tolson's willingness to oblige them with personal acceptance as from the Halls' appreciation of his art. (In Julie Hall's kitchen hangs a photograph of Tolson sitting on a green hillside between her and her sister. Michael Hall dedicated his first book, *Stereoscopic Perspective*, to three "mentors": his father, Peter Voulkos, and Edgar Tolson.)

His identity disclosed, Tolson invited the young people to his Campton workshop, then to Maude Rose's house at Malaga, where the Grassroots Craftsmen maintained a small salesroom. There the Halls purchased a wooden figure of a woman for eight dollars. Thereafter, they would not buy through the crafts co-op but directly, earlier pieces from Wolfe Countians who were willing to sell and new work from the carver himself.

The notorious spring and summer of 1968 witnessed cataclysmic political events: Lyndon Johnson's announcement he would not seek reelection, the assassinations of Martin Luther King and Robert Kennedy, and the bloody Democratic presidential convention in Richard Daly's Chicago. These same reeling seasons brought turning points for Tolson and the Halls, points from which the field of folk art would emerge.

Accepting Ralph Rinzler's invitation to take part in the second Smithsonian Festival of American Folklife, Tolson traveled to Washington. Among the eighty-some crafts demonstrators were eight more woodcarvers, including West Virginian Connard Wolfe, who chiseled a crucifix during the festival, and santos carver George López from Córdova, New Mexico.[29] The extent of Tolson's contact and exchange with these other artists remains uncertain; however, a map of the festival grounds shows the carvers were stationed together for four days of demonstration, and, since the Smithsonian typically houses visiting craftspeople together in dormitories, there would also have been ample opportunity for Tolson to meet the other woodcarvers more privately.

The most striking new piece Tolson produced in 1968 was his first *Expulsion*, a tableau of Adam and Eve being driven from the garden by a sword-wielding angel. This image had long been part of the López family repertoire, carved repeatedly by José Dolores López from as early as the 1920s and later by his son George.[30] Since Tolson's first rendering of this image was made in

1968, he may well have been stimulated by seeing George López's version of the theme during the Smithsonian festival.

A New York art collector who had traveled to Campton in November 1968 to buy an Adam and Eve carving wrote in February of the next year, "How are you getting along with your project—the series of carvings from Adam and Eve in the Garden up to Noah's Ark?"[31] Rinzler contended that it was Carl Fox who suggested the Noah's Ark theme to Tolson, recommending, as John Tuska had, a stock folk art image. According to Hall's notes, Tolson declared in the spring of 1968, "Some day I'm going to carve Adam and Eve all the way through till Eve bears Cain. . . . I told this fella about that idea and he said he would pay me $500 for it. Think of that. Some day I'll do it."

Association with the Smithsonian shaped Tolson's sense of his own wood-carving in manifold ways. Sales through the museum shop, at the festival it-self, and then to correspondents who had met him in Washington convinced Tolson that he could depend on buyers. He said in 1981, "The first selling I [did was] to the Smithsonian and anywhere around that is out in the public. I did sell some before that to Berea. They had that little craft thing going on there. That's before I first started first selling my dolls for necessity, buddy."[32] Tolson here drew a distinction between selling a few odd items at the guild fair ("that little craft thing") or privately, to the Tuskas, and his arrangement with the Smithsonian ("out in the public"). Only after his involvement with Carl Fox and Rinzler did Tolson consider carving a source of income ("selling my dolls for necessity"). Along the same lines, he told Skip Taylor, "I never carved the Adam and Eve until after I got the sale for them."[33] While the ro-mance of folk art may suggest an ideal of pure creativity, regardless of mater-ial gain, in Tolson's case the promise of sales definitely spurred both his imagination and his productivity.

Praise from official sources also aroused Tolson's pride. Of taking his first Adam and Eve piece to the Smithsonian, he said: "When I got up there every-body went wild about that. There was everybody reaching for it."[34] While Tol-son had enjoyed a few occasions of local recognition, as at the library dedica-tion when he presented a cane to the Kentucky governor, he reveled in this new attention from reporters, art collectors, and the university-trained artists who, by the summer of 1968, were visiting regularly from Lexington. Their compliments altered his view of himself and his work; he told Hall, "They say I'm an artist, you know, people who buy my carvings."[35] This changed self-conception would prompt Tolson to discuss his pieces more seriously and to attempt increasingly ambitious works.

Equally important, Tolson's contacts with the Smithsonian and the univer-sity supplied him with new ideas for carvings. The Tuskas had requested Adam and Eve and Carl Fox the Noah's Ark; a case has been made that the Ex-

pulsion was inspired by George López during the 1968 Festival of American Folklife, where in any case the Campton whittler saw an array of arts and crafts. Several years later, after visiting Boots Bar in Lexington with a group of young student friends, Tolson began "carving go-go dancers as opposed to Biblical figures: dancers with little bikinis on."[36] Many other pieces originated similarly, through the suggestion or outright request of Tolson's new patrons.[37] Art historian Daniel Robbins has discussed the peculiar symbiosis between folk artists and their fine art admirers: "That many contemporary or recent folk sculptors are discovered in towns like Taos, or Woodstock, or Springs is a double function of the self-taught artist to be instructed and stimulated by his environment and to be 'found' by the searchers in such colonies."[38] This observation certainly holds true for Tolson, whose artistic career flourished with encouragement from museum officials and through contact with the fledgling artist "colony" at University of Kentucky.

Also during the summer of 1968 Michael and Julie Hall, on a trip to New York City, stumbled upon the Museum of American Folk Art, then located near the Museum of Modern Art on West Fifty-third Street. They browsed through a show featuring what have since become classics of American folk art: *Stag at Echo Rock* and *Trapper and Squaw*, both now part of the National Museum of American Art's collection. With characteristic drama, Hall has described the visit as a spiritual epiphany, "Our conversion to folk art was almost instantaneous."[39] Overhearing their excited remarks was Herbert Waide Hemphill Jr., a founding member of the folk art museum, the exhibit curator, and on this particular day its gallery guard. He invited the young couple to see his own folk art collection. Again suggesting a religious experience, a pilgrimage, Hall has said, "I see that Bert's place was targeted that day as a mecca for new collectors and young artists."[40]

Hemphill was a thirty-nine-year-old bachelor, the only child of well-to-do parents from Atlantic City; his maternal grandfather had for more than two decades been chairman of the Coca-Cola Company. Hemphill moved to New York City in 1949 and, living off an inheritance, had become one of the city's foremost collectors of folk art by the early 1960s. In 1961 he was recruited to help found the Museum of Early American Folk Art and over time would serve as its director and curator. Hemphill has described his own artistic taste as "reactionary," inasmuch as he shunned abstraction, the dominant style of the early 1960s, in favor of antiques and figurative works.[41] His shadowy apartment, jammed with twig furniture, gourd snakes, and sculptural wreaths made from old horseshoes, resembles more than anything a vault of stage props, each object more outlandish than the next.

Hemphill's aesthetic was molded by collectors of an earlier generation, especially Jean Lipman, who through a number of publications had codified her

taste for "simplified stylization, surface pattern and design, multiple perspectives and bold, flat areas of color." Art historian Lynda Hartigan has argued that Hemphill, like many collectors, operated from "a subliminal, if not intentional, checklist of desirable acquisitions," a checklist Lipman's books provided.[42] Yet Hemphill's taste was not fixed by precedent. Like Andy Warhol, another omnivorous collector of Americana, Hemphill deviated from established folk art examples to embrace the unlikely or oddball piece. Most famously, presented with a roomful of cigar store Indians to be auctioned at Parke-Bernet in 1956, Hemphill selected a peculiarly crude and chunky figure, cheaper than the more standard draped and feathered statues in the lot. Now widely known as the *Indian Trapper*, this purchase, made at the highly publicized forum of the Parke-Bernet auction, marked Hemphill as an eager and eccentric buyer. Increasingly aware of his tastes, New York dealers were in turn encouraged to scour for and set aside objects that did not fit so cleanly into existing folk art or antiques categories. Hemphill was notably receptive to objects made in the twentieth century, pieces from outside the East Coast, and work bespeaking non-Anglo ethnic traditions.

Julie Hall remarked that after visiting the museum and Hemphill's apartment, both filled with objects by anonymous artists of the past, she and Michael began to reflect on Edgar Tolson. "We said, 'Well wait a minute. Maybe there's one of these guys that is still living.' For all we knew there was only one. It was like the last of a dying species; we really had no idea. In fact I think the analogy was Schimmel, a woodcarver with an irascible temperament, carving forlorn and lonely things, occasionally selling them and trading them." Apprehending the visual, personal, and cultural parallels between Tolson and this accepted "master" of American folk art, the Halls were emboldened to try fitting their own recent experience of Campton, Tolson, and his woodcarvings into the cultural category Hemphill had introduced to them.

After several hours of conversation, the Halls told Hemphill about Tolson's carvings, showing him recent photographs of the carver, his family, and his work. When Hemphill asked to acquire a piece, Hall realized "that coming back into town with a carving for [Hemphill] was a way to initiate an ongoing conversation with this man and to engage his collection again. I was overwhelmed by the collection." Previously, Hall's New York excursions had focused on his own career as a sculptor, but through Tolson's woodcarvings and Hemphill's interest, he glimpsed another possibility, a new and distinct realm of art history and collecting.

> Though I'm sure [Hemphill] would have just been happy to see us anyway, if we came back with a Tolson I felt we would have entrée of another kind. And I also thought on Edgar's behalf, that Hemphill's interest was a

break—a real opportunity. Here's a guy who actually knows something. We were all just little advocates, you know. We were just this scruffy bunch of little boosters who thought Edgar was wonderful and thought his carvings were terrific. But here was a guy who was a real collector, who was a founder of a museum and a trustee of that museum and he wanted to own a Tolson. Well, his enthusiasm reified a lot of things that we believed but we didn't have any proof until a guy like Hemphill, who we thought was larger than life, stepped up and said, "Give me one of those carvings. I want one."

During the summer of 1968 the Halls, Suzuki and Ozaki, and the Tuskas acquired their first carvings of Adam and Eve in the Garden. The Halls also brought Julie's parents to visit Tolson, the Friedmans' purchasing an Adam and Eve carving for thirty-five dollars. "We have shown it to many people so that now you have many admirers in Tennessee," Mrs. Friedman wrote to Tolson that August; she later purchased another Tolson carving for the Nashville newspaper's art critic.[43] At Thanksgiving a New York couple who had met Tolson at the folklife festival drove to Wolfe County to buy an Adam and Eve, paying twenty-five dollars in advance and twenty-five more on their arrival.[44] That winter Tolson gave yet another Adam and Eve carving to a young doctor at the Campton Medical Clinic.[45]

Though perhaps not accounting for his full output of *Temptation* tableaux by late 1968, these records prove that Tolson had come to the admiring attention of several publics by this time: local friends, notably medical professionals and social service workers of Wolfe County; the Appalachian Volunteers and VISTAs; Kentucky Guild associates and fairgoers; Smithsonian officials, including Carl Fox, Joan Watkins, and Ralph Rinzler; visitors to the folklife festival; Lexington's studio art crowd; and Nashville art collectors. As well, newspaper articles out of Washington, Covington, Campton, and Lexington had introduced him fleetingly to a mass audience. Yet interest in Tolson's woodcarvings remained random in character, and the pieces themselves were scattered, standing on local porches, displayed at the Smithsonian, sold at the gift shop, decorating both the desks of Wolfe County welfare workers and the piano in Ralph Rinzler's home. Julie Hall remembered finding a carved doll on a shelf at the Wolfe County Library and buying it from the library staff: "They were kind of like things without a home. As you say now, they were in motion." As Julie Hall explained, Tolson's carvings "had not found their category. . . . He had not found his niche in the history." His pieces would continue to be handled haphazardly until "folk art" became such a niche.

Early in 1969 the Halls delivered an Adam and Eve carving to Hemphill in New York, selling it to him for the New York price of fifty dollars. Hemphill

straightaway voiced his wish to buy more of Tolson's work. It was then, Hall said, "the bells went off in my head." Hall recognized that he and Julie could contribute to a larger, as yet indefinite endeavor. "There was something going on in this folk art thing and Bert knew some of it and we knew some of it, and he indicated that he could show us other things and introduce us to other people who were all part of something even larger. It was a world, and we had just walked in the door."

Exposure to Hemphill's collection gradually transformed Julie Hall's view of Tolson and his woodcarvings. What had been a casual fascination with handcrafted articles, a "community-based cottage industry, with prototypes and certain forms that everyone followed," became a collecting interest in more peculiar objects. "Bert added the other, the one-of-a-kind genius thing." As a consequence, she said, "My interest shifted from the production of craftware to the individual vision."

The Halls' growing advocacy of folk art as "individual vision" also manifested a displaced careerism, ambition taking the form of psychic annexation. Their reevaluation and promotion of Tolson as an original bespoke not only increasing affinity with Hemphill but an effort, not altogether lucid, to invigorate and justify their current artistic circumstances. With the spread of master of fine arts (M.F.A.) programs far from status-making New York, young studio faculty and their students in the "hinterlands" required alternative models of artistic virtue, new terms for success. The unfolding of Michael Hall's own career as a sculptor serves as an example.

While employed at University of Kentucky, Hall also maintained a studio in New York City and made periodic trips north to show slides of his work around the galleries. "I had a career expectation that was very fixated on New York. I believed that I would grow into a peer affiliation with the art world of New York and would at some point phase Kentucky out. . . . Sale of my work would start to be my income and I could leave teaching. It was a very nice little dream. And of course it didn't work."

Hall's pursuit of artistic success along these standard lines in fact had worked rather well. He was represented by a New York gallery, an achievement in itself, and had been selected for the Whitney Museum's 1968 Sculpture Annual, one of the youngest artists ever to gain acceptance in this prestigious national competition. Nevertheless, he described even that accomplishment as profoundly unsatisfying.

"I saw God in 1968," Hall declared. Walking through the Whitney exhibition, "I saw how a show like that is put together. To my eye it seemed that there were ten or twelve styles. There were innovators of those styles and then there were sort of legions of support people whose work extended that style statement in small directions. . . . And I saw my piece as fitting in, in that

sense, as support for a new sort of West Coast energy that was coming into sculpture at the time." Put off by such simplistic categorization (and subordination), Hall said, he turned to his wife, Julie, and swore, "'This is the last time. . . . I won't be back here doing this, this way, again for these reasons.' I just knew that that wasn't what I wanted to be as an artist. I didn't want to just be a part of making up some curator's idea of a style statement."[46]

Hall's disaffection with New York was compounded by other longings, less professional goals. "Somehow, I never felt that I was included. I felt that I had intruded there, and though I was a reasonably successful intruder, I didn't ever have that sense of being embraced. . . . On the other hand, in my intrusion into Kentucky, a situation where I was certainly as much a foreigner as I was in New York, I found a sort of welcome party and I found an acceptance. I found I was appreciated."

Indeed, he had been. Within the fine arts division at UK, Hall had the strong support of chairman George Gunther, who put expanding resources at Hall's disposal. As a consequence, Hall was able to execute a number of plans: to attract strong senior students, arrange short-term residencies with nationally acclaimed artists, increase the amount of studio space, and expand the budget for materials. Additionally, Hall mounted a mail campaign to broadcast both the opportunities and the achievements of UK's department. "We had one simple rule of thumb: every little deal can be made into a big deal, and to make it a big deal you make a poster about it. We were literally a propaganda mill in the name of the UK art department and its programs."

Hall was a dynamic teacher. Through his energy and youthfulness, a penchant too for socializing with students, Hall rapidly drew around himself a community of protégés. One such associate was Rick Bell, at age twenty-two already an accomplished professional photographer and photo editor for the university's yearbook, The Kentuckian. Bell befriended Mike Hall while working on a extended shoot of the Reynolds Building, a former tobacco warehouse the university had converted into studio space. His photographic essay for the 1969 annual, featuring eleven pictures of Hall, portrayed the department as hip, intellectually intense, and intimate. Hall was named a "Pacesetter" by the college yearbook staff.[47]

"The students were just exploding," Bell said of the studio art scene.

I mean, you'd go in there at four in the morning and there would be just incredibly exciting things happening, wonderful, really important kinds of contemporary art . . . and the driving figure of Mike Hall who, if you know Mike, he's a very dramatic person, charismatic, broke down the barriers between faculty and students and was willing to get up and do incredibly ridiculous things and stimulate thinking, and push and demand.[48]

"Seven Sculptors," poster announcing the University of Kentucky Summer Sculpture Workshop, 1967. (Design, Michael D. Hall)

Hall's antics off campus included Son of Teen Angel Day, a 1950s revival, held at nearby Woodland Park. According to Rick Bell, Hall put on an exuberant performance, transforming himself from "hippie prince" to teenage gangster, while rendering a song of lost love. "He shaves his mustache off on stage and he greases his hair back and he's got his t-shirt and he's rolling a pack of Luckies up and he's telling this story about when Carol broke up with him. And it's just hilarious."[49]

Happenings like these galvanized Lexington's tiny counterculture. "I was sort of forming around me a usable and believable community of peers that was accessible, a community that was here and now," said Hall of his years at University of Kentucky. "And as its kind of inspirational head, there was Edgar Tolson. He was the non–New York model in our day-to-day art world. He was a guy who could make good art out there somewhere living under a rock, not in the Soho. And the fact that he was able to do that was inspirational for me in particular."

Elsewhere, other studio artists were likewise turning to nonacademic models. During the 1960s students at the Art Institute of Chicago styled themselves as art world renegades, "outsiders" who could revel in rather than

lament the distance from New York.[50] This defiant stance had been assumed in the "Second City" at least since 1951, when Jean Dubuffet delivered his lecture "Anti-Cultural Positions" at the Arts Club. Damning "complicity with the prestige and promotion machine," Dubuffet advocated *art brut*, a raw expressiveness he discerned in the creations of psychotics. "The production of art," he would later write, "can only be conceived of as an individual and personal

activity in which everyone partakes, and not as an activity delegated to autho-
rized agents."[51]

This maverick posture and identification with nonacademic artists para-
doxically became part of the Art Institute curriculum. According to critic
Michael Bonesteel, professors at the Art Institute beginning with Kathleen
Blackshear, followed by Whitney Halstead and Ray Yoshida, "insinuated the
work of ethnic primitive and modern naive artists into the curriculums of Chi-
cago's future artists, historians, and critics."[52] Art historian Halstead offered
classes in surrealism, dada, African and oceanic art, and required that stu-
dents read Bihalji-Merin's *Modern Primitives* and Sidney Janis's *They Taught
Themselves*, as well as the most current writing on vernacular art, for example
Gregg Blasdel's 1968 survey of folk art environments.[53]

"That's how I learned about Edgar Tolson," explained painter Roger
Brown, a student at the School of the Art Institute from 1967 until 1970.
Brown recalled a 1970 class in which Halstead showed slides of Tolson and
his woodcarvings, among other photographs gathered during summer trav-
els to the Smithsonian and elsewhere. Halstead also knew where Tolson
lived. When Brown drove home to Alabama in 1971, he detoured through
Campton and there purchased an Uncle Sam carving for fifty dollars from
Tolson himself.

Painting professor Ray Yoshida, a collector of African masks and Mexican
folk art, urged students to join him on trips to Chicago's Maxwell Street mar-
ket. Brown joined these "treks" and at thrift shop prices began his own col-
lection of found objects. The Art Institute group's forays netted "popular
manufactured items and things from the thirties and forties and earlier—just
anything that caught your eye that was interesting. We weren't going to flea
markets to look for folk art," Brown said. "We were looking at all kinds of
things that were just visually inspiring to us as artists."

The Chicago art students' hobby and habit of discovery extended by 1968
from browsing for anonymous objects along Maxwell Street to searching out
obscure artists themselves. In late 1967 the *Chicago Daily News* published an
article about retired circus roustabout Joseph Yoakum and his dreamlike
landscape drawings. Yoshida, Halstead, and painter Jim Nutt purchased sev-
eral of Yoakum's works from a gallery on Clark Street, and in the summer of
1968 Brown and fellow art students began visiting Yoakum at his storefront
residence on the South Side. Brown, Nutt, and the other Second City painters
labeled "Chicago Imagists" and "The Hairy Who" cultivated an outsider
ethos in part by rallying around Yoakum, purchasing his work, and arranging
shows for him, finding in him an enviable heedlessness vis-à-vis the New
York art establishment.

"All of us by that time had become familiar with [Henri] Rousseau and the

interests that those European mainstream artists had in Rousseau and other kinds of primitive and folk art," Brown said. "So when we discovered Yoakum in 1968, it was sort of like discovering in a way on a parallel to what the artists that we had been reading about, the European mainstream artists, what they had done in discovering Rousseau. We sort of felt that we were doing the same kind of thing. Here we were starting off as artists and we discovered this great primitive working among us. It was real inspirational." According to Brown, the Chicago painters drew inspiration from Yoakum himself, an artist of originality and confidence working, like themselves, without the sanction of New York's arbiters. Yet equally "inspirational" was an awakening sense of their own powers to authorize: despite their relative obscurity, collectively they could elect a painter even more marginal than themselves. In the process, they reenacted a ritual of modernism, situating themselves by analogy alongside Picasso and Apollinaire.

Likewise, the Halls' affiliation with Edgar Tolson reenacted the impressionists' and later modernists' association with postal inspector and Sunday painter Henri Rousseau. "Le Douanier," exhibiting paintings at the Salons des Independents in 1891 and 1892 alongside Pierre Bonnard and Paul Signac, subsequently became the darling of Parisian avant-garde art circles. Rousseau was not a folk artist, working in accord with an ethnic, religious, or occupational tradition. Rather, he appears to have been aiming for a realism on the order of academic artists like Bouguereau.[54] Failing so peculiarly, however, he could be annexed as a kind of partner in rebellion by avant-gardists who opposed the realist style. For the early modernists his paintings repre-

sented a naive mockery of all they found *retardaire*. Thus was established an art historical precedent: for academically trained artists to align themselves with self-taught makers as a way of snubbing or at least appearing to snub an already imperiled art establishment—whether the French Academy on the wane in the 1870s or the New York dealer/critic system, splintering under the populist and pluralistic pressures of the 1960s.

To ask such fundamental questions as What is art? Who has the power to designate it? constitutes, as Pierre Bourdieu has explained, the cultural new-comer's strategy: to overturn existing cultural authorities and forms of legitimation in the self-interest of setting up new terms for success.[55] The adoption of a nonacademic, folk, or naive artist had, through the example of Rousseau and the early modernists, become a historically sanctioned strategy of this sort, a kind of avant-garde badge of honor. Taking up the cause of a Rousseau, Yoakum, or Tolson, aspiring but as yet unestablished artists might mount a revolt once removed, a challenge without consequences, undertaken vicariously through the figure of the folk artist.

One of the most direct and strident such challenges was made by Michael Hall himself; in a 1985 lecture at Philadelphia's Moore College of Art, he called for detailed art historical analysis of works by Martin Ramirez, whose vertiginous drawings had been enjoyed for their strangeness, as the work of a "psychotic," but never critically investigated for their meaning, their underlying coherence. Again, flexing his own cultural muscle, his power to press for change, Hall ended his manifesto: "As an artist, I am asking the court of critical revision to parole my brother, Martin, now."[56]

Elsewhere around the country, academically trained artists of the late 1960s took up the cause of self-taught painters and sculptors. Art students at the University of Louisville flocked to visit Henry Dorsey, a retired brick mason who had built an immense, mechanized sculpture from cast-off materials in his front yard at Brownsboro, Kentucky. In 1968 Stuart Purser, an art professor at the University of Florida, met local carver and sculptor Jesse Aaron and arranged the first formal exhibition of his work on the Gainesville campus that same year. Also beginning in 1968 students from the University of Arizona initiated their own monthly treks into the Sonoran desert to buy in quantity the figurative woodcarvings of Seri Indian artists.[57]

Chicago Imagist painters Jim Nutt and Gladys Nilsson relocated to northern California to teach in 1968, introducing Joseph Yoakum's drawings to a West Coast audience. Meanwhile, they came upon the drawings of Ramirez, arranging an exhibition the next year and convincing their Chicago art dealer, Phyllis Kind, to take an interest in his work. Also in California, vernacular art environments built by Simon Rodia and Tressa Prisbrey had, like Dorsey's construction outside Louisville, developed cult followings of art students.

Nutt contended that exposure to such powerfully expressive work liberated him artistically: "When you see someone like Ramirez or Rodia or Yoakum striding out on their own, it makes you feel more comfortable with doing that yourself."[58]

In addition to finding "comfort" in expressive freedom, other motivations encouraged schooled artists outside New York to become folk art's advocates, centrally their goal of claiming a place in the nation's art history. By lifting up the native arts of Kentucky or Florida, academic artists toiling away in such culturally ignoble places as Lexington or Gainesville could simultaneously assert their own powers of legitimation and make cases for their own artistic validity. As well, by the obvious contrasts between their artworks and those of local folk artists, university-trained artists in the hinterlands might vindicate themselves from charges of provincialism, for in fact their works more typically resembled New York painting and sculpture, circulated through art periodicals, than vernacular or folk models.

In his examination of artist/intellectuals and their strivings, Pierre Bourdieu has found that under certain conditions, legitimacy is conferred upon those who appear to speak for popular interests.[59] Structural conditions of the late 1960s—an art capital overrun by wanna-bes, proliferation and thus devaluation of university art credentials, pressures to popularize art owing to state and corporate financing, an expanded art audience, and a new cult of celebrity within the American Left—provided just such a climate; Michael Hall, among others, stepped into the spokesman role. "I wouldn't tell you I didn't have my own motives mixed into a lot of this," Hall said, "and I suppose at a certain point my ideas for myself and my view of my career and my idea of Edgar and my advocacy for his art ran conveniently parallel toward the same goals. I never confused myself with Edgar, but on the other hand I sort of felt we were in the same boat and there were times when I didn't mind rowing for both of us in what I viewed as the art professional arena."

"Rowing" for Tolson became the Halls' extensive and deliberate project: "to introduce Tolson to as wide an audience as possible, as fast as possible," Julie Hall said, "and to escalate his prices whenever we could." Their initial enthusiasm and fondness for Tolson over time evolved into an increasingly strategic plan, to develop critical articles and exhibitions and to introduce Tolson's carvings into prestigious private and public collections. "All these things were important to us because we knew that we could do that for his reputation and escalate the prices and bring folk art to a larger audience, which was one agenda. That was a larger purpose. The smaller purpose was to help the Tolson family as a group of people and then to help Edgar as a single artist—all of those things. And we worked at it."[60]

An important first step was to collect, at least to document, all the carver's

works to date, building, in effect, a *catalogue raisonée*, art history's fundamental method. Throughout 1969 the Halls were busy in this regard. On regular trips to Wolfe County they collected many significant new pieces, while scouring the area for earlier works and, when possible, buying these objects from the carver's acquaintances.

In the late fall of 1969 Hall convinced Hemphill to fly to Kentucky and meet Tolson himself, an encounter Hall would make much of in the ensuing years, calling it an "American episode."[61] In several interviews, Hall has reconstructed the afternoon in detail, describing how he, Hemphill, and Tolson sat on overturned government-issue lard cans and talked. Hemphill had brought a box of expensive candy, which the Tolson children enjoyed, and Tolson presented his New York visitor with a walking cane. When Hemphill could not understand Tolson's Wolfe County accent, Hall was enlisted to act as an interpreter. According to Michael Hall, "Hemphill was devastated by the whole encounter."[62]

In all his accounts of this afternoon, Hall has placed most emphasis on a kind of testimonial that Herbert Hemphill offered upon leaving Campton. According to Hall, Hemphill "just started talking about how he wanted to repay us for this gift we had given him. . . . He said, 'You have just made my whole collection come alive for me. . . . Every single thing in my collection I now know had a Tolson of some sort behind it. I will never look at my things the same again.'" Here, as in many other tellings, Hall described the experience in religious terms: "Meeting Tolson seems to have been a revelation for Hemphill."

Based on this "revelation," according to Hall's narrative, Hemphill presented the young couple with an offer: to teach them what he knew about American folk art. They immediately accepted and began meeting folk art collectors, visiting flea markets and historical societies throughout the Northeast, and borrowing from Hemphill's personal library. This "two year crash course in American folk art" enabled the Halls to see Tolson in a new and longer perspective; "the exchange with Hemphill, in retrospect, seems to have been a sort of a trade-off, our world for his. Our world was one of artists and his world was one of artifacts, and they were co-joined in an exchange which Edgar Tolson had somehow facilitated."[63]

In each version of Hall's story, Hemphill is thunderstruck actually to meet a folk artist in the flesh. Hemphill, however, in scores of writings and interviews rarely has mentioned this experience. His remarks in a 1980 catalog do refer to Tolson as "the first folk artist I ever met. He made my collection come alive."[64] In an interview for this study, however, Hemphill contended, "Edgar was not the first folk artist I'd ever met." "That's Mike's story," he added, "And I don't want to anger Mike. Mike likes to say that, but it's just not true."[65]

This discrepancy is worth noting, for it indicates how significant this encounter was, if not for Hemphill, then definitely for Michael Hall. What "came alive" may have not so much been Hemphill's collection as Hall's sense of a cultural possibility, an opportunity latent in this mix of New York connoisseurs and young Kentucky studio artists. Hall described his estrangement from the New York art scene, a sentiment that intensified after the 1968 Whitney show. "New York doesn't need another sculptor," he said. "Every sculptor in New York will tell you that. On the other hand, for the New York folk art collector community, somebody coming in who's seen new stuff and who has access to sources and actual working artists beyond the loop is perceived as curious and interesting and is certainly welcome." This sense of being a welcome newcomer rather than an intruder on the scene seems to have come as a tremendous relief to Hall; through Hemphill he had found a way to discharge his intellectual and creative energies. Of the folk art collecting community he would meet after 1969, Hall observed,

> It was a circumstance where, though not necessarily on the highest level, some kind of an art conversation was open and ongoing and generally fed by a curiosity about the things the community viewed as art, whereas in the contemporary art world, a lot of the dialogue at the time was real focused and was all about displacements. In other words, I found the competition in the '60s fine arts world made it very difficult for me to interject an idea that was supposed to just co-exist with all other ideas. I found myself marginalized in a hegemony, where certain idea-systems had to dominate, a world within a power brokerage that was somewhat different than that in the folk art community in New York and across America at that time.

Through Edgar Tolson's carving, Hall might effect a new means of admission to the New York art world and in collaboration with Hemphill strike an alliance between two unlikely cultural camps: the old-moneyed antiques connoisseurs of New York and young student artists and leftists of Kentucky. Edgar Tolson was indeed the pivot point, a living artist and maverick from the hinterlands (as those in the UK contingent saw themselves) but an elder also, who in his carving, if not in his personal life, embodied those conservative American values—of religious faith, family, craftsmanship—long associated with early American folk art.

A small triangular table in Hemphill's New York living room became the showcase for new woodcarvings the Halls funneled north. By 1969 Michael, Julie, and Herbert Hemphill had convinced Harvey and Isobel Kahn, noted folk art collectors from New Jersey, to buy an Adam and Eve of their own, a decision that for Hall affirmed Tolson's capacity to satisfy a nineteenth-century antiques aesthetic as well as the tastes of contemporary art's younger au-

dience. "Harvey and Isobel were the first collectors, other than Hemphill, out of the East to acknowledge Tolson with ownership. And when we took the piece to them and saw it in their collection, and saw how compatible it was with their other carvings, we understood that Tolson's work spoke of tradition, at the same time that it was contemporary, idiosyncratic, and maybe even radical."

The relationship between these young counterculture artists and the rather effete New York connoisseurs functioned in several important ways. Conceptually, it provided the Halls with a framework in which to place Tolson's captivating but heretofore somewhat inscrutable woodcarvings. Socially, it made possible a rapprochement between two unlikely groups, young academic artists of the Midwest and wealthy art collectors of the Northeast. And materially, it offered Hemphill, an insatiable collector, with a whole new category and supply of fascinating and inexpensive objects to acquire.

Encouraged by Hemphill's ratifying favor, in the fall of 1969 Hall began planning a one-person show for Tolson at the University of Kentucky, enlisting Rick Bell's help to expand the project with black-and-white portraits of Tolson and his family. Bell's photographs "helped to give that show some substance. It turned this no budget little one room show into a big deal." The final arrangement of forty woodcarvings and poster-sized photos astounded even Hall. "It looked so wonderful. It had a power. Tolsons accumulate power as you get more and more of them together. More is more with Tolson. And I stood in front of that exhibition when we got it set up and I just looked at Rick Bell and said, 'This has to go beyond these walls. This should be seen. This needs a window to the world. There's a folk art world out there that needs to know about this.'" Bell agreed: "Seeing it together, it legitimized everything Hall had been saying. This really was great, great art."

As realized, "The Work of Edgar Tolson," installed at the University of Kentucky Student Center Gallery January 19–February 7, 1970, manifested a somewhat ambivalent approach. On one hand, Hall's introductory essay named Tolson as "heir" to nineteenth-century woodcarving traditions of "weathervanes, trade figures, toys, and figureheads" and asserted "his significant contribution to the history of American Folk Art."[66] Clearly influenced by Hemphill at this point, Hall represented Edgar Tolson as a contemporary bearer of the nation's visual folk heritage, evidence that vernacular genius had not perished with modernity.

At the same time, the exhibition manifested Hall's training in anthropology. Bell's large, grainy black-and-white photographs, of Tolson repainting his rock dog surrounded by children or standing on the porch of the old house in Holly, supplied a social-scientific flavor to the show. Of the installation's documentary aspect, Hall explained, "It's done in ethnographic museums a lot,

you know. They'll show an Eskimo mask juxtaposed with a photograph of some Eskimos in a kayak paddling after a seal or something. We just used a standard natural history museum format. It seemed to put the condition of the artist and his life into some relationship to the work." According to Hall, the photographs helped fulfill his larger intention: "They were the informational and didactic side of the exhibition. Part of what we were doing was celebrating some sort of regionalism and the photos spoke to our idea of Kentucky and its artistic resources."

Celebrating the state's culture and asserting the viability of twentieth-century folk art, the exhibition further made a case for Edgar Tolson as peer of the contemporary fine artist. Roughly forty works, borrowed from "Mr. and Mrs. Edgar Tolson" and thirteen collectors, were exhibited under Plexiglas vitrines, and the simple catalog designed by Skip Taylor featured Bell's dramatically lit photographs, several of them details of the figures' carved faces.[67] This presentation, like Hall's text, downplayed the pieces' traditionality and called attention to their sculptural uniqueness. Hall wrote, "It is precisely the originality and expressiveness of Tolson's work that interests and attracts artists and collectors. Like all great primitive sculpture, this work speaks beyond the range of the 'curious' or the 'charming.' Edgar Tolson's carvings speak the language of art and this exhibition records a message well worth listening to."[68] Hall's stress on the avant-garde virtue of "originality," reference to the pieces as "sculpture," and insistence that they "speak the language of art" communicate an earnestness and elegance familiar in the museum world but, in 1970, rarely applied to works by nonacademic makers. By fitting Tolson's woodcarvings into the prevailing fine art model—with its one-man shows, opening nights, catalogs, loan acknowledgments—Hall had found, unwittingly perhaps, a method for authorizing and publicizing folk art.[69]

The opening drew a crowd of faculty and students from the art and English departments. Edgar and Hulda, the guests of honor, had brought their youngest child, Paul, along. In her "country cottons," Hulda kept to the margins of the party while the room filled with the campus hippies, "all these people in wonderful clothes, all the bell bottoms and flowered shirts." According to Michael Hall, while Mrs. Tolson was reserved, her husband signed autographs. "Edgar was the cock of the walk. He put on such airs and he danced around through the whole event. He just corn-poned everybody in the place all night long, just telling stories and jiving and laughing and, you know, being alternately very arrogant and very modest."

Hall remembered that one of the waiters hired by the university student center to serve refreshments that evening was an African American. "When that black waiter walked into the room, Paul clutched onto his mother and

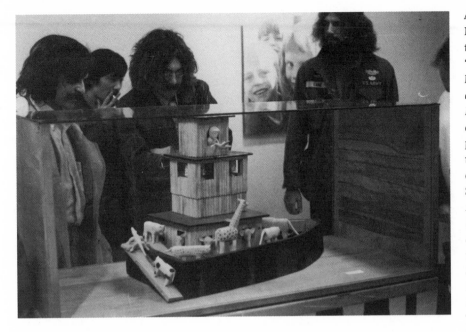

screamed at the top of his lungs, 'Look Mama, it's a nigger, it's a nigger!' He had never seen a black person before." The outburst was appalling. "Everyone in the room, all the liberals, me, everybody from the university were just horrified, embarrassed down to our toes. . . . We were all over there trying to muzzle this kid in the name of our politics." In retrospect, Hall called the evening "a cultural collision. These were worlds that, no matter how well we might have believed they could be conflated—would never really come together. It was all an artifice of our own making. It was a symptom of our time to believe, of course, that the world was all the same when in fact it wasn't. And out of the mouth of this babe came this clear delineation as to how things really were." "For our part," Hall added, "I'm sure that all of the trained college artists that were standing around that night were all looking at Edgar Tolson going, 'Look, it's a primitive, it's a primitive!'"

Attending Tolson's opening was a cadre of the university's left-leaning student journalists, among them Bell, David Holwerk, and Guy Mendes, who had broken with the college newspaper and started their own underground publicaton the *Blue-Tail Fly*. The paper's first issue, appearing in October 1969, included news of Angela Davis's firing from UCLA and reports of drug smuggling along the Rio Grande. Its eleven issues, published between 1969 and 1971, offered conservative Lexington such standard counterculture fare as an interview with Timothy Leary and reviews of *Alice's Restaurant*, yet it also served as a forum for local politics. Journalist Tom Bethell profiled Leslie County, and Harry Caudill sent an open letter to Kentucky governor Louie Nunn protesting Bethlehem Steel's plan to strip-mine in eastern Kentucky.

The 1968 SDS National Council meeting had been held in Lexington. In April 1970 the University of Kentucky ROTC building would be burned to protest the killing of students at Kent State University in neighboring Ohio. Nevertheless, Lexington in the late 1960s remained convention-bound, the great majority of its college students cued to the rites of sorority and fraternity life. Unlike its prototypes *The Great Speckled Bird* and *Berkeley Barb*, the *Blue-Tail Fly*, in the words of former editor Mendes, "wasn't 'off the pig.' It wasn't 'fuck the establishment,' though we were certainly out to circumvent and subvert the established ways and means. We didn't want to be doctrinaire." Its "more literate" character was expressed in photographic nudes, conceptual art works by Skip Taylor, and in January 1970 a profile of "Edgar Tolson, American Folk Sculptor."

Author Jack Lyne portrayed the woodcarver as an existential hero, dwelling on the details and traits that reverberate through subsequent biographies. Lyne's Edgar Tolson is virile (with a "fertility track record likely to make him the first man tried by Planned Parenthood Association as a war criminal"), violent (the tale of the church explosion is repeated, and the carvings themselves are "brimming with latent violence"), victimized ("like the mountains he loves"), and conflicted (haunted in his drunkenness by accusations from his dolls, "tension-filled figures" that "seem at once both spiritual and visceral"). Rendered as sexual and angry yet vulnerable, Tolson served as a stand-in for the student leftists themselves, especially the young men. Bell, Mendes, and Holwerk all were facing, at worst, a draft notice and at best the uncertainty of entering adulthood during a peculiarly disrupted moment in

U.S. history. Painting Tolson as an unruly and potent genius, Lyne spoke to the fantasies and predicament of his peers.

Although perhaps not fully cognizant of his own significance for the restless young men in Lexington, Tolson basked in their adulation. Hall's deliberate and enthusiastic approach, combined with growing popular demand for carvings, encouraged Tolson to approach whittling more seriously. He remarked in 1971: "I've been carving steady now since I met Mike. I carved off and on, that is, you know I'd sit around and whittle out a walking cane or a doll or something like that or a Masonic emblem or something, different things. That's when I was giving it away. But since I met Mike, now, I've carved regular."[70] Rick Bell observed, "The fact that this college professor appreciated [his work], that I think elevated Edgar to the point of being willing to take the chances." According to Bell, it was Michael Hall who continually impressed upon Tolson "that it was okay—you didn't have to turn out the same doll. In fact, anytime Edgar would do anything different, especially, Mike would just go wild." As a consequence, the former whittler of pencil holders, ashtrays, and yard flamingos came to describe his carving differently.

He related in a 1980 interview, "Mike's been a'selling for me now about fifteen years and before him, couldn't give a piece away. It wouldn't sell. It was a lost art—gone. And everybody thought, well, you couldn't talk to people about it. They didn't want to see it. They didn't want to buy it. They didn't know nothing about it."[71] From an idle pastime, though one in which he took obvious pride, Tolson grew to conceive of his works as a "lost art" and, in response to probing questions from Hall, began to expound on the meanings of his carvings.[72]

By 1968, presumably to meet stepped-up demand, Tolson developed a swifter technique for figure carving. Most of his earliest dolls were fashioned from one block of wood, the arms set off from the torso by laborious gouging.[73] Beginning in 1968, however, Tolson began whittling arms as separate appendages and then attaching them with glue, a much faster process. This technique, as well as increasing potential output, enlarged his range of figurative possibilities: the dolls could salute, embrace, point, and reach. Tolson's earliest dancing dolls were made to move as toys; however, once he began piecing and gluing figures, their motion came under his control, as gesture. Tolson could both produce more pieces and, crucial to his artistic development, conceptualize and compose these pieces into deliberate carved narratives.

Not coincidentally, he became more open to thematic innovation at this time. At the Tuskas' recommendation, he produced his first Adam and Eve plucking the apple from the tree of life.[74] The first *Expulsion* followed in 1968, and in late 1969 Tolson carved an image of *Paradise*, bringing to a biblical sub-

ject his more seasoned skills as a whittler of animals. Eve, with a lion cub in her arms, and a mustachioed Adam are surrounded by a small menagerie—elephants, a bear, and an ox—while a dove and owl perch in the tree. Similarly combining biblical figures and animals, Tolson's first *Noah's Ark* was made in the fall of 1969, bought by the Halls for $150 and exhibited at the carver's January show. In 1970 he produced the first of two extant Crucifixion scenes.

The most overt artistic evidence of Tolson's changing self-concept is the magnificent *Self Portrait with Whittling Knife* (Plate 3), made some time between April and September 1970.[75] Lexington artist Joseph Petro asked Tolson that spring, "Have you ever thought of carving yourself in wood?" Tolson answered that he had "done it once. Just the head," but that he was considering carving a full-length portrait "maybe by summer."[76] The piece, at twenty-two inches tall one of his largest single figures, shows Tolson in a crisp, barely delineated suit and tie, holding in his right hand a daggerlike knife and in his left a wooden slat. Most strikingly, the otherwise unpainted statue wears a pair of enormous, round black glasses and, with crew cut and contemplative expression, resembles an earnest young engineer. As well as increasing the numbers of his visitors, January's solo exhibition, presenting Tolson as an individual creator rather than one of a dozen woodcarving demonstrators, altered and dignified the carver's view of himself as a maker.[77] Certainly, Petro's suggestion of a self-portrait may also have induced Tolson to carve this piece.

With the technical means to inject his work with greater narrative content and with demand from trained artists and museum officials for his biblical pieces, Tolson developed increasingly ambitious artistic plans. "I'm gonna make Moses first," he told a reporter in 1970. "Then I'm gonna do the whole story, the whole outfit of the children of Israel crossing the Red Sea."[78] According to Michael Hall, by 1969 Edgar Tolson had conceived of a three-part piece, including *Paradise*, *The Temptation*, and *Expulsion*. Soon after, Tolson "decided to extend his narrative. He told me that he had an expanded idea. He didn't go into a lot of detail. He had some new images in his mind that he wasn't prepared to talk about but which would definitely flesh out the whole narrative as he saw it."[79]

The "project" in question resulted in an eight-part piece later entitled *The Fall of Man Series*, a jewel in the Halls' collection that now belongs to the Milwaukee Art Museum. The eight tableaux depict episodes from the book of Genesis: Adam and Eve among the animals (*Paradise*), the pair taking the apple from the Tree of Knowledge (*Temptation*), Adam and Eve coupling (*Original Sin*), Adam and Eve driven from the garden by the angel (*Expulsion*), a similar scene in which the snake, as well as Adam and Eve, now clothed, stand outside a slatted fence, the boundary of Eden (*Barring of the Gates of Paradise*), a

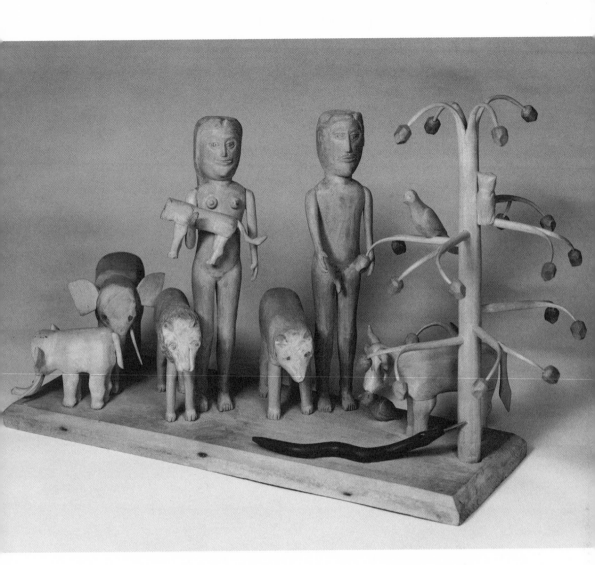

recumbent Eve delivering her child (*The Birth of Cain*), Cain's leaning with a club over his fallen brother (*Cain Slaying Abel*), and Eve's mourning her dead son as Cain departs (*Cain Going into the World*).

Michael Hall followed the emergence of these works closely, from the first *Temptation* tableau he and Julie collected in the late spring of 1968 through the carving of Cain's banishment, purchased in 1971. Many *Temptation* sculptures were made in the intervening months; in fact, Hall sold an early *Temptation*, originally carved for this sequence, and replaced it with a later version of the subject that is considerably taller and coarser. Hall has said that the eight parts were not actually made in succession, and two later carvings of additional Adam and Eve episodes—*The Cool of the Evening* (1972–73), in which the pair hide their nakedness from God, and *She Shall Be Called Woman* (1982), in which God introduces Adam to his mate—have not been considered part

From The Fall of Man: Paradise, 1969. (Milwaukee Art Museum, the Michael and Julie Hall Collection of American Folk Art)

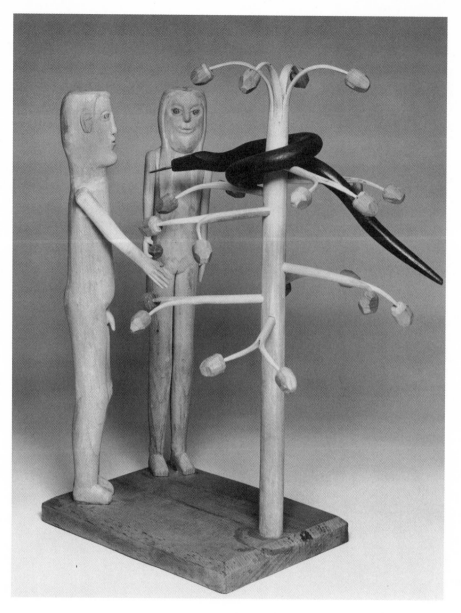

of *The Fall of Man*. Tolson voiced often enough his desire to "do the whole story" of the Bible, but it was Michael Hall who collected these particular eight works from Tolson's output and advanced an argument for them as one coherent and profound expressive statement. It was, in fact, through this piece that Hall himself appears to have developed a full sense of Tolson's artistic importance and found a vehicle for binding the carver to the modernist tradition.

To build his case, Hall emphasized certain elements of the work's creation, stressing Tolson's secrecy and deliberation.[80] "It was built over the space of a year and a half, maybe a little bit longer," Hall explained. "And you could

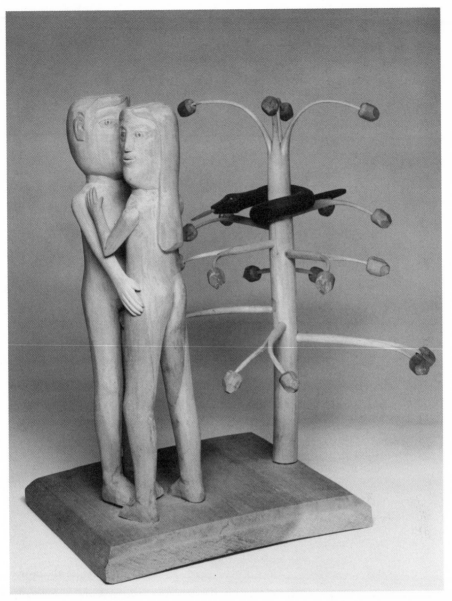

From The
Fall of Man:
Original
Sin, 1970.
(Milwaukee
Art Museum,
the Michael
and Julie Hall
Collection of
American Folk
Art)

tell when he was about to do something more on it because he'd start talking about a new piece. But he was intentionally vague because he liked the element of surprise."[81] Hall too described the piece's development with suspense: "You could tell when he was getting excited and ready to do something because he'd say, 'Well I'm going to have another part of that piece for you when you next come up.' 'What's it going to be?' 'I'm not going to tell you.'"

Michael Hall has insisted that Tolson envisioned these eight parts as a whole, that even though the episodes in the narrative sequence were not carved in order, Tolson had arrived at a fixed idea of their arrangement:

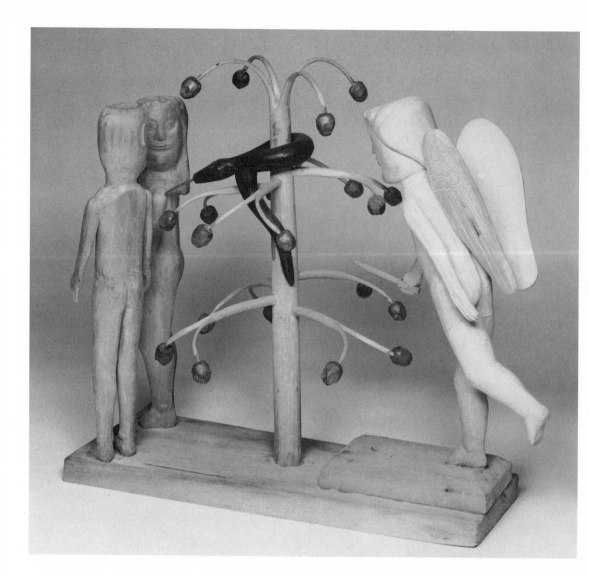

"When you'd come back up to get the piece, he would say, 'Now this goes here'; in other words he would outline the structure for the whole tableau."[82] When Tolson completed *Cain Going into the World*, according to Hall, "he said, 'Now it's done, h'it's done.'" With such supportive details, Hall continually affirmed that Tolson "had a sense of this as a project, which was very positive. And he had the energy and the youth at that time to imagine it and also to execute it. It wasn't one of those idle things."[83]

In an anecdote first published in 1976, Hall extended this argument—that Tolson was not a naive whittler but in fact a highly focused and in many ways modern artist. "I asked [Tolson] one time where these things come from, and he said, 'Michael, a person that makes these things, if you could open up his skull and look inside, you would see the piece there, perfect as it's made. You don't make it with your hands. You form it with your hands. You make it with

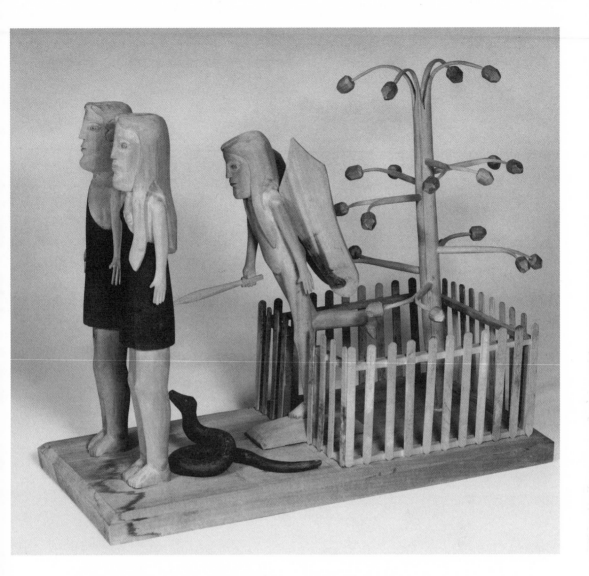

From The
Fall of Man:
Barring of
the Gates of
Paradise, 1970.
(Milwaukee
Art Museum,
the Michael
and Julie Hall
Collection of
American Folk
Art)

your mind.' I defy anybody to find a more succinct insight into the art process than that."[84] Hall developed this statement of artistic will into a full-length essay on Tolson titled "You Make It with Your Mind," published in 1987.[85]

This interpretation of the carvings has favored concept over emotion, gravity over humor, and so distanced Tolson's achievement from popular notions of folk art as offhand, innocent, or whimsical. In his dealings with private collectors also, Hall dwelled on Tolson's intelligence, further elevating him in stature. Michigan collector George Meyer noted, "One of the most interesting things about Tolson to me was Mike Hall's remark about his IQ. That really fascinated me. Hall said that he thought that Tolson's IQ is in the genius level, and for somebody in the backwoods ending up as a carver and having such a varied life, he had to be a genius. . . . It's not what I normally had thought of as a folk artist."

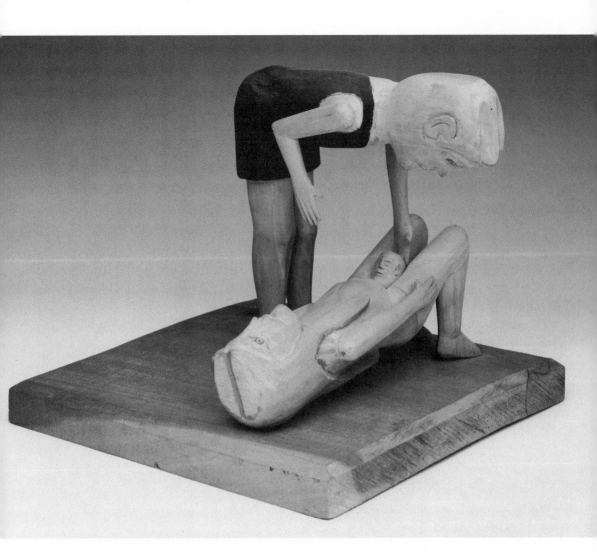

From The
Fall of Man:
The Birth of
Cain, 1970.
(Milwaukee
Art Museum,
the Michael
and Julie Hall
Collection of
American Folk
Art)

Claims of Tolson's extraordinary mental powers, Meyer said, substantiated for him the elaborate and philosophical interpretations Hall offered for the carvings themselves. "When I realized that Tolson, assuming what Hall said was accurate, was that bright, then I realized that he really could be putting into these figures something that others were reading in them, that there was really some thought, and really some unique approach that was other than strictly an emotional approach. I read a lot into the man's intelligence."

There is considerable evidence that the coherence of *The Fall of Man* was as much the product of Hall's rhetoric as the realization of Tolson's artistic design. Hall's log of Tolson's pieces, compiled beginning in July 1971, does not refer to *The Fall of Man* as one work. Instead his ledger notes "The Story of Cain and Abel (4 part tableaux)" for which the Halls paid $250 in 1971; the other four objects in the series (*Paradise, Temptation, Expulsion, Barring of the Gates of Paradise*) are listed separately, grouped with pieces of the same theme.

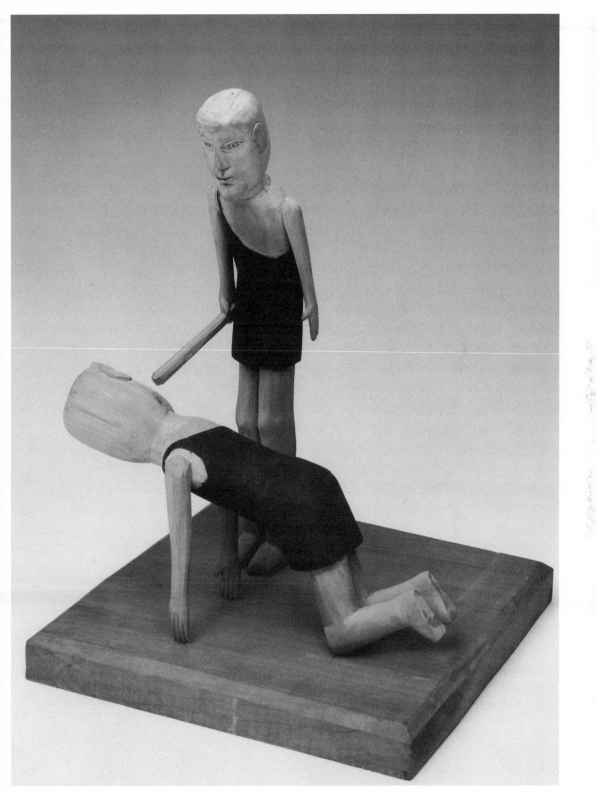

From The Fall of Man: Cain Slaying Abel, 1970. (Milwaukee Art Museum, the Michael and Julie Hall Collection of American Folk Art)

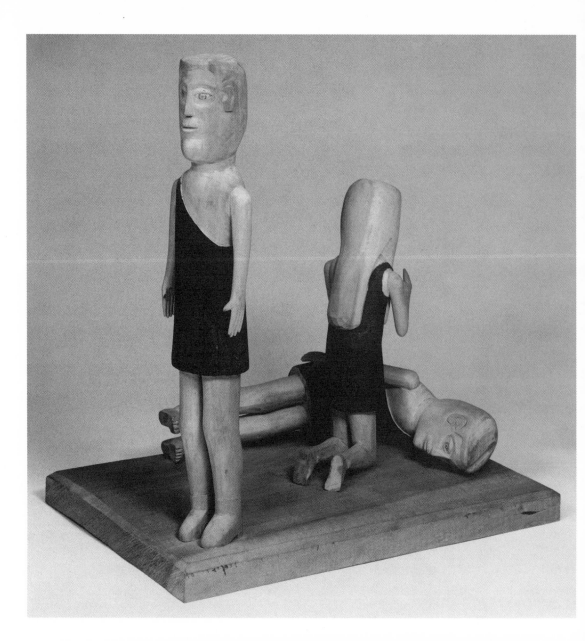

Nor does Tolson refer to the eight-part *Fall of Man* as one piece. In a 1971 conversation with Hall, Tolson suggested that the series might have been extended indefinitely: "That could be run right on down," he said, "but I got tired of fooling with it."[86] There is no evidence that Tolson labeled single pieces as *The Temptation*, *Original Sin*, and so on. Instead it appears that Michael Hall was responsible for the titles and for the contention that all eight works constituted one artistic statement.

A fine artist himself, Hall was concerned with the totality of Tolson's oeuvre. Whether Hall construed a unity of purpose and statement that Tolson did not realize, or in fact was carrying out the carver's "positive" intent by desig-

nating the eight-part *Fall of Man* series is not certain. What can be clarified, however, are the concerted interpretations Hall offered in defense of the work's significance and, in turn, the impact that this piece and Hall's commentary had on the woodcarver's artistic renown.

According to Michael Hall, the eight-part piece elevated Tolson from the rank of craftsman to that of artist-original: "It was key to the building of his reputation because it was that piece that would force his critics to back off and start to deal with him as an innovative artist. It was that piece that would convince people that he wasn't just a craftsman repeating himself, endlessly doing the *Temptation* pieces."[87] Thus from *The Fall of Man* it could be argued, first, that Tolson was an artist of imaginative scope, and, secondly, that his goals exceeded sales alone. The series convinced collectors, Hall said, "that Tolson's work went beyond a reiteration of cute little Bible themes, that he actually could work with some ideas and see something ambitious and complex through to a truly artistic conclusion."[88]

Ambition—evidenced by the carver's ability to sustain an idea through eight works—constituted a peculiarly modernist claim to worth.[89] Of course, the gravity of a religious subject dignified the piece also, as did its rendering of nudity, sex, and murder, weighty themes that set Tolson's work apart from "cute little" carvings, handicrafts, and souvenir stand fare. Despite all these hallmarks of artistic seriousness, the piece nonetheless required Hall's spirited, sometimes angry defense.

The Fall of Man was first shown in the Brooklyn Museum's Bicentennial exhibition "Folk Sculpture U.S.A.," curated by Herbert W. Hemphill Jr. The edited transcript of an interview between Michael Hall and the museum's Sarah Faunce, published in the exhibition catalog, included a testy exchange on the subject of Tolson. Faunce remarked: "In Tolson's *Fall of Man* series the humor is somehow irresistible." Hall replied: "I don't think it's a humorous piece," at which Faunce retreated: "I don't mean laughable." Hall then assumed a pose of superiority and expertise: "I have lived with it long enough to have the feeling that [Tolson's] really giving us something terribly profound." He then delivered an elaborate explication of the work's symbolic content, a lengthy, sophisticated reading of the tableaux that hangs on the final piece, *Cain Going into the World.*[90] "Man's destiny is really what comes through in the piece," Hall said, summing up with a corrective to Faunce's levity, "So the charm in *The Fall of Man* series is superficial. There's something else you're seeing. Tolson is taking you through life as he has felt it and life as he knows it to be, which is from paradise to expulsion, integration to alienation."[91] In a more recent interview, Hall reiterated this position: "In looking at *The Fall of Man*, I believe that we get the best support that I can generate for a serious assessment of the man and his work."[92]

Hall's argument for the depth of the piece was generally, if not universally, accepted. Amy Goldin, writing for *Artforum*, described *The Fall of Man* as "puerile."[93] *New York Times* art critic Hilton Kramer, however, found Tolson to be "one of the most interesting" contemporary artists in the show, writing that his "narrative sculpture on the theme of 'The Fall of Man' is, if not quite the epic masterpiece Michael Hall claims it to be in the catalogue, a very engaging and original conception."[94] In the *Village Voice*, David Bourdon declared Tolson "the most compelling of the living sculptors" and the tableaux series "one of the most extraordinary works in the exhibition."[95]

For the 1993 catalog of the Halls' collection, Russell Bowman, director of the Milwaukee Art Museum, completed his introduction with an extended discussion of this piece: "One has only to look at *The Fall of Man* to realize that it has an essential refinement of form and a narrative focus that is equivalent to some of the greatest medieval manuscript illustrations and architectural decorations." Comparing the eight carvings with venerable religious works of times past, Bowman also pronounced their lasting relevance. "Despite the quasi-medieval timelessness *The Fall of Man* evokes, it is truly a universal statement of the situation of humanity today."[96]

From 1970 onward, Hall proceeded to make his case for the woodcarver through a variety of narrative, interpretive, and more overtly promotional methods, all efforts to cultivate serious appreciation of Edgar Tolson and his work. As Meyer's and Bowman's comments attest, Hall proved an effective agent in this regard. Like artist James Houston, who in the 1940s spurred the introduction of soapstone carving among Canadian Eskimos, and Frank Applegate, who developed a market for New Mexican santos carvings in the 1920s, Hall supplied the encouraging pressure and assured sales that kept Tolson working.[97] Perhaps more important, Hall exerted his considerable skills of argumentation to insist that Tolson be considered an "author"—a modern artist with the drive, intelligence, and skill to produce an oeuvre of lasting merit.

Anthropologist Nelson Graburn, studying the ethnic and tourist arts of the "fourth world," wrote that their evolution requires "great innovators" who "have one characteristic in common: intimate and unusual contact with another group."[98] Just so, the friendship between these unlikely associates—an ambitious California sculptor and college professor, still in his twenties, and a sixty-four-year-old disabled Appalachian farmer—made possible the revaluation of traditional Kentucky carving as contemporary American folk art. The Tuskas may have initiated the change by suggesting the Adam and Eve motif and extending the promise of continuing purchases, yet they were not inclined to authorize Tolson, to undertake the kind of documentary and promotional endeavor that would establish his identity and credibility as an

American artist. The Halls, especially Michael, plunged forward toward this goal, invigorated by many motives: affection, curiosity, acquisitiveness, altruism, and ambition.

Structural forces at work in the United States during the 1960s were especially conducive to such "unusual contact" between a rural woodcarver and an urbane sculptor of steel, conditions that gradually set the collective activities of critics, dealers, artists, and audiences into motion around a whittled poplar doll. For the first time since the Great Depression, the federal government began to exert a strong and direct influence on the arts. In 1965 the National Endowment for the Arts (NEA) was founded, its initial $2.5 million budget steadily increasing to $158 million in 1980.[99] Though a few state arts agencies predated the NEA, the majority were established only afterward, many created with NEA block grants.[100] The Kentucky Arts Commission, among the nation's first, was founded in 1966.

Commitment of government moneys to the arts had been precipitated in part by the Ford Foundation. Though public and corporate arts patronage would become commonplace over the next four decades, Ford, in 1957, was the first major U.S. philanthropic institution to commit resources to the nation's arts.[101] Other corporations and foundations followed suit during the next twenty years; in the early 1960s only 4–7 percent of foundation gifts were donated to cultural endeavors, but by the late seventies, private foundations were allocating more than 15 percent of their funds to cultural activities.[102] During the same period, corporate spending specifically on art also swelled, increasing from $22 million in 1965 to $436 million in 1981, with marked acceleration in the late 1970s.[103] By the early 1980s, a team of sociologists could conclude, "The legitimating and status-granting function of the arts has proven valid beyond a doubt, and in identifying with the arts, corporations enjoy both visibility and prestige."[104]

Gradually, corporations discerned what Richard Nixon's administration had acknowledged in 1969; adviser Leonard Garment, pressing for continued support of the NEA, had counseled Nixon that "for an amount of money which is minuscule" the president might "have high impact on opinion-formers" who "have hitherto not been favorable to this administration."[105] Arts philanthropy exerted a cheap but poignant appeal to the most affluent and influential citizens, notably the chiefs of mass media.

Although few large corporations are headquartered in Kentucky, Ashland Oil did begin an art collection in 1972, and Humana, the state's best-known corporate arts sponsor to date, established its collection ten years later.[106] In the 1970s Citizens Fidelity Bank in Louisville initiated a smaller collection of art, Central Bank in Lexington following its example in the 1980s, though both collecting programs had dwindled by 1990.[107] Edgar Tolson's carvings

were drawn into the corporate art binge.[108] In 1971 Citizens Fidelity Bank, in consultation with curators at Louisville's J. B. Speed Art Museum, considered works by thirty-eight artists with Kentucky ties to enhance the company's new corporate headquarters and purchased three Tolson carvings.[109] In 1979 Chase Manhattan Bank, one of the largest U.S. corporate art collectors, purchased a Tolson *Temptation* from Phyllis Kind Gallery, when the bank opened a Chicago office.[110] A Detroit architectural firm bought Tolson's largest wood-carving, a five-foot *Uncle Sam*, in 1979.[111]

With this infusion of private and public money at both federal and state levels, the number of U.S. arts organizations multiplied dramatically through the 1970s. The number of dance companies rose from 10 to 51; nonprofit professional theaters, from 25 to 101; opera companies, from 23 to 45; orchestras, from 58 to 105.[112] As the proliferation of arts groups took place primarily outside New York City, many regional audiences enjoyed their first professional performances of dance, theater, opera, and symphonic music. Even closer to the grassroots, with new sources of capital behind them, twelve hundred community arts agencies had formed by 1978.[113] This expansion in nonmetropolitan arts institutions was the direct result of government and foundation subsidy.

While the impact of government arts spending has stirred continuing debate—particularly around questions of elitism and obscenity—such spending has undeniably ushered the arts into a larger, more public forum and generated "a political constituency" for the arts;[114] in Kentucky, for example, a statewide arts advocacy group, Kentucky Citizens for the Arts, was organized in 1981. Although government spending, despite official claims, may not have democratized the arts, the political pressures attendant on such expenditures, especially the NEA block grants to state arts agencies, certainly have fostered many new organizations, particularly museums, in the provinces;[115] furthermore, as the allocation of arts funding became more political and public, pressures increased to distribute at least some of those funds to previously "underserved" regions outside New York City. In Kentucky, after only four months in operation, the state arts council had allocated funds to thirty-four counties.[116]

The Kentucky Arts Council figured in Tolson's career also, most directly in 1976, when the state agency underwrote "The Artist and the Idea," a touring show organized by the Junior Art Gallery, Louisville. Gallery director Roberta Williams conceived the exhibit to reveal why and how artists go about their work. Her installation combined objects with photographic portraits of the makers, artists' written statements and, in Tolson's case, a taped interview. She selected a varied group of Kentucky artists and craftspeople, among them a weaver, a photographer, a printmaker, and a clay sculptor. "This show

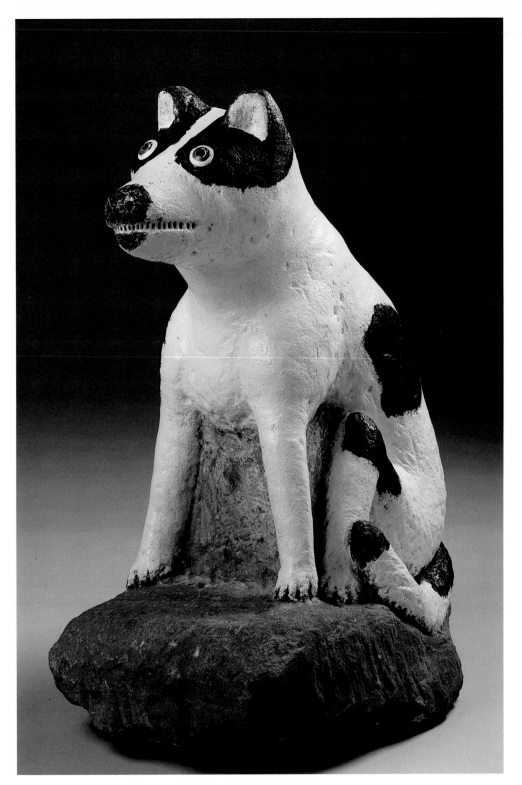

Plate 1. *Rock Dog, ca. 1948, was one of several stone carvings Tolson made to surround the house on Holly Creek. (Milwaukee Art Museum, the Michael and Julie Hall Collection of American Folk Art)*

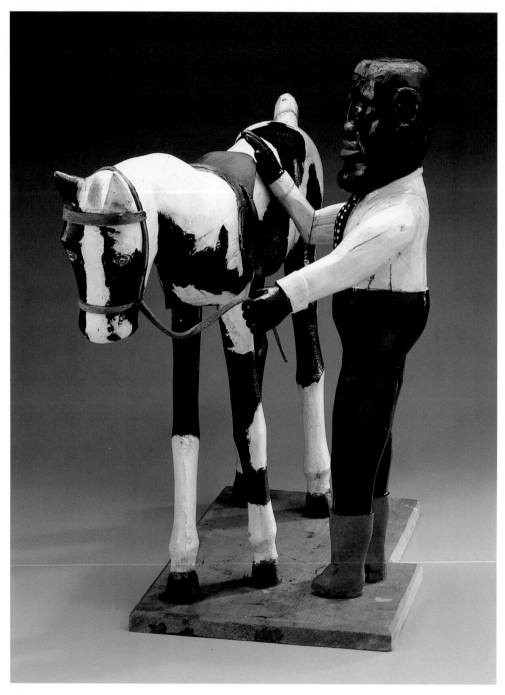

Plate 2. Man with a Pony, 1962.
(Milwaukee Art Museum, the Michael and Julie Hall Collection of American Folk Art)

Plate 3. Self-Portrait with Whittling Knife, 1970.
Collection of Estelle Friedman.

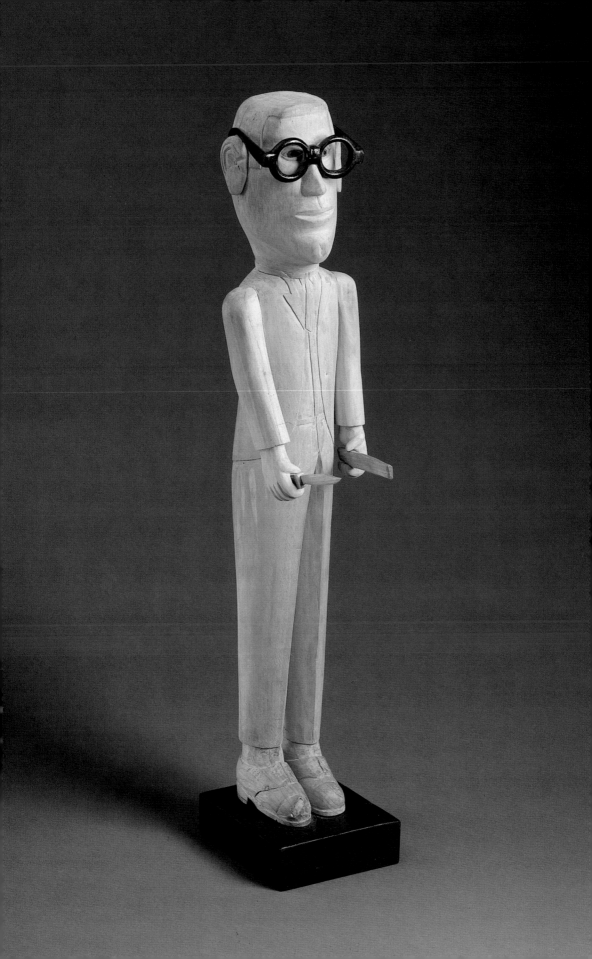

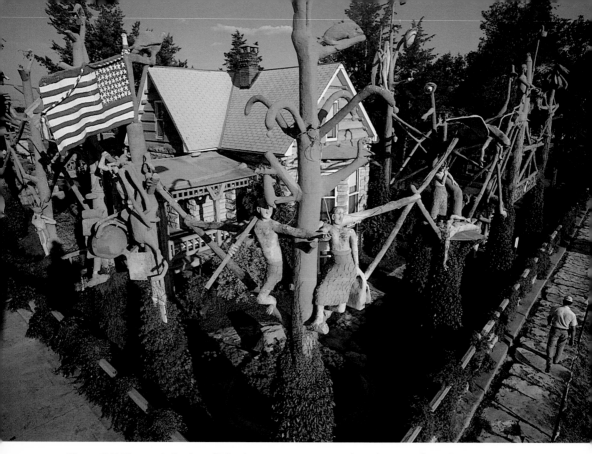

Plate 4. S. P. Dinsmoor's Garden of Eden in Lucas, Kansas, among the environments featured in Gregg Blasdel's 1968 photo-essay for Art in America, stimulated national interest in the more eccentric works of self-taught artists. (Photograph, Talis Bergmanis)

Plate 5.
Joseph Yoakum,
Cumberland Mntn
SO West KY,
ca. 1970.
Collection of
Ellsworth and
Ann Taylor.
(Photograph,
Mary Rezny)

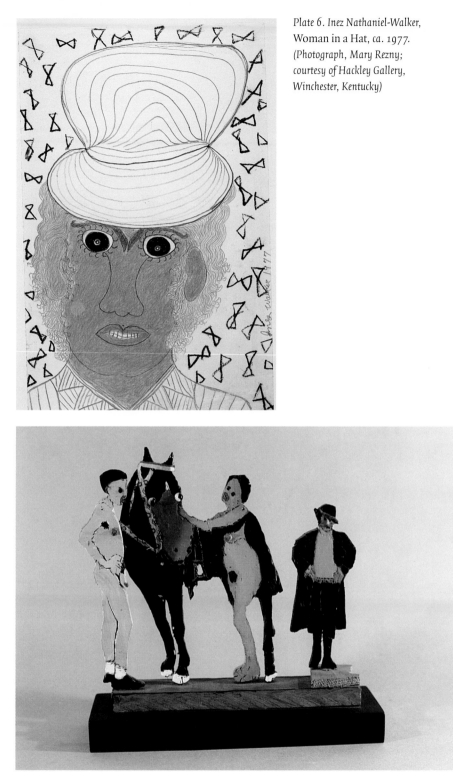

Plate 6. Inez Nathaniel-Walker,
Woman in a Hat, ca. 1977.
(Photograph, Mary Rezny;
courtesy of Hackley Gallery,
Winchester, Kentucky)

Plate 7. Steve Ashby, Couple with Horse and Horse Trader, ca. 1963. (Photograph, Ken Fadeley)

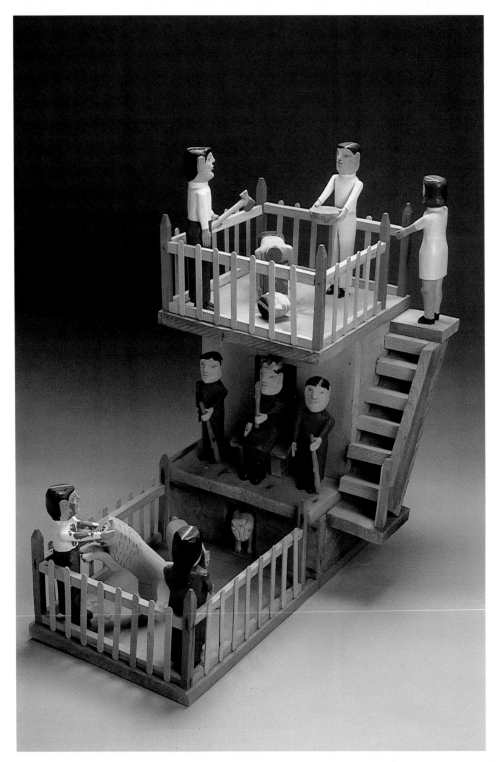

Plate 8. Herod's Palace: The Christians Being Fed to the Lions and the Beheading of John the Baptist, 1976. *(Huntington Museum of Art, Huntington, West Virginia)*

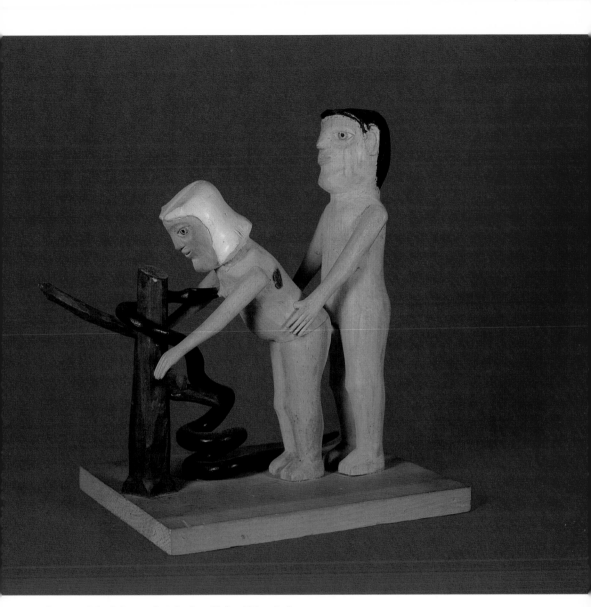

Plate 9. *Original Sin, 1976. Collection of Sal and Mary Scalora.*

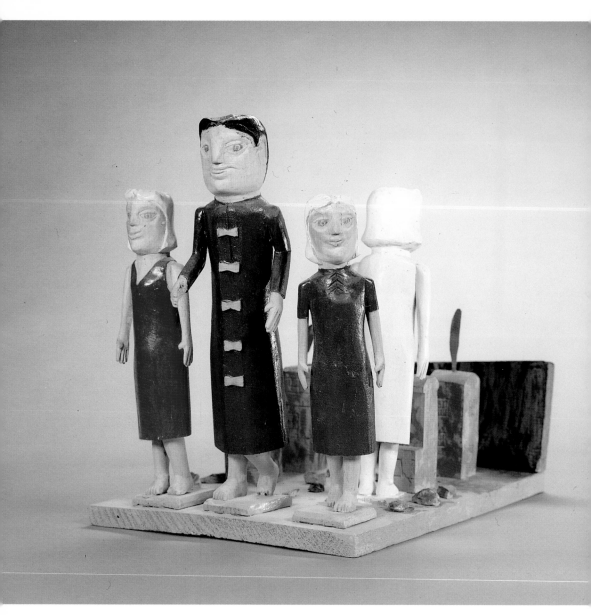

Plate 10. Sodom and Gomorrah, 1980.
Collection of Chuck and Jan Rosenak. (Photograph, Lynn Lown; courtesy of Chuck and Jan Rosenak)

seemed to have a broad appeal in terms of Kentucky," Williams said, "and so we asked for sponsorship" from the state arts council. As for her selection of Tolson, she explained, "It's good to reach across the state. I thought if we were going to have a folk artist or person that was really oriented toward the pure carving, that it needed to be someone with rural roots. And Edgar's work of the ones I'd seen was the most fitting."

The availability of state funding shaped curatorial decisions, inclining museum and gallery directors to "reach across the state" and include makers "with rural roots." Such sponsorship could affect long-lasting decisions also. From "The Artist and the Idea" show, for example, the Kentucky Arts Council purchased two Tolson carvings: in 1981 the state agency donated a *Temptation* piece to the University Art Museum in Lexington and a *Snakehandler* figure to the Kentucky Historical Society in Frankfort. Thus, state subsidy made possible not only temporary exhibition but more permanent institutionalization of rural artists' works.

In Kentucky the increase in visual arts organizations, attendant in part upon government support, has been obvious. Of the six museums statewide that concentrate wholly or in part on exhibitions of art, half were established between 1968 and 1976. Of eighteen other noncommercial art venues in Kentucky—university galleries, municipal art centers—seven were established after 1967.[117] Of ten community arts agencies extant by 1978 in Kentucky, only one, the Greater Louisville Fund for the Arts, predates 1968.[118]

While the greatest share of government arts funding has consistently been dispersed to organizations, the Ford Foundation, NEA, and many state agencies also developed ways to subsidize individual artists directly. The most prestigious of these programs has been NEA's individual artist fellowship, a merit award of up to twenty thousand dollars. Among past recipients of this grant, established in 1967 and now a nationally recognized badge of artistic credibility, is Edgar Tolson, a sculpture fellowship winner from the visual arts program in 1981.

During the 1970s NEA initiated other ways to support contemporary artists less directly: its living-artists grants to museums, for example, matched museum expenditures for contemporary works dollar for dollar. With just such a grant, the Museum of International Folk Art in Santa Fe, New Mexico, purchased from Phyllis Kind Gallery a large *Preacher* carving by Edgar Tolson in 1978.

Foundations, too, supported the careers of working artists. Ford, for example, disbursed $155,000 to the Whitney Museum of American Art between 1966 and 1971, "to assist the careers of artists working and living outside New York City by increasing opportunities to have their art work exhibited in New York City."[119] A group of the Whitney's curators traveled the nation identifying

artists and pieces for inclusion in its biennial survey show of contemporary art, a show that had always been dominated by New York painting and sculpture. Through the auspices of this grant, curator Robert Doty visited Kentucky and encountered the wooden carvings of Edgar Tolson. In 1973, Doty would select several works by artists with Kentucky ties, including a large Tolson *Expulsion*, for the pace-setting Whitney survey show.[120]

In addition to the Whitney's talent search for regional artists and government funding's boost to U.S. art as a whole, preparations for the 1976 Bicentennial augmented a general fascination with Americana. Conceived as a rehearsal for the nation's two-hundredth birthday party, the Smithsonian's Festival of American Folklife, first staged on the July 4 weekend, 1967, drew 431,000 spectators its first year and has endured.[121] With a sorghum mill, fiddle contest, and basketmakers assembled on the national Mall, the festival broadcast and purported to dignify the crafts and cultural traditions of America's varied regions. Tolson came to Washington to demonstrate and display his woodcarving at the second Smithsonian folklife festival, in July 1968, accompanied by Appalachian Volunteer Steve McCurrach.

At the close of the festival itself Tolson was invited to visit the home of a wealthy couple in suburban Maryland, parents of a former Appalachian Volunteer. His host located Tolson on the Mall the last day of the celebration and arranged to meet the carver and his escorts at the Japanese Embassy. Later Tolson told Lexington friends: "They gave me a book of their life's history. They was well-to-do people. They had nigger maids and everything there." With this encounter, Tolson set out on another drinking binge: "God, I spent three days in Maryland before I got out of there. I actually didn't know where I was at. I come to myself and these boys said, 'We've got to go home.' And oh, I said, 'I'm ready, I reckon.' And I said, 'Have we got arey to drink?' Well, that girl went in the house and she come out with a full fifth that hadn't even been broken on. She said, 'Here. This'll do you until you get home.'"[122] According to his medical record, it took Tolson several weeks to recuperate from his debut as a folklife performer. He returned to the folklife festival in 1969 with similar results.[123]

When in 1973 the Smithsonian began featuring particular states at the festival (certain ethnic and occupational groups also), Kentucky was its first selection, an obvious choice for the spotlight. As Cantwell has written, "From the Edenic accounts of seventeenth-century Jesuit missionaries, to the frontier tales of Daniel Boone and the myth of Lincoln, to the idols of the minstrel show and all the popular music inspired by it, even to *Uncle Tom's Cabin*, Kentucky had become almost a pure idea, an archetype of the frontier paradise in which the American character had been bred." For more than a century, local color writers, ballad collectors, and folk revivalists had trained attention on

the state and supplied the popular imagination with a whole gallery of Kentucky "heroes and rogues."[124]

Just such a character, sporting striped pants, plying his wry, offhand wit, Tolson was invited back to Washington as a featured Kentuckian in 1973. His early *Temptation* carving, acquired by Ralph Rinzler in 1968, was pictured on the front of the festival catalog, dramatically backlit, floating on a royal blue background, a low branch of the Tree of Life discreetly covering Adam's genitals.

Tolson was one of thirty-four craftspeople from Kentucky, including a country ham curer, several distillers, and makers of brooms, baskets, nets, and bowls. Among the Kentucky demonstrators were also three "doll makers," while Tolson, who ever referred to his figures as "dolls," was listed in the festival program as a "woodcarver." Rinzler further distinguished Tolson in the catalog text, noting that once "discovered and brought to the Smithsonian for the second Folklife Festival in 1968, [Tolson] has since become internationally known for his skilled and sensitive treatment of familiar Biblical and rural work themes."[125] With some one hundred thousand visitors passing through the festival daily, Tolson's three excursions to the folklife festival introduced him to an immense audience. Ever afterward, participation at the Festival of American Folklife accredited his carvings as national treasures, the quintessence of tradition, Appalachianality, authenticity.

Among the throngs who attended the Festival of American Folklife was author Elinor Lander Horwitz. "I bought a wonderful jug, a covered bowl, and I loved the dulcimer players, and I was just fascinated. And then, it just sort of occurred to me a few years later as I continued to go to these festivals and look forward to them, that I might have an idea for a book. And I proposed it to Lippincott." With her two young sons working as photographers, Horwitz visited Tolson in Campton 1973 and would feature him in three books, *Mountain People, Mountain Crafts* (1974), *Contemporary American Folk Artists* (1975), and *The Bird, the Banner, and Uncle Sam* (1976).

At the state level, preparations for the Bicentennial yielded a spate of folk art surveys. One of the very first of these was undertaken in Kentucky by Ellsworth "Skip" Taylor. A graphic designer and conceptual artist himself, Taylor had encountered Tolson's carvings through his former studio art professor John Tuska and met Tolson in 1969 through Michael Hall. At the urging of the university's Fine Arts Gallery director, Nancy Coleman Wolsk, and with a small grant from the Kentucky Arts Council, Taylor assembled works by thirty-two diverse creators—from chair maker Chester Cornett to evangelist and sign maker Harrison Mayes and assemblage artist Henry Dorsey. The exhibition itself lasted a bare three weeks in November–December 1975, but Taylor made certain to document the show with a catalog of his own design,

1973 FESTIVAL OF AMERICAN FOLKLIFE

SMITHSONIAN INSTITUTION · NATIONAL PARK SERVICE

Folk Art of Kentucky. Art historian James Smith Pierce's introductory essay pointed out, "Skip traveled throughout the state searching, not so much for the traditional craft object, which, since the thirties, has been deeply appreciated—almost venerated—in Kentucky, but looking for works which were individual, unique, and even eccentric."[126] In this respect, Taylor's survey show was an important state-supported harbinger of the contemporary folk art field.

A year later Georgia produced "Missing Pieces," an exhibition spanning two centuries of the state's nonacademic art. This collection of both traditional craft and artistic novelties included Harriet Powers's renowned quilts

of the late nineteenth century and paintings just executed by newcomer Howard Finster.[127] Merging a folkloristic perspective on folk art with a more contemporary and overtly aesthetic outlook, "Missing Pieces" provided a temporary meeting ground for folklorists and connoisseurs.

Many subsequent state and regional folk art exhibitions followed: a 1989 summary accounted for such efforts in an additional twenty-one states.[128] This rash of folk art documentation reflected the Bicentennial's fervor for Americana and the eagerness of new arts councils to excite state pride. It should also, always, be remembered that folk art exhibitions are comparatively cheap to mount, since objects typically are simple to borrow, insure, and tour. By underwriting a state survey show of folk art, any arts administrator could count on a generous return of political goodwill for minimal outlay, especially since folk art exhibitions tend to represent less populous, rural regions, districts without ballet, opera, or orchestra companies, whose state representatives are difficult to court. At the federal level, folk art expenditures likewise appeased congressmen and senators from midwestern, southern, and western states, who might otherwise have shown only tepid support for the National Endowment for the Arts.

The combined effects of these structural changes, both increasing the arts' reliance on public sponsorship and mustering the cultural clout of regions outside New York, in turn shaped artistic style. Diana Crane, examining the aesthetic effects of this regionalization, noted that the new powers in the art world—investor-collectors and regional museums—tended to favor expressionistic, figurative, patterned, and realistic work, styles "that had not been generally accepted by New York museums."[129] While Crane has used these terms as they relate to contemporary fine art painting (neoexpressionism, photorealism, pattern painting, and so on), many of the same qualities describe Tolson's woodcarving and, indeed, the larger group of objects that came to be classed as "contemporary folk art." Folk art aesthetics have, thus, been more in line with provincial tastes, and folk art price tags have better suited these new museums' modest budgets for acquisitions.

As the funding bases for U.S. visual arts shifted from a few private tycoons—the Mellons, Fricks, and Rockefellers of an earlier era—to corporate and state financing, the practices of American art museums changed too. According to Crane, "The fact that these organizations now rely on government and corporate grants for support has changed their orientation toward the public, leading them to seek a larger audience in order to justify, to their new patrons, their use of funds."[130] With an eye toward public funders, arts institutions strained to boost attendance, mounting shows with broader appeal. Wealthy museums like New York's Metropolitan staged such extravaganzas as the 1978 King Tut exhibition; with the same goal in mind, many fledgling

regional museums turned to presenting folk art. As conventionally handled, folk art is "viewer-friendly"; unlike much academic fine art, its realism, figuration, color, and narrative elements are accessible to general audiences.[131] Routinely packaged as patriotic, accessible, "feel-good" objects, folk art has been exhibited as a safe expenditure of public arts dollars.

Not surprisingly, the same qualities have attracted corporate sponsorships. Pepsi-Cola paid in part for "America Expresses Herself," a 1976 exhibition of folk art at the Indianapolis Children's Museum; Brown-Williamson, cigarette manufacturing giant, underwrote "Generations of Kentucky" for the Kentucky Art and Craft Foundation in 1994; and the Lila Wallace Readers Digest Fund has supported several folk art projects, notably the New Orleans Museum of Art's "Passionate Visions" show and the Milwaukee Art Museum's "Common Ground/Uncommon Vision," both 1993. Especially since the late 1970s, as more urbane artists grew polemical, museums seeking corporate funding have turned to folk art exhibitions. A California gallery owner disclosed in 1982, "There is a big market for folk and naive art in the offices of corporations, as corporate heads favor non-controversial art."[132] An invitational museum exhibition of art to be considered for purchase and installation in Louisville's newest bank building included a proviso: "Artists submitting work to the show were reminded that the bank's tastes run toward avoiding controversial artistic items," and an executive of the bank explained that the company "must be careful not to buy anything that would be offensive to customers."[133] Three Tolson carvings, among other works, were ultimately selected.

As change in the structure of arts funding expanded the U.S. visual arts audience and challenged New York's monopoly, so did concomitant developments in education. A populist outlook on the arts took hold in the public schools during the 1970s, exemplified by New York City poet Kenneth Koch's teaching and publishing. In 1968 Koch, underwritten by the American Academy of Poets and the National Endowment for the Arts, began teaching poetry writing to elementary school students at P.S. 61 in Bedford-Stuyvesant. Koch steered students away from rhyme and conventionally poetic diction and, in the manner of the surrealists, urged young writers' free associations of sound and color, setting down their *Wishes, Lies, and Dreams*. With his pupils' successes published in anthologies that have doubled as instructional handbooks, Koch was widely emulated; likewise his guiding assumption, "that children have a great talent for writing poetry and love to do it," contributed to a sweeping revaluation in U.S. arts education.[134] NEA soon expanded its support for Artists in the Schools (AIS) to include the visual arts and, subsequently, many more expressive media; by 1973 AIS programs were operating in all fifty states.[135]

The AIS program reflected structural change in arts funding and the directional effects of government support: pushing federal dollars toward nonelites, children, and rural constituents, in effect popularizing the arts. Philosophically, programs like Artists in the Schools maintained that creative talent is widespread and that a rigorous period of academic apprenticeship should not be a prerequisite for artistic expression. As a teaching method, the program advocated activity over analysis, experimentation over appreciation, by placing working artists in classrooms and urging students to create their own artistic models. Such economic, philosophical, and pedagogical reassessments along more democratic lines increased the production and appreciation of nonacademic art generally.

In time the AIS program realized a direct impact on the emerging field of contemporary folk art. Sending academically trained artists, and folklorists also, into thousands of schools and community centers around the nation, many of them in rural areas, the program made folk art "discoveries" possible. Art historian Daniel Robbins wrote that folk art "must be discovered by someone endowed with the capacity to find, to see its value, and to impose that vision on a willing part of society."[136] Robbins offered the example of Clarence Schmidt, who fabricated an elaborate architectural environment outside Woodstock, New York, and not coincidentally was discovered, Woodstock having been an artist colony since World War I. Similarly, New Mexican santos carvers were labeled "folk artists" and championed beginning in the 1920s by Anglo patrons, the artists and writers who had settled near Taos and Santa Fe.[137]

Artists in the schools, hired by state agencies and often certified with academic credentials, were likewise "endowed" to find, value, and designate "folk art." To use Pierre Bourdieu's terminology, they possessed sufficient "cultural capital" to make their artistic discoveries stick, their power to invest certain objects with aesthetic significance and prestige derived from both class position and the education it had made possible. In combination, such informal and formal training prepared them to arbitrate on cultural matters and to use the language of cultural ratification, giving them access to the institutions where such ratification becomes most public and secure.

In Kentucky alone, artists in education have brought many folk performers and visual artists national attention. Adrian Swain, a potter in Kentucky's AIS program, initially encouraged woodcarver Minnie Adkins of Elliott County to sell her work through his studio-gallery in Morehead; Swain now curates the Kentucky Folk Art Center. Don Bocklege, a folklorist in the schools, collected and generated interest in the work of William Wombles, whom Bocklege met during a residency in Bell County. John Harrod, a folklorist and musician, interviewed a hundred fiddlers in Kentucky after meeting several old-time

musicians during his AIS residency;[138] he came to know Charley and Noah Kinney of Lewis County, who, with increasing numbers of young visitors during the late 1970s, subsequently found a demand for their paintings and wooden sculptures.

In developing understanding, appreciation, and a market for Kentucky folk art, the most important of these former artists in the schools has been Larry Hackley. A sculptor and ceramic artist who earned his master of fine arts degree at the University of Kentucky, Hackley met Edgar Tolson while a graduate student and in 1977 became the carver's primary dealer, working in this capacity until Tolson's death in 1984. In the process of contacting galleries on Tolson's behalf, Hackley recognized that a market existed for other self-taught artists' works as well.

From 1978 until 1982 Hackley taught in the Kentucky Arts Council's artist-in-residence program. During these years in rural school districts, flexible hours and the half-time teaching schedule of AIS employment permitted him to travel, meeting other artists and craftspeople who had been working in relative obscurity. Hackley had seen Skip Taylor's 1975 exhibition and catalog *Folk Art of Kentucky*, "and in a very deliberate way," he said, "I just sort of retraced some of Skip's steps and went back and found Earnest Patton and stumbled onto Carl McKenzie and built a relationship with Denzil Goodpaster."[139] By 1980 Hackley also had begun to collect and sell the work of East Bernstadt gourd artist Minnie Black.[140] Academically trained as a sculptor, Hackley, like the artists who settled in Woodstock and Taos, possessed the cultural capital to "discover" folk artists. He was both disposed and educated to know how artistic reputations are made, how best to approach the dealers, critics, collectors, and curators who could better an artistic career. Yet it was Hackley's four-year stint as a resident artist in rural Kentucky, guided by the precedents of Tolson's success and Taylor's survey, that made possible his involvement and investment in Kentucky's unschooled artists. Since 1982, Hackley has been able to make his living as a full-time folk art dealer and freelance curator.

The shape of higher education from the late 1960s through the 1970s also contributed to an admiration for art in general. Postwar babies reached college age, increasing the nation's collegiate population to an all-time high (baby boomers, born roughly between 1946 and 1953, were graduating from U.S. colleges between 1968 and 1975). Percentages of eighteen- to twenty-four-year-olds enrolled in higher education had also risen steeply, from 12.5 percent in 1946 to 32 percent in 1970, making this generation the largest and best educated in American history.[141] With educational attainment the best predictor of attendance at live arts performances and museums, it is evident that the years from 1968 to 1975 produced more potential art museum visitors

than had any period in U.S. history.[142] Simultaneously, the number of artists rose dramatically. Census figures for 1980 showed an astonishing 81 percent increase in the artist labor force over 1970 figures.[143]

According to John Tuska, a studio art professor who arrived at the University of Kentucky in 1963, "Literally it was the sixties that made the arts respectable. When I went to school, if you were thinking about the arts you were either crazy or queer. That was it. That was the only possibility. There were also more females involved in art classes than anybody else, but obviously in the sixties that changed tremendously." While Tuska viewed the arts as growing "respectable," sociologist Diana Crane has described the change more ambivalently, as "the increasing integration of the artist into middle-class and particularly academic roles."[144] Tuska, who built a thirty-year teaching career at UK, represents just such an artist.

During this same period new college studio art programs, terminating in the M.F.A. degree, proliferated throughout the country. Between 1965 and 1974, 53 M.F.A. degree programs in studio art were inaugurated in the United States, nearly doubling the number of schools offering this degree (previously 55). Of the M.F.A. programs in place in 1987, almost a quarter (32 of 134) were begun between 1970 and 1974, one of them being the program at University of Kentucky, instituted in 1971.[145]

This dramatic rise in the number of university-trained artists, all vying for national recognition, glutted the extant system of artistic repute so that, according to Crane, "by the early seventies, it was no longer possible for New York art institutions to assess and display effectively a valid selection of the artwork that was being produced in the United States."[146] As their academic credentials in studio art began to shrink in value, M.F.A. holders, especially those trained outside New York City, strove to imagine and exercise alternative claims to distinction, and in this effort particularly, contemporary folk art became a rallying point.

Structural conditions, historical occasion, and ideological change all contributed to contemporary folk art's ascendancy beginning in the late 1960s: government and corporate support for the arts, the Bicentennial, a more democratic philosophy of arts education, arts decentralization and regionalization, a huge cohort of college students, and an abundance of university-trained artists. One further feature of the art scene, induced by all the others, must not be overlooked: a healthy and highly speculative art market.

Wider affluence following World War II, coupled with greater access to art education and expanded coverage of the arts as news, enlarged the U.S. buying audience for painting and sculpture during the 1960s. "It was a time of prosperity and the art market began to flourish," Ivan Karp of New York's O. K. Harris Gallery fondly remembered.[147] Fledgling museums and a grow-

Ceramic artist Peter Voulkos (left) paused with art professor John Tuska during a demonstration at University of Kentucky's Reynolds Building, April 1968. (Photograph, Rick Bell)

ing number of would-be collectors sent prices for old-master works soaring, so that dealers encountered a novel problem: "not selling art but finding enough of it to sell."[148] In such a bullish marketplace, contemporary art—and folk art too—would become increasingly desirable. To the many new collectors seeking original artworks but unable to afford a Titian, Picasso, or Rothko, contemporary art, both folk and fine, promised to supply an array of fascinating, accessible objects.

In a historical study of the French art market, Cynthia and Harrison White noted the compatibility of impressionist works with an expanded buying public, bourgeois families in search of "moveable decorations."[149] Likewise, in the 1970s, the grand canvases and sculptures of the New York avant-garde, and the grand prices they had begun to fetch, while fit for a museum or corporate lobby, were ill suited to the average private home. Like impressionist landscapes in the 1870s and genre painting even earlier, folk art was scaled physically to the domestic settings of middle-class buyers and economically to suit those same buyers' means.

High prices brought at public auction for abstract expressionist and pop art works indicated the investment potential of contemporary art. In this respect, Sotheby Parke-Bernet's 1973 sale of Robert C. Skull's collection was a watershed event. "Although the works sold for old master prices, they were quite recent: 39 dated from the 1960s, and about half were less than ten years old."[150] A Jasper Johns painting brought $240,000, the highest price ever paid

for a work by a living U.S. artist, and pieces by contemporaries Warhol, Rauchenberg, Wesselmann, and Stella broke previous records. This newsy evidence of escalating values—what the auction houses term "strength"— both fostered confidence in contemporary art and inculcated the more businesslike attitude toward art that characterized the 1970s. ARTnews reported in 1981, "With inflation continuing to beset the economy, the new collectors are not purchasing paintings on a purely esthetic basis—investment is playing a considerable role."[151] When art prices held steady during financial slumps in the late 1960s and mid-1970s, collectors took note, giving rise to what one market commentator called an "orthodoxy . . . that works of art go up in proportion as capital values, profits, and dividends decline, that as substitutes for money, works of art are not liable to the same erosions as money itself."[152]

Through the late 1960s and 1970s, the large auction houses also multiplied their offerings of various new collectibles—paperweights, porcelain birds, and other "objets d'art"—to the grave dismay of some connoisseurs: "The promotion of non-art has now gone so far that silk cigarette cards, exchangeable at my preparatory school for four ordinary ones, reached Christie's catalogues by November, 1969."[153] In this sales context, quilts, clay crocks, and the poplar whittlings of Edgar Tolson found their way to the public auction block.

As throughout the 1970s galleries multiplied and specialized, prices shot higher, and the number of art collectors increased, it became more and more difficult for *any* museum, critic, auction house, or gallery owner to wield anything like the same centering influence that, for example, dealer Leo Castelli and critic Clement Greenberg had exerted in the 1940s and 1950s. The U.S. art world under the weight of many moneyed and diverse interests began to splinter along several lines—minimalism, conceptualism, pattern painting, body art, performance, neoexpressionism, photorealism—fostering a new conception of art history. No longer framed by a canon of masterworks, instead, a pluralist understanding of American art emerged, a conviction that rather than branching from a single continuum, American art consisted of several contemporaneous approaches, historically and stylistically intertwined perhaps but decidedly different in both intention and appeal. As philosopher and critic Arthur Danto wrote, "Art was no longer possible in terms of a progressive historical narrative. The *narrative* had come to an end. . . . It really did mean that anything could be art."[154] This liberation paradoxically took place within an ever more rationalized art environment, of high stakes sales, mass publicity, government and corporate subsidy, and scholarship. Artistic novelties were swiftly documented, distributed, and commodified within an expanding arts infrastructure. In circumstances antithetical to folk culture itself, a folk art field—with critics, galleries, collectors, scholars, and even a canon of its own masterworks—would be cultivated.

The surge of interest in cultural pursuits and increasing numbers of college-age students nationally were obvious at the University of Kentucky. Its studio art department expanded swiftly during the 1960s, bringing the Tuskas, Halls, and other arts faculty to Lexington, and flowered in a master of fine arts degree program by 1971. As with the AIS program, this development, diverting a stream of graduate art students through Lexington and like-sized cities, brought academically trained artists into more routine contact with unschooled creators. Kentucky's Mountain Parkway, completed in 1965, simplified travel between Lexington and Campton, enabling the Halls and many others to visit Tolson with frequency. Furthermore, the glut of trained artists competing for attention in New York, coupled with new regional possibilities for exhibition and sales, stimulated those working in the provinces to elaborate alternative models of artistic success. Sustaining contact with indigenous, nonacademic artists, and championing their work, provided one way for regional academic artists to accept, even glorify, their own obscurity.

Sociologist Pierre Bourdieu has written: "The art trader is not just the agent who gives the work a commercial value by bringing it into the market; he is not just the representative, the impresario, who 'defends the author he loves.' He is the person who can proclaim the value of the author he defends, and above all 'invests his prestige' in the author's cause, acting as a 'symbolic banker' who offers as security all the symbolic capital he has accumulated."[155] Michael Hall was a particularly influential "banker" for several reasons. First, his own early success as a sculptor lent credence to his aesthetic judgments. Secondly, his rhetorical style, a kind of bullying exuberance compounded with extraordinary verbal talent, amplified his judgments. His social location as a magnetic young professor also enabled Hall to recruit what he termed an "army" of believers, a loyal group of students eager to invest—as salespeople, errand runners, and folk art scouts—in Hall's symbolic bank.

While during the 1970s Edgar Tolson gained authorization according to the norms of mainstream fine art (acceptance in the Whitney Biennial, sales to prominent collectors, better documentation of works, a one-man show, more scholarly and critical attention), the social and political potentials of his woodcarving, and of folk art generally, were eroding. The Halls' folk art experience was both influential and indicative. Julie Hall explained how their initial approach to this material modified over time:

> The politics were first, a kind of an interest in making sure the average guy didn't get messed over, the pockets of places where people were left over, left out of the American dream. I think that the political proclivity was there. And then I think when we went to Kentucky, because Michael was a sculptor and I had had an art background, it kind of found a focus, in the

pottery first, the production pieces from the pottery. And then we found Tolson by going to a craft fair. That's when the aesthetics became a focus for the politics.

Folk art, according to Julie Hall, might link political belief to aesthetic taste, leavening both with a sense of personal mission.

We found, not only could you worry [about] the people who'd been left behind in American politics but you could also find their work to be interesting. You could help them. And I'm not going to say there wasn't a wonderful kind of personal heart-warming feeling that you got, very self-satisfying, and slightly sanctimonious, of going to somebody who didn't have any shoes or vitamins or anything, and appreciating what they did. I mean, I don't think we meant any condescension. I don't think we were condescending, but when I think back about it, we viewed them as some strange exotic thing, which they were for us. I mean, it was the first time that our political impulses had put us cheek to jowl with the thing we were supposed to be helping, in a very intimate way. We weren't buying the stuff through stores or anything. We weren't going in looking through glass and saying, "Let's go in and look at that." We were there watching the making, the way they lived, the whole business, and it was a whole different experience, very exciting.

Julie said that Michael was especially uplifted by the era's tenor of possibility, the optimism and glamour of Kennedy's administration and optimism of Johnson's "Great Society." These larger cultural frameworks provided a political and social context that could invigorate, anchor, and ennoble art.

Yet Michael Hall discerned that this spirited convergence of art and politics was splintering. The band of young artists he had drawn around himself in Lexington by the spring of 1970 was unraveling. The war in Vietnam and, in April, the killing of war protesters at Kent State University forced several of Hall's protégés to reconsider their vocations. Terrence Johnson left for Canada, and Stanley Mock decided that art and politics were incompatible commitments. Increasingly, Hall experienced political activism as a distraction. "It was sort of a hard environment to stay artistic in. All our creativity was going into street protests."

For Hall, the turning point arrived the night that University of Kentucky students, or so it was supposed, burned down the Air Force ROTC building on campus.

The fire was clearly visible out the window of my studio in the Reynolds Building, and I sat there most of the night very conflicted. Much of what I believed in politically was all taking place out there and yet the destructive

aspect of it sort of ran against my sense as a preservationist. You can understand I'd have a hard time torching something myself. But on the other hand what was I doing in a studio, in a garret, thinking great art thoughts when there was a real world out there that was tugging at me pretty hard?

Hall phoned Mike Sweeney, an artist-colleague who, to Hall's alarm, had been tear-gassed during protests that same day at Ohio State University. "I think he wasn't particularly sympathetic toward my little existential dilemma when he had in fact just been through something pretty real. He just said, 'Michael, it's real simple. Art isn't anything, unless you decide that it is, and if you decide that it is then it's something, but only by virtue of your choice.'" Sweeney presented him with a choice between art and the street, and Hall said, "It became crystal clear for me."

> I pretty much decided then that I'd have to leave UK. And I found my alternative in the most monastic appointment possible. I took the position at Cranbrook, secluded behind the perfect walls of an isolated campus in Michigan, that had been built in the thirties by Eliel Saarinen as an art utopia and which remains almost as aloof today as it was in the height of the depression. At Cranbrook, I was so far removed from political protest that I could in fact reinvent a whole idea of art for myself. I opted to have a studio, where the studio in my mind could prevail and not be threatened and compromised. And so my politics moved in a different direction, and my activism turned into my own work and turned into my folk art crusade, I suppose. I think in the end I became more effective from the lecture podium maybe than in the streets. And I wouldn't tell you that sometimes it doesn't sort of tug at you, but I found a way to use my talents and I found a way to sort of reconcile my feelings and to run my life artistically.

Hall's dilemma, and his solution, resembled the choice made by an earlier group of artist-activists, those who through the settlement schools first hoped that cultural endeavor would bear fruit in political change. The history of those settlements, wrote David Whisnant, "can be read as a tug-of-war between those which pressed on *beyond* cultural programs to social action, as it became clear that such programs—however appealing—were of limited social use, and those which turned more and more *toward* cultural programs, as the hazards and frustrations of direct social action emerged."[156]

Singling out Edgar Tolson as a figure through whom to focus their own cultural capital, an unknown artist they might authorize, Hall and his colleagues shifted their commitments. Rather than mobilizing poor people around local crafts, this new movement—based in an ideological "studio of the mind," beyond threat or compromise—would organize affluent Ameri-

The University of Kentucky Air Force ROTC building was set ablaze the night of May 5, 1970, following the U.S. invasion of Cambodia and the slaying of four students at Kent State University. (Photograph, Bill Hickey, Lexington Herald-Leader)

cans and the institutions they controlled around a set of strangers and the strange commodities they made: objects that became known as contemporary folk art.

In the summer of 1970 the Halls left Kentucky as Michael assumed leadership of the sculpture department at Cranbrook Academy, an elite and well-established art school buried in the woodsy suburbs north of Detroit. For several critical years the Halls managed to direct Edgar Tolson's career at a distance thanks to two Lexington art students, Kenneth Fadeley, a Virginian, who had arrived at University of Kentucky that summer hoping to study with Hall, and Skip Taylor, who had enrolled in the new M.F.A. degree program. Before moving north, Hall endeavored to make a pact with these two protégés, asking that they watch over Tolson and monitor the increasingly desirable sculptures he was producing. According to Fadeley, "At the time, Mike wasn't really totally clear as to the importance of Tolson and what it would mean later in terms of this whole thing and certainly mean for him. But he knew that there was some interest in Ed and he wanted to stay real close." Fadeley and Taylor would travel to Campton approximately once a week for the next two years, checking on the woodcarver and collecting the majority of his new pieces. Fadeley especially endeavored to funnel Tolson's new works to Michigan, mailing carvings to buyers elsewhere as Hall directed.

Meanwhile, Hall began logging requests for Tolson carvings in a notebook, evidence of a more deliberate and strategic approach. Hall said he tried to fill requests in order, sometimes leapfrogging an especially prestigious

collector or museum official to the top of the list, the better to advance Tolson's art world reputation. In the process he and Julie Hall edged prices for the carvings upward. "I was seeing contemporary folk art becoming valuable in the sense that it was credible and it was becoming appreciated," Michael Hall reflected. "There was quickly developing a demand that would be larger than the supply. And in that imbalance one can see markets becoming real." This potential boosted Hall's determination and redoubled his promotional efforts "in the interest of [Tolson's] well-being and in the interest of extending his reputation and consolidating for him some respect as a contemporary artist." Specifically, Hall said, the project entailed "going after publications, going after exhibition venues, going after sales and all the other things that are reputation related."

In the process, Hall initiated a professional vita for Tolson: a list of exhibitions, work in collections, publications. "We just modeled his résumé on our own résumés," Hall explained. "We tried to get him into public collections, we tried to get him into real exhibitions. We tried in a sense to sort of remove the handicap of folk art and just let him be another contemporary artist."[157] This overarching strategy—to present Tolson as a "another contemporary artist"—and Hall's indefatigable drive in its pursuit constitute one of his most important contributions to the establishment of a folk art field.

To understand the impact of this change in approach, one may compare it with a transformation in the French art world a hundred years earlier: the erosion of the French Academy's monopoly on artistic legitimation and simultaneous ascendancy of the impressionist painters. The academy traditionally had awarded not artists but individual works through a system of monumental group exhibitions and annual prizes. By the mid-nineteenth century, according to Cynthia and Harrison White, this means of reputation building had begun the fail, primarily because of the staggering number of artists who had come to Paris to compete within it. "It is exceedingly difficult," the Whites wrote, "to evaluate and process a large number of objects, using a single centralized organization, when the objects are defined as being unique."[158] The academy's role as arbiter was, they explained, displaced by a new system of dealers and critics whose focus was not individual canvases but artists and their careers. "A current painting as an isolated item in trade," the Whites found, "is simply too fugitive to focus a publicity system upon."[159] The new system, based on artists instead of single works, served to rationalize a system that had grown overloaded and chaotic, and such rationalization in turn stabilized the art market.

Hall's novel and transformative approach to the category of folk art had a similar rationalizing effect through, initially, the same mechanism: a change in emphasis from single objects to an artistic career. Hall's mentor Hemphill,

like so many early collectors, had approached folk art in a spirit of connoisseurship, the overriding question being whether an individual object appealed to his discerning and rather eccentric eye. Indicative of Hemphill's outlook were the many shows he curated at the Museum of American Folk Art, for example "Permanent Collections and Promised Gifts," a melee of "fugitive" objects that had been validated by a coterie of influential owners. Hall's genius was recognizing that a publicity system could not successfully be focused on such a loose confederation of pieces. Thus borrowing the promotional strategy that had secured artistic reputations among fine artists since the era of French impressionism, he developed an alternative approach to the material called folk art, shifting attention from single objects to artists and their work, and made his first concern not the veneration of isolated woodcarvings but the reputation of their maker, Edgar Tolson. As a consequence, objects formerly handled as ornaments, knickknacks, oddities, mountain handicrafts, or souvenirs could be reenvisioned, as expressions in the recognizable style of a great artist.

Hall arrived at this new approach somewhat unwittingly; his first tactics on Tolson's behalf, in fact, were all derived from several years' experience promoting himself as a sculptor. In the way of exhibitions, Hall had arranged for the one-man Tolson show at the University of Kentucky in 1970 and supplied a group of Tolson carvings for Hemphill's "Twentieth Century Folk Art" exhibition later that year at the Museum of American Folk Art in New York. But the coup de grâce in this effort occurred in 1972 when the Campton woodcarver's work was selected for the upcoming Whitney Biennial, the nation's most prestigious survey show of contemporary art.

According to Michael Hall, he and Julie began in 1968 to make a case for Tolson among various museum curators, including those at the Whitney, arguing that to live up to its own mission, the Whitney Museum of American Art must find a place for Tolson. Over time, Hall said, "We actually made some inroads," though the nomination of Tolson did not succeed: "We sent the museum slides and all the same stuff we were sending on behalf of our own work. We just included Tolson as one of the Kentucky sculptors petitioning for acceptance into the 1968 Biennial." Only Hall and one of his students, Gary Wojcik, were selected.

With growing awareness of the larger arts environment and its funding trends, Hall noted the Ford Foundation grant that demanded the Whitney's curators look beyond New York for new artists. "All of this," he remarked, "was consistent with the politics of the late sixties. The Ford Foundation was funding an elite institution to be more populist, encouraging a fairly monolithic institution to be more broad-based." This development came as good news to Hall and his colleagues: "We had reasons to want to exploit, in the

best sense, this new mandate that the Whitney had taken on." Hall and several of his associates befriended Robert Doty, the curator assigned to scout the midstates region, contacting him periodically during their ventures into the city. Finally they convinced Doty to visit Lexington and, once he arrived, delivered a protracted appeal for bringing Tolson into the upcoming survey show.

> We pitched it this way: "Okay, so if you're doing a more broadbased show, wouldn't it be a fabulous thing to include this self-taught artist along with all the trained artists in the show? Would including Tolson speak broadly to the spectrum of American creativity? Why don't you go for it?" Well, I don't know if he was persuaded by the earnestness of our entreaties and the soundness of our thinking, or simply because it was all just amusing and easier to do than not. But Doty took a bunch of Tolson slides back to New York with him and the next thing we knew Edgar Tolson had been selected for the 1973 Whitney Biennial.[160]

For Hall, whose work was also selected for the exhibition, the 1973 Biennial marked the culmination of his "five year project to get Edgar from unknown to the Whitney Museum. And so we sent them the biggest, showiest Tolson that we could muster," an *Expulsion* tableau from 1970. Seeing this woodcarving, and his own *Covington*—a sagging fence form rendered in steel—exhibited alongside works by such established artists as Donald Judd and Richard Serra, Hall felt his case for regional art had been affirmed.

> For me, Tolson's inclusion in the Biennial was a symbolic convergence where my idea of local art, which was pretty developed by 1973, started to take its place in the national contemporary art scene. It was a blow for all of us. . . . It seemed like it was a proper acknowledgment of Edgar's achievement, and it also seemed that it demonstrated that the regional/provincial/isolate artist could still find a place in the so-called mainstream. So I guess my jubilation was as much on my own behalf as it was on Edgar's.

Another vital strategy was Hall's persistence in disseminating images of Tolson's artwork. Hall understood the value of fine photographic reproductions, and as an art professor he had enjoyed steady access to skilled photographers, many of them friends like Rick Bell, who would work cheaply or for free. Again, Hall modeled a promotional plan on his knowledge of the fine art profession. "When I became involved in the promotion or, in the best sense of the word, the full exploitation of the field of twentieth-century folk art, I understood from my own experience as an artist that photographs were a key to the whole thing. So every time anybody wanted to do a story or a catalog or a book or a brochure on twentieth-century folk art and contacted me for information, I sent them off the information they needed *and* sent them photos."

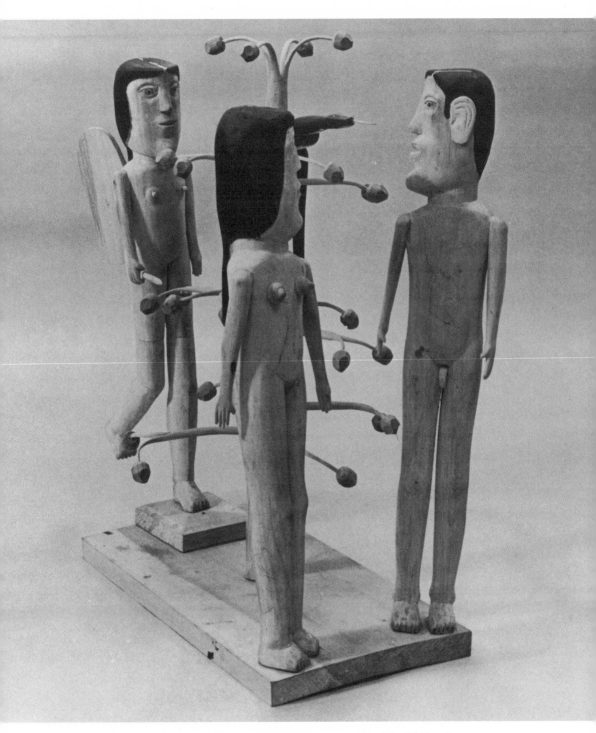

Tolson's large 1970 *Expulsion* was selected for the Whitney Museum's 1973 Biennial Exhibition of Contemporary American Art. Private collection. (Photograph courtesy of Michael D. Hall)

Hall explained, "There was a real cause and effect relationship between the kind of media enforcement you could get as an artist and the photographic materials you could provide to the media. A story without a photo is just a blurb and the story with a photo is an enhanced blurb and the same story with five pictures is a feature."[161]

Taking a similar tack during these years was Robert Bishop, a folk art collector, private dealer, and author, who in 1977 would become director of the Museum of American Folk Art. Through Hemphill, the Halls met Bishop shortly after moving to Michigan, where Bishop was decorative arts curator and publications editor for the Henry Ford Museum/Greenfield Village. "Bob Bishop was very important in that period because he was writing so many books on the field of American material culture, folk art and furniture. He was also someone who greatly appreciated the power of pictures," Hall said. "A picture's worth ten thousand words. And so Bishop wrote picture books with very small text, and then captions that went along with the illustrations. And the books were wildly popular in the collector community."[162] Hall supplied Bishop with a pile of 4 × 5 transparencies, many of them pieces by Edgar Tolson, for Bishop's *American Folk Sculpture*, published in 1974.

Hall assumed a new wariness where Tolson was concerned when in late 1971 the carver was approached by a western Kentucky entrepreneur, proposing that plastic replicas of Tolson's carvings be cast and sold through the state parks' gift shops. While Tolson was receptive to the idea, Ken Fadeley and Skip Taylor notified Hall with alarm, and in late January 1972 Hall had a Lexington attorney draw up a five-year contract naming Hall, doing business as "Pied Serpent Gallery," as Tolson's exclusive agent. "As artists," Hall said, "we, and again that's those of us who were around Edgar in Lexington and Detroit at the time, were a little bit horrified. The specter of unlimited plastic Adam and Eves was not real attractive to us."[163] The prospect of mass production fortified Hall's determination to represent Edgar Tolson as an artist, inducing Hall to rationalize further, through legal means, his heretofore informal arrangement with the carver.

Under the terms of the agreement, Pied Serpent Gallery was to take a 10 percent commission on sales, assume costs of shipping and insurance, set up a trust account for deposit of sales proceeds, and control all "reproduction rights" to Tolson's work. In actuality, both the Halls have insisted they never withheld any sales proceeds from Tolson. According to Michael Hall, "We never took a commission. Every bit of the money that was generated in all of those sales went directly to Edgar."[164] In a gray ledger book, Hall listed all pieces, prices, and sales and kept a running account of disbursements to Edgar Tolson.

Julie Hall contended that despite a long and close association, Tolson

"never gave us a darned thing," except one carved angel, a gift on her birthday. "Edgar was not a greedy man. He didn't have a lot of wants, but on the other hand, he didn't give anything away. The only time people got bargains was maybe if they got him drunk." She added, "He didn't care about the money either that much, because he would go into a bar and give it to some woman or something. I don't think he cared about the money, but he didn't give his work away. Maybe he just thought it was worth more than that."

The Halls' effort to manage Tolson's career succeeded only in part. Although the Pied Serpent contract quelled the state park deal as well as future attempts to mass-manufacture Tolson's work, exclusive control over sales was impossible, a fact Hall recognized from the outset. "It had been our tacit understanding among ourselves and with [the attorney] that we weren't going to exercise this exclusive where Edgar's sales were concerned. We never blocked any sales of any original Tolsons. We couldn't have blocked them anyway. Edgar did what he wanted to do."[165]

According to Michael Hall, during the first year of the management group, 1972, he established a price range of $250–$400 for an Adam and Eve tableau, "and we were getting that for them in New York, Chicago, and elsewhere." Nevertheless, during the same period he knew people were buying *Temptation* carvings directly from Tolson for as little as $10 and $25, "if he was in the right mood or if they were persuasive enough."[166] Tolson, while eager to profit from his work, reveled in the company it brought him. From his standpoint in Campton, where kudos like a Whitney Museum show, a demonstration at the Smithsonian, or sale to a New England museum collection simply did not carry much weight, a stream of well-dressed visitors with cash in hand logically brought him both personal satisfaction and local prestige. "He'd sell to anybody," said his son Donny. "He didn't just hold every piece he made for [Hall and Fadeley] to sell. I mean, there'd be plenty people drop by because they figured they could get it cheaper, I guess, that way too a lot of times. He'd get acquainted with people and make new friends, and Dad thought more of friends than anything."[167] Irascible as he could be, especially toward his own family, Tolson typically was compliant and genial with strangers, filling scores of personal orders for woodcarvings and inviting passersby to stay and visit. "I like people," he said, "And I like to do something to please them. And that's always been my goal."[168] More to the point, after taking a few drinks with guests, Tolson was inclined to part with pieces he might have promised to Hall or others. Several collectors described taking liquor to Tolson or driving him to the local bootlegger; a first-time visitor from Brooklyn recalled, "We chatted for awhile. And bad ol' me, I guess I had some bourbon for him too. . . . I gave him a bottle of Cutty Sark. That was it, and thought that would be an intro."[169]

Tolson's medical record suggests he typically set off on drinking binges with the income from his woodcarving: from October 2, 1969, "Senile anxiety, also has been nipping on the bottle again so I guess he sold some more of his woodcarving. If he doesn't get in a hospital and stay off the booze for a while, he is going to die"; December 3, 1969, "Said that he had some friends down from New York last offering him a drink and he just couldn't stop and now he is drunked up again." Paul Maddox, Tolson's doctor for almost thirty years, described the pattern: "He'd whittle one of those Adams and Eves . . . and he'd get drunk and [someone] would roll him and take his money off of him, then he'd sober up, which maybe saved his life, and then he'd whittle some more and get drunk again."

Once Ken Fadeley moved to Michigan in 1973, the Halls had less and less contact with Tolson. "By '78," Michael Hall said, "we were out of it. It was too fatiguing. By '76 it was not working."[170] As Hall's struggle to build Tolson's renown succeeded, his control over the carver's career began slipping away. In an effort to steady prices, to oversee Tolson's sales and thus control the development of his artistic reputation (perhaps also to head off the drinking episodes and their damage to the carver's health), Hall discouraged collectors from traveling to Wolfe County, but his admonitions seem only to have stimulated greater curiosity. Increasingly, commercial dealers and collectors of folk art were finding Tolson independently. By 1973 Smithsonian folklife festival originator Ralph Rinzler, gallery owner Phyllis Kind, and Chicago painter Roger Brown had all been to Campton. Others likewise were intrigued rather than deterred, and by 1974, the trickle of visitors had become an even stream.

By 1976, Hall said, "I had placed pieces well and, I think, strategically, and had done about all that I could do." Tolson carvings had been acquired by the New York State Historical Museum at Cooperstown (in 1971), the Museum für Volkskunde in Basel, Switzerland (1971), the Henry Ford Museum (1973), and the Museum of International Folk Art in Santa Fe (1975, 1978). Additionally, the Museum of American Folk Art and Abby Aldrich Rockefeller Folk Art Collection in Williamsburg were seeking Tolson acquisitions, and, according to Hall, "Even some fine art museums were starting to look at them; however, beyond that, the next step was a huge step and would take a long time. It really hasn't happened yet but, in my mind, I would see a Tolson finding its way into the Museum of Modern Art or the collection at the Whitney Museum."

At the same time Hall's own interests were shifting. Their deepening association with Hemphill had encouraged Julie and Michael to concentrate on their own collection of folk art; Tolson's work would be a crucial part of this effort but only a part. Promoting the emergent field of twentieth-century folk art, rather than Tolson as a solo artist, divided the Halls' energies. Their sub-

sequent curating efforts, such as "American Folk Sculpture: The Personal and the Eccentric" and "Transmitters," subsumed Tolson within larger arguments the Halls hoped to make about folk art as a whole. "There were no more converts to be made at the next level up," Michael Hall said. "By '76, we had done what we could do. We had placed them with museums and they had become real and they had become official."[171]

Management of Tolson's career was gradually assumed by Larry Hackley beginning in 1976. A friend of Ken Fadeley's since their undergraduate days as art students at Virginia Commonwealth in Richmond, Hackley had earned an M.F.A. degree from the UK studio art program and with Fadeley visited the Tolson family several times beginning in 1971. While still an art student in Lexington he had collected baskets, quilts, and traditional North Carolina pottery (inspired by Rinzler's books on the subject), as well as miscellaneous flea market carvings, most of them anonymous works.

Throughout the summer of 1976, Fadeley worked in Kentucky, staying at Hackley's rented farmhouse, and the two of them made frequent trips to Campton. According to Hackley, it became clear to everyone that neither Fadeley nor the Halls would be returning to Wolfe County much, "and that Edgar needed somebody to kind of help him out. I don't know if Fadeley said something to [Tolson] or it was just that I was up there a lot that particular summer and that I continued to go back, but it helped to sort of strengthen that relationship." By 1978, when Hackley was hired as an artist in the schools in eastern Kentucky, he found time to visit Campton more frequently and to search for other self-taught artists, realizing in representing Tolson to galleries and collectors that "there was really a market for things other than his as well."[172]

Larry Hackley (left) became Tolson's primary art dealer in 1976; Tolson's son Donny (right) took up carving in 1979. (Photograph, Bill Bishop, 1982)

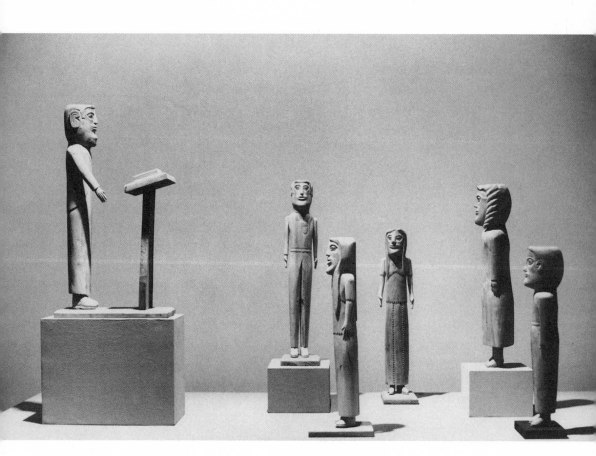

It was Hackley who persisted in presenting Tolson as a contemporary artist, the approach Hall had initiated with the one-man show of 1970. The culmination of Hackley's effort in this regard was his application on Tolson's behalf for a National Endowment for the Arts Sculpture Fellowship in 1981, the most ample federal award to a visual artist. Based on the earlier résumé Hall had prepared for the Whitney Biennial and supplemental information Hall helped provide, Hackley assembled a complete record of Tolson's exhibitions and publications and a list of public and private collections that had purchased the carver's works. Advised by staff at the Kentucky Arts Council to submit an identical fellowship application in the Crafts category, Hackley wrote to officials at NEA: "Mr. Tolson thinks of himself as a sculptor and his work has always been viewed and collected as art . . . period!"[173]

Tolson was awarded a $12,500 fellowship in 1981, along with Robert Arneson, Keith Sonnier, and twenty-nine other American sculptors;[174] the same year, Howard Finster of Summerville, Georgia, received $4,000 from the federal endowment. Tolson is one of only five U.S. folk artists to have received NEA visual artist fellowships, and his $12,500 grant more than doubles the amount awarded to any other folk artist.[175] With his stipend, Tolson bought a lot and trailer home on Washington Street at the edge of Campton.

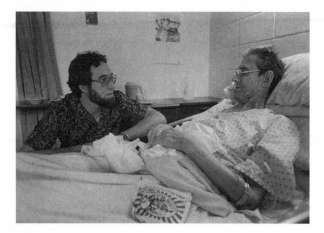

Also in 1981, Priscilla Colt initiated a retrospective exhibition of Tolson's work at the University of Kentucky Art Museum, inaugurating the museum's new and spacious location.[176] Titled "Edgar Tolson: Kentucky Gothic," the exhibition featured ninety works, from the fireplace post Tolson had built into the house he made by hand at Holly in the 1940s to a unicorn carving Hackley had collected in 1981. The show included *The Fall of Man* and many other both wooden and stone carvings in the Halls' collection, as well as dancing dolls belonging to the Tuskas, the proto-unicorn Marian Broadus had requested, his quizzical *Self-Portrait*, the 1970 *Expulsion* selected for the Whitney show, and a chaste and beautiful *Crucifixion* Skip Taylor had purchased in 1973. Also available for viewing on video was a recent documentary about Tolson made by Fred ("Mr.") Rogers for his *Old Friends/New Friends* series; this sensitive documentary described Tolson as the "son of a minister, still in search of a place for himself in the human scene."[177]

Tolson would carve intermittently after this point, until 1983, but his health was failing. Throughout the 1970s alcoholism debilitated him physically and, in combination with mood-altering medications, induced waves of anguish. Repeated hospitalizations to detoxify were inevitably followed by more drinking binges, an exhausting pattern further complicated by steady doses of phenobarbital, Librium, and Valium. In August 1978 Tolson attempted to take his own life. Troubled by emphysema and heart disease, as well as his chronic stomach ailments, he became deeply depressed again in 1983 and in June swallowed an overdose of pills.

Despite his loyalty and affection for the Halls, Tolson seemed to find necessary a certain distance. "Edgar knew how to manipulate people," Hall said. "He was smart, he was canny, he was inward. Most of the time you really didn't know what he was thinking." Hall understood even Tolson's charm as a form of evasiveness. "He had a wonderful way of being able to verbally feint with

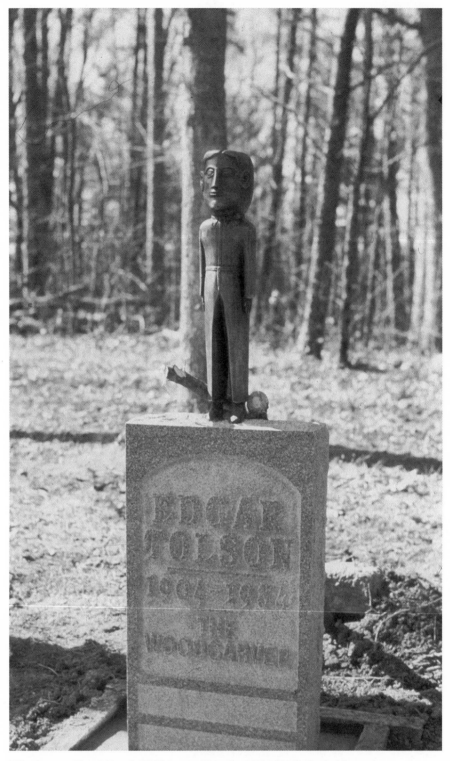

Tolson's grave, Hiram's Branch, Wolfe County, Kentucky. Michael Hall, Ken Fadeley, and Larry Hackley produced and placed a monument on the burial site in 1986, in the company of Tolson's family. (Photograph, Michael D. Hall)

anybody and 'corn pone' people right out the door. I watched him do it all the time. He did it to me. You just had to understand that that was Edgar. He was a person who had decided, for whatever reason, that nobody was going to get very close to him."

Tolson's daughter Flossie Watts agreed: "He was the type of person that didn't show his feelings a lot even with us growing up." Wanda Tolson Abercrombie said of her father, "He loved us but he just was the type of person that didn't show his affection. He was sort of a person that was quiet and didn't have much to say and didn't socialize much." Tolson's children all remarked how lively and excited Edgar became when Michael Hall would visit, but according to Hall, "There was something that Edgar kept to himself. And that something had to do with the way he kept the little trailer as a retreat, and it's probably part of why he carved, and it had something to do with his alcohol problem and a lot of other stuff in his life. But sometimes I thought that Edgar was just so smart, and in a very real way just so mean, that it wasn't in him to go out very far to others."

Suffering from recurring pneumonia, Tolson spent several months of his final year in nursing homes, first in Stanton, then Jackson, returning home to Hulda and the children's care whenever he could regain enough strength. From the Nim Henson Nursing Home in Jackson, where he spent the summer of 1984, Tolson was transferred to Manchester Hospital in Clay County. He died there on September 7, 1984.

Family friend Omer Spencer preached his funeral at Shackelford's Funeral Home in Campton on September 10. He was buried at Hiram's Branch, on top of a steep hill north of town, beside the infant child, Linda, he and Hulda had lost almost thirty years before. In 1986 Michael Hall, Ken Fadeley, and Larry Hackley prepared a monument. Hall cast a bronze replica of one of Tolson's wooden dolls, attaching it to a carved granite block. It reads

<div align="center">

Edgar Tolson

1904–1984

The

Woodcarver

</div>

etween 1967, when Edgar Tolson's woodcarvings were haphazardly displayed at the Kentucky Guild fair, and 1981, when he sat to be interviewed for the Archives of American Art, cumulative changes thrust his handiwork into an ever brighter and steadier light. In significant part, Tolson's reputation developed from the endorsements of admirers, certainly those like Hall, Rinzler, Doty, and Fox, with the cultural clout to authorize him. During the 1970s, however, recognition of Tolson's individual achievement was subsumed within a larger art historical development, the identification and institutionalization of twentieth-century folk art. Through the 1970s, a field of collecting, scholarship, and marketing emerged, the result of both intensive collaboration and dramatic contention. The advancement of Tolson's career, or what is more accurate the accreditation of his woodcarvings, parallels the rise of "twentieth-century American folk art" writ large, as through the 1970s and 1980s, in addition to finding buyers, contemporary folk art gained a kind of symbolic solvency. Through many forms of deliberate and casual cultivation, Tolson's whittlings were transmuted into rarities, manifestations of "a lost art," and with other heretofore fugitive objects found their niche and name.

In 1970 twentieth-century folk art had no institutional existence. The Museum of American Folk Art (having dropped its restrictive "Early" in 1966) claimed only 450 members in 1969, most of them old guard and wealthy collectors from the Northeast.[1] Yet among even these "overwhelmingly conservative" enthusiasts, as Hartigan as written, "the possibility of genuine contemporary expression was of negligible interest."[2] There were no contemporary folk art galleries in 1970 and very few writings on the subject, nor had such work appeared at public auction. Antiques dealers and even the large auction houses had handled the incidental twentieth-century piece, nearly always by an anonymous hand, but generally objects made since 1900 were assumed to have been influenced by machine-made articles or modeled on elite or popular sources and thus did not properly constitute "folk art" at all. Moreover, since folk art's pricing was derived from the antiques trade,

"Drawing for Philadelphia College of Art," by Howard Finster, 1981. Announcing the opening of the "Transmitters" exhibition, Finster's drawing illustrates how the folk art field developed around a core group of disparate artists. Fittingly, Tolson's name appears at the base of a pillar on the building's facade. (Collection of the University of the Arts, Philadelphia, Pa.)

twentieth-century objects lacked the cachet of years and so were typically passed over. The idea that American folk art had survived into the twentieth century or that *any* art of note might be produced outside New York was not yet widely accepted.

In the autumn of 1968, a breakthrough piece of arts journalism began to knock at these assumptions. Kansas painter Gregg Blasdel, with funding from the National Endowment for the Arts and the Whitney Museum, published his photographic account of more than a dozen twentieth-century folk art environments in *Art in America*.[3] Entitled "The Grass-Roots Artist," this article stimulated interest in and pilgrimages to such unlikely spots as Lucas, Kansas, site of S. P. Dinsmoor's *Garden of Eden*, an architectural melding of Old Testament stories, Masonic symbolism, and Populist Party exhortation (Plate 4).[4] Blasdel's article, documenting fifteen spectacular examples, argued that the rural art environment was not just an isolated outburst of creativity; rather, there appeared to be a kind of vernacular genius alive throughout the nation, at work without sanction from art's institutional commissars.

Scattered group shows and solo exhibitions, the Edgar Tolson installation organized by Hall and Bell in Lexington being one, featured nonacademic contemporary art.[5] Typically these exhibits were arranged by schooled artists working outside New York, though the organizers do not appear to have been aware of one another's efforts. Except for a William Edmondson show in 1965, exhibitions at the Museum of American Folk Art concentrated on eighteenth- and nineteenth-century works.

In 1970 Mike Gladstone, former chief of publications at both the New York State Council on the Arts and the Museum of Modern Art, became the folk art museum's director. Distressed at low attendance and driven by Hemphill's own growing fascination with twentieth-century objects, Gladstone and Hemphill proposed that the National Endowment for the Arts underwrite a series of exhibitions organized around the theme "Rediscovery of Grass Roots America."[6] Funded by the NEA, this project yielded three immensely popular shows, "Tattoo!," "Occult," and "Macramé," each tapping a strain of pop cultural wonder. Maintaining his cordial ties to the more conservative group of early American folk art collectors, those with whom he had founded the museum, Hemphill nevertheless threw his support firmly behind these new shows of contemporary material. In large part Hemphill's goal was to strengthen the museum itself by broadening its base of interest: "We wanted to stimulate the younger audience," he said.

To the same end, in 1970 Hemphill decided to curate an exhibition of twentieth-century pieces, despite objections from board members who could not countenance contemporary objects as "folk." Hemphill reasserted arguments made earlier by Holger Cahill and Sidney Janis: that twentieth-century self-taught artists "continued in an honorable tradition established by anonymous limners in seventeenth century New England."[7] To works of such noted artists as Grandma Moses and Morris Hirshfield, Hemphill added many pieces by lesser-known contemporary painters and sculptors, among them Eddie Arning, Minnie Evans, Sister Gertrude Morgan, and Edgar Tolson. Of the installation itself, Hemphill said, "The whole back bay window was filled with all Tolsons," most of them borrowed from Michael and Julie Hall.

Although not widely publicized, the exhibition was covered in *Newsday*, an article that featured Tolson, the carvings and the man. One photograph showed a single doll and the *Noah's Ark* Hemphill had commissioned. A second illustration featured one of Rick Bell's large photographic portraits of Tolson, with the bespectacled *Self-Portrait* alongside it. The review opened by alluding to "a Kentucky woodcarver who lives with his second wife and many of his eighteen children in a three-room shack," later referring to "a 68 year old carver who is somewhat less prolific as an artist than as a father."[8] *Newsday*'s story added that Hemphill, "the museum curator, who has had long discussions with [Tolson] in his three-room shack, said that he is, indeed, a highly intelligent philosopher." This article, like Phil Casey's *Washington Post* piece two years earlier, reveals why contemporary folk art has been such a cinch story for journalists: the objects seem to require no art historical understanding, yet the artists' lives abound with picturesque details of human interest, like the "three-room shack" twice mentioned in this brief report.

"Twentieth-Century Folk Art and Artists," in contrast with the Tolson exhi-

bition Hall and Bell had curated earlier that same year, did not showcase the skill of one artist or regional tradition; instead, it presented an argument for reevaluating folk art as an idea, alleging that this dimension of U.S. culture had not vanished with industrialization but lived vigorously on. Hemphill told *Newsday*, "Most people think that the heyday of folk art in this country was the nineteenth century, but folk art is a continuing thing, not limited to the past." To make this assertion stick required not one person's artistic oeuvre but a convincing group of artists. Hall's goal had been to lift up Edgar Tolson as proof great art was being made in the U.S. hinterlands. Hemphill's intention was to redefine folk art in accord with his own collecting budget and aesthetics.

The Halls, artists themselves, put their first energies behind Edgar Tolson, the individual maker, endeavoring through fairly conventional strategies of the fine art world to build his reputation. Their drive to distinguish the wood-carver as an original talent led them initially to downplay or even deny the efforts of other contemporary carvers. Hemphill bought an Adam and Eve carving from George López for Hall in 1972: "And Mike didn't want it," Hemphill remembered. "He said it was too like Tolson. That was one of Mike's peculiarities. He thought it was competing with Tolson." Nor have the Halls been enthusiastic about other Kentucky carvers, Earnest Patton, Carl McKenzie, and Donny Tolson, who were inspired by Edgar's example. Bridling against the same curatorial technique that had induced him to "see God" at the 1968 Whitney Biennial, Hall said, "The Campton School seems, through my eyes, to have distracted a bit from Tolson because it makes it more difficult to see how special Tolson was when you have to view his work against a backdrop of other work that's close and derivative and confusing."[9] Julie Hall responded similarly to more recent woodcarving from Kentucky: "In some ways, there are rules for carving down there now. They've got emulation and there's a Campton style, and it's not the same game. It's another thing altogether."

The Halls first viewed folk art as the zero-sum game they had known in the fine art world, "where certain idea systems had to dominate." Surprisingly, they found the milieu of folk art collecting much more open, hospitable both to new objects and unknown artists, characterized by an eager, curious spirit, which Hemphill exemplified. "I'll go to the devil himself to buy art," Hemphill has said. Best known as a collector of nontraditional work, eccentric one-of-a-kind pieces, in fact Hemphill has placed few restrictions on his aesthetic proclivities. Well aware of the Halls' devotion to Tolson, he does not share their views of other Campton carvers. "The reason I never bought it [was] because it, Earnest Patton, made Mike and Julie angry because he imitated Tolson, they thought. Well he's broadened a lot since then. I love his new work. I'm going to buy one if I see one." With reference to families in which a son or daughter begins making art after seeing a relative's success, Hemphill re-

marked, "Mike [Hall] doesn't like that either, when to me that's just grand. Like with Mose Tolliver, when his daughters are painting and there's all of them working, that's like the history of European art, African art, or New Guinea. That's a new piece that I bought in New Guinea but it's done exactly like the old, that they've been doing for hundreds of years. That doesn't bother me, family tradition or ethnic tradition. I like it."

As Hemphill curated the twentieth-century folk art show, and thereafter, his eye turned increasingly to contemporary pieces, just when his collection began an extended tour. Traveling to twenty-three venues from 1973 until 1988, the Hemphill collection effected a powerful, visible campaign. Its fifteen-year tour, at a time when American folk art was still an uncertain artistic category, alerted many thousands of viewers to the field, ratified twentieth-century works, and established Hemphill's taste and perspective as definitive.[10] Most exhibitions of the Hemphill collection took place outside the largest metropolitan areas, in cities like Indianapolis, Sheboygan, Omaha, and Akron, and at the university art galleries of Ohio State, the University of Chicago, and the State University of New York, Potsdam. These same regions of the country, which shared a decided preference for figurative art, had since World War II experienced a flowering of new public art spaces, museums in particular.[11] Hemphill's collection of folk art, with its preponderance of recognizable and representational imagery, was a judicious selection for many of these new exhibition venues. Likewise, it posed a fascinating but friendly notion of art, suitable for relatively unsophisticated art audiences. Mildred Compton, director of the Indianapolis Children's Museum, chose the Hemphill collection for the institution's 1977 inaugural show. She wrote, "We wanted something to appeal to both children and adults, to contribute to the Bicentennial celebration and to give a special feeling about America."[12]

As well, the tour of Hemphill's collection validated American folk art through the authority of its owner. Rather than stressing the integrity of an existing regional or ethnic art tradition (an ethnographic approach) or the talent and oeuvre of an individual artist as Hall had endeavored with the 1970 Tolson show (a romantic appropriation of the fine art model), these many presentations of Hemphill's collection subsumed both folk traditions and individual skill under the encompassing vision of one connoisseur.

"Folk art writers and collectors, emulating Marcel Duchamp's 'readymades' (but lacking his wit or humor), have set out to parade their own creativity," art historian Kenneth Ames has observed.[13] Although this practice certainly is not alien to the fine art world, in which patrons have exerted power and demanded credit for centuries, by the 1970s in the drama of the visual arts the collector had been relegated to a spot behind the scenes, and the artist him- or herself—Andy Warhol or Judy Chicago—was overwhelmingly

the pivot point of renown. In the field of folk art, however, collectors could continue to dominate. Adrian Swain, curator of the Kentucky Folk Art Center at Morehead State University, said wearily of the cultural milieu in which he works, "Everybody's an expert. And I suppose that's just natural, because it's a world of collectors."

The power of collectors has in turn shaped the ways museums—and artists themselves—address folk art. Attending the Milwaukee Art Museum's 1993 symposium on folk art, Swain called the proceedings "strange. . . . I understand that maybe this is politically expedient," he said, "but so much of the emphasis was on the collecting expertise of the people that collected it rather than on the content of the collection itself." At a reception/exhibition held in conjunction with the first Outsider Art Fair in New York, a somewhat frazzled painter from Alabama, whose works were on display, declared: "There are 80,000 collectors out there. I want to make a painting for every one, but I won't have time before I die."[14]

This same method of exhibition—organized around connoisseurship and a collection rather than an originating artist, ethnic group, geographic region or some other criterion—also hastened the development of twentieth-century folk art as a whole. As dealer-critics of the nineteenth century had fostered a popular sense of the French impressionists, collectors (and the repeated display of their collections) cultivated the field of twentieth-century folk art by presenting such disparate creators as Tolson, New Orleans evangelist and painter Gertrude Morgan, Mexican immigrant Martin Ramirez, and New Yorker Harry Lieberman repeatedly under a common rubric. As a consequence these artists, unknown to one another, came to constitute a perceptible group.[15] Michael Hall asserted in hindsight, "The group was critical. And the rise of the group was necessary even on the most prosaic level of economics, because until you have enough of something to discuss and desire on a broad base, you don't have a collectible area. Isolated and nonclassified things end up in the realm of esoterica."[16]

Thus, despite Hall's original project to "just let him be another contemporary artist," Edgar Tolson would find acclaim less through his singular achievement than through his membership in an increasingly predictable selection of twentieth-century makers, all of them working without academic credentials and admired by a group of taste-making connoisseurs. Tolson and the artists with whom he came to be routinely identified had little in common—Joseph Yoakum, hero among Chicago's Hairy Who (Plate 5); Inez Nathaniel-Walker, who began to draw while incarcerated for manslaughter (Plate 6); Clementine Hunter, a Louisianan who painted scenes of plantation life; and Eddie Arning, a mental patient from Texas best known for his bold stencil-like crayon drawings, many of them patterned after magazine adver-

tisements.[17] Even so, as Michael Hall has said, "All of those artists provided context for Tolson and Tolson, in a reciprocating way, provided part of the context for all of them. And the context was our idea of folk art. So, as surely as consciousness more or less invented the group, the group fed the consciousness that had longed it into being or imagined it into existence."[18]

An aesthetic approach to folk art, obfuscating the historical and local sources of an object and substituting for them a set of imaginary or purely formal affinities, tended to melt down the creations of nonacademic artists "into one unsophisticated but expressive lump."[19] Simultaneously, this approach invented a new and autonomous context for objects based on the collection itself.[20] It is this very autonomy, this power to "refract every external determination" that signals a discrete cultural field.[21] Hemphill's collection and his show of twentieth-century American folk art, the prototype for twenty more years of folk art exhibitions, asserted such autonomy by collapsing differences of race, gender, historical circumstance, region, and motivation and drawing together a curious jumble of curiosities instead. As Michael Hall, who assisted with the installation itself, described it: "The stuff was just hodge-podged together. It was presented visually. It wasn't displayed chronologically, it wasn't grouped geographically, it wasn't organized stylistically. It was just, 'Here it is. Check it out. This is contemporary folk art.' It was just a survey thrown out for your appetite."

To establish an autonomous field of contemporary folk art based on aesthetics, however, Hemphill's collection would need both to emulate and to be emulated by others. His taste reflected the influence of earlier well-established collectors, notably Jean Lipman and Sidney Janis.[22] As for his influence on younger enthusiasts, Julie Hall described how closely she and Michael followed Hemphill's lead:

> Bert showed us that there was a whole body of material which was being collected, sold, bought, auctioned — a whole arena of activity around these things. And at that point, then, I think Michael's collecting habits kicked in and he thought, "Well, if there's a body of material, then we're going to find out the parameters of it and the reference points within the circle. And we are going to make sure that we have fine examples of all of those points."[23]

The Halls' friends, most of them University of Kentucky and Cranbrook Academy artists, were inspired by Michael's and Julie's advocacy of Edgar Tolson as well as by the collecting activity evident both in Hemphill's "Twentieth-Century" show and, soon thereafter, in the Halls' own house. Visiting Lexington and Campton often between 1970 and 1972, Hall kept his Kentucky art associates dazzled with newfound pieces from his expanding folk art collec-

tion. With such models as enticement, young protocollectors dispersed in search of their own "discoveries," a corps of associates Hall called "the army."[24] His former student Lester van Winkle befriended carver Miles Carpenter in Waverly, Virginia, in 1972; Mike Sweeney met barber-woodcarver Elijah Pierce in Columbus, Ohio; Lewis Alquist encountered Florida artist Peter Minchell, interesting the Halls in his drawings; and in 1972 Ken Fadeley met cane maker Denzil Goodpaster at the Sorghum Festival in West Liberty, Kentucky. In each instance, these protégés channeled photographs and artwork back to Hall, the hub and publicist.

Fadeley had known self-taught artist Steve Ashby since childhood, but only after the Halls introduced to him the concept of contemporary folk art did Fadeley see Ashby's yard assemblages as sculpture (Plate 7). Returning to his native Virginia in December 1972, Fadeley reflected on the folk art objects Hall had shown him and made the connection: "I said, 'You know, Steve, Steve used to make some of these things.'" By the following year Ashby was included in "Six Naives," a group show Hall and Hemphill curated together for the Akron Art Institute; the exhibition also featured Mary Borkowski, Ralph Fasanella, Angela Palladino, Inez Nathaniel, and Edgar Tolson.

Fadeley brought Steve Ashby's assemblages to the attention of Phyllis Kind, whose Chicago gallery handled paintings of folk art advocates Jim Nutt and Roger Brown. As Michael Hall explained, the activities of his own network of young collectors were paralleled by a group of Chicago enthusiasts.

> There was that army that was around Phyllis, and they were very effective seekers too. They found Yoakum and Ramirez and brought a lot of new work forward. They also found Drossos Skyllas. [Henry] Darger came out of the late phase of that search. Chicago enthusiasts also turned up a lot of just unique individual objects. That happened in both camps. And they weren't necessarily competing camps; they were complementary. The Chicago group worked out of a Chicago base and found things that were in their immediate vicinity. The group that I worked most closely with was stretched out all along I-75 between Detroit and Lexington and down to Nashville.

Phyllis Kind arranged her premier group show of contemporary folk art in March 1972, "Contemporary American 'Naive' Works," selecting a detail of a Tolson *Uncle Sam* carving for the cover of the exhibition brochure. Kind sold all six Tolson pieces she had taken on consignment, buying for herself an imposing *Preacher*, now in the collection of the Museum of International Folk Art in Santa Fe. In reference to Tolson's pieces, Kind's gallery assistant wrote to Hall at the close of the show, "We would love to have more and we know they will sell."[25]

As their associates met more artists, the Halls promptly alerted Hemphill, who was in nearly every case eager to buy. "And the more new things that came up, the more convinced he became that Tolson wasn't just a fluke, wasn't just an isolated phenomenon," Hall said. From a core group of self-taught artists, a formative conception of this new visual arts category—contemporary folk art—emerged. It was this group, substantiated by Hemphill's wide-ly publicized collection, the Halls' and Kind's affiliation with two troupes of highly mobile young artists combing the landscape for intriguing objects, and an expanding market backed by established dealers like Kind that began to coalesce in the early 1970s as a cultural field.

The long tour of some of Hemphill's most fascinating possessions, con-sistently including works by the Campton carver, served to encourage other collectors, but at least equally influential was the book that evolved from the 1970 exhibition: *Twentieth Century American Folk Art and Artists*, published in 1974. This text codified Hemphill's aesthetic, method, and, to the extent that he has one, his ideology. Researched and written with Julia Weissman, the book reiterated in print form the 1970 show at the Museum of American Folk Art, adding works by artists the collector had encountered later through Hall and Kind. Though the book was remaindered by the publisher, it nonetheless became the reference work enthusiasts of contemporary folk art held in com-mon, and as such, it shaped art sales, collecting practices, and future exhibi-tions. Folk art gallery owner Larry Hackley, an art student at the University of Kentucky at the time, recalled, "When the Hemphill book came out it was like this sort of bible of contemporary folk art, that we all bought copies of and dog-eared."[26] Russell Bowman, who later would become director of the Mil-waukee Art Museum, remembered traveling with his wife to the Carolina coast on vacation in 1976, motoring through Waverly, Virginia: "There was Miles Carpenter with his truck backed up to the road with his carvings on it,

just like I had seen it pictured in Bert's book. And so we made a quick U-turn and went back to talk."

Chicago art collectors Jim and Beth Arient described first encountering the Hemphill and Weissman publication: "Every page was a revelation. We just looked at that and thought, 'Gee, I wonder if this is collectible.' . . . It just dawned on Beth and I that maybe these people, if they had created this art and this man had collected it, maybe somebody else could collect it and maybe these people were approachable." The Arients used *Twentieth Century American Folk Art and Artists* as a guidebook in their travels to collect: "We went through and we made a list of people who appealed to us and just started doing common sense research. We went to the library and looked up their names in phone books to see if they had a phone number. Most of them did."[27]

With *Twentieth Century American Folk Art and Artists* Hemphill and Weissman posted an unofficial roster against which other collectors and curators might gauge their own selections, just as Hemphill's taste had been seasoned by Jean Lipman's earlier books. Clay Morrison, an artist, collector, and freelance curator who mounted several folk art shows in Chicago during the late 1970s and early 1980s, said of his first such effort, "There was a book that had a big influence on me doing this exhibit. It was Herbert Hemphill's *Twentieth Century American Folk Art and Artists* that came out in the mid-'70s. And I had over thirty-five artists who were represented in that book in the show," including Edgar Tolson. Morrison was not the only curator to organize an exhibition along the lines Hemphill had set down.

Through this heavily illustrated volume, Hemphill also arrived at an immediate way to describe and extend his own collection. On collecting trips, he no longer needed to investigate indigenous conceptions of folk art but could instead search directly for mirrors of prior acquisitions. Explaining his collecting method, Hemphill said, "I usually use the back roads. And I go first to the newspaper publisher . . . and if they don't know what folk art is I would show them the book . . . and say, 'Is there anybody around here who does work kind of like his?'" Thus Hemphill, and many others too, came to equate a personal aesthetic with twentieth-century American folk art.

Hemphill's "bible" exerted a profound influence on Edgar Tolson's reputation. The publication, like Robert Bishop's works, was primarily a picture book of photographs and cutlines, but Hemphill and Weissman did coauthor an introductory essay to set out the "spirit and significance" of the 1970 show.[28] Folded through the discussion of folk art's history in the United States were ten photographs of Tolson and *The Fall of Man* series. The carver is pictured in Rick Bell's photographs toothlessly smiling and walking from the distance toward his carving of *Paradise*. Another illustration frames the carver's hands at work on a wooden goat. The seven other tableaux are dramati-

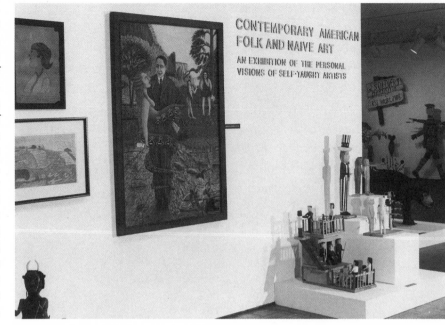

Clay Morrison, a former student at Berea College, mounted an early show of twentieth-century folk art at the School of the Art Institute of Chicago in 1978. Morrison, like many other curators, based his selections on works pictured in Hemphill and Weissman's book, including several carvings by Edgar Tolson. (Photograph, Clay Morrison)

cally pictured against a rich red, with the *Temptation* piece blown up to a full page. "By putting Edgar in the introduction and letting the story form around a photo text, [Hemphill] was just acknowledging what was actually already a fact," Hall contended. "Tolson was the pivot."

Repeatedly during the early 1970s, dealers, presenters, and authors chose Tolson to personify the emerging field. In Hall's words, Tolson "had been one of the first discoveries, and because his work had found a broad base of appeal, he remained sort of symbolically at the center of this whole thing for a number of years." The woodcarver was chosen, always without his consent, to represent a variety of folk art interests: the gallery, the national museum, the private collector. Tolson's *Uncle Sam* had been pictured on the front of Phyllis Kind's first folk art brochure (1972); an early Tolson Adam and Eve carving, belonging to Ralph Rinzler, was reproduced on the front of the Smithsonian Festival of American Folklife program (1973); and Hemphill and Weissman's book opened with images of the carver and his works, accompanying a definitional essay (1974). Skip Taylor agreed that circulation of these printed materials fixed the worth of Tolson's woodcarvings. "When the stuff is reproduced in every major publication, not only magazine but book about folk art and sometimes occupying more space than anybody else, like the first sixteen pages of Bert Hemphill's book, you can't help but say, 'Well, it's an important statement and it has to be kept. We know all about the man, and so it has to be kept alive.'"

Art critic Donald Kuspit has argued that, in fact, only through such circu-

lation and display does an object become actualized as art in our time. Traditional art communicates through a shared ideology, "but in modern art there is no ideology, only mass mediation—the belief in mass mediation as such is the ideology. . . . We value the work of art only insofar as, through its mass distribution, it runs for office, makes an appearance in a campaign, submerges all its interests in its self-interest."[29] Certainly, the combined efforts of Hall, Hemphill, Kind, and Rinzler effected such a campaign for Tolson's art.

Kuspit has also contended that circulation through mass media animates an artwork to "creatureliness," "which not only nourishes its growth, but makes it catalytic in the growth of other creatures."[30] Discussing the artists presented as a group in Hemphill's "Twentieth-Century" exhibition and perpetuated as a group in successive shows and publications, Michael Hall described this catalytic process:

> The people who were brought together in that early group—Miles Carpenter, Inez Nathaniel, Edgar Tolson, perhaps Mario Sanchez, certainly Jack Savitsky, Ralph Fasanella, Mary Borkowski, there were a fair number of them, about twenty I suppose over all—Peter Minchell et al., all went into the literature. After the dust settled, because they had all impacted in the literature that became the bibliography on twentieth-century folk art, they all emerged as the "classics." They had sort of won by bulk alone. The volume of notes and entries and reproductions of their work that flooded through the publications of the late sixties and all through the seventies separated them out and let them become the people everybody recognized, the people who set the standards, that everybody collected toward.[31]

Furthermore, their works became models other carvers and painters, with their own access to the period's publications, would emulate.

Two more influential books appeared in 1974 featuring Edgar Tolson: Robert Bishop's *American Folk Sculpture* and Elinor Lander Horwitz's *Mountain People, Mountain Crafts*. Both written for popular audiences, these publications lured many more collectors to Wolfe County. According to Skip Taylor, who was visiting Tolson regularly at the time, "1975 on is when it got to be hectic." Tolson's daughter Flossie Watts agreed: "All the time there was someone coming, especially during the summer months. . . . '74 and '75 and on up a few years, there were a lot of people." In a 1981 interview, Tolson himself acknowledged the impact of these books and articles during the mid-1970s: "Along in there, people went to drifting in, wanting to buy it. And they printed two or three, four books on me and my work, and it got scattered over the world and I've never had no rest since."[32]

Publications not only spread his renown but also functioned as sales catalogs from which collectors would, in Tolson's words, "select a piece." David

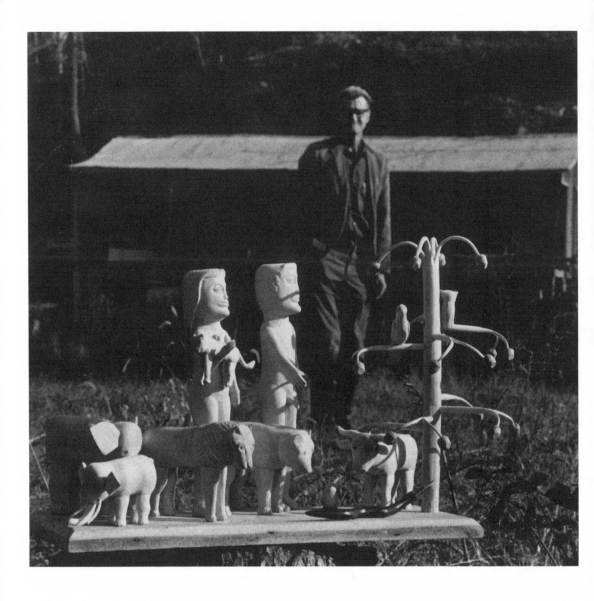

Holwerk's 1971 feature story "Whittlin' Man," published in the *Louisville Courier-Journal* Sunday magazine, with photographs by Rick Bell, prompted many mail orders.[33] "Please let me know cost of either a dove such as you were working on while being interviewed or a coal miner as pictured in the story," asked one correspondent.[34] A minister from Pennsylvania wrote the carver in March 1975, "I have been reading about you and your work in the paperback book *Mountain People, Mountain Crafts*."[35] Most pointedly, a New York collector, living in France, wrote Tolson in the spring of 1976, "We would very much like to have your carving called 'Original Sin.' It is picture number 354 in Mr. Robert Bishop's book on American Folk Sculpture."[36]

Fadeley, among others, contended that Tolson never carved to order, and in fact he did not scrupulously fill all requests for specific pieces, but Tolson

certainly did accommodate many would-be buyers, both indirectly, through Hall's monitored master list of requests, and directly, on orders from Campton visitors and mail correspondents. "I've carved everything from a butterfly to an eagle and from a mouse to an elephant," Tolson told one visitor. "If you sit down and write me and tell me what kind of piece you want, what you saw—I never have turned anything down."[37] He qualified this guarantee in his interview for the Archives of American Art: "They write me letters. And there's a lot of people comes here—they want different things. They get it in their mind what they want and then they give me the order, and if I can get to it I try to carve it. That's about the way it goes on. But I don't near fill my orders. I can't. It's more than I can do."

Tolson's reputation blossomed in part because he was willing to meet collectors' requests, usually by repeating subjects they had seen elsewhere and admired: the unicorn, Uncle Sam, and especially Adam and Eve. "That's mostly what I guess I carve now, is Adam and Eve, *The Temptation*, the beginning of time," he told Buck Pennington in 1981. "And most everybody comes who wants a piece of my work, that's the first thing they order. And I guess I've made more of them than any other piece I know of."[38] Although a complete accounting of all Tolson's pieces on this theme may never be made, seventy-seven versions of the *Temptation* alone can be documented.[39] Eleven of these tableaux belong to museums, and one was purchased by Chase Manhattan Bank's corporate collection.[40]

"He would knock that thing out," said Rick Bell, a regular visitor during the early 1970s. "He knew that was a sure seller and popular and [it] basically became very mechanical. That was his bread and butter. Almost all artists have a bread and butter piece."[41] According to Bell, Tolson could produce an Adam and Eve carving in a day and a half and often would have three or four willow blocks soaking at a time, in preparation for splitting and bending into the tableaux's "trees."

Duplicate Adam and Eve carvings made possible more flexible exhibition strategies, which in turn advanced Tolson's name. For example, staff at the Brooklyn Museum discerned that the version of Adam and Eve's *Temptation* shipped for its "Folk Sculpture U.S.A." show in 1976 was not the same piece they were expecting: "Temptation #7 is not same as object in Xerox and catalogue but same theme."[42] With several tableaux of *The Temptation* on hand, Hall's exhibition plan was less constrained; he could develop increasingly complex methods of promotion, photographing one object for potential sale or exhibition purposes but later providing an alternate version of the same subject, as necessary. More recently the Kentucky Folk Art Center at Morehead, which owns two Tolson *Temptations*, has enjoyed the same situation; in the summer of 1993, for example, one piece was on display at the Morehead center and the

Edgar Tolson walks from the house he built at Holly Creek toward a carving of Paradise. Picture from Hemphill and Weissman's classic Twentieth Century American Folk Art and Artists. (Photograph, Rick Bell)

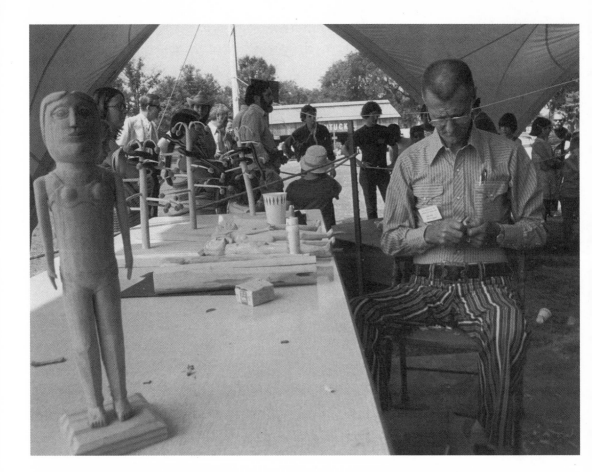

other on loan to a college gallery in Pennsylvania. While one tableau enhanced the university's folk art center as an attraction, its twin broadcast the collection's (and Tolson's) name.

The Adam and Eve theme became Tolson's signature work, and because he was willing to repeat the subject, an immediately recognizable motif, he inadvertently turned his carvings into collectible objects. Yet transforming an object into a "collectible" involves more than numbers of recognizably like things. Particularly in the case of folk art, which, by definition, cannot make a case for its own worth, value accrues to a piece through the social status, the cultural capital, of those who possess it. "The hard thing, the important thing about naive artists," advocate Sterling Strauser said, "is to get them into strong hands. Bert [Hemphill] is strong hands; somebody whose collection makes other people wish they had it."[43] By the mid-1970s Tolson's pieces, largely through the Halls' calculation and effort, had moved into many such hands. Museum collections, as an institutional endorsement, of course offered the most secure evidence of the carvings' value, but so did the support of elite private collectors. In addition to Hemphill and Ralph Rinzler of the

Smithsonian, others who had purchased Tolson's carvings or received them as gifts by 1975 included Robert Bishop; William Hull, the first director of the Kentucky Arts Commission; Harvey and Isobel Kahn, old guard collectors of early American folk art; John Hightower, director of the Museum of Modern Art; authors Jonathan Williams and Elinor Horwitz; art critics Clara Hieronymous of Nashville and Sarah Lansdell of Louisville; and noted collectors Chuck and Jan Rosenak. Artist-collectors, in addition to the Tuskas, Halls, and Roger Brown, included Ted Singer, David Middlebrook, Guy Mendes, Peter Voulkos, and Henry Faulkner. Art dealers who had personally bought Tolson woodcarvings, in addition to Phyllis Kind, included Tim Hill, Jeff and Jane Camp, George Schoellkopf, and Pat Parsons.[44] Although not in a league with Clement Greenberg or Nelson Rockefeller, these purchasers nonetheless possessed sufficiently "strong hands" to advance Tolson's reputation and increase demand for his work.

Edith Halpert, Sidney Janis, and other art dealers had handled works by self-taught painters and sculptors as early as the 1930s; however, the artists they had identified were by 1970 "forgotten and largely dismissed."[45] A thorough survey of contemporary folk art's gallery history lies beyond the scope of this study, but an effort is made here to describe the market between 1970 and 1982, the date of the Corcoran Gallery of Art's highly influential exhibition "Black Folk Art in America: 1930–1980." With this nationally touring show, the number of commercial galleries specializing in contemporary folk art exploded. From 1970 until 1982 only 21 commercial galleries offering contemporary folk or self-taught art can be documented;[46] a 1993 index of outlets listed 137 galleries that carry twentieth-century folk, self-taught, or outsider art.[47]

The earliest twentieth-century folk art enterprises include the Kallir family's Galerie St. Etienne, which from the 1930s offered works by Horace Pippin and Grandma Moses as well as European expressionists. Edith Halpert first established the practice of selling contemporary fine art and folk art in tandem, through her Downtown Gallery in New York; Phyllis Kind modified her fine art gallery likewise in 1972, to be followed by many more dealers. Presenting academically informed and nonacademic art as mutually ennobling has been crucial in establishing the legitimacy of folk art—certainly, at setting high prices for it—and remains the prevailing strategy of dealers who handle the most expensive work in this field. "One validates the other," asserted Carl Hammer, who in 1993 was offering a nine-thousand-dollar Tolson *Temptation* at his Chicago gallery.

John Ollman, director of Fleisher-Ollman Gallery in Philadelphia, explained that in the late 1970s, "We started getting very serious about people perceiving [contemporary folk art] as a serious field, and that it be treated like

art with a capital 'A'." To this end, Ollman began alternating folk art shows with exhibitions of emerging contemporary fine artists and integrating schooled painters with their self-taught counterparts in theme exhibitions. As well, Ollman decided to cull from the gallery many of the self-taught artists whose works he had purchased early on and to focus on a few self-taught painters and sculptors instead. "We've dropped a tremendous number of people whose work just didn't hold up for us," Ollman said, a time-honored method for improving one's status in the arts: rejection, which bespeaks a taste for ever finer things.[48] Ollman's selectivity, in fact, served to enhance both his gallery's position as an outlet for "premier" folk art and the prestige of folk art as a whole.

The 1970 twentieth-century show at the Museum of American Folk Art, which Hall dubbed a "hodge-podge . . . just a survey thrown out for your appetite," was reprised at Janet Fleisher Gallery in 1975, after publication of the Hemphill and Weissman book. Ollman solicited many additional objects from collectors around the country, painted the walls red (perhaps to imitate the book's illustrations of Tolson's *Fall of Man*), and managed to squeeze eight hundred objects into the gallery, a design reminiscent of Hemphill's own crowded apartment. "It was *very* claustrophobic," Ollman admitted, "but it was very much the spirit of the way that people dealt with the material at that point in time." In such an installation one perceives the legacy of nineteenth-century ethnographic museums, their troves of scantily labeled, often tenuously related objects compressed into one room or even one crowded case.[49]

This mode of presentation, harkening to the period rooms of historical museums, restored homes, and the decorative arts galleries of major museums, was originally favored by those, like Robert Bishop and Carl Hammer, who had come to contemporary American folk art through an interest in antiques. Carl and Tricia Hammer, schoolteachers in suburban Chicago, had purchased a second home in rural Wisconsin and begun decorating it with antiques; as a sideline, they sold furniture and other early pieces as Pine Creek Farm Antiques from their country residence. At an antiques show the Milwaukee Art Museum organized in the early 1970s, Hammer encountered the striking style of Detroit dealer Tim Hill. Hammer remembered coming upon Hill's booth:

> For the very first time, instead of junking up his booth with a re-created room, here he was lifting the object out of that context and elevating the objects into levels of appreciation and understanding that you only saw in museums. I remember turning to my wife and I said to her at that time, "I want our collection to look as good as this. This guy has really got the answer to what we want to do with our collection." It made me stop really try-

ing to re-create eighteenth- and nineteenth-century looking rooms and start identifying the objects that we want to look at as art, treat them as art, instead of just a possession that has a lot of provenance to it.

By the late 1970s Ollman, as well as art dealers Tim Hill and Roger Ricco, owner of an ethnographic art gallery in New York, had abandoned both period reconstructions and a cluttered-attic aesthetic; instead they displayed American folk art objects in isolating and austere stagings. Such presentation, including archival matting and framing, insisted on the museum quality of this new field of objects and justified asking museum-league prices. The success of these techniques in elevating folk art—and the concurrent rise in folk art's status—can be witnessed in more recent adjustments within the market. Such prestigious fine art galleries as Knoke in Atlanta, Hirschl and Adler in New York, and Valley House in Dallas have added folk and outsider art to their inventories; Hirschl and Adler succeeded in selling two Bill Traylor drawings to the Metropolitan Museum of Art in 1992, the ultimate institutional validation.

The earliest galleries to handle contemporary folk art employed one of several "crossover" sales techniques. Some, like George Schoellkopf in New York, simply began to add occasional contemporary pieces to their selections of fine antiques and early Americana. Several quilt dealers gradually widened their scope to include sculpture and painting. Other galleries, notably in the West, specialized in ethnic arts: Davis Mather's Santa Fe outlet for Native American artifacts and Brigitte Schluger's Denver gallery featuring Northwest Indian art.

Still others tried to develop exclusive sales agreements with one self-taught artist and to build a gallery's reputation around his or her success. Gilley's Gallery in Baton Rouge specialized in the paintings of Clementine Hunter; Galerie St. Etienne handled Grandma Moses; Jeff Camp's American Folk Art Company sold large numbers of sculptures by Miles Carpenter and, for several years, the paintings of Howard Finster. The short-lived Pied Serpent Gallery, though in actuality little more than a business card, was likewise born of the market the Halls had created for Edgar Tolson's woodcarvings. This form of highly focused dealership, bordering in many cases on outright advocacy, contributed enormously to the viability of contemporary folk art as a whole. In the 1970s, contemporary folk art was still a curious and unknown commodity, its pricing structure uncertain. As in the case of Durand-Ruel, whose near monopoly of the impressionist painters steadied a highly speculative market for their works, dealers like Jeff Camp and the Halls assiduously made names for the artists they represented and, through close management of sales, both rationalized and escalated prices.[50]

Michael Hall noted with satisfaction that Tolson's pieces have continued to sell well through two decades:

> The prices for Edgar's work were built on solid footing. He is, I'm proud to say, one of the very few folk artists from the period who went on to become a classic, whose prices haven't taken some great correction in the last few years. Every Tolson that has gone to public sale has bettered its previous best. This is a very interesting thing to be able to claim, because that tells you that the credibility invested in Tolson's work early on has stayed in place.

While the Halls and others nudged prices for contemporary folk art upward, a secure collecting field required more public sales venues. Museum acquisitions were important in this regard so that folk art objects, rather than vanishing into a collector's private home, might receive highly visible, definitive endorsement by a committee of experts, social and institutional approval rather than simply personal favor. In 1978, art promoter Sanford Smith initiated what would become an annual American folk art sales event: the Fall Antiques Show in New York. According to Carl Hammer, this was the first show of its kind to focus on Americana, and because it doubled as a fund-raiser for the Museum of American Folk Art, Hammer said, "a lot of us felt that it was saying something about the level of acceptance and popularity" for folk art. An invitational gathering of dealers, the Fall Antiques Show has maintained an air of exclusivity, though Smith and Associates certainly work to draw a crowd. Moreover, continued association with the Museum of American Folk Art has lent the show prestige: publicized as a benefit, the event turns shopping for antiques into an act of museum patronage and thus transforms every buyer into a potential benefactor.[51]

Unlike the confidential negotiations between dealers and private collectors, sale at auction provides even greater visibility, publicly establishing benchmark prices that guide and solidify future sales of an artist's work.[52] The large metropolitan auction houses, Sotheby's and Christie's, began in the 1970s to sell contemporary art with frequency and to offer folk art as well. Sotheby's, previously Parke-Bernet, had sold folk art intermittently since the 1944 sale of George Horace Lorimar's collection of Pennsylvania pottery and fraktur.[53] Sotheby's director of American folk art, Nancy Druckman, explained:

> We always sold some quilts and weathervanes and things that came in sort of tagged on to the ends of collections that we were selling, but it never really took shape or took an identity and took form until the early seventies, when the Garbisches started to sell. And then quite coincidentally the Whitney Museum mounted "The Flowering of American Folk Art," which

was an assemblage of the most incredibly wonderful and irresistible folk art objects. It kind of provided the venue in which large numbers of people could really see this material as a separate and distinct kind of collecting category.

The Garbisches' collection, already renowned thanks to the couple's many gifts to museums, sold in 1974. Other notable collections offered at auction in ensuing years included Stewart Gregory's in 1979, Howard and Jean Lipman's in 1981, Andy Warhol's Americana in 1988, and Bernard Barenholtz's in 1990. Twentieth-century folk art first sold at Sotheby's in small lots attached to these larger, well-known collections of eighteenth- and nineteenth-century objects, high-quality contemporary pieces receiving "an extra kind of boost" from the collectors' famous names. Druckman said, "I decided to sort of make a virtue out of necessity, with an awareness of the fact that this is an area of collecting which is in its infancy now but where there is a tremendous amount of interest. . . . I was aware of the fact that there were probably hundreds of thousands of people in the United States now who are beginning to be interested" in twentieth-century folk and outsider art. Beginning in 1990 with the sale of Robert Bishop's collection, which included a substantial selection of twentieth-century works, Sotheby's has annually scheduled contemporary folk art into its January auction.

Edgar Tolson's woodcarvings appeared at public auction several times during the 1980s. In 1984 a *Temptation* piece from an unnamed "New York private collection" failed to meet its minimum. (Sotheby's price estimate for the piece was listed at three thousand to five thousand dollars.) A more coarsely carved Tolson *Expulsion* also "from a New York collection" was offered in the June 1985 sale, estimated worth three thousand to four thousand dollars, but likewise failed to sell. In each instance the auction catalog illustrated Tolson's carving with a small black-and-white photograph.

A more concerted push came in October 1989 when Sotheby's offered a later *Temptation* from the Mr. and Mrs. Robert P. Marcus Collection. This time the auction catalog dedicated an entire page to an abbreviated Tolson biography, describing him in familiar terms: "Tolson, a hard-drinking, tobacco-chewing, storytelling philosopher, and survivor of numerous mountain feuds, married twice and fathered 18 children." With its allusion to "mountain feuds," a fabrication, the Sotheby's biography invoked the stalest of Appalachian stereotypes; along the same lines, several Tolson stories are conflated, better to portray a renegade: "the colorful Tolson recalled burning down two of his houses and blowing up his own church during weekend alcoholic binges." To this burlesque, Sotheby's appended a decorous listing of the museums that had acquired Tolson's work and a bibliography of references.

Another full page was devoted to the carving itself: a large photograph, the object's exhibition history, and its provenance (through Robert Bishop's longtime associate Jay Johnson). A peculiar combination of the freakish and the dignified, this marketing strategy helped sell the Marcus carving, valued at five thousand to eight thousand dollars, for fifty-five hundred dollars.[54]

Two months later, at the January 1990 Sotheby's sale, a Tolson *Expulsion* was offered as part of the collection of Robert Bishop, director of the Museum of American Folk Art and himself a skilled, successful promoter. Bishop's name attached a powerful cachet to the works offered. Additionally, Sotheby's invested in a more sumptuous presentation of the twentieth-century folk art pieces, grouping the Bishop lots with several Bill Traylor drawings from an anonymous midwest collector. For sale were works by the "classics" that had been featured in Hemphill's inaugural twentieth-century folk art show: in addition to Tolson, the by-now familiar artists were Justin McCarthy, Victor Gatto, Minnie Evans, and Jack Savitsky. Others, equally well known by 1990, whose works were offered in this sale included Mose Tolliver, Inez Nathaniel-Walker, Mattie Lou O'Kelley, Howard Finster, William Hawkins, and Sam Doyle. Many of the lots, including the Tolson carving, were photographically reproduced in full color and presented without accompanying text. A Tolson biography, printed on the facing page, offered a more muted portrait than the ribald version of October, omitting his "alcoholic binges" and describing the woodcarver as a contemplative witness rather than a participant in the region's mayhem: "He lived in the Appalachian Mountains and witnessed domestic violence, strikes in the mines and bloody feuds. His religious beliefs and conviction are evident in his carving."[55] Still rendering a "colorful" and stereotypical personage, this account of Tolson's life stressed skill, craftsmanship, and religious faith. A more cerebral and serious characterization, it appears to have originated in Hall's essay "You Make It with Your Mind," cited in this longer list of references. Provenance of the piece was also through Michael and Julie Hall. With an estimated value of $6,000–$8,000, *The Expulsion* brought $10,450, which *Maine Antiques Digest* reported as "a record for a Tolson work."[56] Only three pieces of twentieth-century folk art in this first January sale topped its price.[57]

The next significant public auction of a Tolson work occurred in November 1992, when Ralph Rinzler's early yellow poplar *Temptation*, featured on the cover of the 1973 Smithsonian Festival of American Folklife catalog, was offered at a Litchfield, Connecticut, sale of twentieth-century folk art. David Schorsch, a New York antiques dealer, purchased the piece for seventy-six hundred dollars, the highest-priced object in the sale.[58] Subsequently, Tolson's tableaux have been offered at between eight thousand and twelve thousand dollars by galleries in New Orleans, New York, Philadelphia, and Chica-

go and through private dealer Larry Hackley, the most consistent source for Tolson's work since the late 1970s. An early Adam and Eve brought eight thousand dollars at Sotheby's January 1995 sale; single carved figures have sold for as much as four thousand dollars through private dealers.

Nancy Druckman has described the auction market as "a reactive system. We're not in an area in which we can kind of create a market for something that doesn't have a market someplace else." Dedicating a portion of its annual January sale to twentieth-century folk art beginning in 1990, Sotheby's so acknowledged the existence of a collecting field. Sanford Smith and Associates did likewise in 1993, staging its first Outsider Art Fair at the Puck Building in trendy Soho. Two of the firm's young associates, Caroline Kerrigan, then a graduate student of art history, and Smith's son Colin, conceived the event after spotting a front-page news story in the Wall Street Journal: "'Outsider Art' Is Suddenly the Rage among Art Insiders."[59] With advice from New York dealers Aarne Anton, Roger Ricco, and Frank Maresca, who had participated in the firm's Fall Antiques Show, Kerrigan and Smith polled 110 galleries to gauge interest in such a sales venue, then inviting thirty-three "quality" dealers from the United States and abroad.[60] Booth fees the first year ranged from nineteen hundred to three thousand dollars.

Smith and Kerrigan asked Lee Kogan of the Museum of American Folk Art to organize a symposium at Phyllis Kind's New York gallery in conjunction with the 1993 fair. The organizers expected an audience of 75 for brief talks by Herbert W. Hemphill Jr. and others, but 180 people purchased tickets, and others were turned away at the door. In three days, the first Outsider Art Fair drew more than 4,500 visitors to the Puck Building.

According to Colin Smith, the firm chose a Soho location hoping to attract "the contemporary art people, who may be different than the upper east side antique people." Press releases compared the event to the 1913 Armory show, "which was maybe going a bit far," Smith conceded, "but I think for this material it was equivalent in a lot of ways, in terms of introducing something that hadn't been seen before to the New York art market." Radio spots, describing the event as cutting-edge, aired on the city's two all-classical stations and the two all-news stations, since, according to Smith, "they have the highest demographics in terms of income and education. It benefits us to bring in masses of people, but in the long run it doesn't do the show any good unless the people who come in are people who are knowledgeable enough and have the resources to buy." The Outsider Art Fair, like Sotheby's sale, has become an annual January event in New York, the 1997 fair drawing a crowd of six thousand to the booths of thirty-five folk and outsider art galleries.[61]

While auction sales and events like the Outsider Art Fair have publicly identified the field of folk art collecting, profits have enlivened it. Several fac-

tors have made folk art peculiarly attractive to buyers. Though fine art typical-
ly sells on commission, artists usually splitting sales evenly with their dealers,
folk and outsider art ordinarily is purchased outright, at which point dealers
may triple or quadruple prices with impunity. As one gallery owner ex-
plained, "I buy directly from artists. I pay them what they ask. I don't try to
make deals unless I'm buying a whole lot of things and I ask for a discount.
And then I somehow get the work back to Washington, and I set about trying
to determine how much I can sell it for."[62] Having purchased folk art up front,
dealers have greater incentives to sell. In addition, since folk artists are less
apt and able to maintain watch over the business affairs of galleries far from
where they live, dealers may take greater liberties in handling their work. Chi-
cago painter Roger Brown noted of his dealer, "As the years have gone by I've
sort of felt like [her] interests for instance have gone more and more into the
folk art area. And I think it's partly because dead artists are a lot easier to deal
with than live ones, and ones that are back off in the sticks somewhere who
don't really—aren't that sophisticated about stuff."

In the case of Tolson, both Michael and Julie Hall insisted they took no
commission on his carvings and spent considerable resources, personal and
financial, to promote him. One coup was the 1976 sale of Tolson's largest
carving, the five-foot *Uncle Sam*, to a Detroit architectural firm for $5,000.
Still, with an overview of the folk art market they helped to create, the Halls
were able to collect Tolson's work and hold it for optimum profit later. Some
270 pieces from their collection, including the *Fall of Man* series, *Man with a
Pony*, and eleven other Tolson carvings, sold to the Milwaukee Art Museum in
1990 for approximately $2.3 million, a "bargain sale" similar to the arrange-
ment Michael Hall had facilitated between the National Museum of American
Art and Herbert W. Hemphill Jr. four years earlier.[63]

Edgar Tolson, it appears, understood this effort to promote his work and
cooperated in Hall's collecting plan. For example, in 1968, when Hall began
with deliberation to chronicle and buy the carver's early works, Tolson rou-
tinely encouraged Campton friends and family to sell carvings he had given
them, promising to carve others in their stead. Daughter Monnie Profitt re-
membered asking her father to repair a carved yoke of oxen he had given her:
"The prettiest thing ever was." After mending the piece, Tolson chose to sell
it. Hall asked the carver to try to buy back from Joan Watkins his first Adam
and Eve carving. "They give me twenty-five dollars for it and I offered them
$1500 and they turned it down," Tolson said. "Michael Hall wanted it. I
wouldn't have it myself. I don't keep none of it."[64]

After repeated requests, Monna Cable was convinced to sell the *Man with a
Pony* to Hall. "He come about three times before I let him have it. That was
after my husband was dead and I knew I couldn't keep it out anywhere after

that." Mrs. Cable had placed the large carving on her porch, but after learning of the work's value, she said, "I figured somebody would take it if I had it out in the yard." She said Hall told her "he was going to put it in a museum," and indeed the piece, included in the Brooklyn Museum's 1976 "Folk Sculpture U.S.A." exhibition, now belongs to the Milwaukee Art Museum. Originally, Mrs. Cable said, she was reluctant to sell the *Man with a Pony*: "I just wanted to keep it because Edgar gave it to us." Yet when Tolson himself accompanied Michael Hall, asking her to sell, she relented: "I believe [Tolson] wanted me to give it to him," she said, "or he wouldn't have come with him." She sold the piece for seventy-five dollars in 1969. Seven years later, prior to the "Folk Sculpture U.S.A." exhibition, Hall valued the piece for insurance purposes at fifteen thousand dollars, two hundred times the purchase price.[65]

The trade in other Tolson pieces also evinces folk art's astounding leap in value during the late 1970s. Gallery owner Phyllis Kind purchased a large Tolson preacher carving in 1972, at the time of her first folk art show, for $250. While the Halls took no commission on the sale, Kind's gallery did take 40 percent; thus, Kind in effect paid $150 for the carving. Six years later, in 1978, she sold the same carving to the Museum of International Folk Art in Santa Fe for $2,113, nearly fifteen times the original price. Hemphill's and Horwitz's books had been published in the interim, as had Bishop's *American Folk Sculpture*, which included an image of this very object. Furthermore, "Folk Sculpture U.S.A." had toured from Brooklyn to Los Angeles, and Tolson's *Expulsion* had been chosen for the Whitney Biennial.

The speculative possibilities of this new field of art became swiftly apparent to both dealers and collectors. By the late 1970s Roger Ricco "was buying and selling 'raw things,'" mostly anonymous found objects that he, like Tim Hill, presented singly on pedestals, museum style, stunning the folk art collecting world by asking and getting extremely high prices for what he termed "pre-art."[66] Carl Hammer, enthralled by Hill's elegant presentation of objects at the Milwaukee Art Museum, began also to weigh the economic potential of an altered approach to folk art.

For Hammer, a collecting expedition to New England served as the turning point:

We went in to this one antique shop's location and they had these really beautiful Windsor chairs, set of four, bow-back Windsors. . . . Of course, we're very green and this was the very first New England trip we made. And we're standing there, my ex-wife and I, looking at this and thinking that we would take them back to Chicago and try to make some money off them. And we were looking at the pieces and they're asking maybe, at that point of time, twenty years ago, probably a fairly outlandish sum of money,

maybe a couple thousand dollars or something, and telling us that they think that there's a least a couple of hundred dollars left in that set of furniture. And I walked out. There was just something about that that kind of went "Wham," hit me right in the face, and I walked out of that place. . . .

It was very unsettling for me. I think it took me a couple of days to really put my finger on it, but I said to my ex-wife at the time, I said, "If I have to come out to New England to find something that I can only bring back to Chicago and there's a couple of hundred dollars left in it," I said, "there's something that just isn't there for me. It does not have for me the kind of existence or the kind of promise of being a dealer or being a businessman that I want. It's like eking out an existence." So I said, "I want something that has ten times more dynamicism than that. I want something that has obviously a higher profit margin."

Just such potential for higher profits induced many antique shop and fine art gallery owners to handle twentieth-century folk art; however, profit margin accounted for only part of its commercial appeal. Even more basic, contemporary folk art was cheap. Especially during the inflated art markets of the late 1970s and 1980s, intriguing folk art was the best bargain available. Prior to the 1976 opening of Georgia's survey show "Missing Pieces," Bert Hemphill ran into his old friend Robert Bishop at the Atlanta airport; Bishop, just arriving from a visit with Montgomery painter Mose Tolliver, "had bought everything that Mose had. There were crates of them," and he gave Hemphill two paintings outright.[67] Michael Hall said that Bishop "taught me that if you find something interesting, take it home, live with it, and figure it out."[68] The Halls bought three Tolliver paintings from Bishop for forty-five dollars, "and at an investment of fifteen dollars, it was fun. We had fun in those days. Not that we can't still have some fun, but it's not the same kind of fun when it costs you eighty-five hundred dollars to find out if something is amusing or interesting or entertaining or compelling or seductive or curious or wonderful or dumb."[69] Low prices in this still amorphous collecting field maintained a mood of experimentation and openness among folk art appreciators through the early 1970s.

Folk art's displacement from the realm of charming bric-a-brac to what John Ollman called "Art with a capital A" is perceptible in descriptive and rhetorical changes that took place in folk art discourse through the 1970s. How, to use Tolson's own phrasing, did his woodcarvings become objects you could "talk to people about"? While depictions of Tolson obviously were not subject to any orthodoxy, nor did they progress in a strict or linear fashion, a history of texts describing the woodcarver and his works discloses how valuation and understanding evolved.

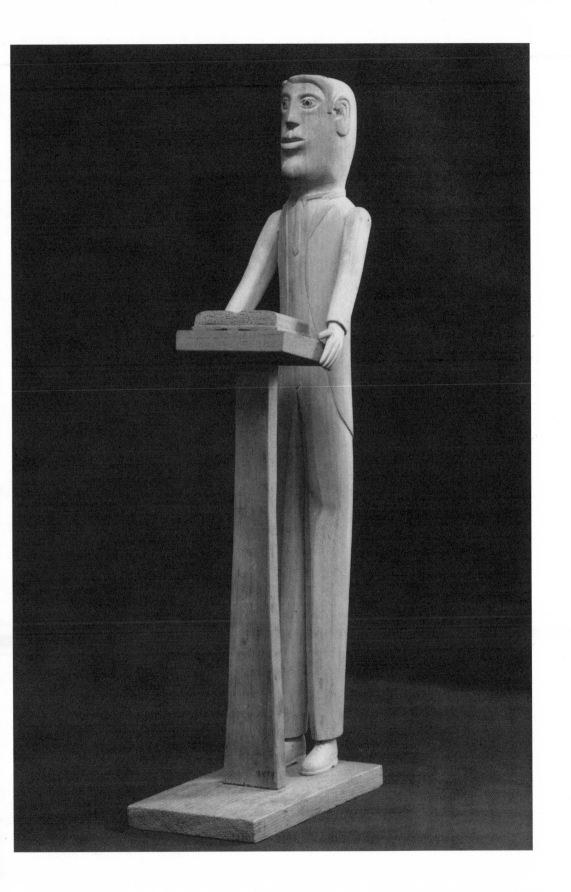

The Grassroots Craftsmen presented Tolson's canes and dolls as authentic and regional. In modest efforts at marketing the co-op offered quilts and carvings to prove the more general craftsmanship, traditionality, and industriousness of Appalachian people as a whole. Press from this period, circa 1968, openly discussed the income that Tolson and other members of the cooperative received from objects they had made, for in fact the Grassroots Craftsmen's program aimed at economic self-help, a strategy of political organizing mobilized around small-scale development. The *Lexington Leader* reported in June 1968, "Some of [Tolson's] pieces will be exhibited in the Smithsonian Halls of Natural History, and in the History and Technology department, and others will be sold ranging from $8 to $100 each and most of the money will go to Tolson." The article went on to quote the carver: "It will help—along with a $60 a month disability check to support my big family."[70] Here, Tolson is portrayed as a humble, struggling provider.

Subsequent newspaper pieces, beginning with Phil Casey's article in the *Washington Post* from March 1968, rendered Tolson instead as a crusty character, the target of a feature story, dwelling on his mountain dialect and country humor. Another piece published soon thereafter reported that though Tolson had built two guitars, he confessed, "I can't hardly play a victrola." Asked if his children were woodcarvers too, Tolson replied, "Naw, my kids don't show no interest. They couldn't sharpen a stick you could drive in the ground."[71] Both these stories alluded to Tolson's rugged physical appearance, depicting a stereotypically lean, lanky, unkempt mountaineer. Casey described a "tanned weather beaten man who is built like a knife." Wagner evoked his "thick mane of brown, gray-flecked hair and long legs that carry him boldly into a room," adding that Tolson wore "a pair of baggy brown slacks, a white shirt with a stain over his heart and a t-shirt soiled along the neckline." In the same spirit, Casey noted, "It isn't clear just how many children he has fathered since his stroke, but it seems he's had about a half-dozen." Rather than a fretful father, Tolson is pictured by these reporters as profligate, filthy, neglectful—a wonderfully odd and virile primitive.

This more colorful, amazed, and derogatory mode of characterization developed through the early 1970s into a succinct, customary folk art discourse. As the terminology and practices of collecting came to dominate understanding of contemporary folk art and a group of "classics," including Tolson, through repetitive exhibition came to represent the emergent field, so did a form of minute biography. Hall alluded to it when he described Robert Bishop's "picture books with small essay introductions and narrative captions."[72] This caption-style discourse functioned in several influential ways: it suited the format of the coffee-table book, text in support of a photograph; it could

fit on a museum's or commercial gallery's exhibition label; and it provided reporters and reviewers with handily abbreviated information.

Through vivid epithets and idylls, caption style attached bright identificatory tags to each folk artist and provided dealers, collectors, and reporters with a kind of communicative shorthand. If, as Susan Stewart has written, "the collection replaces history with classification," caption style, as the language of collecting, aims to classify, effectively reducing artists to caricatures—immediate, recognizable, salable.[73]

Hemphill's *Twentieth Century American Folk Art and Artists* and Bishop's *American Folk Sculpture*, both brought out in 1974 and both highly influential in the field, included nearly identical biographies of Edgar Tolson:

> Edgar Tolson was born in Lee City, Kentucky, in 1904. Educated through the sixth grade, he has been married twice and is the father of 18 children. A descendant of seventeenth-century settlers of English origin, he is a hard-drinking, tobacco-chewing storytelling philosopher of Campton, Kentucky, where he now lives. He calls himself a wood carver now, but has been a preacher, farmer, cobbler, chairmaker and itinerant worker. He recollects mountain feuds, whittling his own teeth, burning down two of his houses, and, while on a weekend binge, blowing up his own church during Sunday prayers. He has been carving for over 35 years, sometimes in stone but mostly in wood. [Hemphill and Weissman][74]

> Edgar Tolson, the tobacco-chewing, hard-drinking philosopher of Campton, Kentucky, was born in 1904. This colorful wood carver, the survivor of numerous mountain feuds, has enjoyed a varied career, which includes being a preacher (he ultimately blew up his own church during Sunday prayers), a cobbler, a chairmaker, a farmer, an itinerant worker, and finally a wood carver. For the past thirty-five years, Tolson has sometimes worked in stone, but prefers the texture of wood. He is probably best known for his numerous versions of the Adam and Eve theme. Museums today eagerly seek his "whittlings." The eight-part representation of "The Fall of Man" shown on these two pages is one of Tolson's most significant works. [Bishop][75]

Whether one of these biographies was copied from the other (both books were published by E. P. Dutton under the same editor) or both came from a common source is unknown. Michael Hall may have supplied the text to both authors, since he and Julie Hall contributed photographs of works from their collection—including most of the Tolson illustrations—to both book projects; however, Michael Hall's folk art discourse from this same period stands

in considerable contrast. More likely, the text originated with Chicago dealer Phyllis Kind, since eleven of the twelve artists represented in her earlier group exhibition "The Artless Artist" were featured in Hemphill and Weissman's book. Kind also contributed a photo of the large Tolson *Preacher* for Bishop's *American Folk Sculpture*. The stories of the church explosion and homemade dentures had been published prior to 1972 in Kentucky newspapers, but as presented here they reflect Kind's characteristically defiant and aggressive style. "I am not concerned with the self-conscious dabblings of the pseudo naive nor with the saccharin cuteness of an awkward copyist," she wrote in 1975. "I refer to the kind of intensive personal statement made by a man like Joseph Yoakum who had to make pictures or he would go mad."[76] Furthermore, these punchy, brief biographies would be suitable for a gallery's wall label or for the informational sheets art dealers typically make available to clients. In any case, this short biography has proven enormously durable. Later references to Tolson, in exhibition and auction catalogs, newspaper articles, reviews, and books, routinely mention his many children and, with varying degrees of accuracy, the church explosion.[77] The *exact* phrase "hard-drinking, tobacco-chewing, story-telling philosopher" actually makes seven later appearances.[78]

Such "folksy" epithets were not exclusive to promotions of Tolson. In fact, similar stereotypes of marginality—Martin Ramirez "the schizophrenic Mexican mute," Gertrude Morgan "the street preacher and gospel singer," Jack Savitsky "the coal miner," Eddie Arning "the Texas mental patient," Frank Jones "the prisoner"—have been routinely used to identify and certify folk artists within the collector community. The most serviceable phrases for folk art nomination emphasize some combination of the following traits: poverty, religiosity, non–Anglo-American ethnicity, old age, history of menial employment, criminal record, lack of education, rurality, and physical or mental disability. In effect, these characteristics best warrant someone as a "contemporary folk artist" or, in the more recent parlance, an "outsider." Caption style, stringing together such traits, served to establish contemporary folk art as a field of immediately recognizable collectibles, each artist sharply, if inaccurately, labeled through a vivid qualifying trope.

By the 1990s caption style's crudeness had fallen somewhat out of favor in the field of folk art except in marketing, where stereotyping, because of its expediency, continues to prevail. Colin Smith described the radio broadcasts his firm wrote to promote the 1993 Outsider Art Fair.

> There was just a brief listing of "Outsider art is the southern preacher who paints his religious visions. . . ." We didn't name any particular artist but it was taken from Howard Finster. And Bill Traylor—we said, "The former

slave who drew powerful figures on bits of cardboard." And we did one that was Wölfli, on "the artist who was hospitalized." I think it wasn't totally successful but I think we did as good a job as you can in sixty seconds with a subject like this.

John Ollman vehemently has advocated the more muted approach to which the auction houses and most other high-priced galleries increasingly have turned. Ollman insisted, "I'm absolutely not interested in anecdotal information about the artists. I think it's demeaning. So we'll put together a résumé for a self-taught artist just the same way we would for a trained artist, but I'm not interested in whether they're left-handed and black, or whatever the hook is that people are hanging work on today." After representing Fleisher-Ollman Gallery at the first Outsider Art Fair, Ollman noted with disgust, "Lots of it's being sold on, 'He's autistic, he's in a mental institution, he was born a . . . ,' whatever, as opposed to saying, 'Look at it as a work of art.'"

Michael Hall was an early proponent of this more decorous treatment of nonacademic art. In contrast with caption style, Hall engaged a less anecdotal language, more formal, laudatory, and restrained. A press release he composed in preparation for the 1970 University of Kentucky student center show introduced Tolson and his work: "This exhibition is the first comprehensive showing of this unique sculpture with a selection of forty pieces representing the full range of Mr. Tolson's accomplishments." Hall chose not to portray an eccentric mountaineer but "a gifted primitive sculptor whose work reflects a vitality and originality rarely matched by most trained artists." Hall argued that Tolson's woodcarving manifested both folk and modernist legacies: "though similar in appearance to some of the work of the nineteenth century [it] is unique in its emergence from what is most assuredly a pure expressive motive."[79]

In succeeding years, Hall's discourse—circulated in exhibition catalogs, interviews, and published essays, as well as in the classroom and from many a museum lectern—shifted increasingly to a fine art model of interpretation. For the first group show of folk art he curated, Hall's catalog essay included an explication of Tolson's *Man with a Pony*. Hall termed the work "a complex sculptural composition" and went on to parse its significance in an analysis focused on the "relationship" between the African American male figure and the saddled spotted horse standing before him. Hall described this relationship as "not so much formal as it is spiritual": the animal, tethered on a rein, is subdued by the man, "who has clearly accepted the biblical mandate to go into the world and have domination over all creatures."[80] Hall's interpretive zeal, while not unconvincing, is nonetheless remarkable considering that the

piece it explicates may also have been Tolson's wooden rendering of the pop-
ular jockey boy yard ornament.

Julie Hall likewise contended that folk art required an act of interpretation,
a reaching past the literal. In a 1981 exhibition catalog, she pointed out:
"Edgar Tolson built his *Beheading of John the Baptist* just after the Watergate
scandal, and though he never mentioned the word Watergate to me or spoke
of President Nixon to me at that time, I believe that this work is a statement on
the abuse of political power" (Plate 8).[81] Five years later Michael Hall seized
on this idea and asserted, "Edgar Tolson responded to the Watergate hearings
he watched on television by carving an allegory on the abuse of power," fur-
ther contending that the soldiers seated on either side of King Herod in Tol-
son's piece supplied "a subtle reference to Nixon's aides, John Erlichman and
H. R. Haldeman."[82] In a 1986 exhibition catalog, Hall even went so far as to
retitle the work *Abuse of Power (Watergate)*. Handling folk art as cultural sym-
bol, and consequently subjecting it to the sort of analytical scrutiny typically
reserved for art of the historical canon, Hall has consistently maintained that
folk art be demythologized and wrung for its richly meaningful contents.[83]
His sometimes bombastic efforts in this regard have amused and annoyed
some commentators as overserious.[84] Even so, Hall's early art historical exe-
gesis of self-taught artist's work constituted a kind of protoscholarship, a
critical alternative to both folkloristics and ad copy, in the burgeoning field.

Hall further enhanced the appreciation of such works as Tolson's carvings
through comparison to accredited examples of fine art: "Like Giacommetti,
Tolson enforces his artistic vision through an endless focused manipulation
of just a few basic images."[85] Over time, others have compared the Campton
carver's work to "the 15th century Flemish Mosan marbles with their discreet,
gentle narrative style"[86] and "statues from Assyria and Babylonia and Meso-
potamia that had the same stare, the same eternal look."[87] Though Hall's
comparison (like his recommendation of Tolson for the Whitney Biennial) at-

tempted to establish the woodcarver as a modernist while others associated Tolson's work with Gothic and ancient art, all these comparisons venerate folk art by binding it imaginatively to classics of the canon.

As well, Hall's rhetoric invoked terms of justice: "The figures and animals seen in this exhibition have peopled Wolfe County for the past three decades but have only recently attracted the attention they deserve," he wrote to introduce the 1970 one-man exhibition.[88] This aesthetic defense, the art collector or curator rescuing folk productions from obscurity, has proved an enormously serviceable perspective on collecting, with the power, it seems, to transmute acquisitiveness into a noble act. Such a conception implies that nonacademic artists "deserve" the sort of appreciation that only experts can provide. One striking example, the portrait Howard Finster painted on commission for Herbert W. Hemphill Jr., rendered the collector as "the man who preserves the lone and forgotten." Here, and in other cases, the folk artist himself has adopted the language of justice and affirmed an image of the collector's beneficence. Of course, this kind of flattery abounds in the history of arts patronage and portraiture.

Both these discourses—the curiosity and mild amusement of more journalistic treatment, echoing earlier local color writing, and the narrative of worthy art coming inexorably to public recognition—have served to popularize and to certify works such as Tolson's woodcarvings, posing their revaluation as a kind of vindication. By as early as 1970, however, discourses of touristic amusement and artistic veneration had both become flecked with anxiety. What initially had been rendered as a cloudless opportunity and revelation had grown problematic; Tolson's ever widening circle of admirers assumed the shape of a trap or noose. In subsequent news stories fame was posed as an impending threat to the carver—success, especially monetary gain, seemed a poison he might be too delicate to withstand.

A 1970 feature article from the *Lexington Leader*, structured like hundreds of folk art stories, narrated a visit by the writer and three artist friends to Tolson's home in the wild: "A tiny house set on a hillside." The article concluded, "The four of us left the wood sculptor in his little house. As we walked down the path to the road, it was Peggy Gray who said what most of us had been thinking. 'He's happy. No one should try to change him.'"[89] Guy Mendes offered a more sardonic approach in his 1972 photo-essay: "It would be nice to say that the attention hasn't done Tolson any harm alongside all the obvious benefits, but it wouldn't be true."[90] Mendes noted that once Tolson's pieces "became art he no longer gave them away, much less let the kids play with them," and contended that income from woodcarving "can't help but make the expensive bootleg booze more accessible, making it easier for Edgar to reacquaint himself with his central demon."

This discourse of dismay, of peril, marks quite a long trajectory from the Grassroots Craftsmen's wholesome story of economic self-determination. It also stands in contrast with the aestheticizing language with which such experts as Hall and Hemphill lifted Tolson up. What all these rhetorics share, however, is a spirit of helpfulness, a sense that through the instrumentality of folk art well-meaning people might come to the aid of the poor—marketing "native" handicrafts to fellow nonnatives who can afford them, preserving "lone and forgotten" artifacts and raising them to the status of art, or decrying such efforts' harm. In each case it is the poverty worker, the dealer, the art historian, the folklorist, the reporter—but never the folk artist—who presupposes and exerts what Antonio Gramsci called "the means to goodwill."[91] As investigated here, such means involve command of the language, whether altruistic, aesthetic, or critical, through which speakers and authors may exert their own perspectives of folk art and simultaneously allege their own virtue, status, and intellectual depth.

Until the late 1970s contemporary folk art writings were largely unsystematic, the enthusiasms of dealers and collectors outpacing any scholarly research; in fact, most of the early publications about contemporary folk art were set down by excited collectors (Nina Fletcher Little, Jean Lipman, Herbert Hemphill), dealers (Sidney Janis, Phyllis Kind), artist-collectors (Michael Hall), and journalists (Elinor Horwitz). The field was characterized by more zeal than probity, and since the objects themselves were still inexpensive, a playful tone infused even the serious collectors' prose.

Furthermore, the boundaries among collectors, curators, critics, documentarians, and dealers were highly permeable, not yet crystallized into specialties. Hall, for example, worked in all these capacities through the mid-1970s. As a public speaker, he addressed art students and audiences at museums and historical societies. As curator, he arranged exhibitions and scripted catalogs, many of them based on original field research. Meanwhile, he and Julie Hall were amassing a large personal collection of folk art and selling both antique and contemporary pieces as Pied Serpent Gallery. Hall may have been the most energetic and multifaceted player in the emerging field, but many others also wore a number of hats. Hemphill was not only a collector but a dealer, author, curator, and museum trustee. Robert Bishop, holding a Ph.D. in American studies and best known as the Museum of American Folk Art's director, produced lavishly illustrated books and, though he never established a public gallery, frequently sold folk art from his home. Hall described some of Bishop's activities during the Greenfield Village years.

Bob, in the early seventies, started having what you might call folk art "salons" over at his house. They were actually just the funniest cocktail parties

you ever saw in your life because Bob could put together the strangest menagerie of friends you can imagine for a party. He was comfortable across all sorts of class lines. So he used to throw these "salons" out at his place in Inkster, Michigan. And the guest list would include very sedate, conservative, what Julie always called "old wrinkled money" collectors from Birmingham, Michigan, and Grosse Point who would find themselves rubbing shoulders with very stuffy curators from the Henry Ford Museum who in turn would be rubbing shoulders with college students and young collectors from Cranbrook. All these folks were thrown in with businessmen, art investors, and sometimes even motorcycle club members, all of whom would find themselves discussing Bob's latest finds with people in green chiffon cocktail dresses and beehive hairdos that Bob had met at some seminar on quilts that he had run over at the museum.[92]

According to Hall, Bishop hosted these gatherings for pleasure and profit too:

Bob would throw these parties because he liked to have fun. He liked to have people around and he loved to entertain. He also was building, very carefully, a new coalition of people who might be interested in American decorative and folk arts. So he always had stuff on the walls of the main room of his house, and, quite frankly, it was generally always for sale. You would come and spend an evening with Bob and then as people would start to file out, somehow the checkbooks would come out and little deals would be struck. The walls started to be stripped and by the time it was over Bob was just sitting there with a pocket full of checks, an empty living room, a big smile on his face, and everybody had scattered into the night.[93]

While conflicts of interest (or, more accurately, coincidences of interest) might have deterred Bishop from opening a commercial business and induced the Halls to operate somewhat discreetly as Pied Serpent Gallery, in the early 1970s such role shifting was fairly commonplace; to a degree far greater than in other art fields, it remains permissible today. Though museum ethics oppose such practice, Hemphill admitted that in fifteen years as an administrator of the Museum of American Folk Art, "Every show that I curated, I'd start collecting that." Many other museum officials themselves own extensive personal collections of contemporary folk art. Even Ralph Rinzler, director of the Smithsonian Festival of American Folklife, eventually traded on his standing in the field of folk art. During collecting and scouting trips for the Smithsonian from the mid-1960s onward, Rinzler amassed a large collection of folk art himself, concentrating on traditional pottery yet including many

other more eccentric pieces, for example, two Tolson woodcarvings. Rinzler and his wife, Kate, arranged for two public auctions of this work in the 1990s, in each instance their status as Smithsonian associates and folklore specialists accrediting the objects up for sale.

Another form of this role shifting has involved dealers and private collectors who tout objects they own through sumptuously illustrated documentation. Roger Ricco and Frank Maresca, art dealers whose New York gallery specializes in self-taught artists' work, have published two books about contemporary folk and outsider art, and cane collector George Meyer helped to underwrite *American Folk Art Canes*, published under the imprimatur of the University of Washington Press. Again, the development of academic art history confirms this practice is not new—wealthy collectors subsidized much of the discipline's early scholarship; yet, as art history struggles to establish and maintain a degree of objectivity, in folk art studies shortcuts are still countenanced, because few documentary alternatives have been available and because quilts and woodcarvings are objects that middle-class people, like writers and museum employees, can actually afford.

Prior to 1970, folk art research had been undertaken within Winterthur Museum's university program, founded in 1951, and through graduate studies established under Louis Jones at the New York State Historical Association at Cooperstown in 1964. Both programs focused on material culture of the past. Early folk art scholars were trained in American decorative arts, the history of technology, or American historical archaeology; scholarly interest in contemporary folk artists and, particularly, the handling of their works as expressive objects came only later.[94] According to Michael Hall the 1971 summer seminar in folk art held at Cooperstown, New York, was momentous in this regard.[95] After lectures by several scholars and officials from the Abby Aldrich Rockefeller Collection, the Smithsonian, and the Museum für Volkskunde in Basel, Switzerland, the session adjourned into an open discussion of folk art, dealers and collectors mixing with the Cooperstown students and invited speakers. Hall recounted that "Hemphill, during the break, asked me if I had any photographs of any of the things that I had been looking at. Well, funniest thing, Michael had a whole tray of slides." As the seminar reconvened, Hemphill introduced his protégé, called for lights out, and drew the audience's attention to Hall and his photographs.

> I had Edmondson slides and I had Carpenter slides and I had Tolson slides, and the whole place started buzzing about this work, especially the Cooperstown students, who immediately found the stuff I was showing to be exciting. They had been studying traditional folk art—cigar store Indians and carousel horses—until they were blue in the face. This contemporary stuff

was an eye opener for them. Some of them knew the work and some of them didn't, but this was the first time to my knowledge that the "old guard" collectors like Jean Lipman had seen some of this material.

According to Hall, Lipman "was positive in her remarks that day," and Hemphill, Hall's friend of some three years by this point, "of course was very outspoken in his advocacy." At the close of Hall's presentation, the seminar participants wanted more information, most of all guidance about how they, too, might meet contemporary folk artists like Tolson. The group's curiosity was magnified by another speaker and more images supporting Hall's contention: that American folk art was alive. When Floridian Louise White showed slides of the painted relief carvings of Mario Sanchez, a self-taught artist from Key West, Hall said, "The place just went up for grabs. It was like, 'There's folk art everywhere.'"

This burst of interest was driven by the combined forces of several cultural authorities, not the least of them the New York State Historical Association, the institutional stage of Cooperstown itself. As Hall explained it, "Hemphill had opened the door, Lipman had applauded, and as the session went on it became clear that we weren't just witnessing an isolated thing. Louise's slides supplemented and augmented and extended what I had shown." Furthermore, the promise of an unlimited supply of contemporary folk art, whether in the mountains of Kentucky, downtown Nashville, rural Virginia, or the Florida Keys, incited feverish enthusiasm. "It was almost like in a cartoon," Hall remembered. "When the session ended the building just emptied and everybody who was in there raced out and became a picker. They just disbursed into the countryside to start the great quest, the great hunt for contemporary folk art. . . . It was the beginning of a decade of discovery."

State-by-state folk art surveys and exhibitions, many undertaken by trained folklorists, were instigated upon the nation's Bicentennial. These endeavors, and the touring shows they spawned, familiarized a larger public with folk art. The most influential exhibit in this respect, however, as Nancy Druckman has suggested, was "The Flowering of American Folk Art (1776–1876)," curated by Lipman and Alice Winchester for the Whitney Museum. While proclaiming the nineteenth century the nation's great folk art era, the striking assemblage of objects and its installation at the Whitney Museum of American Art, long associated with the avant-garde, also served to raise interest in twentieth-century productions. According to art historian Lynda Hartigan, "The Flowering of American Folk Art" "codified the appreciation of early folk art as an aesthetic statement. . . . Indeed, the dramatic increase in the popular audience for folk art stems from this exhibition."[96]

Folklorist Michael Owen Jones published *The Handmade Object and Its Maker*

in 1975, a masterful combination of ethnographic research, technical exploration, and psychology focused on the life and work of Kentucky chair maker Chester Cornett. Although Cornett, of Dwarf, Kentucky, with his overalls and fuzzy beard, would have been a perfect subject for caption-style treatment, Jones instead brought precision, depth, and detail to his investigation. Alternatively, since Cornett was engaged in a long-standing trade, he might have been studied as merely a tradition bearer, but Jones addressed Cornett's massive chairs as both utilitarian craft and personal statement. Relying on field research, the author drew tradition and expression together and, in so doing, set down a new challenge for scholars of material culture.

Why, after decades of neglect, did scholars begin examining contemporary folk art objects at all? In part they followed the larger trend of new social history initiated in English and French universities.[97] European historians during the 1960s were shifting attention from "great men" of the past to the lives of nonelites, studying such convulsive changes as industrialization and immigration and their effects on ordinary people. In material culture studies, this redirection prompted scholarly interest in anonymous, domestic, and humble artifacts, as clues to everyday life.

Career pressures equally fostered academic interest in contemporary folk art, as art historians strove to locate objects that had not been trampled to analytic shards by earlier commentators. George Kubler wrote in 1962, "Nothing was left to discover unless it was contemporary art. The last cupboards and closets of the history of art have now been turned out and catalogued by government ministries of Education and Tourism."[98] Kubler's tolling declaration was, of course, premature, as subsequent "discoveries," of women artists in particular, have evidenced. Yet it is also true that a kind of overcrowding in humanities scholarship was stimulating study of vernacular culture. The nervous search for new subject matter began in earnest just as, demographically, the number of graduate students bulged. Since the norms of scholarship reward discoverers more richly than later commentators, the impetus to study previously unexamined objects was strong. Contemporary folk art, promising just such a trove of novel objects and thus a potential source for scholarly reputation building, fomented understandable excitement in the academic world.

In the history of American folk art scholarship, a 1975 project instigated at Winterthur Museum marked a critical advance. Art historian Kenneth Ames wrote in *Beyond Necessity*, the publication born of this endeavor, "Although Winterthur's folk art holdings had not actually been ignored, they had played second fiddle to the artifacts of the affluent for which the museum is most widely known." Ames intended to "encourage further study of folk artifacts, generate new questions, and open new areas of investigation";[99] such pur-

poses reflected, among Ames's other goals, art history's quest for previously underdocumented material, intellectual fodder for rising scholars.

Informed by Kubler's expanded, some would say explosive reconceptualization of art history—to include all things made by human hands—and Michael Owen Jones's more behavioristic examination of the role objects play in daily life, Ames drew 225 pieces from Winterthur's collection, works rarely exhibited at the museum, and proposed to handle them as "historical and sociological phenomen[a]" rather than pieces for purely aesthetic contemplation.[100] The pieces were installed at the Brandywine River Museum, outside Philadelphia. Although not an unprecedented treatment of folk art, Ames's project, because advanced under the auspices of two institutions that typically favored a more aesthetic approach to objects, sounded a delicious note of defiance and innovation. Again striking a valiant pose, Ames would later use the militant image of the Trojan horse for his intellectual project: "One's view of folk art is dependent upon position. . . . What I offer is an outsider's view of the folk art movement."[101]

His catalog essay, published in 1977, brought the tools of French deconstruction to folk art, its associated assumptions and collecting practices. In a powerfully argued essay, Ames explored the "damaging" effects of folk art's continued romanticization, with reference to several trenchant "myths": of the folk artist as eccentric individual, the "poor but happy artisan," the virtue of handicraft, and "a conflict free past." Simultaneously, Ames proposed that while folk art had been superficially enjoyed for its whimsy and charm, once scholars applied methods as determined and assiduous to folk productions as they had to objects deemed fine art, "complexity and conflict [would] emerge."[102]

Yet it was not Ames's application of art historical precision to hooked rugs and tea kettles that rattled his audience. It was rather his fixation on questions of power. Near the close of his essay, Ames declared, "Folk art has been used by a small but vocal faction against the rest of society and exploited as a means to personal and financial aggrandizement."[103] This was not the first attack on reigning folk art discourses or practices (Daniel Robbins's "Folk Sculpture without Folk" and Amy Goldin's "Problems in Folk Art," both published the previous year, had leveled important critiques), yet it stands as a watershed work in the history of the field for an important reason: despite his contention to the contrary, Ames's critique was in fact leveled by an insider, one of the cognoscenti, published through a venerable institution, and laid open for discussion at that supremely "insider" of social events, an academic conference. At the time Ames was an adjunct art history professor at the University of Delaware, with teaching responsibilities at Winterthur itself. His book was published by Winterthur in conjunction with the Brandywine River

Museum exhibition in the fall of 1977, and it subsequently became the center-post for the museum's November folk art meeting, what has since become known as the "shoot-out at Winterthur."[104]

According to Scott Swank of the museum, "By the time the Winterthur conference on folk art convened in November, most specialists in American folk art had read or heard about Ames's essay. It established the tone for the conference which became a sociological phenomenon in its own right."[105] Folklorist Marsha MacDowell, who also attended the three-day event, wrote:

> [Conference participants] came "ready to take up" the challenge Ames had made to so many assumptions about how folk art had been collected, ex-hibited, and analyzed. Collectors, dealers, and art historians took sides against the folklorists and anthropologists. Emotions ran high, general-izations ran rampant, intellectual interchange sparkled. . . . The 1977 Win-terthur conference on folk arts continues to be used as an intellectual his-torical reference point by participants, conferees, and the folk art world in general.[106]

Beyond Necessity and Ames's "Folk Art: The Challenge and the Promise" (also published by Winterthur in an anthology of essays representing all sides of the 1977 conference) brought to the discussion of folk art a new language, more aggressive, political, and barbed. This change in rhetorical style en-dorsed a new perspective on folk art: more than a source of revenue, a cultur-al text to be interpreted, or an object of formal interest, folk art had become a field of social forces in contention. This critical edge, tempered in the heat of the Winterthur gathering, established folk art as a term and a value worthy of struggle. As underlying conflicts among competing folk art interests were dramatized in an institutional setting, the cultural field gained a heightened social reality.

The case of folk art divulges what Pierre Bourdieu's theoretical work con-tends: that in culture's realm, contestation is both generative and centering.

> When we speak of a *field* of position-takings, we are insisting that what can be constituted as a *system* for the sake of analysis is not the product of a coherence-seeking intention or an objective consensus (even if it presup-poses unconscious agreement on common principles) but the product and prize of a permanent conflict; or, to put it another way, that the generative, unifying principle of this 'system' is the struggle, with all the contradic-tions it engenders.[107]

With Winterthur 1977, the drawing of lines among various ideological camps—folklorists, connoisseurs, dealers—and, just as important, the intro-duction and consecration of an inflammatory critical discourse, marking folk

art as "the product and prize of a permanent conflict," effected just the sort of soldering struggle Bourdieu has described. After Winterthur, the folk art stakes could and did escalate, evidenced in both the overt bidding dramas that would take place at public auctions and the "term warfare" of the 1980s, as several groups vied to establish themselves as the most legitimate spokespeople in this cultural arena.

While academicians and authors tend to overrate their own influence, the engagement of university scholars in this conflict certainly intensified the discussion of folk art, signaling that those who "have the last word," who can bestow "ultimate consecration" in the realm of culture, had entered the fray.[108] Robert Bishop, while director of the Museum of American Folk Art, arranged a brilliantly strategic alliance between the museum and New York University, establishing in 1981 a two-year master's degree in folk art studies through NYU's Department of Art and Art Education. By summer 1993, some sixty-five students had earned advanced degrees through the program.[109] Academic norms discourage scholars from directly serving commercial businesses, yet the NYU folk art studies program actually built in such ties through mandatory internships. One student fulfilled this requirement at the Americana Department of Sotheby's while others have worked at George Schoellkopf, Ricco/Maresca, and American Primitive galleries. Hemphill characterized Robert Bishop as "a P. T. Barnum, a real go-getter," and Bishop's skill as American folk art's ringleader was nowhere more evident than in his instigation of the folk art studies program. He recognized and seized upon the symbiosis among art scholars, auction houses, and private dealers, seeing that even while maintaining public and professional antagonism, these authorities operated in collusion: All of them promoted folk art.

Druckman of Sotheby's described the impact of scholarship on the art market.

> It's a chicken and egg kind of thing but when something sells for a lot of money at auction, it makes people pay more attention to it. It develops a direction for scholars, and also, conversely, when scholars really begin to delve into a particular artist and begin to publish and to present more material about it, people become more interested. They begin to value it more. And so the next time that a Tolson or an Edmondson or a Hawkins or something like that comes up at auction, there's a much more sensitized, focused and interested community out there who will understand what the quality and the importance of that work is and, therefore, the price is higher. It's one of those kind of ongoing, cyclical relationships.

Michael and Julie Hall attended the 1977 Winterthur Conference and duly modified their approach to folk art as a result. Hall said that after encounter-

ing Ames, as well as folklorists John Vlach and Henry Glassie, he altered his plan of collecting. From this point, he said, "We saw the collection turning outward to be part of a cultural argument and becoming an instrument in an art world discourse, not just a discourse in the world of antiques." Breaking with the simpler, more purely formal perspective of their connoisseur friends, the Halls imposed new collecting criteria: "It meant that when we considered something for acquisition, it was tested not just against what you would call aesthetic criteria, but against political criteria. 'What will this really do in the argument?' 'What will this say in the discourse?'"[110]

The Halls' more politicized and ideological approach to folk art coincided with an influx of newcomers to the field. Through Ken Fadeley and Skip Taylor, the Halls had been able to control the distribution and sale of Tolson's carvings, but once Fadeley left Kentucky and Tolson's name had circulated widely through books and newspapers, they could no longer exercise consistent management of his output. Michael Hall said that by 1978 he and Julie had relinquished their role as Tolson's sales representatives: "Given the confusions created by all the dealers who were becoming involved, the speculators who were chasing after the work and the hordes of collectors that were pounding their way up the parkway—there wasn't anything that we could do that was effective."[111] As a consequence of both feistier competition for Tolson's new pieces and Hall's own expanded interest in folk art as an argument about culture, he revised his public relation to the woodcarver: "My work for Edgar really became more of a matter of representing him in a critical arena rather than in a marketing arena. That's when I began to write about him."[112]

The development of folk art criticism, from the late 1970s to the present, has made explicit the "system of positions" that, in Bourdieu's conception, constitutes a cultural field. A 1993 anthology entitled The Artist Outsider, coedited by Michael Hall and American studies scholar Eugene Metcalf, in-

dicated the system's manifold dimensions, with essays by folklorists, art critics, artists, art therapists, curators, art historians, and anthropologists. Codifying several perspectives—romantic, aesthetic, therapeutic, ethnographic, and critical—works such as this anthology have served to institutionalize folk and outsider art and establish its cultural legitimacy. Several U.S. art magazines have also devoted special issues to the subject in recent years, indicating folk art's continuing capacity to touch the sympathies of art world sophisticates.[113]

As, by the 1980s, contemporary folk art collecting had become increasingly businesslike, growing numbers of buyers sustained more than a dozen specialty publications. The Museum of American Folk Art's *Clarion* (now known as *Folk Art*) blossomed from newsletter to full-scale magazine in 1975. *Folk Art Finder*, a simple stapled monthly newsletter, was begun in 1980 by ceramic artist Florence Laffal and her husband, Yale psychiatrist Julius Laffal, "to accomplish an exchange of information among collectors, gallery owners, museum personnel, and whoever might be interested in folk art." In 1989 John Maizels, an English schoolteacher of art, began the semiannual magazine *Raw Vision*, lavishly illustrated in color. Editorially the publication espouses *art brut*, as set down in the writings of Jean Dubuffet and popularized in England by critic Roger Cardinal, a regular contributor. The magazine generally ignores traditional folk art, devoting itself instead to the creativity of psychotics, isolates, and prisoners.[114] Several other periodicals double as newsletters for societies of folk art collectors and admirers. The *Folk Art Messenger*, a quarterly begun in 1989, speaks for the Folk Art Society of America, based in Richmond, Virginia. Composed primarily of collectors, the group also holds an annual meeting, which combines informative lectures, exhibitions, and tours with opportunities to buy and sell. More recently In'tuit, a society of outsider art enthusiasts based in Chicago, developed a Web site on the Internet.[115]

Publications, however, have not been folk art's only critical arena. A constellation of competing positions has also been maintained through symposia addressing folk and outsider art; Winterthur 1977 is an early, potent example. In most cases, these gatherings have been held in conjunction with exhibitions.[116] Evidencing new heights of self-criticality, one conference was organized to reassess an early state survey show; "Missing Pieces or Missing the Point," held in Atlanta in 1994, proposed to reconsider Georgia folk art in light of the emphases and omissions of the 1976 "Missing Pieces" exhibit.[117]

Significantly expanding the market for contemporary work was the 1982 *Black Folk Art in America: 1930–1980* catalog and show, originating at the Corcoran Gallery of Art and touring the country.[118] In contrast with the well-traveled Hemphill collection, with its somewhat staid and decorative antiques aes-

thetic, the Corcoran show presented a gloomier, more expressionistic view of self-taught artistry. According to dealer John Ollman, Hemphill's collection "had a kind of acceptability to it," whereas "the Corcoran show was a real in-your-face kind of show. It wasn't about acceptability. It was tough and it was demanding, and the work was not easy to look at. It wasn't pretty. It was a very confrontational show and it was the first one like it in that regard."

In 1976 Hall and Hemphill had featured this raw, asymmetrical and brooding style through "Folk Sculpture U.S.A.," a tacit challenge to Lipman and Winchester's popular "Flowering of American Folk Art" exhibition mounted in 1974. "Folk Sculpture U.S.A." was designed to present "pieces which possess a powerful expressive form," "to show that the folk tradition is not exclusively of the past or the world of antiques," and "to get away from the quaint" with a darker sensibility.[119] Critic Amy Goldin wrote that the exhibition "has few pretty, fanciful and old-timey works, but many large scale, emotionally intense pieces. Much of the art was produced by living artists, and some of it is even scary."[120]

This somewhat brutal aesthetic ascended during the 1980s and in the 1990s has dominated the field of folk art collecting, edging out the more colorful and homey cheer favored by Lipman. Such grimly expressive work generally goes by the name "outsider art." Chicago gallery owner Carl Hammer described his own taste for it:

> I think underneath, inside of all of us, is an element of our human structure that probably we don't like sharing or exposing to the rest of the world, secrets or skeletons that we'd rather not share with other people. Artists have a way of sometimes just letting that all really hang out or making us really think about it and encounter that. I think it's really important to encounter it and not hide from it and think that life is a Grandma Moses painting or life is a kind of a memory painting of the way life should be—the little figure with the smile on his face, the "have a nice day figure." I think there's too much of a notion that that's what folk art and outsider art is all about. I think it's much grittier and deeper and [more] significant than that. It has a lot more introspective qualities about it than that blank, kind of bland surface level idealism.

Drama and angst, so long associated with modernism and the avant-garde, have come to characterize the preferred style of twentieth-century folk art, as collectors abandoned more traditional forms and media—stoneware pottery and log-cabin quilts—to the folklorists.

The Corcoran venue itself said something quite different about contemporary folk art than could a show at the Museum of American Folk Art, the Indianapolis Children's Museum, or, in fact, even the Brooklyn Museum. The

Corcoran, located in Washington, D.C., has primarily showcased contemporary art, mounting such controversial work as Robert Mapplethorpe's erotic photographs; in such an exhibition space, folk art gained a cachet of daring. Furthermore, the 1982 Black Folk Art show was organized on a fine art model; rather than subordinating individual works to the aesthetic of a collector or to a set of organizational themes (religion, patriotism, and so on) as Hemphill's collection had typically been displayed, the Corcoran show presented twenty artists, stressing authorship over content. By adopting this elite model of artistic veneration, *Black Folk Art in America* simultaneously dignified the work of self-taught artists and spurred an artist-based approach to collecting.

The Hemphill and Hall collections, it should be remembered, included many anonymous pieces, and in the world of antiques from which their aesthetics and early buying habits were derived, authorship weighed less heavily in appraising a work than age and provenance. The emphasis on identifiable artists, set forward in the Corcoran show, followed the contemporary fine art model instead and, in the process, simplified collecting. No longer obliged to consider the full spectrum of past and present handmade objects, collectors could follow a more limited and reliable collecting script. According to Ollman, after the Corcoran show, "people really began focusing on black American folk art or black American art. There were collectors who decided only to collect that. They had their Corcoran catalog and they knew exactly what they wanted."

The Corcoran show additionally stimulated increased field research and scholarship. Liza Kirwin of the Archives of American Art noted that the Washington exhibition drew her special interest because so many of the artists represented were elderly. Sensing that documentation of these artists was of urgency, Kirwin and the archive applied for and received a grant from the Luce Foundation in 1984, "to expand our mid-Atlantic collecting program to include the territory below the Mason-Dixon Line and east of the Mississippi River."[121] Such efforts at documentation signal that the definition of American folk art had expanded both temporally and spatially. Collectors would extend their attention into the twentieth century and beyond Pennsylvania and the New England states. Combined with the Halls' and Kind's previous efforts in the Midwest, the Corcoran show secured a new conception of folk art, as a nationwide and enduring phenomenon.

Folk art authorship, in its more traditional guise, was also publicized through the National Heritage Fellowship awards, sponsored by the National Endowment for the Arts Folk Arts Program.[122] Begun in 1982, this program annually recognizes "American folk masters" of the traditional arts—lace makers and fiddlers—with honoraria of five thousand dollars. Alan Jabbour,

director of the Library of Congress American Folklife Center, explained that
the heritage awards were designed to celebrate folk art practices as much as
or more than individual practitioners: "The honor isn't just honoring the in-
dividual, it's honoring the art, which in turn encourages more people to think
of it as an art worth pursuing. You might say, hopefully, it's a marketing strat-
egy not a reward strategy. It's not betting on horses, it's encouraging horse
racing." For the most part, works by those named American Folk Art Masters
are too "folky" for the collectors of self-taught art, and pieces by "outsider"
artists are too idiosyncratic for the folklorists, yet at least two National Her-
itage Fellows, carvers Elijah Pierce and George López, are also among the
most sought after artists in the twentieth-century folk art marketplace. On the
wall of his office at the Library of Congress, folklorist Jabbour displays a
painting by noted "outsider" Howard Finster entitled *The Hidden Man of the
Heart*. These are not coincidences but further evidence that, rather than re-
straining folk art, the excited opposition of folklorists and connoisseurs,
avant-gardists and traditionalists has in fact generated and galvanized this
field of art.

The realities of cultural life are such that "adversaries whom one would
prefer to destroy . . . cannot be combated without consecrating them."[123]
Thus, the bridling of academic folklorists against commercial dealers and
connoisseurs has only raised the stakes in the discussion and, concomitantly,
the prices at market. Folklorist John Burrison conceded, "The market doesn't
really develop until there's information out there, usually. And I guess that's
where people like me come in. We've contributed to that market whether we
like it or not."[124]

Suzanne Seriff has discerned the competing discourses of elite art patrons
and folklorists. For the discovering collector an object of folk art "takes on the
highly romantic character of a cultural goldmine whose riches lay in wait for
the keen eye of the visionary art explorer/patron."[125] Alternatively, the folk-
lorist "is slated to textually record, and thereby redeem, the folk master's tal-
ent for mediating the destructive history to which he and his art seem in-
evitably to be fated."[126] Despite their differing concentrations—on aesthetic
discovery and "textual salvation" respectively—each of these approaches be-
lies a form of cultural domination: "Although motivated by different values
and interests, dealers, collectors, and scholars are symbiotically interdepen-
dent, sharing an overlapping socioeconomic niche in which they cooperate
and compete for control of both the processes and the products of native aes-
thetic culture."[127]

Lest Tolson seem merely the prey of all this activity, it should be remem-
bered that he was both cognizant of and enthusiastic about the burgeoning
folk art world. Granted, Tolson was not familiar with the fine art historical

canon. He may not have fathomed the entire rationale behind Michael Hall's advocacy, but to conclude he knew nothing of the folk art field would be mistaken. Tolson received letters of adulation and encouragement from 1967, beginning with Smithsonian official Carl Fox's suggestion of a one-man show, until his death. Tolson asserted, "I know I've got a lot of work scattered all over the world and I get a lot of letters from people and I meet quite a lot of people from different countries, from Canada and England and India. I don't know how many different nations has come to visit me and has had my work or wanted to buy some of it."[128] During the summer months especially, vacationers would travel to Campton in the hope of buying woodcarvings, and Tolson seems to have enjoyed these visits enormously, taking quite seriously the task of pleasing his company. He told Hall, "What discourages me here now, Mike, I never have a piece to set back for myself. And then somebody come in, 'I'd like to see some of your work.' Well, there you are. You're down and out. Well, it absolutely takes something out of you, Mike, to think that you can't show nobody your work."[129] Interviewed for the Archives of American Art in 1981, Tolson declared, "I like people. And I like to do something to please them. And that's always been my goal and I hope it always will be. . . . That's one reason I guess I do it. I know people likes it and I want them to have it. And they're something that makes me known and I'll please somebody some way. And that's why I do as much as I do do."[130]

Tolson also understood the panoply of roles he was expected to enact and ordinarily fulfilled his visitors' expectations, whether for a crusty mountaineer or an uninhibited primitive. "They'll holler, some of them, I'm famous. I'd say, 'Hell no, I'm not. I'm just an old hillbilly raised back here,'" he told friends from Lexington.[131] Yet with other visitors, notably Hall and the other young male artists who came frequently to see him, Tolson wore another face. He described for Hall "the best piece I ever made . . . It was a woman, Eve was at the tree here and there was an old snag here and she was bent over and holding two limbs and Adam was pokin' it to her behind. And there was a snake down under her coiled up over this limb here and had her by the tit" (Plate 9).[132] Tolson said, "I've had a hundred calls for that damn piece," adding that he'd suggested to one buyer, "Son, that'll be a teaser for you. Just set it in front of your bed."[133]

Tolson actively supported the Halls' promotional efforts. He attended the 1972 exhibition they arranged at Gertrude Kasle Gallery in Detroit and was interviewed by two city newspapers at the time. "I went to Louisville twice," he recounted in 1980; "I've had two shows down there now."[134] Tolson was also aware that a gallery scene had developed during the 1970s: "There's been five or six shows in New York, Chicago. Phyllis Kind, she's got a gallery now in New York. She wrote me a letter and wanted to buy a lot of my work."[135]

Moreover, the woodcarver recognized the impact of writings about him and kept track of published references to his art: "I've got five books wrote on me now," he said in 1980. "Bert Hemphill wrote one in New York. Bob Bishop wrote one in Michigan; he's in New York now. And Mary [Elinor] Horwitz wrote one on me." He acknowledged that these publications had introduced him to a far wider audience of potential collectors: "They buy a lot of them books and they get scattered out and they come to see me about buying some of my work."[136] When Skip Taylor in 1979 asked the carver how people became aware of his sculptures, Tolson credited Hemphill's book. "It's went all over the world. . . . They get that, select a piece or find out I'm a woodcarver, then write me whether I can carve so and so, you know. And that's the way I get my orders." Asked how many years he had been taking orders like that, Tolson replied, "About five years"[137] — in other words, since 1974, the year that authors Hemphill and Weissman, Bishop, and Horwitz all published books featuring him and his woodcarvings.

Tolson's cooperation was, of course, crucial in building his reputation. Had he failed to meet either the expectations or demands of the collectors and authors who sought him out—refusing to carve Adam and Eve for the Tuskas, evading New York visitor Herbert Hemphill, passing up the opportunity to attend the Smithsonian folklife festival, shunning Rick Bell's camera lens and Hall's field recorder, rejecting orders for carvings, turning newspaper reporters away—Tolson would not have developed anything like the renown he ultimately achieved. Once the field of contemporary folk art was established, antisocial artists might stand a stronger chance at success, at least in the marketplace; isolation, irascibility, even criminality, autism, and mental illness have, in fact, been deployed by dealers to warrant authenticity, emotional power, and visionary genius. Yet throughout the 1970s, Tolson's intelligence and personal complexity along with his willingness to please made him a perfect subject for the many camps then vying to claim folk art. The motivation for his compliance is uncertain. Obviously, he cooperated "for necessity," to make money. He may also have been driven by vanity, a wish to satisfy and thus maintain the adoring attention of strangers. But Tolson too found comfort in carving itself; he described his work as therapy: "It clears my mind, and when I feel bad I have a thing to take my mind. That's one of the reasons I keep with it."[138]

A flair for the dramatic and personal gregariousness, as well as his manual and visual talents, contributed enormously to Tolson's success, but beyond these gifts, Tolson possessed a canny understanding of the collecting urge and the fascination he held for visitors. Rather than being "created by the field," as Bourdieu claims Henri Rousseau developed, Tolson took a strong, if subtle, role in creating the contemporary folk art world.[139] Like any savvy art-

ist, he paired this knowledge with his own ambitions, ambitions he had pursued in early carvings, the walking canes he publicly presented to political candidates, pieces he gave to the local banker and doctor, works he donated to the new Wolfe County Library knowing they would be set on public display. As Tolson said, "They're something that makes me known."[140]

Two episodes in particular indicate Tolson's resistance to the idea that he had been—or even could be—entirely defined by others; both examples concern, not surprisingly, the figure of Michael Hall, who had been Tolson's greatest champion but who also, as Tolson understood, gained the most from a near monopoly as his spokesperson, dealer, and interpreter. In 1980, an interviewer asked Tolson, "How did you meet Mike?" "He met *me*!" Tolson retorted, proceeding to explain how, though the Tuskas had guarded his identity, Hall persisted searching and ultimately located him.[141] According to Tolson's account, he had not sought a patron but been tirelessly pursued by the young art professor.

Even more vividly, in a 1976 interview liberally cited in his essay "You Make It with Your Mind," Hall drew the woodcarver into an interpretation of *The Fall of Man*. Hall wrote: "Here I interrupted him to tell him that at least this audience of one had thought about [the work]; to tell him that I did grasp the broader historic and symbolic implications in the piece. He brushed my comment aside with a gesture of impatience and frustration. He shook his head. 'No—you don't know that. It's about the whole thing. There ain't many fellers what's *done* that.'"[142]

In this rebuke one senses Tolson's annoyance and, crucially, his unwillingness to be constituted entirely through any interpreter, validated through any source other than his own accomplishment. Such an observation is not meant to deny that Hall's many efforts made Tolson a more credible artist, for, of course, they clearly did; by portraying Tolson as headstrong and independent in this very encounter, Hall added to that long-standing, legitimating argument. But Tolson was neither ignorant of Hall's status as a "symbolic banker" nor content with the huge discrepancy between his own prestige and the prestige that Hall, as a literate, urbane, middle-class sculptor and art professor, was able to invest in him.[143] Here, the carver seems to bristle at this knowledge, and in an effort to save face, rather than clarifying yet another interpretation of *The Fall of Man*, which Hall in turn might add to his own rhetorical arsenal, Tolson denies him, withdrawing into his own grandiose and cryptic claim: "It's about the whole thing."

Through the 1970s, few folk artists considered their work a full-time livelihood. Many, like Tolson, sustained themselves on government assistance checks rather than proceeds from art sales. Others, like bicycle repairman Howard Finster or barber Elijah Pierce, were tradespeople who did not pri-

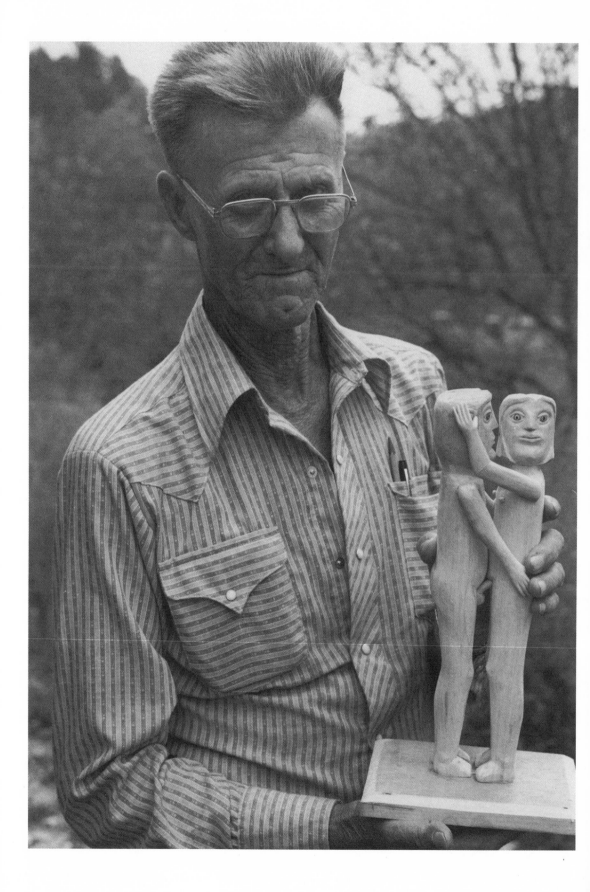

marily depend on an income from art. Since the audience for their work was still inconsiderable, prices low, and sales erratic, such dependence would not have been possible anyway. In New Mexico, where a market for wooden santos carvings had been established as early as the 1920s, a few carvers had made a living off their art, but here also only the surge of popularity for folk art during the 1970s made it possible for carvers to become full-time, working artists. One of them was Savinita Ortiz, niece of George López and granddaughter of José Dolores López. For twelve years Ortiz carved part-time and commuted from her home in Córdova to nearby Los Alamos to work as a housekeeper. "And one day I was thinking and I said, 'Well, I think I better quit my job here in Los Alamos and go full time carving,' 'cause I knew how. My dad, my uncle had taught me how." This was 1977.

During the 1980s as the field of folk art expanded, with increasing documentation and commerce, it also became professionalized. For-profit galleries and folk art journals became feasible and viable. Prices thrust upward as large-scale museum exhibitions (particularly "The Flowering of American Folk Art" and "Black Folk Art in America") spun off tremendous national publicity and metropolitan auction houses incorporated contemporary folk art into their yearly schedules of sales. These changes both indicated and girded a newly stable folk art economy. In the 1970s Hemphill supported his folk art collecting habit primarily through an inheritance. The Halls relied on Michael's salary as an art professor, though both Hemphill and the Halls sold folk art also. In the 1980s, however, it became possible to make a living as a folk art dealer, as many pickers and gallery owners have proven.

By the mid-1990s three folk art encyclopedias had been published, by George Meyer, Chuck and Jan Rosenak, and Betty-Carol Sellen. These sources have functioned and will continue to serve as collecting guides and stimuli, as did the Lipman, Hemphill and Weissman, and Livingston and Beardsley books in preceding decades. Through the 1980s, Sotheby's auction house began receiving stray twentieth-century folk art pieces within larger collections of Americana and earlier folk art. By 1993 Nancy Druckman of Sotheby's acknowledged a solid following for contemporary folk art and, beginning with the dispersal of the Bishop collection in 1990, set aside a portion of the January Americana sale specifically for twentieth-century self-taught artists' work. A hungry and expanding population of collectors has strengthened the resolve of many hobbyists and, for some, made art a reliable livelihood. Such self-conscious careers raise problems, however, in a field where naïveté and self-effacement have been identifying hallmarks.

With the establishment of a folk art field has also come an increasing, though by no means thorough, division of labor. Whereas in the 1970s dealers routinely wrote catalog essays touting the artists whose works they had

Edgar Tolson with his carving Original Sin, 1973. (Photograph, Ellsworth Taylor)

Herbert W. Hemphill Jr. (foreground) received accolades in September 1990 at the National Museum of American Art, Washington, D.C. The museum acquired more than four hundred pieces from Hemphill's collection. In attendance were (left to right) Michael and Julie Hall, David Davies, Jack Weeden, and Marshall Hemphill. (Courtesy of Antiques and the Arts Weekly, Newtown, Conn.)

for sale and collectors, like Hemphill, authored picture books featuring their own possessions, some current periodicals, for example *Folk Art Messenger*, have adopted editorial policies prohibiting dealers from authoring articles. Michael Hall became more active as a critic, stepping back from his activities as a dealer in folk art into a more disinterested and intellectual pose. Of course, as he and Julie Hall sold their collection to the Milwaukee Art Museum in 1989, it became clear that this more critical endeavor had likewise served him well. Hall himself said, "There is now much more a hegemony in folk art. The collector community is much more conscious of power, the wielding of power, the gathering of power, and the use of power, much more so now than in 1970."

In 1984 twenty-five universities offered courses in folk art; at least one more, the School of the Art Institute of Chicago, has added a class in folk and outsider art since that time.[144] By developing a presence within academia, folk

art, like opera and dance before it, improves its cultural status and simultaneously engages the interest of the young.[145] Only the education system, Bourdieu wrote, can turn a work of art into a "classic" with an appropriately "durable market."[146] Furthermore, increasing numbers of fine art museums are mounting folk art shows and purchasing nonacademic contemporary work.[147] Edgar Tolson's woodcarvings alone have been donated to or purchased by five fine art museums and seven other institutions of folk or decorative arts. Once a rather random assortment of fugitive objects, folk art and its Caliban-like cousin, outsider art, have gained admission to both educational and museum institutions.

Their identity and meaning within these institutions, as every living cultural legacy, remain subject to debate. Is an Edgar Tolson carving primarily an aesthetic object discerned by a great collector's eye, the work of a creative genius, a "folk survival" of centuries-old craft traditions, tourist art made to order, an expression of Appalachian Protestant faith, or a veiled commentary on the modern condition? As Bourdieu's examination of the cultural field suggests, persistent tensions among these various readings, indicative of many sustained "position-takings," do not cast doubt on the worth of Tolson's work but rather maintain its value.

In 1976 *Artforum*'s critic Amy Goldin, amazed by the "Folk Sculpture U.S.A." show, wrote that folk art "challenges the process of legitimization itself," owing to its "equivocal relationship to normally accredited art."[148] Twenty years later, folk art has in fact been legitimated through all the most conventional means: scholarly analysis, formal exegesis, gallery shows (often alongside the work of university-trained artists), museum exhibitions and purchases, diffusion through art magazines, public auction, government fellowships, critical acclaim, and the nomination of selected artists to "classic" status. Consequently, some commentators have advocated that the distinction between folk/outsider art and fine art be abandoned.[149] Enshrined in established museums, contemporary folk and outsider art has, it seems, become part of "the neutral history of art."[150]

Simultaneously, disputation, the struggle among positions that first constituted the field, has become predictable. At folk art symposia, now somewhat commonplace, the "usual suspects" are rounded up from various corners of the folk art world. For example, at the conference that marked Milwaukee's installation of the Hall Folk Art Collection, John Vlach was called upon to deliver his fundamentalist folklore sermon, Lynda Hartigan brought art history's polish, Ames rolled in the now-not-too-sneaky Trojan Horse, and as a special treat archconnoisseur Hilton Kramer was on hand to add a snide but bracing flash of political incorrectness: the pear-shaped vow-

els of embattled Greenbergian aesthetics. Some participants were duly enraged, but that too was theatrical, part of the swordplay that makes a conference memorable. After a spell of escalating tensions and prices, roughly a ten-year span from 1975 to 1985, the struggle that made contemporary folk art a high-stakes field in U.S. culture has become decorous, a consensual fight among old collaborators.

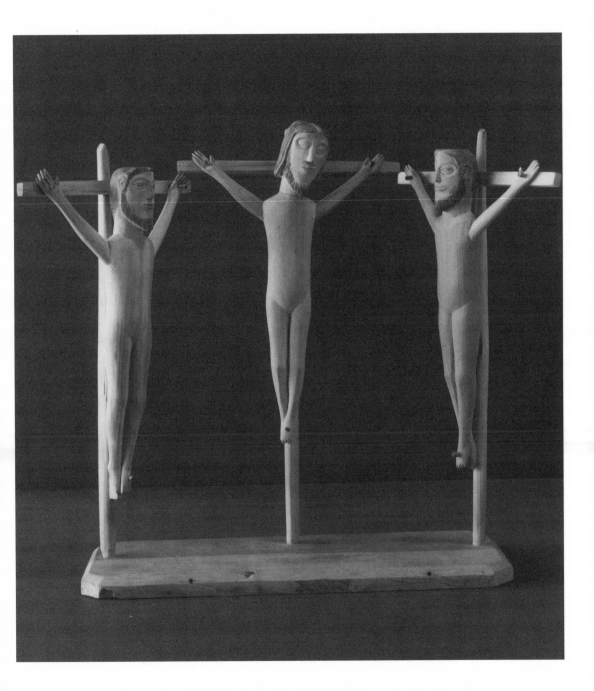

 ecause folk art is not factual but cultural, its understanding requires more than an objectifying lens or sociological analysis can provide. Textual and photographic renderings of folk artists, their works, a marketplace, and the settling of objects into legitimating fortresses—American universities and museums—are only the crude, most measurable aspects of symbolic life. Cultural understanding always requires broaching shadowy, less accessible precincts, those of emotion and human subjectivity, for it is here one glimpses the distinguishing integrative feature of culture itself. As Georg Simmel, writing in the first decade of this century, explained, neither religious nor material life is cultural, for the one realizes value only within the self, the other only through exteriorization. Culture, instead, demands we draw into our development something beyond ourselves, when "the perfection of the individual is routed through real and ideal spheres outside of the self."[1]

The life story of Edgar Tolson reveals this cultural capacity of twentieth-century folk art—the power, in Simmel's words, to bear human subjects "to their next higher station." Woodcarving permitted Tolson to mediate penury and self-possession, to resolve Christian fundamentalism—his legacy—and the desires that shaped a more profane actuality. Through illustrating the Bible stories familiar to him since youth, Tolson was able to reanimate a childhood faith and confess the temptations that had diverted him from a religious calling. He carved preachers only after he "got too rotten" to preach; he whittled men in overalls when infirmity forced him off the farm.

Overleaf:
Crucifixion,
1973. Collection
of Ellsworth
and Ann Taylor.
(Photograph,
University of
Kentucky Art
Museum)

This is not to call his woodcarvings merely compensatory. Rather, they permitted Tolson to enact who he was, who he hoped to be, in keeping with the experiences that confronted and changed him. To use Simmel's terms, Tolson was able to cultivate himself through external objects, his canes and dolls, creating in and through them a sustaining adjustment to circumstance. "It helps me forget my sickness," he explained to Skip Taylor. "Now just setting around and doing nothing, you get wore out. [If] you've got something to occupy your mind, why, it's not so bad."[2] Retiring to his trailer-studio, Tol-

son could also flee the clamor of his large family, drink in private, and labor over a miniature world subject to his full control. Michael Hall asked Tolson how making art affected him. "Does it take anything out of you?" Hall asked. "No, it puts something in me," Tolson replied, "puts it more real. Makes me more of a believer than I was. 'Cause I know it happened, 'cause I've read it. Now I've made it and so I couldn't have any doubts, Mike."[3]

The college students and other visitors who gathered at Tolson's home during the 1970s were wrestling with doubts of their own. Raised in a period of unprecedented affluence, in an educational milieu that stressed the arts and culture, these young people had met with "collective disillusionment," what Bourdieu has described as a "structural mismatch between aspirations and real probabilities, between the social identity the school system seems to promise, or the one it offers on a temporary basis, and the social identity that the labor market in fact offers."[4] For the young men and women who became its advocates, folk art suggested a mysterious, liberating alternative to the too real probabilities in view—the military, academia, the professions, or unemployment. In championing Tolson and his dolls, they developed a vague but preferable version of the future.

Approached now not through its objective fortunes but its emotional freight, what were the promises folk art extended?

For many admirers, folk art represented freedom and the impunity of childhood, connotations with special poignancy for people of college age. Kuspit noted this nostalgic dimension of its appeal, calling the folk object "a species of toy." He used Tolson's "whittlings" explicitly to illustrate folk art's "quickly thrown-together look . . . , at once the sign of its childish soulfulness and the trivial things that are its objects and that it renews."[5] In contrast with the intellectual reserve of much fine art and the special knowledge required to crack its code, folk art, through formal simplicity and, in some cases, awkwardness, seemed an invitation to reanimate the world through irrational and spontaneous play.

Art historian Kenneth Ames, a critic of this sunny, uncomplicated view of folk art, has studied how often folk art objects express vulnerability and, in so doing, arouse the viewer's sense of mastery. Ames has alluded to the abundance of animal images in folk art, writing that they "provide an outlet for tender feelings that the tensions and complexities of human life repress or thwart."[6] Tolson, it should be remembered, carved scores of animal figures: yoked oxen that memorialized logging and premechanized farming, as well as barnyard animals and local wildlife—woodpeckers, squirrels, owls. He produced more exotic carved creatures also, alligators, kangaroos, elephants, giraffes, incorporating many into biblical tableaux. Still other animal figures were commissioned: the dove, first requested by Rick Bell, the unicorn Mari-

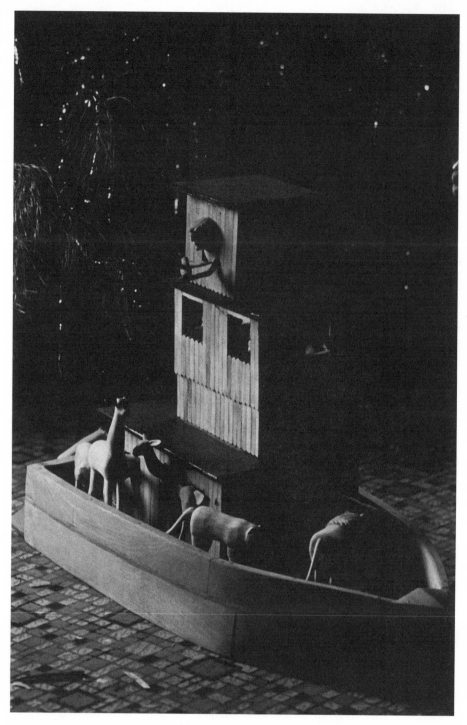

Noah's Ark under the Tolsons' Christmas tree, 1969. (Photograph, Rick Bell)

an Broadus asked him to carve, and portraits of the Halls' pet dog Winston. These latter pieces offered patrons physical, formal, and social control over handmade miniature animals and the craftsman who could be urged to produce them. Susan Stewart, in her discussion of the miniature, likewise contends that such objects cultivate fantasies of utter safety and control: "The miniature, linked to nostalgic versions of childhood and history, presents a diminutive, and thereby manipulable, version of experience, a version which is domesticated and protected from contamination."[7] Pieces like Tolson's *Paradise* and *Noah's Ark* offer evidence redoubled. The original couple stand in prelapsarian happiness, surrounded by a benign menagerie; wild animals cluster together, while above them Noah holds the beneficent dove.[8]

Tolson's unicorn is a similar image. First requested by Marian Broadus, then revised and refined by the artist, this subject became one of his most popular. "The unicorn has a special kind of symbolic feeling for people," Broadus said, describing her own fascination for the mythical beast, "kind of captured innocence that now is lost." In later versions of the theme Tolson, in fact, worked up this aspect of the animal's captivity, based on the Cloisters tapestry, with a fence made of popsicle sticks, a leather collar and chain tethering the beast to a tree. Yet it is not the unicorn only that symbolizes a version of experience "protected from contamination." Author Elinor Horwitz transferred this sense of guardedness and purity to the artist himself: "I loved when he said he wasn't really quite sure whether there were unicorns," Horwitz remarked. "And I said I wasn't either. I mean, you know, it seemed such a nice idea, to have unicorns." Guy Mendes remembered Tolson's saying of the unicorn, "'You know, I'd really like to see one some day, but I think they keep 'em all over there in Europe.' And I said, like, 'Mm, that's probably it, Edgar.' I didn't want to say, 'Oh no, Edgar. There's no such thing.' I thought his naïveté there was really beautiful." While Broadus, Mendes, and Horwitz might no longer have been able to believe in unicorns themselves, they were convinced and consoled by Tolson's belief. The unicorn carving suggested the persistence of wonder and magic, if at one remove.

Michael Hall opposed Broadus's commissioning the unicorn, arguing that the request itself amounted to a form of contamination. Broadus said Hall came to her after learning she had proposed the subject to Tolson: "He asked me not to ask Edgar to do anything—to let Edgar produce and then buy them if I wanted them but not to ask him to carve something." According to Broadus, "I said, 'I don't know what you're talking about, Michael Hall.' And he said, 'It's a very delicate balance. And it could upset his way of doing things.'" Hall's effort to screen Tolson's themes, to stand between him and other collectors, also constituted a form of protection. Each of these responses—requesting the unicorn, enjoying Tolson's "nice idea" that the fabulous animals

existed, and shielding the carver from the taste and experience of his pa-
trons — belied a sense that the woodcarver possessed not just a valuable skill
or talent but also a precious state of being, endangered in its difference from
the patrons' own.

Eugene Metcalf, examining the motives and function of folk art collecting,
wrote that folk art objects "preserve and make available to modern society a
residue of bygone, yet treasured cultural meanings which Americans feared
they had lost forever."[9] Like the revival of the unicorn, the collecting of folk art
in part represents a desire to resuscitate the past and palliate fear of change.
While Stewart has emphasized the longing for childhood's irresponsibility
and safety through the miniature and Kuspit the magical intensity, the ani-
mating power of the child's fixation on the toy, Metcalf has viewed folk art as
an emblem of loss and hope on a national scale. Among the beloved cultural
meanings folk art embodies, Metcalf has included "individuality, democracy,
and the virtues and values of handcraftsmanship and agrarian society — ideals
which were . . . fundamentally challenged by the reality of modern American
experience."[10]

Functioning most overtly in this way is an entire category of folk creations
typically referred to as "memory art,"[11] a phrase customarily applied to the
pastoral paintings of Anna "Grandma" Moses, the domestic scenes of Horace
Pippen and works like them, as well as Tolson's own wooden farmers and
oxen. The desire to awaken and sustain such memories appears widespread.
A Berkeley professor of political science, for example, wrote to Tolson in
1968, after reading Phil Casey's piece in the *Washington Post*, "I grew up on a
farm myself and would love to have a carving of a cow."[12] The same rural im-
ages were enormously popular in Wolfe County also.[13]

In the late 1960s, especially among the collegiate crowd who became Tol-
son's early supporters, patriotism had been deeply shadowed. The civil rights
movement had jolted the nation's conscience, demanding a reassessment of
the American past and confrontation of the suppression and injustice that
had been veiled from most middle-class whites during the 1950s. Marian
Broadus said of the times, "The nation was riding on a sea of guilt." Many of
the students and young faculty at University of Kentucky, as elsewhere,
reached the limits of civic loyalty and rejected the Vietnam War. Prefiguring
these dilemmas was Paul Goodman's *Growing Up Absurd*, published in 1956.
"Patriotism is the culture of childhood and adolescence," Goodman wrote. It
creates "the chance of entering upon a great and honorable scene to develop
in." Of the mid-1950s, he contended, "For the first time in recorded history,
the mention of country, community, place has lost its power to animate. . . .
Our rejection of false patriotism is, of course, itself a badge of honor, but the
positive loss is tragic and I cannot resign myself to it."[14]

Folk art assuaged that loss. Its abundance of flags, eagles, and presidential portraits suggests a refusal entirely to resign from belief in national virtue. Herbert W. Hemphill Jr.'s first gift to the Museum of American Folk Art, establishing its permanent collection, was the nineteenth-century *Flag Gate* from the Darling Farm in Jefferson County, New York. Prior to the nation's Bicentennial, which itself stimulated scores more patriotic works, Elinor Horwitz compiled and published a book of these images in folk art, *The Bird, the Banner, and Uncle Sam*, including Tolson's carving.[15]

Photographer Rick Bell had suggested the image of Uncle Sam to Tolson in the fall of 1970. "One day I took Edgar into Campton to the post office to pick up his check, his welfare check, and there was an 'I Want You' poster," Bell related. "I said, 'Ed, you ought to carve one of these.' I said, 'Uncle Sam's great.' . . . And the next time I saw him he had three of them."[16] As with John Tuska's request for Adam and Eve, Bell proposed a stock image from the folk art repertoire, conventionally conceived. Asked why he requested this particular subject, Bell answered, "It's just such an American icon" and "the kind of art that Hall was doing, this Americana. I was going to his house and seeing these great flag pieces and it just seemed consistent."[17] In this instance, as with the *Temptation*, one sees Tolson in training, complying with a request for "folk art."

Bell wrote to Hall once Tolson completed the carving: "There is a great story of irony in that piece. He got the idea for it when I took him to the Post Office to pick up his relief check. Fantastic."[18] To produce an image of patriotic duty while living off the government dole suggested a contradiction to the young photographer, yet a further and keener irony may be found in Bell's own initiating request. At this very time he was negotiating alternative service as a conscientious objector to the Vietnam War. Bell had been granted the CO without much delay by the same West End Louisville draft board that heard the cases of Appalachian Volunteer Joe Mulloy and, more notably, Cassius Clay, soon to be known worldwide as Muhammad Ali. "I've never considered opposition to the war as being anti-American," Bell said. "I always thought it was motivated very powerfully by disappointment by what America was doing."[19]

Bell's actions—taking note of the induction poster, suggesting Uncle Sam as a theme to Tolson, and then acquiring this woodcarving for his home— confirm Goodman's assertion that young people especially long for the "first culture" of patriotism. His response likewise accords with Metcalf's argument, that folk art collecting professes belief in tradition and value—here, a national ideology of strength and duty—when that same ideology has become least tenable. Tolson's *Uncle Sam* provided Bell, and subsequently many others, with a way to voice their own patriotic urges, to redeem their sense of loyalty even as they opposed the reigning political administration. Marian

Broadus, another outspoken opponent of the war, purchased an *Uncle Sam* for her draft-age son as a Christmas present and a second such carving as a wedding present for two young friends. She remembered taking a photograph of one of these carvings and picturing Uncle Sam as imprisoned. "It was in this time of real injustice," she said. "And I put him behind a wire fence to look like he was a captive."

Metcalf has written that not only its overtly national emblems but all folk art has been assumed to represent American values;[20] and, in fact, collectors have voiced such an understanding of folk art. Dorothy Rabkin, who immigrated to the United States from Germany after World War II, said most of the pieces in her collection "have been carved by people who came to this country, as I did, in search of freedom and a life without bondage." She added, "These folk carvings represent America which accepted me as a Displaced Person."[21] New Mexico collector Chuck Rosenak referred specifically to Tolson in this regard: "Edgar Tolson was a truly American phenomenon and I was an American. I was Jewish. My father, my grandmother came from Austria. Jan's from Ireland. But by the time we were grown and educated, we really were Americans. We weren't European. And so in finding out about ourselves and of our history and life here in America, it was important for us to find out a little bit about America."[22] Like Simon and Garfunkel's wanderers of song, "all gone to look for America," and summer vacationers out to "See America First," the Rosenaks undertook the work of "finding out about ourselves" by traveling across what they have called "dirt track America" and acquiring an enormous collection of painting and sculpture.[23]

Along with its capacity to evoke a personal and a national past, folk art has exemplified safety, congruity, and wholeness. Julie Hall, describing what drew them to Wolfe County, explained, "[Michael and I] were interested in the folk, natural man, whatever, the primitive. Now that sounds corny but at the time it seemed really that somehow there was a reality there. There was a one-to-one relationship with life that was something to be interested in and learn about." This dream of a "one-to-one relationship with life," immediate and given, suggests the existence of an alternative to the hypermediated, dubious condition of modernity.[24] Dean MacCannell, investigating this aspect of contemporary life in his work *The Tourist*, argued that the multiple and multiplying differentiations of modern existence stimulate longing for totality; anxiously unsettled in their own lives, those with the leisure modernity provides embark on searches for authenticity as sightseers, amalgamating the lives of others through touristic episodes into a new photo-album-like identity. "Sightseeing," MacCannell wrote, "is a kind of collective striving for a transcendence of the modern totality, a way of attempting to overcome the discontinuity of modernity, of incorporating its fragments into a unified ex-

perience."[25] Unmoored from traditional "attachments to the work bench, the neighborhood, the town, the family," tourists are simultaneously "developing an interest in the 'real life' of others."[26]

Folk art is enjoined in this search, in fact, becomes its perfect object, a relic of those very bonds that modernity has severed. It possesses "reality" in large measure through its reference to "tradition," whether real or invented. Tolson's blacksmiths and miners, his oxen and biblical tales in wood all bespeak such traditional attachments, the dignity of rural trades, devotion to a fundamentalist faith. According to MacCannell, "Tradition remains embedded in modernity but in a position of servitude: tradition is there to be recalled to satisfy nostalgic whims or to provide coloration or perhaps a sense of profundity for a modern theme."[27] Thus while Tolson's work owed as much to Dame Olive Campbell and the Brasstown carvers she trained to sell to tourists, to Doris Ulmann's sepia-toned photographs of the Ritchie sisters, and to John Tuska, who prompted a reenactment of Wilhelm Schimmel, as to anonymous chain whittlers and ax-handle makers of eastern Kentucky, his carvings have been *interpreted* as traditional. Herbert W. Hemphill Jr. said that upon encountering Tolson's work for the first time, "That's all I thought: this is a Kentucky mountain carver." Similarly, Rick Bell interpreted Tolson's biblical pieces not as compliance with a patron's request but as the manifestation of the carver's social context: "The story of Adam and Eve was so compelling, so obsessive with that group of people . . . and you could not talk long to Edgar . . . or any of those other people without the conversation coming around to Adam and Eve."[28] By dint of the many differences between folk art's buyers and makers—class, education, region, age, and ethnicity—the notion of folk art's traditionality could be sustained and its totalizing dimension admired from a comfortable distance.

Tolson's carvings, and the discourses that describe and re-create them in museum catalogs and newspaper stories, in fact exemplify each ideal on MacCannell's list of premodern "real life" bonds. The sculptures, according to the *Washington Post*, "all done with only his old pocketknife," signal his enduring attachment to "the work bench."[29] One admirer, comparing Edgar's carving with his son Donny's work, reaffirmed that the elder Tolson's pieces were more authentic: "Donny does a better job than the old man, but he cheats and he uses electrical tools. . . . The old man used an old whittling knife."[30] Despite the facts that Tolson did occasionally use power drills and other electric tools and that he was constantly purchasing new knives as he lost and wore out the blades of earlier ones, writers and commentators typically refer to his carving knife as singular and "old." Further ascribing a "work bench" ethos to Tolson are photographic close-ups of his wrinkled hands as they carve; such images appeared both in Horwitz's *Mountain People, Mountain Crafts*, and

Hemphill and Weissman's *Twentieth Century American Folk Art and Artists*. Finally, Tolson's brief biography, duplicated again and again in exhibition catalogs, recounts a litany of former occupations: "Tolson held a variety of jobs including chairmaker, carpenter, tombstone carver, coal miner, farmer, shoemaker and preacher."[31] Except for the reference to his lay preaching, this promotional résumé stresses his credentials as a craftsman of rather arcane trades, all of them jobs requiring physical strength or manual dexterity—his work bench credentials.

Representations of Tolson likewise typically emphasize his tie to a locale, what MacCannell abbreviates as "the neighborhood, the town," further vouching for his authenticity. The *Washington Post* story noted, "Tolson's home town is Campton, in east central Kentucky. 'Campton has about 600 or 700 people,' [Tolson] said, 'and I like most of them.' He must for he has seldom left home."[32] The sonorous word "home," which occurs twice in this passage, is used liberally. In fact, Tolson's birthplace was not Campton but Lee City, and as an adult, he moved his family nearly every year; he had also taken factory jobs in Ohio and Indiana. Yet here as in many other accounts, Tolson is portrayed as a man, if not happy, then at least resigned to small-town life. Unlike the peripatetic readers and collectors who find him intriguing, Tolson is anchored. His obituary in the *Lexington Herald-Leader* noted, "Despite the acclaim that Tolson received, he remained in Eastern Kentucky throughout his life and did not change his rural life style."[33]

In written accounts, the artist is always encountered at home, caught in the act of living "real life." Here, for example, is the opening of Mendes's "Found People" sketch:

> It's a warm afternoon in Campton, Kentucky, the worked-out seat of Wolfe County in the Appalachian hills, but up on the smooth concrete verandah at Edgar Tolson's place it is considerably cooler than it is across the street in front of the IGA store. Tolson sits in a tubular kitchen chair, smoking and fingering the brown chaw stains in the creases at the corners of his mouth. His wife, Hulda Mae, in tired gingham and kitchen apron, sits on the stoop. There is talk of relatives going on as a couple of visitors settle onto the edge of the porch.[34]

In an age of
manufactured
goods, folk art's
evidence of hand
craftsmanship
makes it a rarity.
Although Tolson
did occasionally
use power tools,
he was always
depicted as
working with
"his old
pocketknife."
(Photograph,
Rick Bell)

In this introductory passage, it is as if we readers had silently intruded. Tolson is fixed in space (Wolfe County, across from IGA store, in tubular chair, on the porch) and languorously goes about life, "found" by the undetected author. Apparent disregard, the carver unabashed about his "chaw stains," his wife too busy or "tired" to remove her "kitchen apron," authenticates the setting—neighborhood, town, home—a seedbed from which equally authentic art might sprout, likewise heedless of contaminating influences.

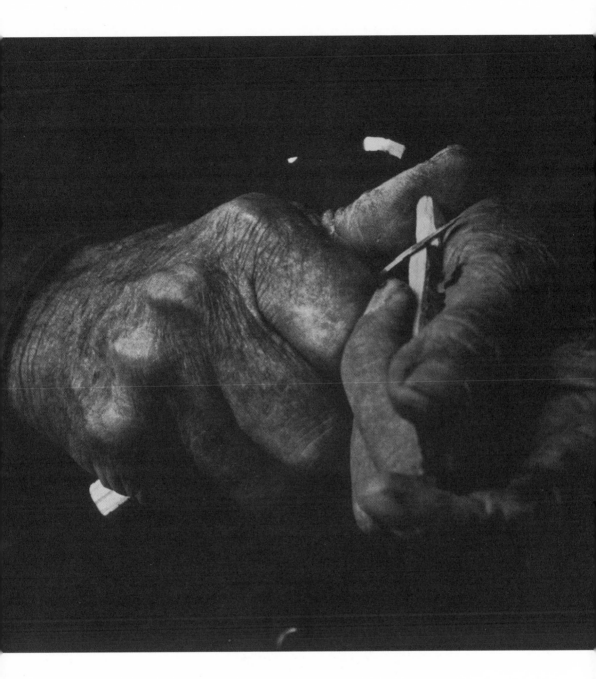

The primary device used to confirm this attachment to place has been photography. Gregg Blasdel in his provocative 1968 photo-essay "The Grass-Roots Artist" declared that folk art "cannot be separated from the circumstances of its creation."[35] Now that bits of Howard Finster's sprawling "Paradise Garden" and sculptural chunks of Eddie Owens Martin's "Pasaquam" may be purchased through art dealers, that David Butler's house in Patterson, Louisiana, has been stripped of its tin ornamentation by collectors, and that enthusiasts have bought up the pieces by Edgar Tolson that once

stood in the local library and Campton barber shop, it is clear Blasdel's re-mark was only wishful. Folk art has constantly been "separated from the circumstances of its creation"; in fact, photography itself has been the most forceful method for such separation, detaching not just folk art but *all* art, from its originating circumstances.[36] Though Blasdel might have been short-sighted about the future of the actual folk art sites and objects he admired, he rightly binds the social value of folk art to "the circumstances of its creation." Whereas the terms of fine art appreciation stem from aesthetics and the context of display, folk art's identity and valuation depend in large measure on the circumstances of its origination.

Photographers have developed a number of conventions to convey these circumstantial prerequisites, all of which picture the work or the artist, or both, in situ. Rick Bell's photographs of Tolson, with which the Hemphill and Weissman book opens, show the artist in an unidentified but patently rural scene (actually he is strolling away from the plank house in Holly that the family had abandoned more than a decade earlier). "I was most interested in the man in his environment, more than the man and his art or the process," Bell said.[37] "Folk art comes out of daily life. And I was much more interested in Edgar's daily life than him dressed up for an opening."[38]

Bell communicated a sense of Tolson's daily life in various ways: he pictured the carver among his children, standing in a Campton country store, and visiting the Wolfe County Library. Guy Mendes's photographs likewise have shown Tolson carving on his front porch, sitting on a worn-out couch, a weathered board wall behind him. Another, better-known Mendes photo posed the carver outside his tiny trailer, a prop that bespeaks rural life, domesticity, and poverty all at once.

To be of value in the touristic search MacCannell described, the folk artist must be viewed in "real life" rather than framed in a studio portrait or "dressed up for an opening." Photographic conventions for rendering authenticity typically involve images of both a rural and impoverished locality (trailer, tin roof, pickup truck) and the artist's physical indifference (dishevelment, toothlessness, eyes averted from the camera). An ideal portrait would show how the folk art object itself "comes out of daily life," and Bell was especially adept in this regard. In one photograph, included in both the 1970 solo show and the Museum of American Folk Art exhibition, Tolson sits on the ground painting one of his stone pieces, a building with a tin roof in the background. Behind him two boys sit and lean on the tailgate of a truck; one, his son Donny, grins and points into the face of the animal his father has made. Like Mendes's picture on the front porch, this image shows the folk art object coming into being in a rural setting, under the gaze of a stern, aged

man. What Bell's photo adds is the last nostalgic attachment in MacCannell's list of modern attractions: family.

The Tuskas read a familial theme into their favorite pieces, two figures Tolson produced for them in 1967 "that we call Mr. and Mrs. Tolson";[39] Tolson himself, however, never considered these pieces or any others, save the 1970 *Self-Portrait with Whittling Knife*, as renderings of specific people. Publicity about Tolson, whether in exhibition catalogs or news articles, nearly always took account of his many children, further evidence of Tolson's traditionality in a time of changing sexual mores, when birth control in the form of the pill had become widely available. By calling attention to Tolson's progeny, authors have further embedded him in an objective "circumstance," one that casts him as a real, obligated person rather than a weightless, leisured one.

Guy Mendes provided the most visceral such written portrait of Tolson, again using the woodcarver's paternity as metaphor for his creativity and authenticating burden.

One thing Tolson does recall is the recurring drunk dream in which his dolls come to life and march in to surround him, saying "You made me! You made me!" Hundreds of the small pale dolls with their blank expressions and wide unflinching eyes, flanked by 18 children and umpteen grandchildren, perhaps, with mess in their pants and dirt on their faces, all pointing their stubby little digits up at Tolson, confronting him with his deeds, "You made me! You made me!"[40]

Extrapolating from the story Tolson first related to Jack Lyne, Mendes turned the carver's artistic creativity into a Faustian curse. To Mendes, Lyne, and the other middle-class college boys who had come to know Tolson, his situation must have indeed seemed exotic and somewhat horrifying in its responsibilities, yet it was these same familial burdens, these "attachments," that qualified Tolson as a folk art attraction.

In her analysis of Texas-Mexican folk art's commercialization during the 1980s, Suzanne Seriff described how the search for authenticity has been extended: from the fetishizing of folk art objects to the fetishizing of the people who make them. "We are not talking here about an essentially antiquarian search for souvenir objects from our collective, yet anonymous past," she contended. The folk art quest seeks instead "the successfully intimate interaction in the present—that one-on-one, face-to-face encounter with the non-alienated individual"—the folk artist.[41] "The artifact is no longer treasured as an end in itself," according to Seriff, "but merely as a clue to the true object of desire, the designing artist."[42]

Rick Bell expressed this very desire as he described his enduring search for folk art, an interest he developed after meeting Tolson in 1969. "I think I would not enjoy it nearly as much if I only saw their products," Bell explained.

> It's knowing them. It's getting to know these people who work so out of the mainstream of conventional art. You just got back from Santa Fe. That world of the Santa Fe dealer, the Santa Fe artist, holds no interest to me at all. The world of the reservation trader and the naive folk artist really just fascinated me. It's what I enjoy most. That's why people always find it odd when I say I admire Gallup, New Mexico, far more than I can ever respect Canyon Road in Santa Fe. It just seems completely artificial to me, only propped up by trust funds, when in Gallup it's literally the trade. Twenty pounds of wool is worth this much, a bracelet you have made. It's real. It's real give and take.[43]

Bell's search for the real among artisans and traders of New Mexico, among the elderly men of Appalachia, mirrors the work of MacCannell's tourist, who seeks in the day-to-day activities of others a longed-for vividness and psychic weight. Likewise, Bell specified that the ultimate object of his quest is not a folk artifact but a "true" artist: "Immediately I just thought the world of Edgar Tolson, one of the real true characters I've ever met in my life."[44]

Art historian T. J. Clark, in his sociocultural study of nineteenth-century painting, revealed how fixation on character served the early modernists well. In his first two decades of painting, Edgar Degas explored the street life, shops, and entertainments of contemporary Paris, convinced that modernity might be communicable in the figures of rotund musicians and sallow

drinkers of absinthe.[45] The sense that one's interior life was written in the alphabet of clothing, expression, gesture, and circumstance both justified an aesthetic attitude toward life and anchored public identities. Yet in the late nineteenth century, these very clues became blurred and unreliable: new forms of entertainment "generalized the uncertainty of class" as fashion became distributed and available on a mass scale.[46] Painters like Édouard Manet mined such ambiguities with portraits of increasing detachment. A new psychic response, both highly aesthetic and blasé, grew to characterize the avant-garde in particular and modern society as a whole. "The great fact of bourgeois society," Clark wrote, is that "the inside cannot be read from the outside." With the ascendancy of popular culture and fashion, the "previous pictorial concept of the psyche," the "notion of the self as something acted out, in familiar contexts and informing roles," was no longer reliable.[47]

The incipient processes Clark tracked through mid-nineteenth-century France were, of course, full blooming and profuse in the 1970s, the force of popular culture having wound its way into all cultural institutions, even such fortresses as the church, the university, the museum. In this context, folk art offered a critique of popular culture, a means to allay the queasiness class un-

Rick Bell, photographer and former University of Kentucky student, visited Tolson in 1971, working with journalist David Holwerk on a feature story about the woodcarver. (Photograph, David Holwerk)

certainties had induced.[48] What for Degas had been "a nostalgia for times when identities had been stamped on a man's skin" was revivified in the search for folk art.[49] In a nation where the role of artist had become both increasingly sought after and normalized yet where the prospects of middle-class youngsters appeared to have diminished, class ambiguities grew only more irritable. Under these conditions, a figure like Edgar Tolson proved profoundly satisfying as a readable character. His toothless mouth, Appalachian drawl, stained t-shirt sufficed in the old way, as identity "stamped on the skin." Likewise his simple, unpainted poplar carvings with their overtly narrative themes suggested a "one-to-one relationship" between artist and art object, what Michael Hall termed a "one man, one pocket knife statement," without the slippery ironies of an Andy Warhol silk screen, the reticence and detachment of minimalist sculpture, or the cerebral twists of conceptual art.[50]

In defense of Tolson's work, Hall professed, "It was so terribly limited that it *mattered*. . . . Because it was Tolson's limitation and nobody else's that brought that thing into existence. And it therefore stood for Tolson and Tolson stood for it and neither could be removed."[51] In fact, of course, Tolson's art has been removed: reproduced in the Smithsonian festival catalog, auctioned at Sotheby's, installed in the corporate office of American Express, displayed next to a voodoo doll at the National Museum of American Art, written up by journalists, critics, and academic studies, like this one. With the power to conserve and effectively display Tolson's carvings as art, Hall himself, the Tuskas, Mike Royce, Mary Dunn, Ralph Rinzler, Carl Fox, and the institutions they represented can be said to have "brought" Tolson's sculpture "into existence." Yet because of its plainness, because it did not overtly exhibit their influence, and, crucially, because Tolson himself never significantly changed his way of life, his woodcarving could be represented as a supremely reliable and authentic object.

The assertion of immediacy and sincerity as regards Tolson's carving, a position that Hall himself has moved beyond, approximates what Theodor Adorno referred to as "the jargon of authenticity." Adorno scorned the language of existentialism as a form of evasion, one that, in its longing for just the sort of concreteness that Hall and many others extolled in Tolson's works, neglected the social and historical foundations of perception, subjectivity, and expression. Hall's equation of limitation with substance recapitulates the jargon Adorno decried, which "elevated limitation . . . to the level of virtue."[52] Adorno also scoffed at the existentialists' fantasy of a completely free subjective realm, noting how liberally this fantasy borrowed its language "from the era of handcrafts. . . . The stereotypes of the jargon support and reassure subjective movement. They seem to guarantee that one has achieved it all himself, as an unmistakably free person."[53]

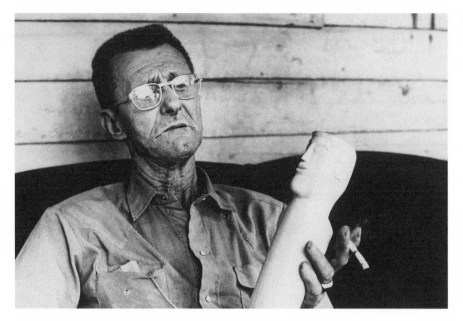

Edgar Tolson,
1972.
(Photograph,
Guy Mendes)

Hall and others, too, have described Tolson as just this sort of autonomous maker: "He was a self-contained entity in the world that he had built for himself, and between him and the pocket knife he didn't undertake anything that he couldn't finish. And so he was a kind of a throwback to the idea of frontier self-sufficiency. And sometimes he seemed a bit of an anomaly in our world. Maybe that was one of the reasons he appealed to all of us university kids."[54] The apprehension of the folk artist as "isolate," a position from which Hall has considerably withdrawn but that much of the writing around "outsider art" maintains, still ignores the socially mediated and historically contingent nature of handmade works.[55]

Popular desire for an unmediated art was both stimulated and satisfied by crafts fairs and folklife festivals, events that proliferated as leisure-time attractions during the 1970s and functioned as both tourist occasions and marketing venues for nonacademic art. The craft fair typically situates makers and their wares at booths, a setting conducive to transacting sales, of course, but, equally as important, one that provides a vivid, authenticating experience for prospective buyers. Craftspeople in this circumstance often explain how an object was made or may even offer a brief demonstration: in any case, this one-on-one encounter constitutes a kind of value added.[56] During the 1970s, the inception of the Smithsonian Festival of American Folklife and its many local and regional imitators and increasing numbers of craft fairs, such as the Kentucky Guild's gathering in Berea, enhanced opportunities for these one-on-one encounters.

Simultaneously, the pleasure of acquiring arts and crafts spawned another,

even more deliberate mode of acquisition: the folk art homes tour. In the mid-1970s, after publication of Hemphill's, Horwitz's, and Bishop's books on folk art and upon completion of a national system of interstate highways, collectors could locate and reach artists fairly simply. In doing so, they evolved a novel cultural entertainment combining elements of pilgrimage, weekend antiquing, safari hunting, and amateur ethnography. These quests further demonstrate that folk art's value is based neither in formal aesthetics nor in an object's markings of traditionality; instead, the persona of the folk artist, as experienced and interpreted by an adjudicating visitor, must vouch for a piece's worth. Of course, many artists have adjusted accordingly to this manner of retailing. One Tennessee woodcarver explained: "I've got a donkey here, so the tourists can really see one. He's a family pet and a dead expense to me but a livelihood because of the tourists." Having rented a workshop and sales outlet in Gatlinburg, this carver decided to move his studio to his home five miles from town at the suggestion of tourists. "They told me, get back out where you live; we'd rather come there."[57] Likewise, Savinita Ortiz, santos carver of Córdova, New Mexico, could sell her work in Santa Fe but instead keeps a table at her home: "I have the people here and there is no need to take my things out to sell them out in galleries or shops. People when they come and buy from me they say that they prefer to come and buy from the carver. . . . They say, 'We want to know the artist who made the piece of wood,' like a santo or whatever they're buying. They like to meet with me."

In part, the homes tour functions to certify objects that have not been fully authorized by an established art world; its very detachment from systematic handling, of course, nominates the work to the category of "folk art" in the first place. Furthermore, this process of nomination is just what delights folk art collectors. Herbert Hemphill explained, "It's much more fun for me to collect living artists when I can meet them and decide whether I think they're truly naive or primitive." According to Jan Rosenak, "We insist on visiting the artist. You can often make your judgment based on visiting the person. That is an important part of it, at least the sort of folk art we're looking for. . . . We got very spoiled by Edgar Tolson, Steve Ashby, Sam Doyle. There are very few of that sort of folk artists still living." Criteria from the world of antiques collecting—age and scarcity—have been imposed on people, who likewise are seen as vanishing or endangered, and thus appropriate objects for both acquisition and preservation.

In his study *The Invention of Appalachia*, Allen Batteau contended that folk art comes into being through this very process, as "the symbolic production of a relatively powerless group, [is] selected for its distinctiveness and specificity, and presented to the audience through the intermediation of a properly credentialed authority, so that the audience will know it is 'authentic.'"[58]

Thus, folk art is designated through a social interaction, involving a relatively powerful consumer and a relatively powerless maker, a discoverer and a "found person." As a consequence, the artist can never actually vouch for him- or herself. Such warranty requires "a properly credentialed authority" and, typically, such documentary evidence as that authority can gather, usually in the forms of photographs (preferably of the artist at home), an interview (sometimes taped, often reinscribed in a journalistic or scholarly essay), or, most customarily in the realm of folk art, an object the found person has made.

The folk art homes tour, while undertaken in a spirit of serendipity and adventure, is in fact a tightly choreographed interaction. With role expectations bordering on rules, this cross-class ballet is a highly structured encounter. The collector or visitor is, by definition, a person of leisure with some access to transportation, with both the time and the disposable income for travel. Freelance writer Elinor Horwitz, for example, first visited Tolson in 1972 with her two sons, during their spring break from school. She explained: "I wrote to a lot of people. I tried to map an itinerary. I said, 'I'll be in your neighborhood and would like to see you.' And nobody wrote me back. I mean, I wrote them a couple of months in advance, being a city girl who thinks that's the polite and proper thing to do, that you make an appointment. And most of them didn't have phones. I tried to call people and essentially we started out with no idea. Really it was a great adventure." The uncertainty of these travels seems to inspire rather than discourage visitors, redoubling their sense of excitement. Horwitz remembered her amazement that Tolson, like most of the craftspeople she sought to interview, was so available to her. "Edgar was just like everybody else, in that he was at home working. I mean, when we came he was sitting whittling. When we looked for basket makers we found them sitting making baskets. I had so little understanding. I thought people would be out of town. You know, it's spring vacation and children would be out of school and people would be on trips. You know most of these people were elderly, poor, didn't travel. . . . Everybody was at home."

The discrepancy between the leisured writer or vacationing collector and the homebound artist has been an important dynamic in the development of contemporary folk art: a class of roaming collectors and enthusiasts comes upon a class of stay-at-home creators, fit for photographing, interviewing, shopping. Gallery owner Carl Hammer remembered his first collecting trips in the South: "That was one of the great advantages of being a schoolteacher because we had summers to hop in the old car and travel around the country and followed up every lead." Lacking the means to travel themselves (as well as any mechanism of gatekeeping), folk artists, especially rural dwellers, have been easily turned into tourist sites, a process facilitated by the norms and re-

alities of country life: people commonly know one another, welcome drop-in company, and are generous in giving directions.

The folk art homes tour entails several props also. The artist, of course, is expected to supply a piece or, preferably, a selection of pieces for sale, and the collector or visitor is expected to bring cash, though some artists accept personal checks also. Tolson actually issued credit, permitting his more regular customers to take work away and pay him later. Letters to him through the late 1970s included many plaintive excuses. One customer wrote in the spring of 1978, "I received your fine letters and I have by no means forgotten *you* or my *debt* to you. I've had a very rough time of it moving here. . . . As soon as I get a couple of paychecks I will send along some cash to you."[59] Folk art collectors also tend to come prepared to document their visits. When in the summer of 1987 I dropped in on painter Jimmy Lee Sudduth at his home in Fayette, Alabama, Sudduth greeted me cordially, showed me to a room filled with teetering stacks of his plyboard paintings, and pulled out a harmonica to play a song. "Where's your camera?" he asked. "Where's your tape recorder?"

Many contemporary folk artists ask visitors to sign a registry of guests. Tolson never maintained such a list, yet from 1968, when the Tuskas and Halls first traveled to Wolfe County, until Tolson's death in 1984, he was visited with regularity. Among his most illustrious guests were Ralph Rinzler (1969); painter Roger Brown, who purchased an Uncle Sam on one trip, a snake handler the next year (1971 and 1972); Van Deren Coke, former curator of photography for the Museum of Modern Art, who purchased a snake handler carving for the Museum of International Folk Art in Santa Fe (1974); and Fred "Mr." Rogers, who shot a half-hour television documentary on Tolson (1979). Also in 1979 a German film crew came to Campton to make a movie about the woodcarver. Mary Tolson remembered that her father had nothing available to sell, so the film's director asked, "'Do you care if I pick up some of these shavings to take with me?' And Daddy kindly got tickled. He said, 'You can have all of them you want.'"

One contemporary art critic has inquired, "Are these not the arts of the discovered in the first place—a re-presentation of the evidence and process of discovery?"[60] As they articulate why folk art appeals to them, many collectors seem to concur. Chuck Rosenak, for example, explaining what motivated the immense collection he and his wife, Jan, have gathered over twenty years, contended: "The hunt, and the discovery, that's why we did it, not for the money." Relished as a metaphorical event, the journey to the artist's home invests the folk art object with drama and meaning. Here is Rick Bell's account of first meeting Edgar Tolson in 1969:

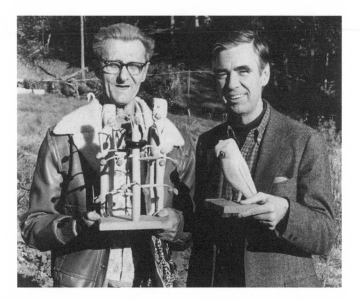

We drove out Highway 15 and they were living out by the edge of the road in a little green house, a little house by the side of the road, just outside of Campton maybe five or six miles. And we walked in and there was this sort of inevitable scene of a single bare light bulb hanging down from the ceiling and a wood stove going with a pot of beans, soup beans that never emptied. It was always just being refilled and continually cooking. And real thick sweet coffee that you always had to drink. And just chaos. And here's this skinny, small man with a brushy haircut sort of standing in the middle of it, trying to create.[61]

The perceived contrast between the Tolsons' chaotic home and Edgar's own focused attempt to make art intensified most visitors' appraisals of the carver and his talent. Ken Fadeley, for example, saw Tolson as exceptional: "Edgar stood out. He was different than 99.9 percent of people in Campton at the time. And he was that way until he died. He was a very, very bright man." Mike Royce, former Appalachian Volunteer, remembered his amazement at "going in the middle of nowhere and finding a thing of beauty"—Edgar Tolson's poplar dolls. This tale of locating a "diamond in the rough" has become part of the stock folk art narrative.

For collectors, the uncertainty of finding a piece for sale only heightened the drama, whetting their anticipation. Rather than being guaranteed a carving, visitors had to settle for whatever Tolson had on hand. As Julie Hall attested, "You never knew. Varied interval reinforcement's a strong motivator." Since Tolson had no telephone until 1981, the Halls ordinarily contacted his daughter Flossie to learn if he had produced any new pieces. They, and oth-

Through the 1970s Tolson received a stream of visitors. In October 1979, Fred "Mr." Rogers brought a film crew to Wolfe County, producing a documentary about Tolson and his family for the "Old Friends, New Friends," series. (Photograph © Family Communications, Inc.; used with permission)

ers, tried also to exact promises from the carver, that he would hold carvings for them. According to Julie Hall, while

he'd say, "Yes, I'll have it for you," you could talk him out of it. If somebody went up with a fifth of whiskey and said, "Here, let's sit here and drink and I'll buy that from you," he would sell. He liked the company and he wouldn't save it for you, which used to make Michael mad, kind of like one of those "look at all I've done for you and I got up here and you just sold this thing." But Edgar didn't care. I mean he's living an Appalachian life.

The indeterminacy of these trips and purchases clearly did infuse the purchasing of woodcarving with greater intimacy and excitement, transforming a mere buying trip into something more like a hunting expedition. To "land" or "bag" a piece might require more than just cash. Carl Hammer described buying his first Tolson sculpture as a protracted task. It involved

going over and visiting with him in his trailer and going out in his carving trailer with him. And then going into town to the doctor's office and showing me the little museum that had been set up by the doctor in town. And then just dying for a piece and kind of almost crying enough and whining to him loudly enough so he'd say, (whispering) "I'll get you a piece." Somehow he would go into that doctor's office and just open up the cabinet and get a piece out and then we'd drive away. I was just so incredibly elated that he did that, and somehow it made it really special.[62]

How else were motoring trips to Wolfe County turned into odysseys? In the retelling, these narratives dwell on strong sensory detail. According to Rick Bell, "You were sort of enveloped by the experience. You didn't just visit Edgar. It was the whole thing. It was the soup beans on the pot and the super sweet coffee in your hand and the chaos and noise. You were really like walking into a world, and then there was this figure in the middle of the world creating his own world, this sort of second world."[63] Bell, and many others, recalled the sensations as well as the occasions of their trips to Wolfe County. Though a photographer by profession, Bell retained and still evokes not only strong visual images but the more intimate memories of taste and smell.

"In a society whose great vice is seen to be its impersonality, people are more than ever obsessed with achieving the illusory experience of 'intimacy,'" Suzanne Seriff observed.[64] And indeed, many of Tolson's former visitors dwell on just such "intimate" vignettes when they recount meeting the woodcarver. Skip Taylor explained,

I would go up there, I loved it, going up to this world. I'm from New Jersey, you know and, yeah, there's Lexington, but hell, Lexington is pretty cos-

mopolitan, and there's an aristocracy and an intelligentsia, and the University Press, and art shows. And you go up there and, hell, they're eating sour food and there's a fly in the buttermilk. I wasn't aware that people lived like that. Well, it didn't seem to affect them at all. I mean, they could survive. The commode didn't work, if they had a commode. There's a picture of Jesus in every room but the bathroom.

Julie Hall described her first trip to the Tolsons' home with equal vividness.

Then we went to his place and I remember how raw it was in those days, and I mean as far as the social conditions or the economic conditions. There was no running water. He had burned the house down the year before or something, and every time you moved you moved the garden and everything you planted. The kids were dirty and poor looking. It looked like dust bowl pictures and they went to the bathroom in a room in the back of the house because they didn't even have an outhouse.

Dean MacCannell has written that the tourist lusts for access to "backstage" regions, where imagined secrets hide and private life is carried on. "Sightseers are motivated by a desire to see life as it is really lived, even to get in with the natives."[65] Just so, Hall and Taylor recount the grislier details of the Tolson household less to pass judgment than to affirm their own intimate standing vis-à-vis the folk artist: as proof of what anthropologists term "getting in."

As her narrative progresses, Julie Hall evolves from a backstage witness to a participant:

And Edgar was passing around this bottle of some gruesome wine, something like Thunderbird, and he passed it to us, and obviously it was one of those moments where if you were with the people, you do it, so I just took a big slug out of it and I saw Michael's face. I mean, I thought he was going to drop dead; it's like, "I'm not touching that." But I realized, hey, we're here, we're doing it, let's go with it, so I took it a big slug of wine. The bottle of wine went around and we started talking.

In Julie Hall's narration, drinking the wine as it is passed to her signals an initiation, a ritual of joining that establishes her bond: "and we started talking, and we made friends with him and then we just went up on a regular basis, got to know all the family." In time, Michael Hall, too, sought and expressed his closeness to the Tolsons. According to Flossie Watts, "Daddy, he did, he really got close to Mike. And Mike always told Mom, he'd say, 'Your oldest child has come home,' when he'd come to visit."

As an art student at Kentucky and in ensuing years Ken Fadeley found fellowship at the Tolsons' home. He explained that the family members both de-

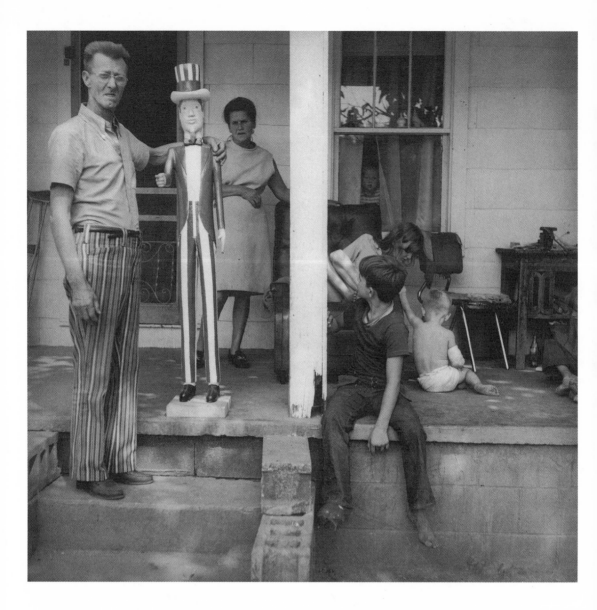

tected and were assured by his own ease among them, again, reflected in the imbibing of food.

I think they sensed that right on. And when I could sit there and snap beans with them and I wasn't ever embarrassed. I mean, I would go up there with friends and they would say, "Well, do you want something to eat?" And other people would say, "Uh, well, no." They could sense when people were uncomfortable. It's like animals. If you're fearful of a dog, a dog knows it. If you're not fearful, he accepts you. That's the way they did. They could sense when people felt uncomfortable. And I think that the fact that I never felt uncomfortable and my wife never felt uncomfortable and got right in

there and did things with them. And they could see that what I was doing was not just for Edgar, but was for them and I genuinely cared about them.

Chuck Rosenak recounted his journey to Campton, affirming its sensory excitement. "It was in the fall. We smelled the mash brewing and we drank moonshine bourbon with Edgar. . . . It was a great adventure." Michael Hall, according to Rosenak, had tried to discourage collectors from visiting, but in effect Hall's warnings only stirred greater interest, luring the curious to Wolfe County with rumors of mystery and danger. "Mike Hall, who was very secretive, said that he had visited Campton but you can't visit Campton because they make bootleg whiskey there. They'll shoot at you. It's very rural. So that intrigued us and we went to Campton, Kentucky."

This added element of peril, real or imagined, further dramatized and ennobled the act of folk art collecting. Accordingly, Herbert Hemphill related a story Michael Hall had told him, of traveling to a remote spot in the county when a group of local men "arrived with an open truck with guns."[66] Hemphill explained, "In the mountains of Appalachia, it's very dangerous unless you're a native." Hall and Rick Bell were hoping to photograph one of Tolson's early works, a plan that went awry when they found themselves, unwittingly, at the home of a single woman and surrounded by her relatives, who had followed them up the hollow. With long hair and hippie attire, the young men from Lexington raised suspicion: Charles Manson had just that week been taken into custody for the Tate-LaBianca murders.

In Hall's account, this episode also brought about his "getting in." Once Tolson heard of the confrontation, Hall said, the woodcarver instructed him to stay out of Campton for ten days.

I came back in a week and a half and went back over to see Ed. He was sitting outside the house and he said, "It's okay." And I replied, "What's okay?" He said, "I told them you're my family and that they are not to touch you." And in that moment I received what I understood as a Campton passport. I had been given this little diplomatic immunity. . . . And I think in that moment I became closer with Edgar and I also think that the family accepted me in another way too. . . . I had suddenly been involved in something that was kind of scary and maybe life threatening. Ed and the family had resolved my problem their way. The whole matter had caused them to review what it was that they wanted from me and who I was in their world. And I felt that I had found another kind of acceptance and had been punched into Campton life and into the Tolson family a little deeper than the typical person just coming up from the university to talk to Edgar or to buy some of his work. And so the relationship stayed family in that way from then on.[67]

Stories like these have become conventions of folk art collecting, stylized over time into tales of outright heroism. Chicago folk and outsider art dealer Carl Hammer depicted visiting Wolfe County in histrionic terms: "The streets of Campton seemed, as I recall, to be built up above street level or the sidewalks. They were sitting there looking. You know, here are these people sitting on their benches, looking. I mean, the images I have of these guys sitting there could have been these stereotypical guys that you think about from the movie *Deliverance*." The Wolfe County residents "just spooked the hell out of us," yet, for Hammer, fear and estrangement were tinged with grandiosity:

> The more and more I did that, the more and more I became immersed in and fell in love with southern culture. It has something of a phenomenon that was somewhat foreign to me, and I fell in love with the food and the cooking and to some extent even the people, though I'm always a little suspect of people because I always feel that they're looking at me as kind of like this Captain America who's on his motorcycle and doesn't fit in. You know, have you ever seen *Easy Rider*?

Hammer described his gradual affection for "southern culture" and increasing confidence on voyages to collect it; from the predicament of the middle-class canoeists in *Deliverance* and the paranoia and glamour of Peter Fonda's inscrutable biker, Hammer emerges as an action hero, a leading man. "I always had these kind of Indiana Jones romanticized ideas of what I was doing, you know, driving my van through the South and kind of studying southern culture at the same time I'm doing this kind of collecting thing." The protagonist of Steven Spielberg's huge cinematic successes *Raiders of the Lost Ark* and its sequels, Indiana Jones is a mild-mannered archaeology professor who springs from the classroom to save ("collect") the Ark of the Covenant, the Cross of Coronado. After learning that the piece may fall into the hands of mere treasure seekers, Harrison Ford clenches his jaw and, much in the spirit of the Halls and Hammers, proclaims, "That cross is an important artifact. It belongs in a museum!"[68] Imaginatively, Hammer, himself a former a high school English teacher, might likewise be catapulted from mere acquisitiveness or tourism into a valiant mission.

The discomforts of these folk art journeys—bad food and beverages, poor sanitation, and even incipient violence—all appear to have heightened their allure, while furnishing what MacCannell calls "a store of 'exquisite memories.'"[69] Forty years before the discovery of twentieth-century folk art, Antonio Gramsci strove to expose and clarify the cosmopolite's lust for danger: "People aspire to the adventure which is 'beautiful' and interesting because it is the result of their own free initiative, in the face of the adventure which is 'ugly' and revolting, because due to conditions imposed by others."[70] Him-

self a native of Sardinia, Italy's "hinterlands," Gramsci pursued from prison his tremendous insights into cross-class fantasy and the romanticizing of human hardship. He wrote, "What is most significant is that alongside Don Quixote there is Sancho Panza, who does not want 'adventures' but security in life, and that a large number of men are obsessed precisely by the 'unpredictability of tomorrow' and by the precariousness of their daily lives, in other words by an excess of probable 'adventures.'"[71] Larry Hackley knew Tolson as just such a man: "Everything was very much hand to mouth."[72] Hackley surmised, "There was not one day in his life when Edgar wasn't worried about money." According to Flossie Watts, "Dad had days that he was real depressed and probably felt hopeless. He probably thought, 'Well here I am with all these children.' . . . Being a mother, a parent now, I can almost know that it was terrifying. He had to be scared and I'm sure that he worried. There was probably lots of nights that we slept that he didn't, that he worried about what was going to happen."

For urbane, middle-class collectors, the experience of being the outsider in a small town was exhilarating. It provided the sense of backstage authenticity that, as MacCannell has written, modern tourists perpetually seek. But as MacCannell has argued, touristic experiences are more than pleasurable; they provide the elements from which modern people, without traditional attachments, construct their very identities. Michael Hall said as much in a 1976 interview.

> I think what is meaningful is that I was born in California. I had that rootless sort of West Coast identity, a product of the post-war period when my family moved out there, as many people did. I was born into a world where history was the last five minutes. It was quite an eye-opener to move east. I went to Colorado. Then I moved to Kentucky, where I taught at the university and met Bert Hemphill in the mid-'60s. And all of a sudden, some kind of connection to a history—a cultural history—seemed to fascinate me. Then to find it in these objects, which I perceived as beautiful, made it very intriguing. I had that great sense that I could simply declare my roots. I didn't have to be from some New England family and know that a particular group of portraits was my birthright. I could just say, "This is my birthright." I elected my birthright rather than having to find it in a family or find it in a subculture or find it in an environment. That was exciting.[73]

This is the very process MacCannell has described, in which objects are divorced from traditional contexts, the solidarity of groups erodes, and modern people—at once liberated and weightless—must build identities from cultural shards in which they have recognized some facet of themselves.

Although Hall depicted this process of self-invention as freedom to "de-

clare my roots . . . elect my birthright," an opportunity, MacCannell has portrayed this same condition as a rather desperate obligation. "Modern man has been condemned to look elsewhere, everywhere, for his authenticity, to see if he can catch a glimpse of it reflected in the simplicity, poverty, chastity or purity of others."[74] This uneasy sense of vacancy, propelling tourists from home in search of the real, strangely accelerates the progress of modernity itself. Splitting off certain regions (the South, Appalachia, the "Third World"), ethnic groups (African Americans, Haitians, Chicanos), classes ("the poor"), modern tourists then select and consume from the cultural smorgasbord at will. With folk art, this process typically involves suppressing certain aspects of the artist's personal history and foregrounding others, accentuating the differences between collector and artist in order to enact, over and over, a story of salvage, education, and triumph.

One self-perpetuating feature of this process is what collector Chuck Rosenak refers to "the legend of the artist," one criterion he has used to designate objects as folk art and to estimate their value. In the case of Edgar Tolson, Rosenak said, the legend was the amalgamation of several key features: "The blowing the corner off the church, and the preaching, and he can't live it—because his parishioners can't live it, he can't live it. The fact that he was a drunk and had lung problems and was suffering but he had a personal vision to which he was very true. And he never became influenced by what was going on around him." In this encapsulation of Tolson's mythology can be found the keys to folk art's designation, themes that have recurred in more than two decades of praise and commentary: violence, conviction, religiosity, drunkenness, suffering, personal vision, and isolation. Each of these qualities poses a counterpoint to the life and material circumstances of the collector/admirer.

As well as the many allusions to Tolson's adolescent prank, other violent stories continue to circulate. Herbert Hemphill recounted, "He had burned down a couple of his houses, and one of the houses overlooked the main street. And it was Fourth of July and they had a parade and Edgar was drunk and took shots at the people in the parade." This tale, too, makes Tolson a renegade, a man who cannot bear the hypocrisy of patriotic or religious display, presumably because his own convictions burn more deeply. In sum, these anecdotes compose a portrait of the avenging romantic artist.

Other sources indicate Tolson's violent outbreaks were far less ideological. His medical records of July 3, 1960, note that Tolson, "apparently drunk yesterday, tried to shoot his wife and everyone else around, finally arrested and put in jail." In her interview with Fred Rogers, Hulda Tolson recounted standing up to Edgar after he had beaten her. Although none of the children openly discussed the conflict in their parents' marriage, one daughter did note bit-

terly that her mother "lived hard all of her life and she died hard. I'm not saying I didn't love [my father]. I did love him. But I think he could have done better, toward my mother anyway."[75]

Among those who appreciated his artistry, incendiary tales contributed to the image of Tolson as a rugged, highly sexual man, a stereotypical mountaineer "uncorrupted by the 'lackadaisical effeminacy' which seems to accompany modern civilization."[76] Tolson's virility was expressed in the overt sexuality of his carvings, quite in contrast with the earlier López and Schimmel Adam and Eve pieces in which genitalia are either minimized or absent. As a Methodist missionary who worked with the Grassroots Craftsmen observed, Tolson's work "was unusual in that he made Adam and Eve anatomically correct. That had its appeal to the art crowd."[77] Some collectors have even interpreted the carvings' sex characteristics as indexes of Tolson's creative involvement. John Tuska remarked of the Adam and Eve tableaux, "Now, you can tell where the earliest ones are because the Adam is very proud. As Edgar gets more and more bored with the subject, [Adam] becomes more and more flaccid." Tuska's story, related half in jest, equates sexual impotence with Tolson's increasing popularity. The carver's manhood is both literally and figuratively impaired by association with the schooled enthusiasts who had begun trekking to Campton.

Rick Bell and Michael Hall both related a particularly misogynistic remark Tolson made to entertain them. Of his wife Hulda and her sisters, Tolson said, "Them Patton girls, you could shoot 'em, skin 'em, have sex with the skin, and nine months later'd out pop a baby."[78] This same sensibility surfaces in Tolson's subjects of murder (*Cain Slaying Abel* and *The Beheading of John the Baptist*) and pieces that portray women as sex objects (topless go-go dancers, nude women wrapped with snakes, and carvings of Adam mounting Eve as her breast is bitten by a serpent). Such ribald tales and images titillated audiences and, certainly, supplied perfect anecdotes for spicing feature articles. They served deeper purposes also. Elements of licentiousness and vice supplied folk art with an aura of transgression, a kind of daring and forbiddenness long associated with the avant-garde yet just as rigorously abjured by the American middle class.

This mixture of self-denial and aesthetic indulgence was described by collector Chuck Rosenak. Of himself and his wife, Jan, Rosenak said, "We lived in suburban areas all of our lives. And we consider ourselves very liberal." He went on apologetically,

We didn't know about blacks. There were no blacks at the University of Wisconsin. And when I was in high school I used to go down to what was then the Sixth Ward, which has now been urban renewaled so it's a park-

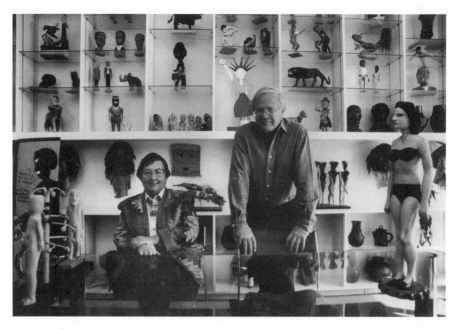

ing lot for the most part except [folk artist] Josephus Farmer lived there. Well, we used to go down there . . . when we were old enough to drive. Our parents forbade us to do it but we were supposed to be at a high school dance or after a dance or something. We would go down to Sixth Street, Third Street in Milwaukee, which was the black area and go into the black bars, and we would listen to the music. And this was supposed to be very sinful—our parents thought and the school thought—and supposed to be very dangerous. But we never had any trouble at all. None. And we were fascinated by it because it was not suburban America.

This tale of cultural crossing and its attendant revelations echoes the writings of Stéphane Mallarmé a century before: "This is what I like in Manet's work. It surprised us all as something long hidden, but suddenly revealed. Captivating and repulsive at the same time, eccentric, and new, such types were needed in our ambient life. In them, strange though they were, there was nothing vague, general, conventional or hackneyed."[79] Rosenak, too, expressed the need for just such a captivating experience as travel to Campton could provide. Its seeming illicitness both barbed and assuaged a liberal conscience and middle-class guilt. "Edgar Tolson didn't follow basic rules in his life and I have always followed," Rosenak contended. "You know, I did what you were supposed to do. I raised two children. I sent them to great universities. I taught them to read and to write and even though I may be idiosyncratic, I always did what was expected of me." While Michael Hall championed folk art as an authentic achievement from limited means, for collector

Rosenak folk art has represented a freedom he himself never exercised. "I never knew you could do anything else. I never knew if a governor told me that you had to have ROTC at a university, that maybe you didn't have to have—I didn't know that. If a swimming coach told me that now you take thirty laps, I took them. And I didn't know that you had a choice. I never knew that. So I still haven't got the choice. So I collect this stuff."

Although their own lives are fraught with ambivalences, collectors of folk art expect and treasure steadfastness from folk artists, seizing upon (or inventing if necessary) the folk artist's conviction. Julie Hall professed, "We were all concerned with whatever integrity is, if there is such a thing. And one of the things that impressed Michael was how little our injection into their culture changed them or [Tolson's] work. . . . The figures over time became more gestural but they always stayed stiff, just like Edgar, and they always stayed about the same." Consistency in works deemed "folk" has been explained in several ways. Folklore typically underscores the artist's devotion to a prevailing local legacy, and as has been seen, Tolson's work was viewed through this lens by many early admirers. Among collectors, however, the appeal of traditional folk art waned through the 1980s, and more idiosyncratic "outsider" art surpassed it in popularity; "integrity" came to be measured less through the observance of inherited forms and techniques and more through demonstrations of the artist's peculiarity and fervor.

In the parlance of collectors and exhibitors, "folk artists" began in the mid-1970s to be displaced by "visionaries."[80] As discussed by those who admire it, this quality of conviction or "vision" combines religious faith and personal sincerity, a quality ascribed to folk artists and their works at least since Leo Tolstoy's nineteenth-century commentaries. He argued that the criterion of sincerity, responsible for all art's "infectiousness," "is always complied with in peasant art, and this explains why such art always acts so powerfully."[81] Likewise, Tolson's admirers routinely described him as candid and genuine. "He was a person you could get fond of because he was so easy to talk to, and you felt like he was telling you what he really thought about things," said James Broadus. According to Elinor Horwitz, Tolson "was dead serious." And according to Miriam Tuska, "It's the sincerity of those pieces that I saw, in the early Ed Tolson pieces, that thrilled me."

Deliberately or not, Tolson appears to have conveyed "sincerity" by several means. Formally, the stiffness and stylization of his figures, both humorous and austere in their effect, suggested an unselfconscious technical approach. Julia Weissman made such stylistic innocence the criterion for folk art:

> The folk artist doesn't choose a style—it is a style that emerges when the folk artist decided to make art—and rarely does he have any conscious con-

trol over it. But in any case there will be or should be evident a palpable naiveté, an innocence in skill and artistic attitude. Expression of the artist's idea, i.e. concept or content, is more important than the style in which it is expressed. But style is important to the collector because it is the key to validity.[82]

In other words, while folk artists have no business deliberating on style, style will be the very criterion used to validate them.

"Somebody like Edgar," according to Horwitz, "isn't saying to himself, 'Well now the body is seven heads long and I might want to distort that for purposes of effect but really the head should go into the body seven times, and arms don't bend quite that way.'" Tolson's classic pieces of unpainted poplar do possess a roughness that suggests an unstudied approach. Even so, there exists considerable evidence, in addition to Hall's essay "You Make It with Your Mind," that Tolson's naive-looking pieces were in fact the result of conscious artistic choices. Donny Tolson, noting that collectors delighted in the knife marks on his father's carvings, reading them as "primitive," explained that this technique was Tolson's effort to naturalize his dolls:

> He figured nobody is real smooth, not even your skin or your surface. It's rough textured if you want to get down and look. So he figured by leaving knife marks and sanding cross grain in certain areas to give it a certain effect or look, he didn't want them to look real smooth. He didn't want them to look like they were a statue, something that's real smooth and been molded or something. He wanted them to look like they'd been created, made to where they look more real like, took on a real character.[83]

As well, while Tolson painted and shellacked many of his pieces prior to 1967 (*Man with a Pony* is the most outstanding example), he chose after meeting with officials at the Smithsonian to leave most carvings unpainted, based on buyers' requests. Again, the look of raw wood seemed to satisfy collectors' presumptions about primitive carving. "I don't know why but museums just don't want it painted," Tolson remarked. "They don't want nothing on it. They want it just plain wood like you carve it out."[84] "I like painted work," he told Skip Taylor. The carver's stylistic choice in this matter is complex, an accommodation to popular taste that involved his own symbolic and aesthetic ends as well. "You can't paint an Adam and Eve without ruining them," he added, implying that bare wood better rendered a Caucasian flesh tone than paint.[85] On the other hand, Tolson insisted that Uncle Sam be painted, and routinely finished the snakes in his religious tableaux with black. "That represents evil," he said. "And then they show up better on the tree than they would some other color."[86] From this evidence one can see that Tolson's

"folk" style, though interpreted as heedless and "sincere," was shaped by conscious choices, decisions molded in part by buyers' preferences but modified according to the artist's own taste and communicative ends.

Primarily, however, Tolson was deemed as sincere in faith, the more so for having left his religious calling. Rather than a devout parishioner, he was viewed as a Jeremiah, with zeal so pure he could not stoop to the day-to-day hypocrisies of organized religion. None of the folk art collectors interviewed for this study described themselves as religious people. One mentioned his membership in the Unitarian Church, but the others, though many had been raised in an organized faith, no longer took any part in religious observances. Elinor Horwitz, for example, remarked, "I'm not a religious person. I'm really not, but I am very well versed in religion and in the Bible so I like the stories." Horwitz has kept her Tolson Adam and Eve carving in the dining room. "It's in my little religious corner," she explained, that includes "a southwestern piece of Jesus that's seated, a kind of strange thing, that I got in a small town in New Mexico. And I have Tolson and I have a St. Francis which is George López, do you know him, from New Mexico? And, what else do I have there? Oh, I have a Mexican devil, a winged devil from Oaxaca."

How perfectly this activity bespeaks modern intellectuals' need, in Max Weber's words, "to furnish their souls with, so to speak, guaranteed genuine antiques." Weber contended that those unable or unwilling to make the "intellectual sacrifice" of faith "remember that religion has belonged among such antiques, and of all things religion is what they do not possess. By way of substitute, however, they play at decorating a sort of domestic chapel with small sacred images from all over the world."[87]

Other folk art collectors, less familiar with Scripture, enjoyed Tolson's religious subjects anyway. Chuck Rosenak, for example, who purchased Tolson's carving of Lot and his family, admitted, "Now, mind you I didn't know the Bible story of Sodom and Gomorrah, but I liked the piece." Rosenak helped Tolson complete this work by driving into Campton and buying paint for the unfinished "brimstone." The following day, he purchased the tableau: "At the motel I was very excited," Rosenak remembered. "I pulled out a Gideon Bible and we read the story of Sodom and Gomorrah—kind of a sexy thing" (Plate 10). Despite their disaffiliation from religion, many folk art collectors have prized pieces that betoken faith and been especially drawn to religious artists. Guy Mendes voiced his fascination for New Orleans street preacher and self-taught painter Gertrude Morgan. "I didn't want to be saved and convert to be a Baptist, but she certainly made me read the Bible. . . . I would leave Sister Gertrude's house just high as a kite from being preached over." Miriam Tuska commented on the Adam and Eve theme, "I don't know that religiously it has any meaning. It's just such a naive concept. It's a hoot to me."

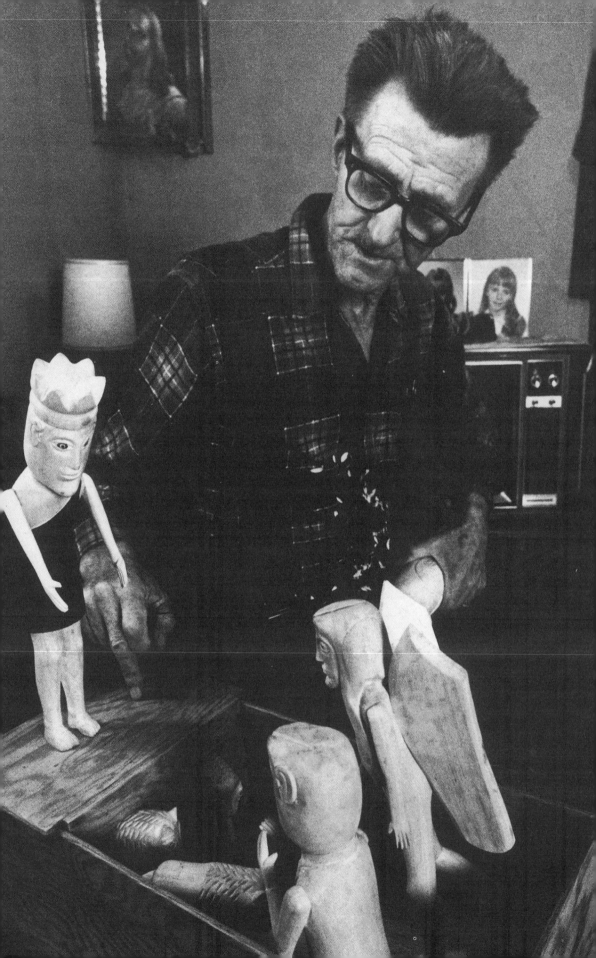

There is evidently a considerable range of response to religious imagery among nonbelievers—curiosity, amusement, perhaps even envy—but in every case, religiosity seems a quality expected of folk artists.[88] In Tolson's case, biblical themes and the "legend" of his lay preaching both authenticated him and imbued his carving with greater value. For collector George Meyer Tolson's subject matter effectively raised the expressive potential and the significance of his art: "The religious carvings are important, the fact that it's religion, because it gives an opportunity to pack in more emotion than you might have otherwise." Similarly, art historian Lynda Hartigan has written of Hemphill's collecting penchants, "While not personally political or religious, Hemphill has collected objects that incorporate social commentary or express a sense of spirituality. These strong expressions of conviction connect the objects to their own time and place and yet lend them universality."[89]

Fixation on religious imagery for its own sake recalls Adorno's critique of existentialism, its "readiness to view men's positive relation to religion as something immediately positive, even when the religion has disintegrated and been exposed as something untrue.... One needs only to be a believer— no matter what he believes in."[90] Remarkably few critics have observed this irony: that while generally irreligious people themselves, folk art appreciators tend to cherish the symbols of others' faith. Lonnette Stonitsch, reviewing a 1990 show of the Reverend Howard Finster's work, asked, "Is the Voice of God that directs Finster's art substantially different from the Voice of God that inspires the recent vituperative onslaughts from Congress against expressive freedom?"[91] Calls to dismantle the National Endowment for the Arts in the name of fundamentalist Christianity provoked charges of censorship from scores of artists and arts agencies, the same constituencies that have embraced Finster's proselytizing and Tolson's Old Testament sermons in wood. More pointedly Kenneth Ames, with reference to Edgar Tolson among others, raised the question: "Is folk art a way to say reactionary things and still keep liberal company?"[92]

Ames posed this question in political terms, contrasting the progressive, secular outlook of folk art collectors with the highly traditional, sometimes "fundamentalist" nature of the objects they cherish. Yet religious folk art clearly touches more than a clandestine conservatism. Roger Brown reflected on a combination of yearnings reflected both in his fascination for self-taught artists and in his own painting.

Generally what I've tried to do is come from kind of a populist background, which is very natural for me coming from the South. . . . I sort of see it as a good place to be, rather than being way far out on the left or way far out on the right, to sort of be somewhere in here. And I think that's

Tolson at home with his rendering of Daniel in the Lions' Den, 1971. (Photograph, Rick Bell)

mostly where traditional values are. They're sort of somewhere in the middle, in kind of a nice, safe place rather than being way out radical in either direction.

A well-known folk art collector, Brown expressed his own longing for a now untenable belief: "It was like we sort of grew up with this sort of blind faith in a way, and now there isn't anything you can really believe in."

It is not coincidental that folk art's ascendancy as a "universe of belief" occurred in the same decade that a philosophical and aesthetic pluralism infused the fine art world.[93] During the 1970s, feminists, as well as Latino and African American artists, successfully challenged the historical canon, while in other disciplines assumptions of progress, revolution, and objectivity were pried apart, cast as mere "narratives." In these fractious circumstances, folk art was enlisted as an epistemological certainty. Michael Hall praised the Campton woodcarver's work by saying, "It was Tolson's limitation and nobody else's that brought that thing into existence. And it therefore stood for Tolson and Tolson stood for it and neither could be removed."[94] Hemphill contended in his 1974 book on twentieth-century folk art, an oft quoted passage published above a photograph of the Campton woodcarver, "If there is any one characteristic that marks folk artists, it is that for them, the restraints of academic theory are unimportant, and if encountered at all, meaningless."[95] Presumably ignorant of fine art's conventions and poses, the folk artist is perceived as an immediate subject, the last preserve of conviction in doubtful times, the man or woman whose belief, however dubious for the average collector, could at least provide "a hoot," a "high," a "little corner" of curiosities.

Michael Hall endeavored to support and aggrandize the understanding of Tolson's faith through rigorous interpretation of *The Fall of Man*. In Hall's reading, the final tableau *Cain Going into the World* exemplifies both Tolson's belief in a vengeful God and his tragically modern acceptance of personal fate. "That piece is about Edgar himself in his life—Edgar having survived birth and death, and then looking out to a world that he can see beyond himself, but which he can't necessarily enter, because he still remains tied to his community, tied to his own background, tied to his local history and tied to his own limitations."[96] Hall's formal exegesis of the wooden figures expanded to attribute such fatalism to Appalachia as a whole.

> They stand in rather a frozen way, looking out at a world that they can't necessarily affect. This piece for me becomes a sort of metaphor for the whole Appalachian social condition that Edgar has lived through his entire lifetime. Though Edgar and his neighbors consider themselves persons of free will—a view supported by the tenets of their religious upbringing—

they are at the same time sort of trapped in the workings of a larger world, a world determined by an external force, be it God's plan or the conspiracy of the cover culture that has been gobbling up the Appalachian subculture.[97]

This cultural calculus depends, again, on a contrast of fixity and fluidity, fate and choice. The folk artist is limited, tradition-bound, impaled by poverty or strife, anchored in faith. Meanwhile, the collector, like the nineteenth-century *flaneur*, is mobile, liberated, leisured, free to spend and to experiment. Himself highly selective, ambivalent, and variable, the collector is fascinated by the commitments, even the predicaments of others. To weigh the authenticity of art objects, he comes likewise to demand more and more stringent tests, the most reliable proof being the artist's own pain.

In this respect, the artist in modernity has replaced the saint, has become, as Susan Sontag has argued, "the exemplary sufferer."[98] Sontag chose as her example Italian novelist Caesar Pavese—the unsettled life recorded in his journals, his suicide—though we might choose among a hundred other artist-martyrs: van Gogh, Rothko, Hemingway, Woolf, Pollock, Plath, Sexton, Joplin, Morrison, Berryman, Basquiat, Cobain. "It is the author naked which the modern audience demands," Sontag wrote, "as ages of religious faith demanded a human sacrifice."[99]

Chuck Rosenak's recounting of the Tolson legend, and its function as the

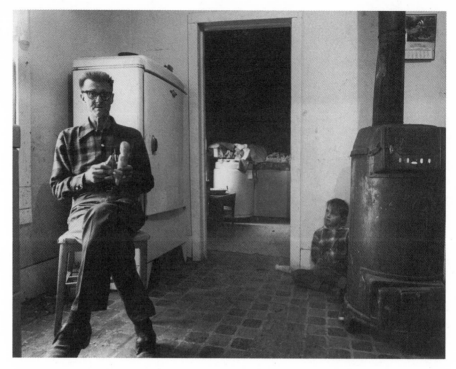

authentication of folk art, stressed this very nakedness and anguish: "The fact that he was a drunk and had lung problems and was suffering but he had a personal vision to which he was very true." Julie Hall remembered too, with some irony, her impressions upon first visiting the Tolson family. "Sitting there with a woman that's had eighteen children, two of them dying, kids without shoes, people without teeth, no comprehension of medicine or vitamins," she said, was "like going to a foreign country and it was very exotic." Hall said she no longer believes "that there was an elevation in primitive man or that there was something essential or different than the way we are anymore," but at the time, the late 1960s, she said, "when you see people who've never been to a dentist, you wonder whether somehow they know things that you don't know. . . . We loved them like anthropologists."

Envisioned as beset by deprivation on all sides, the folk artist fulfills the demands of modern authorship with peculiar conclusiveness. Fine art world contemporaries like Chris Burden, who arranged to be shot and wounded at his own New York gallery opening, or Ron Athey, whose performance piece "Four Scenes from a Harsh Life" has him puncture himself with twenty hypodermic needles, have met this demand of suffering with sideshow exhibitionism. German artist Regina Frank explicitly acted the part of a folk artisan. In her 1993 performance "L'Adieu: Pearls Before Gods," she sat in the window of the New Museum in New York sewing pearls onto a silk gown, earning each day the hourly wage of a seamstress in a different country. On one level

her piece protested the low wages paid for women's work in the Third World and scorned the fetish for handmade luxuries. Yet clearly on another level the performance served to ennoble the artist herself, crouched in a plain black sheath dress, industriously stitching.

By their very eagerness to perform suffering, however, Burden, Athey, and Frank cast doubt on themselves. Edgar Tolson's suffering operates as a more powerfully authenticating badge because Tolson's hardship is understood as his birthright (or curse), the product of circumstance, not staging. Performance artist Karen Finley might strip off her clothing on stage, smearing her breasts with mud, but Edgar Tolson was perceived as "naked" from the start, the captive of his class and region.

The 1970s transformation of U.S. art, characterized by embourgeoisement, regionalization, and credential seeking, had blunted art's critical edge. Harold Rosenberg lamented as early as 1966: "Instead of being . . . an act of rebellion, despair, or self-indulgence, art is being normalized as a professional activity within society."[100] When even abstract expressionism, once considered so immensely daring, had grown popular and successful, the possibility and critical potential of an avant-garde were cast into doubt. Suzi Gablik's elegiac book-length question *Has Modernism Failed?* bemoaned the contemporary artist "who prefers to forfeit the charismatic role, and who has scaled down his ambitions to conform to society's idea of the normalized jobholder."[101] Thus while the role of charismatic sufferer became less and less attractive, or even credible, among academically trained studio artists, folk and "outsider" artists were enlisted to preserve that role.

In the case of Edgar Tolson, as Chuck Rosenak's remarks indicate, personal suffering served as an artistic guarantee. Rick Bell also linked Tolson's sufferings with his creative drive: "He was really tormented by his weakness and the fact that he knew people were disappointed. He didn't like that. He knew it made him feel terrible. Nobody knew more, but he didn't know enough to stop it. I don't think he could have been creative without that other side."[102] Public humiliation thus has served as the folk artist's warranty, evidence of the kind of victimization that marks the modern author. Self-taught artists who, in contrast, achieve some degree of material comfort or psychic peace appear to have compromised; a lessening of torment threatens to fade their visions, to compromise their integrity.[103]

Folk art has also served a disenchanted culture by its evocation of an alternative world, devout and manageable. As folklorist Roger Abrahams divulged, "Getting back to the natural, smaller, familiar, human-sized style of life is an alternative that we do not wish to lose, even if we don't find ourselves choosing to live that way ourselves."[104] It appears folk artists have been enjoined as an order of cultural monks, charged to keep the faith that scholars

and collectors of folk art have abandoned. To those who can no longer either believe in biblical inerrancy or commit to a "human-sized style of life," folk art suggests that all is not lost, that such values remain accessible, retrievable against some future calamity. Consequently, the folk art object functions as a kind of talisman, safeguarding its possessor or scholarly interpreter against an anomic free fall. "It's like a little religion," Julie Hall said. "All these pieces are icons of the true cross."[105]

Julie and Michael Hall are not the only folk art collectors to couch their enthusiasm in religious terms. Others, especially in remarks about Edgar Tolson, have observed a kind of hagiography. Art dealer Carl Hammer declared, "About Tolson, I think he was really a god in many respects. The work that he did was truly spiritual and so derived from what was an inner kind of vision."[106] Smithsonian folklife festival creator Ralph Rinzler called Tolson "the most Christlike man I have ever met."[107] No longer an expressive statement or product of craftsmanship, the folk art piece becomes instead a sacred relic, evidence of holiness, remnant of an Arcadian past.

Tolson fulfilled these fantasies in many ways already examined, and he affirmed his qualifications by possessing, it seemed, no ambition to manage overtly his own charisma into a career. Asked about his renown, Tolson answered, "I'm very proud of it. It's a right smart honor to me but [it] don't make no fool of me. I just want to be what I am, an old hillbilly farmer raised up back here. And I don't want to get away from that." "That's great," his interviewer replied.[108] Through statements such as these, Tolson professed an utter transparency—"What you see is what you get"—and accordingly, many of those who visited the woodcarver assumed a great deal about him. "I don't think that Edgar's motivation was the paycheck. It was the doing," said Rick Bell.[109] Chuck Rosenak ventured further, "Edgar Tolson had I think all the money he wanted. He didn't want to send his kids to college. I don't think he knew about it. They didn't know. Certainly he had food. He had bourbon." Tolson's own children, however, describe him quite differently. Mary contended, "Daddy was always interested in my schooling, always. He always told me, 'Mary, you [get] on through school and I'll put you through college.'" In contrast with the straightforward man collectors remembered, his daughters described Tolson as complex, reserved, even inscrutable. "Daddy was a scared person, really. Daddy acted. People thought he was a tough person, heartless or whatever, but Daddy was just a real gentle person."[110] Wanda Abercrombie admitted, "I really don't know that much about my father, as a person. . . . I would have liked to have known his really inner feelings, what made him tick . . . but I don't know that man."

In Pierre Bourdieu's analysis, art requires "the production of belief" and so depends on such seemingly transparent characters as Tolson to establish it-

self. "'Sincerity' (which is one of the preconditions of symbolic efficacy) is only possible—and only achieved—where there is a perfect and immediate harmony between the expectations inscribed in the position occupied (in a less consecrated universe, one would say 'the job description') and the dispositions of the occupant."[111] Tolson was an ideal applicant for the "job" of folk artist. His ascribed traits (poor, handicapped, Appalachian, elderly) and his subject matter (traditional, toylike, religious, sexual), as well as his obvious alcoholism, all fulfilled expectations of the folk artist. Tolson was deemed "sincere" by living up (or "down") to the stereotype, a construct molded from manifold sources: the precedent of nineteenth-century carver Wilhelm Schimmel, a larger myth of pastoral life in its special Appalachian manifestation, and romantic idealization of the artist's role.

His reasons for acceding to these expectations will never entirely be known, yet, reasonably, they included the pleasure he took in making objects well, the possibility of financial gain, and some combination of egotism and hospitality. Fadeley and Hall have observed that Tolson, too, regarded the process of his own discovery as a kind of sport. He often made spontaneous gifts to young women visitors and to especially solicitous and powerful collectors, like Hemphill. Through both his carving and his storytelling, he enjoyed exercising the power to shock; with a semicircle of admirers at attention, he would play the sage, tapping his preaching ability to cite and interpret Scripture for dazzled college students. Just as often, he went for the laugh, cursing the Republican president or tossing off a lewd remark. Even for those visitors who arrived during a binge, Tolson seldom failed to please, if only by providing a hoped-for intensity. "I guess the thing that impressed me was that he was really drunk. He was totally out of it. . . . I'd been around drunks before but I had not, I guess, realized how abusive they could be. He was really very abusive to his wife but sort of cordial to us. I can remember even though he was drunk, I can remember him joking around and being, having all kinds of smart ass remarks to make." This first-time visitor described the experience as "an unforgettable event but I don't remember being disappointed."[112]

What has freighted such scenes with aesthetic interest and meaning? What kept admirers returning to Tolson's bedside for the better part of a decade? One answer may lie in the many affordable avenues to distinction folk art opened in the late 1960s, just as the prospects of a large cohort of young middle-class Americans diminished. "If this is an elite," wrote Barbara Ehrenreich, "then it is an insecure and deeply anxious one. It is afraid, like any class below the most securely wealthy, of misfortunes that might lead to a downward slide."[113] Ehrenreich has examined why the professional middle class of Americans turned to political conservatism during the 1970s, contending, "The key shift, the one which seems most closely linked to the de-

Julie Hall,
Tolson, and
Janis Katz,
1978.
(Photograph,
Michael D. Hall)

cline of liberalism, was the middle-class perception of itself: from the naive mid-century idea that the middle class was America, and included everyone, to a growing awareness that the middle class was only one class among others, and an isolated privileged one at that."[114] Chuck Rosenak expressed how this very revelation came to him upon meeting Tolson: "Edgar Tolson was the first folk artist we met. Suddenly I realized, really for the first time, that America was not just the affluent middle class. I mean, there were other people, and these people had dreams and visions and ambitions and that this collectively made up an America that we knew nothing about, and had never read about, had never experienced. And so I set out . . . to find what it was like in America."

Donny Tolson, when asked to describe the people who have taken greatest interest in his carving, stressed several qualities they share: "I think a lot of people that like my art are people that love art and are probably very sensible people that understand the different types of people more so than maybe the common person."[115] The younger Tolson underscored that it is folk art's capacity to display "difference" that attracts collectors; logically, those who would go searching for such displays are those same "sensible people" who stand at some advantage once such difference is made manifest.

Donny Tolson added, "I think more the common person, poorer people and stuff, I think some of them like art but maybe not as much so as some people that have a more comfortable life style that can afford to, and it's something for them to do to occupy their mind and they enjoy it. They enjoy looking at it and they enjoy collecting it and it's something almost like hunting treasures for them."[116] Leisured folk art collectors require some diversion

"to occupy their mind," in contrast with "the common person," with neither disposable income nor time for "hunting treasures."

As for how his carving is received locally, Donny Tolson said, "I have a lot of friends that like my work. I think they don't understand it fully or understand as much folk art as they probably would fine art. I think probably they'd probably prefer fine art over folk art." Asked why, he replied, "I think because maybe they're trying to strive to be perfect and . . . fine art is more perfectionist or done more precisely in shapes and real reality and stuff. I think they like stuff like that more than they do folk art."[117] Remarks that Wolfe Countians made about his father's carving confirm Donny Tolson's view. While most Camptonites were tactful and some were complimentary of Edgar's art, others were less enthusiastic. Mary Dunn allowed, as if pointing out the obvious, "Edgar's work is ugly." To account for its popularity with collectors, she explained, "It looks wild or something primitive, different from anything they've seen."[118] Billie Adams, Campton's librarian, also called Tolson's carving "ugly," though somewhat more apologetically. She, like many other local citizens who received Tolson's carvings as personal gifts, have sold the pieces in recent years to folk art collectors.

The designation of contemporary folk art seems to involve a fantastic, perhaps even willful misunderstanding, a kind of interpretive slippage. Sociologist Arnold Hauser alluded to this habitual misconception and misrepresentation in discussing folk music, but his analysis applies to the plastic arts as well: "Dialect songs come for the most part from professional poets who think they have to lower themselves to the people, whereas the people when they write poetry are not—as the romantics believed—'natural' but are presenting themselves emotionally and linguistically in their Sunday best."[119] From this perspective, the appeal of pieces by Tolson and others revered as twentieth-century folk art classics involves a large dose of irony, as collectors relish a kind of falling short of fine art standards. Adrian Swain explained, "Its awkwardness . . . is part of its power. It doesn't conform to all those norms and standards of excellence that are held up, that artists are taught to aspire to." For those versed in the canon of art history, collecting folk art provides a second-degree rebelliousness, even though folk artists may have intended no such transgression of artistic norms but in fact donned their "Sunday best." Folklorist John Michael Vlach has attacked this element of irony: "The seeming terms of endearment that one frequently hears offered in praise of folk art," he writes, "are actually expressions of mild contempt. . . . There is evidently much snickering in the background."[120]

Psychologically, Tolson's carvings, as much of the rest of contemporary folk art, appears to have issued a promise of childish security and ease for young middle-class Americans embarking on independence and adulthood.

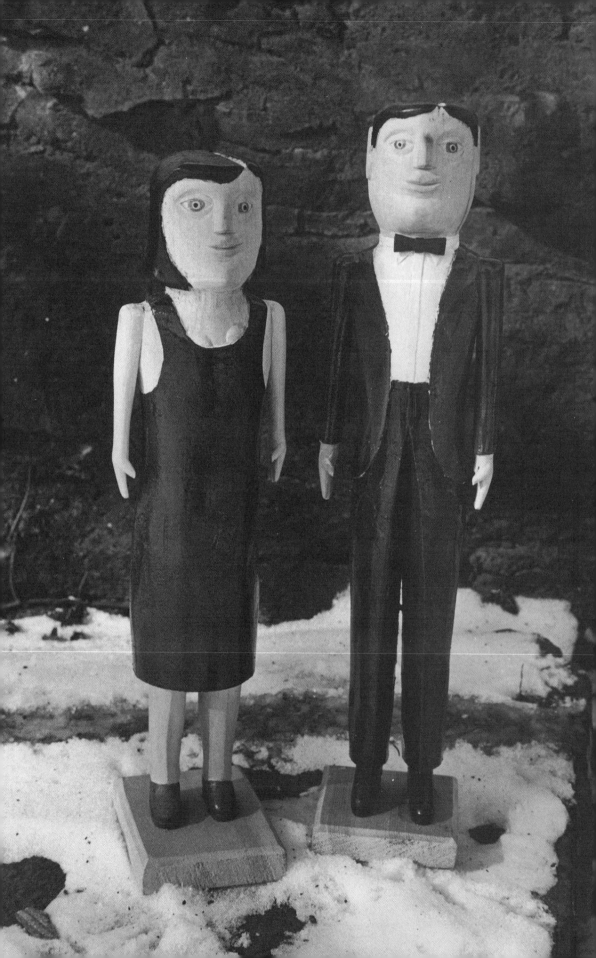

A Massachusetts Institute of Technology psychiatrist wrestling with the motivations of the young people who joined the Appalachian Volunteers referred to a "dark unconscious need to justify their own lives that are so filled with questions; perhaps searching for and hoping for approval from simple people as they come to savor the complexity and frustration of [their] more 'advanced' way of life."[121] Tolson, by his hospitality and acceptance of the many young visitors who found their way to Campton, provided just such a haven. "He became like a Dad to me," said Ken Fadeley. "I feel comfortable down there. I mean, when I drive back now and I get to about Slade, it's like where I belong."[122] Similarly, John Harrod, who was collecting fiddle music in Kentucky during the 1970s and 1980s, explained, "There was a lot more to it than the music. . . . I think I was sort of like somebody who just had hundreds of grandfathers and grandmothers. . . . More than just the music, it was about how to live in the world."[123] Like Hall, Harrod sought to elect a birthright, claiming the fiddle tunes he collected throughout rural Kentucky as a cultural legacy and the fiddlers themselves as adoptive ancestors.

Such individual motivations mirrored a larger cultural necessity too, as young artists strove to preserve art's autonomy in an increasingly commercial climate. Bourdieu, studying how cultural interests develop into discrete fields of production, has analyzed what cultural autonomy requires.

> The economy of practices is based, as in a generalized game of "loser wins," on a systematic inversion of the fundamental principles of all ordinary economies: that of business (it excludes the pursuit of profit and does not guarantee any sort of correspondence between investments and monetary gains), that of power (it condemns honors and temporal greatness), and even that of institutionalized cultural authority (the absence of any academic training or consecration may be considered a virtue).[124]

Clearly, folk art and its successor "outsider art" meet these specifications with a terrible kind of perfection. As art produced by society's "losers" (the "slaves and schizophrenics" touted on radio, and all those marginalized by poverty, geography, poor health, old age, racism, or prejudice), folk art seems to hold at its heart a kind of warranty. It has not so much turned its back on the bourgeois demands that might compromise it, collapsing its autonomy into ulterior systems of meaning and exchange. In fact, "by lot" such possibilities have been closed off, eliminated for the folk artist. Denied education, wealth, or honor, the folk artist like Edgar Tolson possessed the strongest qualifications for cultural autonomy; in looking away from his own career, or seeming to do so, Tolson and others deemed folk artists perpetuated a belief in the disinterestedness of art even as the commercial market boomed.

Ken Fadeley expressed how folk art helped maintain his own artistic

Two painted dolls, 1977. Private collection. (Photograph, Ellsworth Taylor)

ideals. "A lot of the quote 'art' that was being done at the time just became a lot of the emperor's new clothes. It wasn't about a whole lot, whereas this work, it was what it was. It wasn't being made for the art market. It wasn't being made to hype or anything. These people were making it on their own. They didn't care if anybody ever saw it."[125] Fadeley's sentiments echo the definitional statement Hemphill and Weissman offered for contemporary folk art in their influential book. "The vision of the folk artist is a private one, a personal universe, a world of his or her own making. There exists only the desire to create, not to compete, not necessarily to find fame."[126]

Unlike the M.F.A. graduate diligently shooting slides of his work, applying for National Endowment Fellowships, compiling a résumé of shows, the folk artist is assumed ignorant of such "ordinary economies." If he gains acclaim or honors, or even succeeds in selling his work, it is always through intermediaries, those who are savvy in the ways of the art world, who in shielding folk artists from such crassness may also withhold its rewards. In an era when the old avant-garde had grown dubious, through its endorsement of middle-class and academic values, it became, in the despairing words of one commentator, "more and more difficult to find a position of estrangement."[127] The folk artist, because born to his estrangement and, seemingly, locked there with no means of escape, unwittingly became the vestigial bearer of avant-garde ideals. Excluded from the bourgeoisie and presumed to lack interest in the accolades and profits to be made from artistic success, the folk artist maintained the renegade fantasies of modernism, paying the price for marginality while others enjoyed the cultural bargain.

Guy Mendes specified that folk art's distinguishing feature is its source in relative powerlessness. Fine artists, according to Mendes, are "more worldly wise and are out to sell their work if they can, to promote their work, to have others see their work." Mendes added that such artists are also shrewd; "[they are] not as likely to be corrupted by you. They're not as likely to be appropriated and ripped off by you. . . . The line is different for the fine artists and the outsider artist or the folk artist, in that they're not thinking that much about the art world and the economics of it and the politics of it. I think they're more susceptible to the greed of others and avaricious designs."

From early in Tolson's woodcarving career, the lore of his artistic practice incorporated this idea of disinterestedness. Michael Hall's first commentaries attested: "Tolson's only commercial carving came in the forties when he cut several tombstones. . . . No one, however, supported his carving which seems to have filled only a personal need."[128] Certainly in later years, Tolson was aware of the popularity and commercial value of his own work. In several interviews he enumerated the exhibitions and publications that had featured him, even boasting of prices his pieces had brought, yet wisely Tolson

downplayed his ambition and success when interrogated directly. In a 1972 interview, when Michael Hall asked Tolson to discuss his status as an artist, Tolson replied, "Well now, you put that to it, because I don't think any of it gets better and none of it's any good. You're the one wants it. I don't."[129] Folk artists who, on the contrary, have taken direct charge of their own careers — pitching their work to prospective dealers, advertising, or demanding better prices — have been viewed with swift suspicion. In fact, the folk art field of the 1990s is steeped in nostalgia for "the good old days" of twenty years ago, before prices jumped and folk artists gained an understanding of the market. Carl Hammer posed such a comparison: "The work that [Tolson] did was truly spiritual and so derived from what was an inner kind of vision. The preponderance of the successive waves of Kentucky folk carvers are basically copy cat artists." Referring to "the disappointments of the folk art field," Hammer attributed the lesser quality of more recent carvers' work to their awareness of art world realities: "because they've seen the success and the commercial kind of marketability that Tolson's work has had or experienced and enjoyed the museum acclaim and everything." Likewise, Jan Rosenak explained, "One of our criteria is initially [folk art work] should not be for sale. You should be making it out of your own need, compulsion." While such voracious collecting as her own has, of course, fostered a folk art market, Rosenak lamented that "folk artists today are making it with profit in mind."

George Meyer, whose publication *American Folk Art Canes* stimulated renewed fascination in walking sticks among collectors and carvers alike, remarked,

> It seems that some of these people, particularly in the outsider groups, now are being overpromoted and whatever abilities they had before and whatever drive they had before [have] been now directed toward a market, and it's just hard to believe that it's possible to maintain a lot of the "folk" part of "folk art," with that kind of a market orientation. I think that if an artist can be left alone and turn out the work or be supplied maybe with paper and paint or wood and stop there, he can preserve much of his artistic creativity, but I think in many cases it's gone much too far, and the artists themselves are being promoted and pushed to create for a specific market.[130]

Once folk artists show an interest in profiting from their work or even an awareness of the art market and its publicity system, their artistic qualifications begin to fracture. Folk artists must be "left alone," "supplied maybe with paper and paint and wood."

These assumptions, of course, conscript artists to a kind of defeat: as Bourdieu wrote, they "cannot even denounce the exploitation they suffer without confessing their self-interested motives."[131] Only artists like Tolson, who en-

acted an attitude of grateful humility, surprise, and nonchalance, preserve the possibility of a disinterested and estranged position, "the economic world reversed" that validates art as an endeavor. In his interview for the Archives of American Art, Tolson contended, "I don't want nobody to think that I am a little different than anybody else, maybe a little high or something. I don't want that. I want to stay down in the crowd. I think it's a lot better. . . . If you stay down low and you do get lifted up, you know you're higher than you were. It makes it a lot difference. But when you go to lift yourself up you can probably fall."[132] Aware of the risk "when you go to lift yourself up," Tolson articulated the art world's rule: others must do the "lifting," or the leavening agency of disinterestedness will fail.

Rarely has folk art been handled in accord with fine art's marketing norms. Instead, collectors have acted like the patrons of centuries past, attempting to monopolize a particular artist's output and then to build an artistic reputation through promotion, exhibition, and strategic sales.[133] Although it is not possible here fully to gauge the ramifications of such financial arrangements, two dimensions of folk art's flexible marketing practice are worth noting. First, the potential for huge markups, buying folk art low and selling high, has made the field even more prone to speculation than the fine art market.[134] Without the 50 percent consignment fee as a temporizing weight, it is possible for dealers to purchase large quantities of an unknown artist's work, hype it, and then sell off pieces at enormous profit. This potential has induced many undercapitalized enthusiasts to enter the field. Secondly, and more germane to this study, this practice has further consecrated folk art by thrusting into the foreground the artists' "disavowal of the economy." While the fine art world may be thoroughly tainted by competition and greed, the folk artist still can be touted as "disinterested," a preserver of more purely cultural virtues.

Bourdieu's work further suggests how tightly these two features of the folk art economy are braided. He has characterized the makeup of the artistic field thus: "Those who enter this completely particular social game participate in domination, but as *dominated* agents. . . . They occupy a dominated position in the dominant class, they are owners of a dominated form of power at the interior of the sphere of power."[135] Tastemakers, with sufficient cultural capital to pronounce and even distribute their interests to some effect, they are still dominated by more intransigent economic and political forces. Bourdieu has observed, "The literary and artistic fields attract a particularly strong proportion of individuals who possess all the properties of the dominant class *minus one*: money. They are, if I may say, *parents pauvres* or 'poor relatives' of the great bourgeois dynasties, aristocrats already ruined or in decline, members of stigmatized minorities like Jews or foreigners."[136]

And how accurately this description fits the champions of folk art:

Edgar Tolson
and Michael
Hall, 1978.
(Photograph
courtesy of
Michael D. Hall)

Hemphill subsisting on his small trust fund; Michael Hall, son of two teachers and a college art professor himself; government lawyers Chuck and Jan Rosenak; Robert Bishop, whose openly gay life made him vulnerable to social stigma; Ralph Rinzler, the son of Russian immigrants. Occupying status positions of social indeterminacy and lacking, in most cases, the immense fortunes that fine art collecting by the 1970s required, such people found in folk art an affordable status symbol. Its prestige-making potential was in 1970 comparable to other "middle-ground arts," such as film and jazz music. "These arts, not yet fully legitimate," wrote Bourdieu, "which are disdained or neglected by the big holders of educational capital, offer a refuge and a revenge to those who, by appropriating them, secure the best return on their cultural capital."[137] For a relatively small financial outlay, the Halls, Hemphill, and others reaped both profits and prestige from their folk art investment. Michael Hall, describing the inspiration and thrill of living among Tolson's works, admitted, "I could walk through a room with three of four David Smiths or a Mark DiSuvero or a Peter Voulkos and feel the same kind of thing. . . . If I could own the Smiths, I would have them too."[138]

By the late 1980s, these thrills—of owning a Tolson woodcarving or visiting folk artists in the hinterlands—had begun to wane. Folk artists began to routinize visits with accessories like guest registers and sales receipts, or to present their works in glass cases, more like wares than wild butterflies. In 1987, the Museum of American Folk Art organized the first of many "Explorers' Club" tours, chartering buses to transport folk art fanciers by the score to visit artists, collections, environments. Clay Morrison explained, "I guess it was in the mid- or early eighties. I lost interest in collecting a lot of the contemporary American folk art. It just seemed like so many people were becoming interested in it." Folk art collecting, once the province of a select

group of enthusiasts, became far more popular, in effect diluting its powers of distinction. Dealer Carl Hammer expressed disdain for the growing ranks of collectors and the increasing number of artists being designated in the field: "It's kind of almost like a trading card, baseball trading card process or stamp collecting process where you've got to have this example and this example and it makes absolutely no sense to me. There's a lessening, lessening of connoisseurship in this field than what I would have really wanted to see." Roger Brown more explicitly spoke to the issue of distinction: "For me part of the excitement of collecting [folk and outsider art] was the thrill of discovering people doing things that the intellectual art world didn't know anything about. When a whole society seems to want the stuff, I want to go in another direction."[139]

Morrison and others drifted away from contemporary folk art when greater popularity blurred its efficacy as a status marker.[140] But equally important was the effect of expanded interest on costs. Morrison conceded, "I'm sure there were probably financial reasons why I stopped collecting, too, because as the demand grew, then artists started raising their prices and I was sort of priced out of the market."

This same escalation of prices likewise contributed to the Halls' decision in 1989 to sell the majority of their folk art collection to the Milwaukee Art Museum. "We couldn't afford to keep it, that's all," said Julie Hall.

> In the end things that become expensive go to the wealthy people. This is the bottom line and I'm telling any young collectors now, if you start collecting something and it gets popular, you will not be able to afford to keep it. It will have to go to somebody with more money than you. . . .
>
> You have, say, children, and they're going to have to go to college, and all of a sudden you're earning forty thousand dollars a year and you have something that you bought at twenty-five hundred dollars [that] is worth thirty thousand, and you want to send your kids to college. You have to sell it. And someone that doesn't need that thirty thousand dollars 'cause they're making two hundred thousand dollars a year will buy it, and they're taken from you. And it's obnoxious, but it is the truth of the world—that all of us that found that stuff on the grassroots level, that could pay for it with a teacher's salary, can't afford to keep it, and we can't afford to buy it.

Not only folk art collectors but nearly all of Tolson's own family members, too, have in later years sold the pieces he gave them. Despite substantial differences in their finances, for the Tolson children, as for Julie Hall, having turned the carvings into cash is a source of regret and some embarrassment. Flossie Watts explained why so many Wolfe Countians opted to sell her father's work:

I think people valued it and kept it for many years and liked it, but you know everyone in this area; I'm sure that there's very few people that have got enough money to live comfortably and pay their bills. Very few people like that. And the people in this area that had pieces of Dad's, I think they got in hard spots. They needed the money desperately and they got a good price out of it and they sold it. . . . It wasn't because they was just money hungry and greedy or that they didn't appreciate or value that piece. It was that they needed.

To see fully a wooden carving, or any piece of art, is as Meyer Schapiro has written "a goal of collective criticism extending over generations."[141] Still, looking at Tolson's carving now, certain features stand in boldest relief. Folk art has accorded with the longings of middle-class Americans. It evokes times past through agrarian, religious, and patriotic imagery, through its wrought evidence of the human hand, and, crucially in the period under review here, through the charisma of the folk artist—typically a rural elder like Tolson, who is assigned the part of a crusty, mythical grandparent. An object of nostalgic desire, folk art satisfies fantasies of anchorage, tenderness, and control among those who by choice and social circumstance cannot find such satisfactions otherwise. In his meditation on folklife, Robert Cantwell has evoked how some black performers display "precisely those powers that, in the spectrum of human possibility, white culture will not permit itself *except* in their degraded forms as play or amusement."[142] Folk art, likewise, radiates those very powers—of religious devotion, misogyny, patriotic nationalism—that for folk art collectors had become publicly untenable.

Its formal "awkwardness," coupled with the physical and material vulnerabilities of its makers, has evoked a response of protective affection, an intimacy inconsistent with the grandiloquence, polish, and hyperintellectualization of contemporary fine art, which too often exhibits a "calculated coldness," which "takes back and refuses what it seems to deliver."[143] In contrast with such arrogance and self-determination, folk art supplied the art-consuming public with "moveable decorations," affordable, literal, and scaled for the living room. Lacking the avant-gardists' obligation to *épater les bourgeois* and lashed by material hardship, folk artists were more amenable to the direction of buyers: unlike the fine artist, who ostensibly must be driven to work according to some inner daimon, eschewing or denying the motivations of social compliance or gain, Edgar Tolson carved both "to please people" and "for necessity, buddy." Only because of his extreme status difference from art patrons—gauged by such features as appearance, dialect, geographic location, and age—could his compliances be accepted and in fact enjoyed rather than read as artistic compromises.

Finally, the field of contemporary folk art made available not only objects but stories and a form of entertainment—the folk art home tour. Visiting artists across "dirt track America," collectors could turn art acquisition into an inexpensive safari. The promise of coming upon "found people" stimulated a new kind of arts tourism, quite in contrast with museumgoing yet with its own rules and rituals. Again, this activity provided the pleasures of intimacy by bringing collectors backstage into the lives of poor people, episodes recountable through the pungent memories of moonshine, beans, and dirty diapers. From this journey, fantasized as a perilous and exciting odyssey, visitors might capture a souvenir piece of folk art and, along with documentary photographs, audio and video tapes, return with an exquisite story to tell.

In an effort to understand the appeal of a very different creative endeavor, fifteenth-century Italian painting, Michael Baxendall wrote, "Much of what we call 'taste' lies in this, the conformity between discriminations demanded by a painting and skills of discrimination possessed by the beholder. We enjoy our own exercise of skill, and we particularly enjoy the playful exercise of skills which we use in normal life very earnestly."[144] Baxendall found that the specific skills cultivated by fifteenth-century Italians—noting proportional relationships, reducing complex forms to compounds of simple forms, discriminating among reds and browns—produced a "taste" for the works of Piero della Francesca.

What skills did the 1960s exercise, and the 1970s, in the United States? Affluent Americans began with earnestness to exercise their sensitivity to class. Having discovered poverty in the land of plenty—and, later, the "working class"—they experienced a "fear of falling," anxiety about their own economic demise. This uneasiness was especially acute among middle-class youth, a generation embarking on a future of uncertain class attachments. In response, as Quattrocento Italians developed eyes for volumetric proportion, middle-class Americans in the 1960s honed their skills at perceiving class differences and, through such discerning perceptions, endeavored to brace themselves at a worried distance from classes below. This is the very sensitivity to which Donny Tolson alluded in describing folk art collectors. These "people that love art," the collectors of his father's and his own woodcarvings, were those "very sensible people that understand the different types of people more so than maybe the common person."[145]

As Ehrenreich, MacCannell, and Clark all have written, and of course Thorstein Veblen before them, consumption has always been the middle class's primary strategy "to establish its status, especially relative to the working class."[146] Yet in the 1960s, middle Americans encountered trouble in this regard: "How could one signal a crucial status difference in a world where so many people had access to the same vast display of consumer goods?"[147] Folk

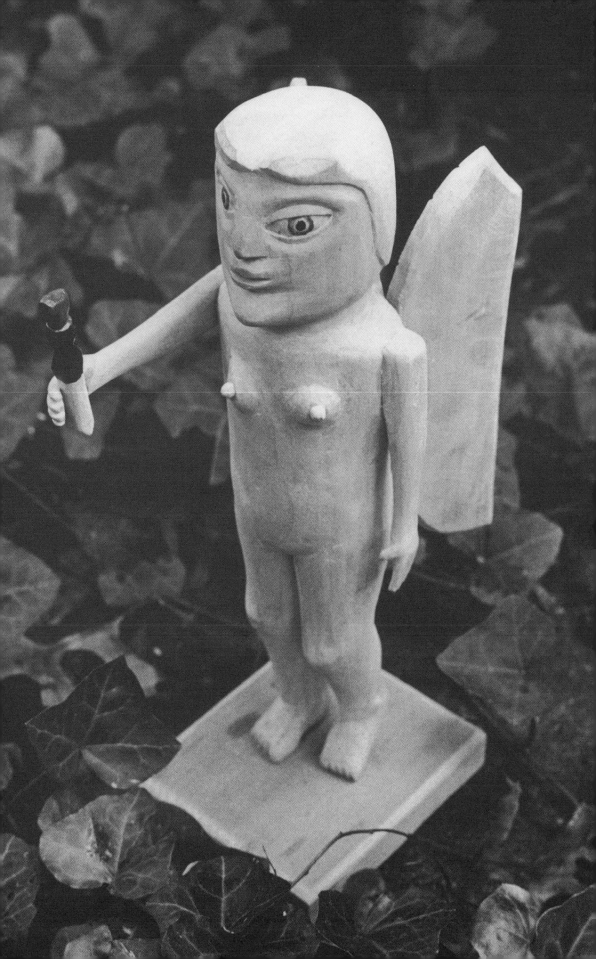

art offered an affordable signal. An emblem of authenticity, in contrast with mass-produced, machine-made items, folk art, like handicrafts, bespoke a distinction—especially since it, ideally, was not acquired through a purely commercial transaction but through an experience of intimacy, a journey to the folk artist's residence. Furthermore, since, as Donny Tolson noted, working-class people typically designate more "perfect" objects as art—even rejecting folk art as "ugly"—collecting and displaying folk art marks one's class distinction.

Perhaps the strangest feature of all in folk art's appeal has been the manner in which it permits collectors to envision themselves as charitable, as those who "preserve the lone and forgotten." "I've always sort of championed the cause of the underdog in society," said art dealer Carl Hammer of Chicago. His attraction to folk and outsider art, he explained, "goes back to Carl Hammer wanting to defend defenseless people or people who have not won their full recognition as part of the human picture." Yet there is, of course, a difference between possessing a piece of folk art and associating with folk artists, between wanting to defend the defenseless and working to alleviate the need (and urge) for such self-congratulatory heroism. It would be unjust to expect such a goal of folk art collectors or folk art scholars, except that they, we, have pursued acquisition and documentation as such ennobling missions.

The fact remains that while the field of folk art has palmed some cash to poor people, many folk artists are legally proscribed from making anything like regular profit from their work. Even those who are prepared and able to get off welfare (perhaps a foolhardy decision given the erratic nature of art sales) risk losing their entitlement to Medicaid; most of the folk artists with whom I have spoken have one or more preexisting ailments and simply could not afford private insurance, could they in fact find it.[148] Edgar Tolson certainly labored under these constraints. According to his doctor, Paul Maddox, "He'd come in with a couple thousand dollars in cash and lay it out and say, 'Now look, you know, if I put this in the bank, they find out I've got it, I'll lose my check.'"[149] In one instance, Tolson actually mailed five hundred dollars in proceeds from sales of his carvings back to Michael Hall in Michigan, in a quandary as to how he could safely handle a sum this large. Under such conditions, folk artists cannot afford to succeed materially, lest word or evidence of their income catch the attention of an unsympathetic welfare official.

Inasmuch as contemporary Americans can sustain a notion of the holy, the folk art object, as grail of a touristic crusade, qualifies as a piece of the true cross. Relic of another's pain, it claims the power of the talisman, a bit of sympathetic magic to hold off our share of suffering. Robert Cantwell concluded his study of folklife with a harsh insight: "Now at last we descry in ourselves what we have demanded others to embody, enact, perform, and exhib-

it to us, our own nakedness and vulnerability—and in it the truth of human suffering that levels all distinctions."[150] Donny Tolson found the words to concur: "That's something we've all got to do. Dad done beared his cross."[151]

As much moral freight as folk art has been asked to bear, the imagined time of Cantwell's awakening has not yet arrived. Rather, folk art continues to mark the margin of escape affluent Americans hope to and have maintained, returning from dirt track America and rinsing the red clay from their shoes. The Folk Art Society of America, a national organization of collectors, emblazoned a recent circular with a remark—ennobling, endearing, and above all reassuring—from Hazel Kinney, a painter from Fleming County, Kentucky. Kinney, who knows the rules by now, observed, "Our work can go where we cannot go."

CONCLUSION: THE TEMPTATION

Over Edgar Tolson's wooden dolls, and much twentieth-century folk art, has extended the tumid, inviolable glow that institutional acceptance brings. And with this public sanction—the outcome of affection, dispute, photographic flash—folk art has grown oddly quiescent, as if in achieving their capacity to "speak the language of art," Tolson's dolls call out now only for distilled interpretation and respect, the most muted kinds of engagement. If the mood here grows elegiac it is because formerly, from roughly 1967 through the early 1980s, folk art pointed down a far more daring and purposeful route. It once suggested that the most painful social and economic inequities might be addressed in expressive terms, that the goal of social justice could be advanced through aesthetics' noncoercive and immediate means.

Throughout this same period, and extending into the last decade of the century, U.S. avant-garde art too took on a political cast, yet in comparison with the works of Hans Haake, Barbara Kruger, and other sophisticated artists, folk art's project was both less and more direct. As an art movement, it was mobilized almost wholly from without, by poverty workers, anxious college students, undercapitalized collectors, young academic artists, and scholars with much to prove; collectively they endorsed a group of otherwise unaffiliated woodcarvers, painters, and backyard assemblers, based on those makers' stylistic eccentricities and personal hardships, and gave their creations a name: twentieth-century folk art. Thus, unlike surrealism, pop, or conceptualism, contemporary folk art was fundamentally an invention and federation of collectors, rather than a formal aim or a fellowship of artists. Also in contrast with more urbane art movements, folk art's political significance lay less in content or technique than in mere presence. Folk art posed its argument directly, through celebratory assertion rather than critique. Exuberantly, it disclosed that a nation's most disadvantaged people could speak the profound, venerable language of art and so warranted the rewards society pays for that magic work. Further, folk art implied that such rewards were due not only to individual artists but to the hard-hit groups from which they, in suffering and imagination, came. It is this social and

Adam and Eve, 1968. Collection of John Tuska and the estate of Miriam Tuska. (Photograph, Charles Bertram)

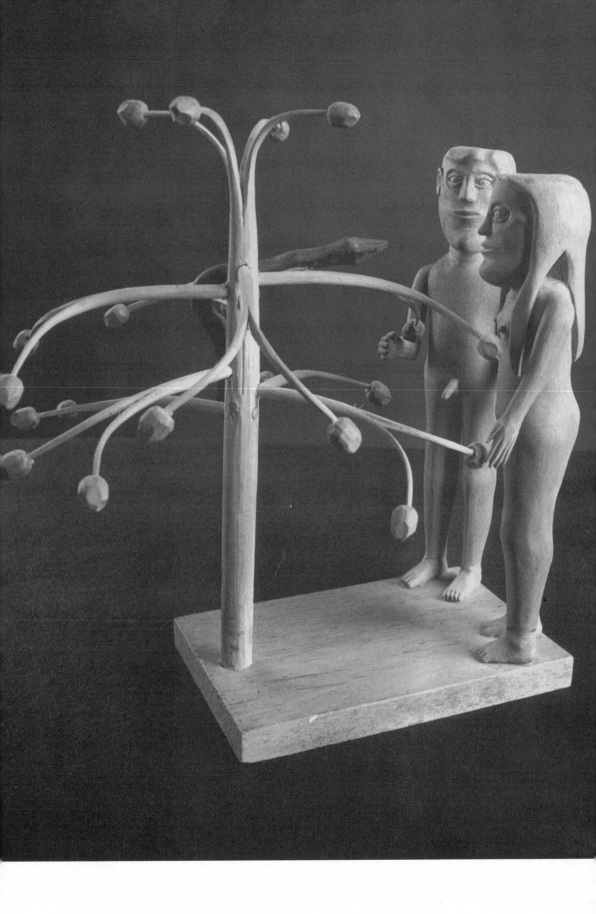

moral freight, more than any formal qualities, that accorded folk art its special value.

Yet the potential dynamite in mixing art with politics, chemistry of enterprises like the Grassroots Craftsmen, strangely backfired. Where originality and expressiveness were to further social justice, instead poverty and racism became increasingly aestheticized, their political actualities squeezed out, leaving wondrous husks behind. From social realities and the perplexing prospect of changing them most folk art enthusiasts withdrew, fixating instead on their own material successes and ethical failures. The moral potency of folk art, once a blueprint for social change, came to be enacted through chagrin, accusation, and individuating (thus, self-exonerating) charges of exploitation and villainy. Having abandoned its larger aims, the folk art field now preserves its cultural gravity with morality tales of personal ambition and greed. Popular magazines condemn "The Selling of Howard Finster" and ask of contemporary self-taught painters "How will all this success affect their art?"[1] CBS's 60 Minutes program televised an attack on Atlanta art dealer Bill Arnett for his management of Thornton Dial's career, and before a seminar audience, gallery owner Joe Tartt introduced himself with mock apology as "a grateful recovering folk art dealer."[2]

The Tolson children have also questioned whether Edgar received his due. Wanda Abercrombie asserted, "Oh, I'm sure his work helped a lot, a few people out, made them quite wealthy, you know. But as far as my mother, it didn't do nothing for her, nothing." Donny Tolson conceded, "I just always kind of felt bad. I thought Dad should have got more out of his work all along. Dad just never did move up his time, you know, for shopping and stuff. He didn't know the value of nothing really."[3] The centering conversation in this cultural arena—involving dealers, scholars, commentators, artists, and their families alike—over time has ceded faith in folk art's social and political potentialities and instead decries personal injuries; a reader of this manuscript insisted on knowing "who the heroes and villains are." Who, indeed?

The complexities of Tolson's story alone demonstrate that, however tempting, such dichotomies falsify both historical fact and cultural reality, in which sympathy and collusion balance—often override—self-interest and estrangement. To envision folk art as the product of cultural domination alone drives too sharp a division between folk artist and collector and reduces their interaction to a fable of oppression. This legend disguises what is typically, as Tolson's story shows, a more collaborative symbolic venture. Although the apprehension of differences—in regionality, age, and social class—certainly contributed to Edgar Tolson's allure, especially among non-Kentuckians, in fact the success of his woodcarvings owes as much or more to those sensibilities he and his admirers shared: his affectation of the renegade role, his artis-

tic ambition and skill, penchant for self-promotion, political liberalism laced with cynicism, his struggle to be free of attachments, and, crucially, his religious longing and doubt. In these important respects, Tolson and his admirers inhabited a shared culture, and from that commonality his carvings drew much of their communicative power.

Furthermore, though collectors profess to enjoy Tolson's carvings for their originality and primitive strangeness, most of his themes were suggested by collectors themselves: John Tuska first asked for Adam and Eve, Marian Broadus requested the unicorn, Carl Fox solicited Noah's Ark, and Rick Bell recommended that Tolson attempt Uncle Sam. Some of the carvings were in fact collaborations: Tolson allowed that James Broadus had helped him pattern and stripe the trousers of his prototype Uncle Sam, and during a 1978 recorded interview with the woodcarver, Michael Hall and others can be heard helping Tolson with sanding and assembly.[4] Public reception also changed Tolson's artistic style; "I like painted work," he remarked, though gradually he gave up painting and shellacking his carvings after learning collectors' preference:[5] "I don't know why but museums just don't want it painted. They don't want nothing on it. They want it just plain wood like you carve it out."[6]

Time and again, Tolson worked from images collectors provided: Sarah Asher's postcard of the Cloisters unicorn tapestry, a book of Doré biblical engravings Sal Scalora gave him. Tolson fashioned his first Noah's Ark after "somebody sent me a photograph from New York that showed the shape of the building."[7] The woodcarver adapted other subjects from popular sources: "I was watching a Walt Disney show," he told Skip Taylor, "and they popped up a unicorn, something they'd created theirself out of cement or something. It was a statue of a unicorn. And I got a glimpse of it and I sat down and carved it. That was my first one."[8] Michael Hall remembered that Tolson's carved giraffe was based on a Hi C juice can's label. In other words, though his works bear traces of folk sources, they owe as much or more to the tourist arts of Appalachia popularized through Allen Eaton and the Campbell Folk School, to mass culture, and to the influences of folk art collectors themselves. Once Tolson was hired as a commercial artist, to carve a sign for the Lone Wolf restaurant.[9] He was not so different after all from Michael Hall, who, as a California teenager infatuated with calypso music, had carved wooden tikis and masks for sale as restaurant decor.[10] Artists and their patrons have been portrayed as "two distinct sides" of a cultural drama, but on closer inspection the line between them blurs.[11]

A vision of powerful collectors and powerless artists also fails to recognize the extent to which participants like Tolson have themselves cultivated, in fact, *created* the folk artist role. To Michael Hall, Tolson may have expounded

on the book of Genesis, to Skip Taylor his definition of art, but with many others he struck a less dignified pose. As if cloaking himself in Appalachian stereotype, he told Marian Broadus, "They'll holler some of them I'm famous. I'd say, 'Hell no, I'm not. I'm just an old hillbilly.'" Of his own children, he told me, "I had six in the first litter."

Through the years Tolson remained remarkably consistent. He dwelled on many favorite stories, pounding his core themes—disdain for perfection, the persistence of sin, and a mixture of utter confidence and diffidence concerning his own artistic talent. Still, there are signs that he also adopted a somewhat "folkloristic" attitude toward his carving, shaped by waves of admirers, participation in organized festivals, and much published praise. Quite reasonably, he assumed the mantle of the tradition bearer, a role others had ascribed to him. To explain his proclivity for Old Testament subjects, he told an interviewer in 1971 simply, "I was raised around the Bible. I like it," but nine years later he could profess, "I'm sort of a Bible historian."[12] Early on Tolson described woodcarving as a personal impulse, a kind of itch that only the leisure of forced retirement could relieve: "It was always in me. By God, I always wanted to do that. I never seen a damn thing in my life I couldn't sit down and whittle out something just like it. And I've had that in me ever since I was a boy but I never would fool with it till I got knocked out of work."[13] By 1980, however, after contemporary folk art had been established as a discrete and reputable art subculture with conventions of its own, Tolson had adopted those conventions. He was comfortable describing his woodcarving as "a lost art" and, with all the contradictions this suggests, had become a professional folk artist. "I'm really proud that people think that much of my work," he said in 1981, "because it's something that makes a record for you and it's something that you're going to leave behind one of these days. And it'll be here when you're gone. And there ain't too many fellows left anything here as they went out, that you could see."[14]

Tolson not only answered the expectations of his patrons; the public self he crafted, as well as his remarkable woodcarvings, became standards later folk artists and collectors would emulate. Jan Rosenak remarked, "We got spoiled by Edgar Tolson, Steve Ashby, Sam Doyle. There are very few of that sort of folk artists still living." In Carl Hammer's judgment, "The successive waves of Kentucky folk carvers are basically copy cat artists." Rick Bell agreed:

> I've seen folk art wanna-bes. And you see a situation like Edgar in his community. When he started getting attention and making money, others say, "Oh, I can whittle too." There's a difference between art and craft. Those are craftspeople. There's nothing wrong with that if you want decoration, but they're not the visionaries. They're not the ones who are breaking rules

and often suffering for it. I think Edgar really suffered a lot of public humiliation and was an outcast because he did these crazy things.[15]

Bell's appraisal of Edgar Tolson's extraordinary gift, a judgment shared by many others, begins to explain why the contemporary folk art field over time betrayed its former social and political promises. The terms of traditional Western aesthetics, centrally its principle of disinterestedness that calls for the renunciation of power or gain, were utterly incompatible with goals that required political force, self-investiture, and blatant economic demand. Staked on aesthetic virtues, their requisite "inversion of ordinary economies," folk art's ideology ceased to view poverty and racial injustice as problems to be attacked but rather as credentials to be admired. To engage in the political arena, daring to win, imperiled a system of cultural privileges anchored by a caste of "losers." And because vying folk art collectors, dealers, and scholars, sharing a reasonably comfortable socioeconomic niche, rather than scattered painters and woodcarvers, dominated the folk art field, the goal of preserving disinterestedness, the gold standard of artistic culture, would always override the interests of folk artists themselves.

Meanwhile, folk art's cause has dwindled to repudiation and lament. Artists feel compelled to pledge that they have "never had any training whatsoever in art, not even a class,"[16] while collectors air their misgivings: "Though I fear public exposure may endanger the creative output of these sensitive souls, it is important for me to share my collection because I truly believe that the public will be enriched by the simple wisdom of these people and the evocative power of their art."[17] Folk art collecting continues, though less and less convincingly, to make possible the pose of social and aesthetic protector. "I was concerned back then and still am concerned today about the influence of the dealers and of the gallery and museum economic system and what effect it has on artists, primitive artists, untrained artists," one collector said. Ken Fadeley allowed that, as Tolson's patron and friend, he found himself increasingly disgusted: "People would dismiss him as just being another hick or a hillbilly. And I think over the years I certainly resented that." Fadeley alluded to "all the artists and the collectors and the dealers and everything coming in and walking away from that situation . . . hearing their really ignorant comments of the situation. I found myself over the years becoming very protective of him. When I got off the phone from you last week, I felt like that was coming out again."[18] Folk art collecting has involved extra-aesthetic motivations. It has stirred ethical and emotional wells, enabling collectors to see themselves not as acquisitors and adventurers only, but as beloved friends and philanthropists. Through an enjoyable diversion, traveling out of the way, buying good art for low prices, folk art enthusiasts may compliment them-

selves on a certain altruism, on exercising what Gramsci called "the means of good will."[19]

In the case of Edgar Tolson, this goodwill took many forms: women who visited the Tolsons often brought gifts and other household supplies. Miriam Tuska recounted taking soap and shampoo to Hulda Tolson. Julie Hall gave a bedspread to Hulda, which Mrs. Tolson chose to store away in a drawer rather than soil with use. The Halls brought the Tolson children a bicycle. Young men from University of Kentucky, Hall, Fadeley, and others, moved the family's belongings among several residences and carried out maintenance chores of carpentry, flooring, and roofing. Hall, Fadeley, Taylor, and Hackley, of course, also served as Tolson's promoters in the art world, working variously as tour guides, critics, dealers, biographers, and fellowship applicants.

In a sharply cynical appraisal of this kind of assistance, West Virginian Bill Best wrote in 1979,

> Our helpers from the left come here more to be healed than to help—to partake in the psychic nurture that, for many reasons, escaped them or eluded them during their formative years. Appalachian "Soul" is their "Ace in the Hole," just as surely as coal is "Kentucky's Ace in the Hole," because Appalachian Soul can help heal the split of the psyche caused by over indulgence in things material, quantitative, and conceptually abstract, and the concurrent denial or suppression of feelings, spirituality, and the arts.[20]

Best's essay, for all its harsh truths, failed to acknowledge a more pardonable reality, a more general dilemma in which these "helpers" found themselves as, by visits, promotions, purchases, photographs, they attempted to imbue folk art with purpose. Through wooden dolls, prisoners' drawings, and quilts, folk art's champions had tried to shift essentially social problems onto a personal plane, the better to solve them. Thus did Edgar Tolson's admirers hope to fight prejudice with friendship, political domination with personal respect, economic oppression with individual generosity. Their failure reflects naïveté compounded by hubris, to assume one's own kindness could annul the enduring history of inequality.

Anne Toepker Glenn, former Appalachian Volunteer, saw in hindsight,

> I was this bleeding heart who wanted to do some good, but to this day, people say, "What did you do in VISTA?" I say, "Well, I drove a truck, I helped people get to the doctor and I just enjoyed tremendously getting to know the families that I got to know." But truthfully I have to question whether I did any real good in a way. Because I was just so young and I had no experience, I had no training, and I didn't really know how to help these

Tolson and his son Charles, 1969. (Photograph, Rick Bell)

people. Now you think, gee, what really can someone like that do without training? These people had no jobs, they had no money, they had no way to get a job. I couldn't change those circumstances. . . . Now when I look back on my years as a VISTA volunteer, I think, oh my Lord, I was so naive and young and, almost misdirected in a way. I mean that in the sense that I really didn't know how to impact any change there. . . . Now I look back at it and think the only way to make any change in eastern Kentucky would have been politically.

Michael Hall, who came into Edgar Tolson's life soon thereafter, turned deliberately away from politics the night the ROTC building burned, to find

where a studio in my mind could prevail and not be threatened and compromised. . . . My politics as such moved into a different direction, and my activism really turned into my own work and turned into my folk art crusade, I suppose. I think in the end I became more effective from the lecture pulpit maybe than in the streets, and I wouldn't tell you that sometimes it

doesn't sort of tug at you, but I found a way to use my talents and I found a way to sort of reconcile my feelings and run my life artistically.

The Appalachian Volunteers and young artists who came after them to Wolfe County confronted what Reinhold Niebuhr called "one of the tragedies of the human spirit: its inability to conform its collective life to its individual ideals."[21] While in individuals the natural impulse of altruism might counterbalance or even overrule egotism, at the group level egotism cannot be checked, he argued, without conflict and force. "The justice which even good men do is partial to those who design it."[22] This underlying reality required that altruism be socially enforced, even though political recourses risked new forms of injustice and violence. These same conditions laid a vexing temptation before those who had been oppressed: "In order to undermine their oppressors' claims to moral superiority, they had to avoid such claims on their own behalf. They had to renounce the privileged status of victims."[23] Only through such renunciation might subalterns stand as imperfect equals. Throughout twentieth-century folk art's history, neither justice's "designers" nor injustice's "victims" have solved these twinned problems.

In the folk art market, where affluent buyers typically encounter impoverished sellers, political interventions have been, if not fully implemented, at least proposed. Scott Cook, working with the artisans of Oaxaca, Mexico, recommended to the Mexican government several measures to improve the bargaining position of carvers and weavers. He presented a plan, ultimately ignored by the government, to regulate both the acquisition of materials and the marketing of finished works, its goals to "stimulate a process of social (as opposed to individual) accumulation" and to reduce the sort of self-exploitation so prevalent among handicrafts producers and folk artists alike.[24] Analyzing why this proposal failed, Cook blamed foremost the Mexican state's bias toward capital-intensive development, but he alluded to another important obstacle as well: aestheticism. "Mexico's artisans are impaled by a paradox: ideologically and politically they are first class citizens sanctified as bearers of the authentic Mexican cultural heritage; but economically and existentially they are second class citizens condemned to a perpetual struggle for survival and presented with few opportunities for capital accumulation, or even for material progress, through enterprise and hard work."[25] The organization and mobilization of artists run counter to core principles of Western aesthetics, which since the Renaissance have obfuscated, and in some instances forbidden, artists' prosperity and social attachment. This ethos has demanded not only disinterestedness but alienation, a requirement applied with such stringency today as to authorize only the most autistic and debilitated of creators.

As if Niebuhr's "tragedy" were instead only a hard bargain, those with the means of goodwill have sought some compromise, some navigable middle way, around material costs, obligation, and the potential for violence that social change requires. With these fearsome alternatives in view, there arises a temptation: to take refuge in private sacrifice, philanthropy, and the eloquent object, which in its beauty and immediacy promises a gateway, heretofore invisible, back into the garden. Folk art ultimately may lead away from rather than toward the goal of justice owing to its suggestion of such a shortcut.

As social inequalities have sharpened, the folk art world broadcasts its obsession with personal rectitude, its cowering guilt over "privilege," failing to recognize that privilege for what it is: the mask of power. Dean MacCannell, writing of the tribespeople whose lives and art have become attractions, made plain, "Their problem is not petty exploitation by tourists. Rather, it is getting money and having it."[26] This was Edgar Tolson's problem, too, a blade that shaped him, but it was not his only difficulty. Like the patrons who cherished him, Tolson too was pained to face his situation, its particular temptation and chance, and to relinquish the trickier privilege of frailty.

NOTES

Unless otherwise noted, all quotations were drawn from interviews conducted by Julia S. Ardery, University of Kentucky Oral History Collection, Lexington, Kentucky (see bibliography for complete list of informants). Uncited quotations from Michael D. Hall come from the interview recorded April 3, 1993.

Abbreviations have been used for materials from the following archival collections:

AV Appalachian Volunteers Collection, Southern Appalachian Archives, Historical Collections of Berea College, Berea, Ky.

KGAC Kentucky Guild of Artists and Craftsmen Collection, Southern Appalachian Archives, Historical Collections of Berea College, Berea, Ky.

WCHM Wolfe County Historical Museum, Campton, Ky.

INTRODUCTION

1. See Hartigan, *Made with Passion*.

2. Sellen, *Twentieth Century American Folk, Self Taught, and Outsider Art*, 3–65.

3. See Milwaukee Art Museum, *Common Ground*.

4. Cantwell, *Ethnomimesis*, 1.

5. See Gans, *Popular Culture and High Culture*; Hauser, "Folk Art"; Howard Becker, *Art Worlds*; and Bourdieu, *Distinction*.

6. See Briggs, *Wood Carvers of Córdova*; Michael Owen Jones, *Craftsman of the Cumberlands*; Bronner, *Chain Carvers*; Suzi Jones, "Art by Fiat"; Joyce, "'Fame Don't Make the Sun Any Cooler'"; Seriff, "'Este Soy Yo'"; Manley, "Robbing the Garden."

7. Several fine studies that comprehend the artist/audience relationship as less patently destructive and antagonistic may be found in Graburn, *Ethnic and Tourist Arts*.

8. Ames, *Beyond Necessity*; Ames, "Folk Art: The Challenge and the Promise"; Ames, "Folk Art and Cultural Values"; Whisnant, *All That Is Native and Fine*; Metcalf, "Black Folk Art"; Metcalf, "From Domination to Desire"; Metcalf, "From the Mundane to the Miraculous"; Metcalf, "The Politics of the Past"; Jane Becker, "Selling Tradition"; Cubbs, "Rebels, Mystics, and Outcasts."

9. Important exceptions to this pattern, combining critique and biography, are Graburn, "Eskimo Art"; Briggs, *Wood Carvers of Córdova*; and Metcalf's analysis of William Edmonson in "Black Folk Art."

10. Benjamin, *Bonds of Love*, 9.

11. See Clifford and Marcus, *Writing Culture*.

12. Only Michael D. Hall, Russell Bowman, and George Meyer asked that they have the opportunity to review and edit cited portions of the transcript.

13. Most of the interviews cited here are available for use through the University of Kentucky Oral History Collection, Lexington, Ky.

CHAPTER ONE

1. Elvin Tolson interview. The Tolson children, by order of birth, were Floyd, Calvin, Tressie, Edgar, Dovey, Maggie, Mahalia (Haley), Logan (Loge), Elvin, Sam, and the youngest son, Shirley.

2. Ibid.

3. Edgar Tolson, interview with Michael D. Hall and J. Roderick Moore.

4. Ibid.

5. Edgar Tolson, interview with Ellsworth Taylor, January 17, 1973.

6. Edgar Tolson, interview with Hall and Moore. Tolson reported that he left school at age eighteen in interview with M. Watt.

7. Edgar Tolson, interview with Taylor, 1973.

8. See Barrett, *Muffled Voices*, 4; Borum, "Term Warfare," 24–31.

9. Edgar Tolson, interview with Marian and James Broadus.

10. Edgar Tolson, interview with Hall and Moore.

11. Conti, "Mountain Metamorphoses," 94–95.

12. Edgar Tolson, interview with Hall and Moore.

13. Conti, "Mountain Metamorphoses," 45.

14. Edgar Tolson, interview with Broaduses.

15. Lyne, "Edgar Tolson, Sculptor," 5.

16. Chuck Rosenak and Jan Rosenak, *Museum of American Folk Art Encyclopedia*, 304.

17. Edgar Tolson, interview with Hall and Moore.

18. Edgar Tolson, interview with Estill Curtis Pennington.

19. Ibid.

20. Accounts of Tolson's career as a minister are sketchy. Brother Elvin Tolson said that Edgar had begun to preach before Elvin and Sally married in October 1933. In notes for a Tolson biography, Ellsworth Taylor wrote that Tolson "began studying the Bible and became deeply involved with the Baptist church" in 1930. Field notes by Michael Hall record that Tolson preached from 1921 until 1962.

21. Monnie Profitt interview.

22. Edgar Tolson, interview with Taylor, 1973.

23. Conti, "Mountain Metamorphoses," 63–73.

24. *Early and Modern History of Wolfe County*, 8.

25. Ibid., 19.

26. Conti, "Mountain Metamorphoses," 78.

27. Ibid., 79.

28. Edgar Tolson, interview with Pennington. It was this work in the Troublesome Creek vicinity, along the Perry/Knott County border, that very likely brought Tolson into contact with early handicraft enterprises then under way at Ary and Hindman. See chapter 2.

29. Elvin Tolson interview. Though it is not clear where Edgar learned this craft, Elvin remembered that Floyd King, a neighbor near Trent Fork, was an accomplished chair maker. Elvin, who also made chairs, claimed to have learned by Mr. King's example.

30. Edgar Tolson, interview with Hall and Moore.

31. Edgar Tolson, interview with Pennington.

32. Edgar Tolson, interview with Taylor, 1973.

33. Rick Bell interview, August 3, 1993.

34. This quote is drawn from field notes made by Michael D. Hall after Hall's first trip to Campton, May 1968.

35. *Old Friends, New Friends.*

36. Kentucky State Department of Corrections, "Tolson, Edgar."

37. *Old Friends, New Friends.*

38. Though his parole report portrayed Tolson as a wandering musician, his children contended that Edgar never played music of any sort. Perhaps the instrument was just a whittler's experiment. Its whereabouts are unknown. A 1968 newspaper article about Tolson noted, "He says he has no musical talent, but has made two guitars." Booth, "Campton Man Launches New Career."

39. Flossie Watts interview.

40. Kentucky State Department of Corrections, "Tolson, Edgar."

41. Edgar Tolson, interview with Michael D. Hall, 1972.

42. Donny Tolson, participating in Elvin Tolson interview.

43. A powerful fictional account of this migration may be found in Harriette Simpson Arnow's novel *The Dollmaker.*

44. Edgar's and Hulda's children are as follows: Blanche (September 13, 1944), Flossie (October 25, 1945), Carl Edward (July 17, 1947), Wanda Lee (August 22, 1948), Edmond (December 15, 1950), Wilgus (August 19, 1952), Corbett (September 11, 1953), Charles David (April 14, 1956), Linda (August 1957), Donald Lee (December 1, 1958), Mary (March 12, 1960), Connie (February 13, 1961), Ronnie (February 5, 1963), Paul (July 27, 1965).

45. Hall exhibited the fireplace post in a 1970 exhibition of Tolson's carvings at the University of Kentucky. See also Colt, *Edgar Tolson,* 24, and Ricco, Maresca, and Weissman, *American Primitive,* 258.

46. Edgar Tolson, interview with Hall and Moore. Michael Hall in an interview with the author, April 3, 1993, also recalled seeing the remains of a stone turtle with crosshatched shell in the yard at Holly, another piece Tolson produced during this period.

47. Notes made by Michael Hall in 1969, his effort to list all Tolson's pieces to date, record "6 Tomb Stones, one set in Holly, cement, rest up in Breathitt (all 44–48)."

48. Ames, *Beyond Necessity,* 29.

49. For more on place markers, see Abernathy, "Folk Art in General, Yard Art in Particular," and Igo, "Guardians, Surviving Folkways," both in Abernathy, *Folk Art in Texas,* 3–15, 30–37.

50. Monnie Profitt interview.

51. Coleman et al., *Rural Development.*

52. Campton Medical Clinic, "Tolson, Edgar." Tolson's medical records, from 1957 until 1984, were made available by Dr. Paul Maddox, Campton, Ky.

53. Ibid.

54. Edgar Tolson, interview with Broaduses.

55. Manley, *Signs and Wonders,* 9. See also Laffal and Laffal, "Demographic Perspectives," 6–7, and Kaufman and Barrett, *Time to Reap.*

56. Manley, *Signs and Wonders,* 10.

57. Edgar Tolson, interview with Broaduses.

58. "Apart from mood disorders, other disturbances of the brain have been associated with artistic creation, in particular, temporal lobe epilepsy," from La Plante, "In the Temporal Lobes, Seizures and Creativity," B6. A scientific examination of how Tolson's mental health affected his artistic output is beyond the scope of the present work, but Tolson should certainly be included in future studies of this phenomenon.

59. Bishop, *American Folk Sculpture*, 328, 337, 345.

60. Bishop's survey includes a nineteenth-century example. For more information on the history and iconography of this piece within the Hispanic carving tradition, see Briggs, *Wood Carvers of Córdova*.

61. Eaton, *Handicrafts of the Southern Highlands*, 192, 228, 238.

62. Ibid., 182.

63. See photograph in Bronner, *Chain Carvers*, 112.

64. See Ardery, "Past and Presence," 12.

65. Hackley, *Remembrances*, 7.

66. Ibid., 12.

67. Edgar Tolson, interview with Hall and Moore.

68. Metcalf, "From Domination to Desire," 226. See also Metcalf's "From the Mundane to the Miraculous."

69. See Sherlock, "Rhetoric of Rusticophilia."

70. Ardery, "From the Well."

71. Bronner, *Chain Carvers*, 12.

72. Ibid., 20.

73. Donny Tolson interview, June 9, 1993.

74. Ibid.

75. Both Donny Tolson and Monna Cable approximated the date of this piece as 1962.

76. Donny Tolson interview, March 24, 1993.

77. See Goings, *Mammy and Uncle Mose*, 18–19.

78. About the same time, according to notes made by Michael Hall, Tolson wrought another large African American figure of comparable scale, this one holding a fish. The piece originally belonged to Earl White, owner of a horse farm near Winchester, but according to Hall, who endeavored to purchase the piece in the 1970s, it was destroyed.

79. In Hall's field notes these pieces were noted as "yard birds." Donny Tolson identified them as "flamingos."

80. Graydon Taulbee interview.

81. Field notes made by Michael Hall, 1969.

82. Booth, "Edgar Tolson Whittles Out New Career." Also Ford, letter to author.

83. Bronner, "Cane Making," 220.

84. Mary Tolson interview.

85. Booth, "Edgar Tolson Whittles Out New Career."

86. Rick Bell interview, August 3, 1993.

87. Ibid.

88. Clifford, *Writing Culture*, 2.

89. The rise of such forms of documentation as types of surveillance, their roles in generating the social sciences, and their impact as inscriptions of power have been

critically investigated by Michel Foucault, notably in his work on prisons and mental asylums: *Madness and Civilization* and *Discipline and Punish*. For example, see "The Examination," in *Discipline and Punish*, 184–194.

90. Geertz, "Impact of the Concept of Culture," 44.

CHAPTER TWO

1. Edgar Tolson, interview with Taylor, May 16, 1979.

2. Ehrenreich, *Fear of Falling*, 10.

3. Cited in Gitlin, *The Sixties*, 128.

4. Ibid., 151.

5. Quoted in Gitlin, *The Sixties*, 161–62.

6. Ibid., 163.

7. West, "Romantic Appalachia," 210.

8. See Arnow, *The Dollmaker*; Batteau, *Invention of Appalachia*; Becker, "Selling Tradition"; Cunningham, *Apples on the Flood*; Miller, *Mountains Have Come Closer*; Norman, *Divine Right's Trip*; Smith, *Strangers and Kin*; Shapiro, *Appalachia on Our Mind*; Whisnant, *Modernizing the Mountaineer* and *All That Is Native and Fine*.

9. Batteau, *Invention of Appalachia*, 202.

10. Gramsci, *Selections from Cultural Writings*, 205.

11. Gitlin, *The Sixties*, 164, 246.

12. Adam Yarmolinsky, quoted in Patterson, *America's Struggle Against Poverty*, 134.

13. Bigart, "Kentucky Miners," 1.

14. Batteau, *Invention of Appalachia*, 160.

15. Conti, "Mountain Metamorphoses," 31.

16. See table 5 in Coleman et al., *Rural Development*, 8.

17. See Wakefield, "In Hazard," 10–25.

18. "Committee for Miners."

19. See Johnson, *Roving Pickets*.

20. Norman interviewed in Johnson, *Roving Pickets*.

21. "Committee for Miners."

22. One example involving Appalachian handicrafts specifically had been the North Carolina–based Southern Highlands Handicrafts Guild. See Becker, "Selling Tradition," chap. 3.

23. See Garland, *Welcome the Traveler Home*.

24. For a critique of this policy see Whisnant, *Modernizing the Mountaineer*, chap. 4.

25. Volunteers in Service to America, *VISTA*, 26.

26. Whisnant, *Modernizing the Mountaineer*, 186.

27. Ibid., 192.

28. See Conti, "Mountain Metamorphoses." This dissertation, based on Conti's 1966–67 VISTA year and additional fieldwork, analyzes Wolfe County using Wallerstein's theory of world systems, chronicling the area's poverty and stratification as evidence of long-term "underdevelopment."

29. Michael Royce changed the spelling of his surname.

30. Wolfe County project sites included Antioch, Bailey Fields, Bloody Creek, Hunting Fork, Malaga, Mullins Point, Pence Branch, Sandy Ridge (Smith), Vortex, and Calaboose.

31. Whisnant, *Modernizing the Mountaineer*, 209.

32. Copies of most issues of *Grassroots Gossip* and its successor the *Kindling Wood* are archived in box 130–34, AV.

33. Conti, "Mountain Metamorphoses," 52.

34. "A Start," in *Grassroots Gossip*, December 16, 1966, 7, AV.

35. "Report from Wolfe County," *Grassroots Gossip*, November 1966, 6, AV.

36. Ibid.

37. "Quilting Meeting Held at Hays Branch Community," *Grassroots Gossip*, November 1966, 6, AV.

38. Bickel, "Story of the Grassroots Craftsmen"; "Mrs. Moore" is mentioned in a Grassroots Craftsmen sales pamphlet, courtesy of Dwight Haddix. See also Mary Dunn, "The Quilting Circle," *Grassroots Gossip*, December 16, 1966, 3–6, AV.

39. Anne Glenn interview.

40. Addams, *Twenty Years at Hull House*, 231–34.

41. See Becker, "Selling Tradition"; Whisnant, *All That Is Native and Fine*, chap. 1; and Shapiro, *Appalachia on Our Mind*, chap. 9.

42. See Becker's discussion of the Women's Bureau's 1934 study, "Selling Tradition," 170–74.

43. Ibid., 373.

44. Ibid., 432.

45. "Exhibitors 1967 Fair," KGAC, box 1, folder 377. A 1976 survey found twenty-two craft co-ops operating in Kentucky, more than in any other Appalachian state. See Arnold, "Appalachian Cooperatives," 21.

46. Mary Dunn interview.

47. Bickel, "Story of the Grassroots Craftsmen," 9, AV.

48. "Grassroots Quilting Co-Op," *Grassroots Gossip*, December 12, 1966, 3–4, AV.

49. M. Dunn, "Can We Wipe Out Poverty?" *Grassroots Gossip*, March 10, 1967, 6, AV.

50. Personal letter from Margaret Magrath Reuss, May 13, 1993.

51. See Mainardi, "Quilts: The Great American Art."

52. M. Dunn, "The Quilting Circle," *Grassroots Gossip*, February 17, 1967, 1–2, AV.

53. Donny Tolson interview, March 24, 1993.

54. "All Boys in the Area . . . ," *Grassroots Gossip*, January 13, 1967, 2, AV.

55. Field notes of May 1968, courtesy of Michael D. Hall.

56. Bishop, *American Folk Sculpture*, 356. See also Lavitt, *American Folk Dolls*, 45–49.

57. Thanks to Robert Boyce of the Berea College art faculty for bringing these photographs to my attention.

58. Several of the Kinney puppets are now in the collection of the Huntington Museum of Art.

59. See "Limberjack or Dancing Doll," 208–13, and Arnow, *The Dollmaker*.

60. Edgar Tolson, interview with Pennington.

61. George Wolfe, letter to Kentucky Guild, May 20, 1969, KGAC.

62. File 389, KGAC.

63. "Sam D. Cecil," 1.

64. Weaver, *Artisans of the Appalachians*, 90.

65. Donny Tolson interview, March 24, 1993.

66. Notes taken by Michael Hall on Tolson's extant pieces, circa 1969, courtesy Michael D. Hall.

67. Donny Tolson interview, June 9, 1993.

68. See Clarke, *Kentucky's Age of Wood*.

69. See also Adler, "Home-Grown and Fotched-On," 14–26.

70. Edgar Tolson, interview with Taylor, 1973.

71. Ardery, "Charley Kinney."

72. For another approach to this question see Ennis, "Back to Basics," 16.

73. Eaton, *Handicrafts of the Southern Highlands*, 86–87.

74. Ibid., 188–89.

75. See Cobb, *Kinfolks*, 16. Thanks to Martha Quigley, director of Bobby Davis Museum, Hazard, Ky., for bringing this source to my attention.

76. Eaton, *Handicrafts of the Southern Highlands*, 87.

77. Ary is located on State Route 476 between two of the school buildings Tolson helped to build, roughly five miles from both Rowdy and Talcum.

78. Eaton, *Handicrafts of the Southern Highlands*, 188.

79. Edgar Tolson, interview with Hall and Moore.

80. Ibid.

81. Colt, *Edgar Tolson*, 30, 34, 35.

82. Edgar Tolson, interview with Hall and Moore.

83. Edgar Tolson, interview with Pennington.

84. The only known exception, other than his utilitarian canes, was an "oak table with a round top 48 inches in diameter, a decorative column and four legs with lions' paws carved where they rest on the floor." Tolson remarked, "I did it for a retired soldier. He gave me $50 but I woulda done it for nothing. He's a friend." (Tolson may have been referring to his commission from Ralph Likens.) Wagner, "Kentucky Woodcarver's 'Stroke' of Luck."

85. Edgar Tolson, interview with Pennington.

86. Field notes, May 1968, courtesy of Michael D. Hall.

87. See "Kentucky Guild of Artists and Craftsmen: Chronology," in *Kentucky Guild*, 39.

88. M. Dunn, "Quilting Co-Op Meets," *Grassroots Gossip*, May 12, 1967, 2, AV.

89. Barker, *Handcraft Revival*, 95. Although total 1967 receipts for the Grassroots Craftsmen are not available, the co-op took in only $125 at the 1969 fair ("1969 Financial Statement, Fair 1969," in "Operations 1960–1970" file, KGAC).

90. Reif, "Spotlight on Appalachian Craftsmen." The Georg Jensen show and sale were, of course, not new ideas; Jane Becker's work has explored many examples of Appalachian crafts sold as status commodities specifically through the Southern Highlands Guild via pricey East Coast outlets. It has been a strategy relentlessly revived and, in Kentucky, overtly politicized: Phyllis George Brown, former Miss America and wife of governor John Y. Brown Jr., appointed herself the state's "crafts ambassador" and in 1981 negotiated an "Oh Kentucky!" boutique at Bloomingdale's department store. See Ardery, "Crafts Book Recalls Browns' Consumer 'Legacy.'"

91. Ellis, "Vanishing Grass Roots."

92. "Crafts Market to Expand in This Area," May 4, 1967, in "1967 Spring Fair Statements," box 1, folder 371, KGAC.

93. Hackley, "Twenty-five Years of Growth," 12.

94. For a philosophical discussion of this principle of "tradition," see "Two Ways," in Yanagi, *Unknown Craftsman*, 132–142.

95. Bickel, "Story of the Grassroots Craftsmen," 7, AV.

96. Ibid., 1.

97. Bly, "Mountain Handicrafts Find Market."

98. Bickel, "Story of the Grassroots Craftsmen," 4.

99. Bly, "Mountain Handicrafts Find Market."

100. Seymour, "New Hope Springs."

101. Bly, "Mountain Handicrafts Find Market."

102. Three 1967 Tolson carvings of figures in overalls are *Farmer, Standing Man with Overalls*, and *Man with Cap*. See Colt, *Edgar Tolson*, 34.

103. Gitlin, *The Sixties*, 163.

104. Garrow, *Bearing the Cross*, 242.

105. In addition to the poppet tradition Eaton called "indigenous" to Kentucky, Polly Page, a carver from Pleasant Hill Academy in Tennessee, had been noted since the 1930s for her wooden dolls, chip carved and dressed in mountain garb (see Lavitt, *American Folk Dolls*, 52). According to author and doll maker Helen Bullard, Page fashioned "Uncle Pink" in cloth overalls and "Aunt Jenny" out of jointed cedar based on the "neo-primitive style" she learned from Margaret Campbell (Bullard, *Crafts and Craftsmen*, 171–72). These prototypes of "an old mountain couple" became models for later students at Pleasant Hill Academy, and literally thousands of such pairs were produced by Page alone. Mary Cole, also an early member of Grassroots Craftsmen, made dolls on the scale of the Page carvings, dressing them also in regional attire. Tolson may not have directly encountered pieces by the Pleasant Hill Carvers, but he surely had seen Mary Cole's dolls both at the guild fairs and at Grassroots' monthly gatherings.

106. Tangerman, *Carving Faces and Figures*, 53.

107. Graburn, *Ethnic and Tourist Arts*, 31–32.

108. Ellis, "Vanishing Grass Roots."

109. Personal letter from Fox, May 17, 1993.

110. Edgar Tolson, letter from Carl Fox, December 5, 1967.

111. See Whisnant, *Modernizing the Mountaineer*, 197–99.

112. "Memo from Executive Office of the President, Office of Economic Opportunity," July 21, 1967, file 67-3, AV.

113. Whisnant, *Modernizing the Mountaineer*, 203.

114. Vance, "Federal Study Team."

115. Casey, "Kentuckian Produces Penknife Art."

116. All references in this discussion are to Ellis, reporting on the quilters' visit, and Casey's feature story about Tolson.

117. Bly, "Mountain Handicrafts Find Market."

118. Field notes, May 1968, courtesy of Michael D. Hall.

119. Gary Bickel, telephone interview.

120. See J. Hall and Bowman, "Interview with Julie Hall," 41.

121. "Reminder!!" box 47, file 7, AV.

122. Though the enterprise persisted as late as 1995, with 1987 sales of over $120,000, it had ceased to operate as a cooperative; nor was its more recent mission fundamentally one of social change. See "Grassroots Craftsmen of the Appalachian Mountains, Long Range Plan."

123. Bly, "Mountain Handicrafts Find Market."

124. Haddix explained: for "a basic quilt, I have $225 to $250 in a quilt that's paid

to the worker, and my wholesale is $350." These quilts, large enough to be bedcoverings, come in such traditional patterns as flower basket and double wedding ring. In contrast, Mississippian Sarah Mary Taylor's smaller quilts, with their longer stitches and startling asymmetrical color combinations, sell for $2,500 and more. In their expressive and bold handling of the quilt medium, Taylor's works lay claim to the more prestigious (and costly) title of art.

125. See Whisnant, *All That Is Native and Fine*, and Becker, "Selling Tradition."

126. For a description of "non-discountable merchandise," see Walle, "Mitigating Marketing."

127. Seymour, "New Hope Springs," and Bickel, "Story of the Grassroots Craftsmen," 3.

128. Nancy Cole as quoted in Bly, "Mountain Handicrafts Find Market."

129. Whisnant, *Modernizing the Mountaineer*, 195.

130. Whisnant, *All That Is Native and Fine*, 172.

131. Scott, *Domination and the Arts of Resistance* and *Weapons of the Weak*.

132. Booth, "Wolfe County Quilts Make Hit."

133. "Memorandum" from Tom Rhodenbaugh, October 2, 1967, file 67-3, "1967 Memos," AV.

134. "AV's Fire Joe Mulloy," *Kindling Wood*, November 30, 1967, 3, file 130-4, AV. This edition of the newsletter, though dated November 30, had to have been published later, since it offered an account of the December 2 firing of Mulloy; the story also is "buried" on page 3, indicating that the editor might have thought it unwise to circulate this controversy more openly.

135. "Viewpoint," *Kindling Wood*, November 30, 1967, 2, file 130-4, AV, 2.

136. Donny Tolson interview, March 24, 1993.

137. Whisnant, *Modernizing the Mountaineer*, 204.

138. Gitlin, *The Sixties*, 233–37.

139. After OEO money for Grassroots ran out, the organization was tenuously maintained by grants from religious groups. These funds dwindled too in the mid-1980s. In 1988 Dwight Haddix bought out the business, which continued to operate out of Lost Creek, Kentucky.

CHAPTER THREE

1. Edgar Tolson, letter from Carla Heffner, December 10, 1967, WCHM.

2. Metcalf, "Public Art," 137.

3. Edgar Tolson, letter from Miriam Tuska, n.d.

4. Edgar Tolson, interview with Pennington. A mid-July memo in Tolson's medical file refers to "five little wooden figurines that he has been whittling on."

5. Booth, "Edgar Tolson Whittles Out New Career."

6. See Colt, *Edgar Tolson*, 31.

7. The Tuskas named their elder son Seth.

8. According to Miriam Tuska, Tolson said he had carved religious subjects before; more specifically he told Michael Hall he had begun in 1962 a "perfect" crucifixion carving, which was subsequently stolen. For a discussion of this piece's likelihood, see Ardery, "The Temptation," 197–98.

9. Casey, "Kentuckian Produces Penknife Art."

10. Edgar Tolson, interview with Broaduses.

11. Edgar Tolson, letter from Ralph Rinzler, April 22, 1968.

12. Receiving order dated July 3, 1968, and receipt from Smithsonian Museum Shops, July 11, 1968.

13. Richard Ahlborn interview.

14. Among those interviewed for this study who mentioned seeing Tolson's work at the Smithsonian were Michael Hall, Larry Hackley, Chuck and Jan Rosenak, Roberta Williams, and Tolson's physician, Dr. Paul Maddox, accompanying a Campton Boy Scout troop to the nation's capital.

15. Wagner, "Kentucky Woodcarver's 'Stroke' of Luck."

16. "Campton Carver of Wood."

17. Edgar Tolson, letter from Mrs. Norma C. Wilson, April 2, 1968.

18. Edgar Tolson, letter from John Bieber, n.d.

19. Edgar Tolson, letter from N. W. Polsky, April 2, 1968.

20. Tolson typically refused to mail his carvings. These arrangements were sometimes handled by others, as in this case by Miriam Tuska; ordinarily, buyers were expected to drive to Campton and pick their pieces up in person or, in later years, to purchase work through Michael Hall or Larry Hackley.

21. Edmondson's sculpture was shown without the "folk art" designation at the Museum of Modern Art in 1937, MOMA's first one-person exhibit by an African American artist, curated by Holger Cahill's wife, Dorothy Miller. Since 1970, and the "Twentieth-Century Folk Art" show Herbert W. Hemphill Jr. organized at the Museum of American Folk Art, Edmondson has been routinely exhibited and sold as a "folk artist," "visionary," or "outsider." See, for example, Yelen, *Passionate Visions of the American South*; Livingston and Beardsley, *Black Folk Art in America*; Hartigan, *Made with Passion*.

22. J. Hall, *Tradition and Change.*

23. See Lears, *No Place of Grace*, 96. See also Fred Davis, "Nostalgia, Identity, and the Current Nostalgia Wave."

24. M. Hall and Bowman, "Interview with Michael D. Hall," 25.

25. Ibid., 26.

26. Ibid.

27. Cantwell, *Ethnomimesis*, 109.

28. Ibid., 257.

29. Smithsonian Institution, *Festival of American Folklife 1968* (program), 22. Other carvers present included Willard Watson, toy maker, from North Carolina; kachina doll maker Edwin Kaye from New Mexico; and Roy Harris, also a maker of wooden figures in the chip-carving style.

30. George López and Savinita Ortiz interview. See also Briggs, *Wood Carvers of Córdova*, 69.

31. Edgar Tolson, letter from Mrs. George Toubin, February 27, 1969. The Toubins had visited Tolson in November 1968, when, presumably, he voiced this idea.

32. Edgar Tolson, interview with Pennington.

33. Edgar Tolson, interview with Taylor, 1979.

34. Edgar Tolson, interview with Broaduses.

35. Michael D. Hall, field notes, May 1968.

36. Guy Mendes interview.

37. Other Tolson carvings whose themes came directly or indirectly from patrons

include the dove and the *Uncle Sam*, both suggested by Rick Bell; the unicorn, requested by Marian "Mike" Broadus and later refined, after Tolson received a postcard Sarah Asher sent from the Cloisters; and the *Woman and Snake*, an image Tolson copied from an anonymous South Carolina piece pictured in the Brooklyn Museum's *Folk Sculpture U.S.A.* catalog (p. 52), which also included images of Tolson's own *Man with a Pony* and *Fall of Man* series.

38. Robbins, "Folk Sculpture," 27.

39. M. Hall and Bowman, "Interview with Michael D. Hall," 24. For another account, see Hartigan, *Made with Passion*, 35–37.

40. M. Hall and Bowman, "Interview with Michael D. Hall," 25.

41. Hartigan, *Made with Passion*, 7.

42. Ibid., 14–15.

43. Edgar Tolson, letter from Estelle Friedman, August 27, 1968.

44. Edgar Tolson, letter from Mrs. George Toubin, November 5, 1968.

45. Edgar Tolson, letter from Mrs. Marshall Segal, February 5, 1969.

46. Michael D. Hall, interview with Dennis Barrie, 104–5.

47. *The Kentuckian* 1969, 164–81, 142–43, University of Kentucky, Special Collections, King Library.

48. Rick Bell interview, August 3, 1993.

49. Ibid.

50. Bowman, "Looking to the Outside."

51. Dubuffet, *Asphyxiating Culture*, 28.

52. Bonesteel, "Chicago Originals," 130.

53. Course syllabi in the Whitney Halstead Papers, Art Institute of Chicago Archives.

54. For two discussions of this thesis, see Goldwater, *Primitivism*, 185, and Robbins, "Folk Sculpture," 19.

55. See Bourdieu, "Principles for a Sociology of Cultural Works," in *Field of Cultural Production*, 183, 187.

56. M. Hall, "The Problem of Martin Ramirez," 236.

57. See Ryerson, "Seri Ironwood Carving," 126.

58. Tromble and Turner, "Striding Out on Their Own," 40.

59. Bourdieu, *Distinction*, 567 n. 53. For a satirical exploration of this "solidarity," see Tom Wolfe's *Radical Chic*.

60. Julie Hall interview.

61. Hartigan, *Made with Passion*, 37. Hall has told this story to several other interviewers, including Barrie, Bowman, and this author.

62. Michael D. Hall, interview with Barrie.

63. Interview with Michael D. Hall, April 3, 1993.

64. Herbert Waide Hemphill, *Folk Art U.S.A. since 1900*, n.p.

65. Herbert W. Hemphill Jr. interview.

66. Hall and Bell, *The Work of Edgar Tolson*, n.p.

67. Pieces in the show included the *Man with a Pony*, Tolson's first *Noah's Ark*, *Temptation*, *Paradise*, and *Expulsion* tableaux, three rock pieces, early ox plaques, several canes, and many single figures and animal carvings. All twenty-six pieces available for sale were purchased the night of the opening. Fudge, "Mountain Craftsman," 2.

68. Hall and Bell, *The Work of Edgar Tolson*, n.p.

69. For an analysis of how "focusing a system of publicity" served the impressionist painters similarly, see White and White, *Canvases and Careers*, 98.

70. Edgar Tolson, interview with Hall and Moore.

71. Edgar Tolson, interview with M. Watt.

72. See Ardery, "How Edgar Tolson Made It," 6–7.

73. In one early tableau, *Man with a Pony*, Tolson carved and attached appendages, but single dolls prior to 1968 are carved from one piece of wood.

74. In repeated handlings of this subject, the gluing technique permitted many variations of composition and gesture. In some tableaux, Adam and Eve together reach for the forbidden fruit. In others, Eve extends the apple to her partner. Others show Eve bringing the apple to her mouth.

75. Ardery, "The Temptation," 240 n. 229.

76. Stacy, "Self-Taught Sculptor."

77. Although the topic of self-portraiture among self-taught artists has not been thoroughly studied, it is worth noting here that Henri Rousseau and Horace Pippin, like Tolson, produced their first known self-portraits only after seminal exhibitions of their work. For Rousseau this was his first exhibition with the impressionists at the Salon des Refusés, for Pippin the West Chester Community Center Show, organized by art critic Christian Brinton.

78. Stacy, "Self-Taught Sculptor."

79. Interview with Michael D. Hall, April 10, 1993.

80. Michael Hall first presented this case in print in Hall and Faunce, "Sorting Process," 39.

81. Interview with Michael D. Hall, April 10, 1993.

82. Ibid.

83. Ibid.

84. Hall and Faunce, "Sorting Process," 44.

85. M. Hall, "You Make It with Your Mind."

86. Edgar Tolson, interview with Hall and Moore. For additional discussion of the series and its organization, see Ardery, "The Temptation," 245.

87. Interview with Michael D. Hall, April 10, 1993.

88. Ibid.

89. For a discussion of the importance of the series in modern art, see Tucker, *Monet in the Nineties*.

90. Hall and Faunce, "Sorting Process," 39–44.

91. Ibid., 39.

92. Interview with Michael D. Hall, April 10, 1993.

93. Goldin, "Problems in Folk Art," 52.

94. Kramer, "Expert Folk Sculpture Show."

95. Bourdon, "Folk Art Flowers in Brooklyn."

96. Bowman, "Introduction," 20.

97. See Graburn, "Eskimo Art," and Briggs, *Wood Carvers of Córdova*, chap. 3.

98. Graburn, "Art and the Acculturative Process," 464.

99. The NEA appropriation decreased slightly between 1967 and 1968 but otherwise rose each year until 1981. Over the last fifteen years, appropriations have fluctuated, declining sharply in 1996; for FY 1997 the NEA budget was $99.5 million. National Endowment for the Arts, *National Endowment for the Arts, 1965–1995*.

100. See Svenson, "State and Local Arts Agencies," 198.

101. Lowry, *Arts and Public Policy*, 10–11.

102. Leonard Garmet, cited in ibid., 69.

103. Crane, *Transformation of the Avant-Garde*, 6.

104. Kamerman and Martorella, *Performers and Performances*, 248–49.

105. Swaim, "National Endowment for the Arts," 185.

106. *American Art Directory*, 112.

107. Thanks to Irwin Pickett of the Kentucky Arts Council, Frankfort, Kentucky, for this information about the history of corporate art collecting in Kentucky.

108. For a comprehensive essay on folk art and U.S. companies, see Karlins, "American Folk Art in Corporate Collections."

109. Citizens-Fidelity Bank purchased Tolson's *Uncle Sam* ($125), *Standing Man* ($100), and *Standing Woman* ($100). Source: "An Exhibition of Art to Be Used in Citizens Plaza, December 14–26, 1971," J. B. Speed Art Museum Library, Louisville, Ky.

110. The bank paid twenty-seven hundred dollars for this piece in September 1979, telephone interview with Trish Percito, Chase Manhattan Bank.

111. Sonya Swigert interview. Smith, Hinchman, and Grylls Associates paid five thousand dollars for this piece, working through Detroit art consultant Mary Denison, a board member of the Cranbrook Academy of Art, who had seen Tolson's work in the Halls' Michigan home. Another Tolson *Uncle Sam*, belonging to the Museum of American Folk Art, was loaned on a long-term basis to the offices of American Express in New York. Source: Museum of American Folk Art Curatorial Office, New York.

112. DiMaggio and Useem, "Cultural Democracy," 200–210.

113. Martorella, "Art and Public Policy," 281.

114. Crane, *Transformation of the Avant-Garde*, 7. The political tenor of U.S. art in the 1990s might, in fact, be partly attributed to the infusion and subsequent withdrawal of government arts funding.

115. See Crane, *Transformation of the Avant-Garde*, 5–6.

116. "Founding of Kentucky Arts Commission."

117. For the purposes of this study, Kentucky museums that have been considered art museums are the Kentucky Museum, Western Kentucky University, Bowling Green (est. 1939); Headley-Whitney Museum, Lexington (est. 1968); Kentucky Historical Society, Frankfort (est. 1836); University of Kentucky Art Museum, Lexington (est. 1975); J. B. Speed Art Museum, Louisville (est. 1925); and Owensboro Museum of Fine Art (est. 1976). *American Art Directory*, 112–16.

118. Daniels, *Community Arts Agencies*, 239–41.

119. Jonathan Green (Ford Foundation), letter to author, April 20, 1993.

120. Michael Hall's own *Covington* was also selected for the exhibition, as was an untitled work by Lester Van Winkle, a former student of Hall's and graduate of the University of Kentucky studio art program. See Whitney Museum of American Art, *1973 Biennial Exhibition*.

121. National Parks Service cited in "Smithsonian Institution, Festival of American Folklife, July 1–4, 1967," in "1967" file, Washington, D.C.: Smithsonian Institution, Office of Folklife Programs.

122. Edgar Tolson, interview with Broaduses.

123. His physician's memorandum of July 9, 1969, described, "Senile anxiety, psy-

choneurosis, about half drunk, has been in Washington, DC and enjoying the fruits of his labor on the way home."

124. Cantwell, *Ethnomimesis*, 224. See also Batteau, *Invention of Appalachia*; Shapiro, *Appalachia on Our Mind*; and Smith, *Strangers and Kin*.

125. Smithsonian Institution, *1973 Festival of American Folklife*, 30, 2.

126. Taylor and Pierce, *Folk Art of Kentucky*, n.p.

127. Wadsworth, *Missing Pieces*.

128. Among the earliest were Pennsylvania (1974, though no twentieth-century work was included), Michigan, Texas, Utah, Wisconsin (all 1978), and Connecticut (1979). For an extended list of state folk art surveys, see "Statewide and Regional Folk Art Exhibitions" and Volkersz, "Mixed Baggage."

129. Crane, *Tranformation of the Avant-Garde*, 132, 41.

130. Ibid., 16.

131. Tolson strove to make his own work accessible. According to Donny Tolson, Edgar "said he tried to carve stories simple, even so simple that little children could understand them." Donny Tolson interview, March 24, 1993.

132. "Focus on Galleries," 4.

133. Houghton, "Building-Boom Sidelight," *Courier-Journal*, December 26, 1971.

134. Koch, *Wishes, Lies, and Dreams*, 54.

135. National Endowment for the Arts, *Toward Civilization*, 161.

136. Robbins, "Folk Sculpture," 22.

137. See Briggs, *Wood Carvers of Córdova*.

138. Crawford, "Scholar Chronicles Traditional Fiddling."

139. Larry Hackley interview, March 10, 1993.

140. For more information about Hackley's sales and documentary work and a partial list of Kentucky folk artists whose careers he has furthered, see Ardery, "The Temptation," 185 n. 61.

141. U.S. Bureau of the Census, *Historical Statistics of the United States*, 383.

142. Useem and DiMaggio, "A Critical Review of the Content, Quality, and Use of Audience Studies," 30.

143. National Endowment for the Arts, "Artists Increase 81% in the 1970s."

144. Crane, *Transformation of the Avant-Garde*, 138. For more about the restructuring of art careers, see R. C. Smith, "Modern Art and Oral History," 603–4.

145. College Art Association, *MFA Programs in the Visual Arts*.

146. Crane, *Transformation of the Avant-Garde*, 130.

147. Truco, "Contemporary Painting," 79.

148. Muchnic, "What's Fueling the Astonishing Boom," 6.

149. White and White, *Canvases and Careers*, 92.

150. Truco, "Contemporary Painting," 80.

151. Ibid., 90.

152. Reitlinger, *Economics of Taste*, 13.

153. Ibid., 7.

154. Danto, *Beyond the Brillo Box*, 9.

155. Bourdieu, "The Production of Belief," in *Field of Cultural Production*, 77.

156. Whisnant, *All That Is Native and Fine*, 45.

157. Interview with Michael D. Hall, August 14, 1993.

158. White and White, *Canvases and Careers*, 88.

159. Ibid., 98.

160. See also Hartigan's mention of Doty's 1969 exhibition "Human Concern/Personal Torment," which presaged an interest in the figurative and expressive qualities of self-taught art, *Made with Passion*, 46–47.

161. Interview with Michael D. Hall, August 14, 1993.

162. Ibid.

163. Ibid.

164. Ibid.

165. Ibid.

166. Ibid.

167. Donny Tolson interview, March 24, 1993.

168. Edgar Tolson, interview with Pennington.

169. Travis Hemlepp interview.

170. Interview with Michael D. Hall, August 14, 1993.

171. Ibid.

172. Larry Hackley interview, March 10, 1993.

173. National Endowment for the Arts, Visual Arts Division, letter from Larry Hackley, October 14, 1980, "Edgar Tolson" file.

174. Judges for this panel were sculptors Jackie Ferrara, Larry Bell, and Manuel Neri and museum officials Lisa Lyons and Ira Licht.

175. The category of U.S. folk artist is by no means fixed. Of the 250 artists included in Chuck and Jan Rosenak's *Museum of American Folk Art Encyclopedia*, only 5 had received NEA visual arts fellowships by 1992. In addition to Tolson and Finster, those awarded have been Jesse Aaron (1975, a $4,000 Artist fellowship); Miles Carpenter (1982, $5,000 Sculpture fellowship); and Felix Lopez (1984, $5,000 Crafts fellowship). The Folk Arts division of NEA has since 1982 granted annual $5,000 awards to traditional folk artists through its National Heritage Fellowship Program. See Siporin, *American Folk Masters*.

176. The exhibition, running from September 13 to October 18, 1981, then traveled to the Cranbrook Academy of Art Museum, November 17, 1981, through January 17, 1982.

177. Filmed in October 1979 and aired the following year, the video is available through Family Communications, Inc., Pittsburgh, Pa.

CHAPTER FOUR

1. References to the Museum of American Folk Art's membership come from Hoffman, "History of the Museum of American Folk Art."

2. Hartigan, *Made with Passion*, 29.

3. Blasdel, "Grass-Roots Artist."

4. Calvin Trillin had perhaps primed some readers for Blasdel's roadside discoveries, publishing "I Know I Want to Do Something," an essay advocating preservation of Simon Rodia's Watts Towers in the May 29, 1965, issue of the *New Yorker*.

5. Sterling Strauser mounted a one-man show of Justin McCarthy's paintings at the Everhart Museum, Scranton, Pennsylvania (1965). Nina Howell Starr, a master of fine arts student in Gainesville, Florida, arranged for a display of drawings by South Carolinian Minnie Evans at two New York Episcopal churches (1966); a Wesleyan University show followed in 1969. Joseph Yoakum, whose drawings had been ac-

claimed by many young Chicago artists, was given a one-man show at Pennsylvania State University in 1969. Influential group shows of this period included "Seventeen Naive Painters" (1966–67), a touring exhibit that reached seven cities outside New York; "American Naive Painting: Twentieth Century" at Virginia Zabriske's New York gallery (1969); and "Symbols and Images: Contemporary Primitive Artists," curated by Blasdel, which traveled under the auspices of the American Federation of Arts (1970).

6. Institutional support for both Blasdel's and Gladstone's ventures further evinces how the arts were popularized and decentralized during the 1970s.

7. Hartigan, *Made with Passion*, 31.

8. Herzig, "People Speak."

9. Interview with Michael D. Hall, August 14, 1993.

10. Hartigan, *Made with Passion*, 79–80. No combination of adjectives fully captures his taste, but the objects Hemphill most often selects are crisply bizarre, possessed of a sharp sense of line, textured details, and slight asymmetry. See Hartigan, *Made with Passion*, 14–19. Tolson's carving, though not so highly decorated as many sculptures in Hemphill's collection, surely appealed to Hemphill's taste for linear and slightly askew figuration.

11. Crane, *Transformation of the Avant-Garde*, 40–41.

12. Children's Museum, *America Expresses Herself*, 3.

13. Ames, *Beyond Necessity*, 20–21. See also Robbins, "Folk Sculpture," 14–16.

14. Woodie Long interview.

15. See White and White's *Canvases and Careers* for a discussion of the impressionists' constitution as a publicly recognizable group, 118.

16. Interview with Michael D. Hall, August 14, 1993.

17. These artists and Tolson are among the "baker's dozen" who art historian Lynda Hartigan noted became well known in the field of contemporary American folk art subsequent to the 1970 "Twentieth-Century" exhibit at the Museum of American Folk Art. See *Made with Passion*, 31.

18. Interview with Michael D. Hall, August 14, 1993.

19. Robbins, "Folk Sculpture," 16.

20. For an evocative discussion of collecting and its psychology, see Stewart, *On Longing*, 151–52.

21. Bourdieu, "Field of Power," in *Field of Cultural Production*, 164.

22. See Hartigan, *Made with Passion*, 14–15, for an analysis of how Hemphill adopted Lipman's aesthetic, as published in her *American Primitive Painting* and *American Folk Art in Wood, Metal, and Stone*.

23. J. Hall and Bowman, "Interview with Julie Hall," 42.

24. M. Hall and Bowman, "Interview with Michael D. Hall," 27.

25. Michael Hall, letter from Ruth Hartman, April 12, 1972.

26. Larry Hackley interview, March 10, 1993.

27. Jim and Beth Arient, interview with Betty Blum.

28. Hemphill and Weissman, *Twentieth Century American Folk Art*, 8.

29. Kuspit, "Art in an Age of Mass Mediation," 388.

30. Ibid.

31. Interview with Michael D. Hall, August, 14, 1993.

32. Edgar Tolson, interview with Pennington.

33. Holwerk, "Whittlin' Man."

34. Letter to Edgar Tolson, March 15, 1971, WCHM.

35. Letter to Edgar Tolson, March 5, 1975, WCHM.

36. Letter to Edgar Tolson, May 12, 1976, WCHM.

37. Edgar Tolson, interview with Watt.

38. Edgar Tolson, interview with Pennington.

39. In 1981, after visiting the artist in Campton, Florence Laffal reported Tolson "is known to have produced over 100 carvings of the Temptation." Laffal, "Adam and Eve in Folk Art."

40. Public collections that include a Tolson *Temptation* include the Abby Aldrich Rockefeller Folk Art Collection, the Henry Ford Museum at Greenfield Village, the National Museum of American Art (2), the Milwaukee Art Museum (this *Temptation* piece being part of the *Fall of Man* series), the New York State Historical Society at Cooperstown, the University of Kentucky Art Museum (2), the Kentucky Folk Art Center at Morehead (2), and the Wolfe County Historical Museum.

41. Rick Bell interview, August 3, 1993. Many of the best-known artists within the "twentieth-century folk" category have indeed developed what Bell called "bread and butter pieces": Helen Cordero's "Storyteller Doll," Jack Savitsky's train paintings, Ted Gordon's larger-than-life drawings of garish faces, Frank Jones's schematic buildings drawn in red and blue, Son Ford Thomas's skulls, William Hawkins's paintings of skyscrapers and other imposing buildings, George López's carved Saint Michael and the Devil, Jimmie Lee Sudduth's log cabins, Charley Kinney's devil paintings. Certainly, the same dynamic is at work in the fine art world, a mechanism that Andy Warhol both exposed and exploited.

42. From "Hall Notice of Arrival," the Brooklyn Museum Archives, Records of the Department of Painting and Sculpture, Exhibitions: "Folk Sculpture U.S.A.," 1976.

43. Quoted in Hartigan, *Made with Passion*, 50. For a discussion of Veblen's "status competition" in matters of taste, see DiMaggio, "Cultural Aspects of Economic Action and Organization," 125–27.

44. Most of these collectors were listed on the résumé submitted to the National Endowment for the Arts as part of Tolson's 1983 Sculpture Fellowship application.

45. Hartigan, *Made with Passion*, 29. Hartigan has investigated in detail the locales where Hemphill searched for material; see 11–14, 38–39, 60.

46. The following listing of early outlets for twentieth-century folk art was gathered through several sources: advertisements and articles in back issues of the *Clarion* and *Folk Art Finder*; the Herbert W. Hemphill Jr. papers; and Sellen's folk art index, 1993. American Folk Art Company, Richmond, Va.; Ames Gallery, Berkeley, Calif.; Braunstein Gallery, San Francisco; Epstein/Powell, New York; Janet Fleisher Gallery, Philadelphia; Galerie Bonheur, St. Louis, Mo.; Galerie St. Etienne, New York; Gasperi Gallery, New Orleans; Gilley's Gallery, Baton Rouge; Carl Hammer Gallery (formerly Hammer and Hammer), Chicago; Hill Gallery, Birmingham, Mich.; Hirshl and Adler, New York; Jamison/Thomas Gallery, Portland, Ore.; Jay Johnson Gallery, New York; Phyllis Kind Gallery, Chicago; Davis Mather Gallery, Santa Fe; Cavin Morris, New York; Naive Art, San Francisco; Luise Ross Gallery, New York; Brigitte Schluger Gallery, Denver; Valley House Gallery, Dallas. Other important dealers included Larry Hackley, Jeff Camp, and the Halls (doing business roughly from 1972 through 1974 as Pied Serpent Gallery); while Camp maintained a shop, the American Folk Art Com-

pany, in Richmond for approximately two years in the early 1970s, during the period under review these individual dealers usually showed and sold work by private appointment.

47. Sellen, *Twentieth Century American Folk, Self-Taught, and Outsider Art*, 3–57.

48. See Zolberg, "Barrier or Leveler?," 199.

49. Fleisher Gallery (now Fleisher-Ollman Gallery), in fact, was a well-known source for "ethnic" pre-Colombian and oceanic art throughout the 1970s. For an insightful discussion of this exhibition practice and its modification as related to African art, see Center for African Art, ART/artifact, 11–17.

50. White and White, *Canvases and Careers*, 99.

51. For more on the link between an ideology of charity and cultural prestige, see DiMaggio, "Cultural Boundaries and Structural Change," 21–57.

52. See Crane, *Transformation of the Avant-Garde*, 3.

53. Lorimar was chairman of the board of the *Saturday Evening Post* and provides yet another example of the long-standing fondness media professionals have held for folk art.

54. All estimates and sales figures, plus citations, come from Sotheby's sales catalogs—December 8, 1984, June 27, 1985, October 14, 1989, January 24, 1990.

55. Sotheby's, *Important Americana*, 24–27, January 1990.

56. "Twentieth Century Folk Art."

57. Bringing higher prices were a drawing by Bill Traylor ($17,600) and paintings by William Hawkins ($18,700) and Mattie Lou O'Kelly ($15,400).

58. Laffal, "Auction in Connecticut."

59. Wells, "'Outsider Art' Is Suddenly the Rage."

60. Caroline Kerrigan interview, February 4, 1993.

61. Caroline Kerrigan interview, March 20, 1997.

62. Joe Tartt quoted in Georgia Forum on Folk Art, "Missing Pieces or Missing the Point?" 18.

63. The Milwaukee museum paid $1.55 million to the Halls, with the balance of the appraised value designated as a tax-deductible gift.

64. Edgar Tolson, interview with Pennington.

65. The Brooklyn Museum Archives, Records of the Department of Painting and Sculpture, Exhibitions: "Folk Sculpture U.S.A.," 1976.

66. Ricco quoted in Hartigan, *Made with Passion*, 61.

67. Herbert W. Hemphill Jr. interview.

68. Interview with Michael D. Hall, April 10, 1993.

69. Ibid.

70. Booth, "Campton Man Launches New Career."

71. Wagner, "Kentucky Woodcarver's 'Stroke' of Luck."

72. Interview with Michael D. Hall, August 14, 1993.

73. Stewart, *On Longing*, 151.

74. Hemphill and Weissman, *Twentieth Century American Folk Art*, 114.

75. Bishop, *American Folk Sculpture*, 195.

76. Renaissance Society, *Twentieth Century American Folk Art*.

77. For a recent revival of this tale, see Mueller, "Son of Famous Woodcarver."

78. "Edgar Tolson," flier from Webb and Parsons Gallery, "Edgar Tolson" file, National Museum of American Art; Merin-Bihalji and Nebojsa-Bato, *World Encyclopedia*

of Naive Art, 570; Brooklyn Museum, *Folk Sculpture U.S.A.*, 41; Abby Aldrich Rockefeller Folk Art Center, *Folk Art U.S.A.*, n.p.; Bourdon, "Folk Art Flowers in Brooklyn," 91; Ricco, Maresca, and Weissman, *American Primitive*, 258; Sotheby's (auction catalog), October 14, 1989.

79. Untitled typescript, personal collection of Michael D. Hall.

80. M. Hall, *American Folk Sculpture*, n.p.

81. Philadelphia College of Art, *Transmitters*, 30.

82. M. Hall, "The Bridesmaid Bride Stripped Bare," 41.

83. Michael Hall's most direct defenses of this approach may be found in two later essays: "The Problem of Martin Ramirez" and "Jahan Maka."

84. See "Woodchopper's Ball," and Kramer, "Expert Folk Sculpture Show."

85. M. Hall, *Six Naives*.

86. Colt, *Edgar Tolson*, 7.

87. Guy Mendes interview.

88. "Tolson Exhibition."

89. Stacy, "Self-Taught Sculptor."

90. Mendes, "Found People," 48.

91. Gramsci, *Selections from Cultural Writings*, 25.

92. Interview with Michael D. Hall, August 14, 1993.

93. Ibid.

94. Schlereth, "Material Culture Studies in America," 20–32.

95. Cooperstown hosted annual summer "Seminars on American Culture." The 1971 event, organized around the theme of American Folk Art, was the twenty-fourth such seminar.

96. Hartigan, *Made with Passion*, 50.

97. See Schlereth, "Material Culture Studies in America," 36.

98. Kubler, *Shape of Time*, 11–12.

99. Ames, *Beyond Necessity*, 11.

100. Ibid., 16.

101. Ames, "Folk Art: The Challenge and the Promise," 293–94.

102. Ames, *Beyond Necessity*, 54.

103. Ibid., 99.

104. Swank, introducion to *Perspectives on American Folk Art*, 2.

105. Ibid.

106. MacDowell, "Folk Art Study in Higher Education," 26.

107. Bourdieu, "The Field of Cultural Production," in *Field of Cultural Production*, 34.

108. Bourdieu, "The Market of Symbolic Goods," in *Field of Cultural Production*, 124.

109. Proeller, "Looking Back, Looking Forward," 50.

110. M. Hall and Bowman, "Interview with Michael D. Hall," 32.

111. Interview with Michael D. Hall, August 14, 1993.

112. Ibid.

113. See special issues of *New Art Examiner*, September 1991 and September 1994; and *Art Papers*, September/October 1994.

114. For more detailed analysis of the folk art periodical press, see Ardery, "Designation of Difference" and "The Temptation," 350–52.

115. In'tuit's site is http://outsider.art.org; another Web site of interest to folk art buyers and researchers is http://www.folkartisans.com.

116. For a few examples, see Ardery, "The Temptation," 349 n. 205.

117. See Georgia Forum on Folk Art, "Missing Pieces or Missing the Point?"

118. Livingston and Beardsley, *Black Folk Art in America*.

119. Untitled typescript, "The Aims of This Exhibition," in the Brooklyn Museum Archives, Records of the Department of Painting and Sculpture, Exhibitions: "Folk Sculpture U.S.A.," 1976.

120. Goldin, "Problems in Folk Art," 48.

121. Kirwin, "Documenting Contemporary Southern Self-Taught Artists," 58.

122. See Siporin, *American Folk Masters*, 14–39.

123. Bourdieu, "Field of Cultural Production," 42.

124. Georgia Forum on Folk Art, "Missing Pieces or Missing the Point?" 12.

125. Seriff, "Este Soy Yo," 9.

126. Ibid., 11.

127. Wade, "Ethnic Art Market," 167.

128. Edgar Tolson, interview with Pennington.

129. Edgar Tolson, interview with M. Hall, July 1978.

130. Edgar Tolson, interview with Pennington.

131. Edgar Tolson, interview with Broaduses.

132. Edgar Tolson, interview with M. Hall, 1978.

133. Ibid.

134. *Old Friends, New Friends*.

135. Edgar Tolson, interview with Watt.

136. Edgar Tolson, interview with Pennington.

137. Edgar Tolson, interview with Taylor, 1979.

138. Edgar Tolson, interview with Watt.

139. Bourdieu, "Field of Cultural Production," 61.

140. Edgar Tolson, interview with Pennington.

141. Edgar Tolson, interview with Watt.

142. M. Hall, "You Make It with Your Mind," 171.

143. Bourdieu, "Production of Belief," 77.

144. MacDowell, "Folk Art Study in Higher Education," 30.

145. See DiMaggio, "Cultural Boundaries and Structural Change," 44.

146. Bourdieu, "Production of Belief," 100.

147. See Sellen, *Twentieth Century American Folk, Self-Taught, and Outsider Art*, 69–97.

148. Goldin, "Problems in Folk Art," 49.

149. See Patterson, "Ten Years in the Life of Contemporary Art's Parallel Universe"; Tully, "Outside, Inside."

150. Goldwater, *Primitivism*, 298.

CHAPTER FIVE

1. Georg Simmel, "Subjective Culture," in *On Individuality and Social Forms*, 230.

2. Edgar Tolson, interview with Taylor, 1979.

3. Edgar Tolson, interview with M. Hall, 1978.

4. Bourdieu, *Distinction*, 144.

5. Kuspit, "'Suffer the Little Children to Come unto Me,'" 455.

6. Ames, *Beyond Necessity*, 50. See also Stewart, *On Longing*, 69.

7. Stewart, *On Longing*, 69.

8. Pat Parsons in 1990 curated an exhibition of folk art devoted entirely to the Adam and Eve theme. See her "Primal Portraits." Another well-known folk art work on this same theme is, of course, Edward Hicks's *Peaceable Kingdom*.

9. Metcalf, "Artifacts and Cultural Meaning," 11.

10. Ibid.

11. See Hackley, *Remembrances*.

12. Letter to Edgar Tolson, April 2, 1968, WCHM.

13. See Ardery, "Past and Presence."

14. Goodman, *Growing Up Absurd*, 97.

15. Horwitz, *Bird, the Banner, and Uncle Sam*.

16. Rick Bell interview, August 3, 1993.

17. Ibid.

18. Rick Bell, letter to Michael Hall, September 10, 1970.

19. Rick Bell interview, August 3, 1993.

20. Metcalf, "From the Mundane to the Miraculous," 59.

21. Rabkin, "New World Freedom," 29.

22. Chuck Rosenak interview.

23. Rosenak, "Folk Art Is Alien to Cultural Aesthetics," 9.

24. See also Geertz's commentary on Lévi-Strauss's "science of the concrete," in "Cerebral Savage."

25. MacCannell, *The Tourist*, 13.

26. Ibid., 91.

27. Ibid., 34.

28. Rick Bell interview, August 3, 1993.

29. Casey, "Kentuckian Produces Penknife Art."

30. Dr. Paul Maddox and Patricia Maddox interview.

31. Milwaukee Art Museum, *Common Ground*, 321.

32. Casey, "Kentuckian Produces Penknife Art."

33. Tower, "Woodcarver Left Mark on Art World."

34. Mendes, "Found People," 46.

35. Blasdel, "Grass-Roots Artist," 25.

36. See Benjamin, "Work of Art in the Age of Mechanical Reproduction"; Berger, *Ways of Seeing*; Malraux, "Museum without Walls."

37. Rick Bell interview, August 3, 1993.

38. Rick Bell interview, August 4, 1993.

39. Miriam Tuska interview.

40. Mendes, "Found People," 48.

41. Seriff, "'Este Soy Yo,'" 65.

42. Ibid., 70.

43. Rick Bell interview, August 3, 1993.

44. Ibid.

45. Clark, *Painting of Modern Life*, 255.

46. Ibid., 238.

47. Ibid., 254.

48. See Ames, "Folk Art: The Challenge and the Promise," 311–13.

49. Clark, *Painting of Modern Life*, 255.

50. Hall and Faunce, "Sorting Process," 35.

51. Ibid.

52. Adorno, *Jargon of Authenticity*, 22.

53. Ibid., 18.

54. Interview with Michael D. Hall, April 3, 1993.

55. This approach is especially prevalent in the writings of *Raw Vision*, a periodical that features outsider art. See also Flood, "Ecstasy and the Doodle," in Philadelphia College of Art, *Transmitters*, 5–7.

56. See Csikszentmihalyi and Rochberg-Halton, *Meaning of Things*, 85.

57. John Cowden, quoted in Weaver, *Artisans of the Appalachians*, 86.

58. Batteau, *Invention of Appalachia*, 82.

59. Letter to Edgar Tolson, March 15, 1978, WCHM.

60. Sondheim, "Unnerving Questions," 34.

61. Rick Bell interview, August 3, 1993.

62. Carl Hammer interview.

63. Rick Bell interview, August 3, 1993.

64. Seriff, "Este Soy Yo," 64.

65. MacCannell, *The Tourist*, 94. The concept of back and front regions was originally developed by Erving Goffman, *Presentation of Self*.

66. Herbert W. Hemphill Jr. interview.

67. Interview with Michael D. Hall, April 10, 1993.

68. Steven Speilberg, *Indiana Jones and the Last Crusade*.

69. MacCannell, *The Tourist*, 33.

70. Gramsci, *Selections from Cultural Writings*, 374.

71. Ibid.

72. Larry Hackley interview, January 27, 1993.

73. Hall and Faunce, "Sorting Process," 33, 35.

74. MacCannell, *The Tourist*, 41.

75. Wanda Abercrombie interview.

76. Berea College president William Goodell Frost, quoted in Shapiro, *Appalachia on Our Mind*, 120. See also Lears, *No Place of Grace*, 98–139.

77. Fern Sheffel interview.

78. Rick Bell interview, August 3, 1993.

79. Mallarmé, "Impressionists and Edouard Manet," 29–30. See also Crow, "Modernism and Mass Culture."

80. The Walker Art Center, Minneapolis, launched this trend with the influential 1974 exhibition "Naives and Visionaries." The Reverend Howard Finster, self-proclaimed "Man of Visions," published his first book by that title in 1982. In 1989 the periodical *Raw Vision* was established, and in 1992 the Los Angeles County Museum mounted "Parallel Visions," an exhibition of "modern artists drawn to, and influenced by, the art of 'outsiders,' or, as we refer to them, compulsive visionaries." The New Orleans Museum of Art opened "Passionate Visions of the American South" in 1993, a touring show that included Tolson's *Crucifixion*, *Self-Portrait*, and *Original Sin*. And in Baltimore, the American Visionary Art Museum, dedicated to presenting folk and outsider art, opened in 1995.

81. Tolstoy, "What Is Art?," 145.

82. Weissman, letter to editor.

83. Donny Tolson interview, March 24, 1993.

84. Edgar Tolson, interview with Pennington.

85. Edgar Tolson, interview with Taylor, 1973.

86. Ibid.

87. Weber, "Science as a Vocation," 155; see also Briggs, *Wood Carvers of Córdova*, 64.

88. Published surveys of American folk art usually devote a chapter to "religion" or "faith," as a category of objects. See, for example, Yelen, *Passionate Visions*, and Milwaukee Art Museum, *Common Ground*.

89. Hartigan, *Made with Passion*, 68.

90. Adorno, *Jargon of Authenticity*, 21.

91. Stonitsch, "Reverend Howard Finster."

92. Ames, "Folk Art and Cultural Values," 90.

93. Bourdieu, "Field of Power, Literary Field, and Habitus," in *Field of Cultural Production*.

94. Hall and Faunce, "Sorting Process," 35.

95. Hemphill and Weissman, *Twentieth Century American Folk Art*, 9.

96. Interview with Michael D. Hall, April 10, 1993.

97. Ibid.

98. Sontag, "The Artist," 42.

99. Ibid. See also Michel Foucault, "What Is an Author?" 448.

100. Rosenberg, quoted in Crane, *Transformation of the Avant-Garde*, 45.

101. Gablik, *Has Modernism Failed?*, 84.

102. Rick Bell interview, August 3, 1993.

103. See Ardery, "'Loser Wins.'"

104. Abrahams, "American Folklore Society," 57.

105. J. Hall and M. Hall, "Conversation," 18.

106. Carl Hammer interview.

107. Ralph Rinzler interview.

108. Edgar Tolson, interview with Pennington.

109. Rick Bell interview, August 3, 1993.

110. Mary Tolson interview.

111. Bourdieu, "Production of Belief," in *Field of Cultural Production*, 95.

112. Larry Hackley interview, January 27, 1993.

113. Ehrenreich, *Fear of Falling*, 15.

114. Ibid., 10.

115. Donny Tolson interview, June 9, 1993.

116. Ibid.

117. Ibid.

118. Mary Dunn interview.

119. Hauser, "Folk Art," 569. For another analysis of this question, see Danto's discussion of expression and manifestation in "Symbolic Expressions and the Self," in *Beyond the Brillo Box*.

120. Vlach, "Wrong Stuff," 23–24. Robert Goldwater noted this ironic appeal in comparing Henri Rousseau with Camille Bambois, another naive painter, who "became self-conscious" and by growing past his original style became bland, simply a "bad" painter rather than a naive one. Goldwater wrote of Rousseau, who himself both admired and emulated beaux arts painting, "Rousseau's style would have been

transformed, and thus for the purposes of sophisticated appreciation would have been spoiled, had he been able to accomplish what he wished" (*Primitive Art*, 188). See also Vlach, *Plain Painters*.

121. Dan Fox, letter from Joseph H. Brenner, M.D., cited in Copetas, "The 1965 Appalachian Volunteers Summer Project," 18.

122. Ken Fadeley interview.

123. Crawford, "Scholar Chronicles Traditional Fiddling."

124. Bourdieu, "Field of Cultural Production," in *Field of Cultural Production*, 39.

125. Ken Fadeley interview.

126. Hemphill and Weissman, *Twentieth Century Folk Art*, 9–10.

127. Gablik, *Has Modernism Failed?*, 53.

128. Michael Hall, untitled typescript prepared for 1970 exhibition "The Work of Edgar Tolson."

129. Edgar Tolson, interview with M. Hall, 1972.

130. George Meyer interview.

131. Bourdieu, "Production of Belief," 79.

132. Edgar Tolson, interview with Pennington.

133. In addition to the Hall/Tolson effort, notable patron/folk artist pairs include Jeff Camp and artists Miles Carpenter and Howard Finster, Richard Gasperi and David Butler, Larry Bornstein and Sister Gertrude Morgan, and more recently Bill Arnett and Thornton Dial. An earlier such arrangement, recently challenged by the artist's heirs, involved Charles Shannon and Bill Traylor. See Vesey, "Drawn into Controversy."

134. See Hitt, "Selling of Howard Finster."

135. Bourdieu, "Field of Power," 164.

136. Ibid., 164–65.

137. Bourdieu, *Distinction*, 87.

138. Hall and Faunce, "Sorting Process," 39.

139. Daniels, "In or Out?" See also Crane, *Transformation of the Avant-Garde*, 20.

140. See DiMaggio, "Cultural Aspects of Economic Action and Organization," 123–28.

141. Schapiro, "On Perfection," 38.

142. Cantwell, *Ethnomimesis*, 178.

143. Bourdieu, *Distinction*, 34.

144. Baxendall, *Painting and Experience*, 34.

145. Donny Tolson interview, June 9, 1993.

146. Ehrenreich, *Fear of Falling*, 14.

147. Ibid., 38.

148. For a detailed account of this problem, see Wolfe, "Position Paper on the Effect of MAC Programs."

149. Dr. Paul Maddox and Patricia Maddox interview.

150. Cantwell, *Ethnomimesis*, 300.

151. Donny Tolson interview, March 24, 1993.

CONCLUSION

1. Hitt, "Selling of Howard Finster"; Tully, "Outside, Inside," 118.

2. See Georgia Forum on Folk Art, "Missing Pieces or Missing the Point?," 18.

3. Donny Tolson interview, June 9, 1993.

4. Edgar Tolson, interview with Taylor, 1973; Edgar Tolson, interview with M. Hall, 1978.

5. Edgar Tolson, interview with Taylor, 1979.

6. Edgar Tolson, interview with Pennington.

7. Edgar Tolson, interview with M. Hall, 1973.

8. Edgar Tolson, interview with Taylor, 1973.

9. Elvin Tolson interview.

10. Interview with Michael D. Hall, March 27, 1993.

11. Briggs used this phrase to characterize the relationship between Anglo patrons and Hispanic carvers of santos art, *Wood Carvers of Córdova*, 3.

12. Edgar Tolson, interview with Moore and Hall; Edgar Tolson, interview with Watt.

13. Edgar Tolson, interview with Moore and Hall.

14. Edgar Tolson, interview with Pennington.

15. Rick Bell interview, August 3, 1993.

16. Kevin Orth quoted in Howard, "Urban Art."

17. Scalora, "Over-Loaded with Wisdom," 3.

18. Ken Fadeley interview.

19. Gramsci, *Selections from Cultural Writings*, 25.

20. Best, "Stripping Appalachian Soul," 16. Of course, this process was not new to the 1970s, as shown in David Whisnant's chronicle of cultural intervention *All That Is Native and Fine*. Subsequently, such "help" assumed a more overtly promotional and politicized character, especially in Kentucky. Phyllis George Brown, a former Miss America, negotiated an "Oh Kentucky!" boutique at Bloomingdale's department store as the state's "First Lady." Brown has authored two books on Kentucky folk art and crafts and now hosts a television program, dealing with crafts through the Home Shopping Network. See Ardery, "Crafts Book Recalls Browns' Consumer Legacy," 20–21.

21. Niebuhr, *Moral Man and Immoral Society*, 9.

22. Ibid., 266.

23. Lasch, *True and Only Heaven*, 378.

24. Cook, "Crafts, Capitalist Development, and Cultural Property," 64.

25. Ibid., 65–66.

26. MacCannell, "Cannibalism Today," 29–30.

BIBLIOGRAPHY

ARCHIVAL SOURCES

Berea, Kentucky
Berea College Library
 Southern Appalachian Archives
 Appalachian Volunteers records
 Kentucky Guild of Artists and Craftsmen records

Brooklyn, New York
The Brooklyn Museum Archives
 Records of the Department of Painting and Sculpture
 "Folk Sculpture U.S.A." (exhibition), 1976

Campton, Kentucky
Campton Clinic
 "Tolson, Edgar" (file), 1957–84
Wolfe County Historical Museum
 Letters to Edgar Tolson, 1971–78
Wolfe County Library
 "Arts and Crafts" (file)
 "Tolson, Edgar" (file)

Chicago, Illinois
Art Institute of Chicago
 Whitney Halstead Papers

Frankfort, Kentucky
Kentucky State Department of Corrections
 "Tolson, Edgar" (file)

Lexington, Kentucky
King Library, University of Kentucky
 Special Collections
 Blue-Tail Fly, vols. 1–2
 The Kentuckian (yearbook), 1967–70
 Student/faculty directories, 1966–70
University of Kentucky Art Museum
 "Edgar Tolson: Kentucky Gothic" (exhibition file), 1981

Louisville, Kentucky
J. B. Speed Museum of Art Library
 "Corporate Collecting" (exhibition file), 1971
University of Louisville Archives and Records Center
 Junior Art Gallery/Louisville Art Gallery records
 "The Artist and the Idea" (exhibition file), 1976

New York, New York
Museum of American Folk Art
 Sotheby's auction catalogs: October 8, 1984, June 27, 1985, October 14, 1989,
 January 24, 1990
 "Tolson, Edgar" (curatorial file)

Santa Fe, New Mexico
Museum of International Folk Art
 "Tolson, Edgar" (curatorial file)

Washington, D.C.
Archives of American Art
 Jeffrey and C. Jane Camp Papers
 "Hall, Michael D." (vertical file)
 Herbert W. Hemphill Jr. Papers
 "Tolson, Edgar" (vertical file)
Library of Congress
 American Folklife Center Library
 "Folk Art" (file)
 "Kentucky" (file)
National Endowment for the Arts
 Visual Artist Fellowships Program
 "Tolson, Edgar" (file)
Smithsonian Institution
 National Museum of American Art
 Department of Painting and Sculpture
 "Tolson, Edgar" (curatorial file)
 Office of Folklife Programs
 Festival of American Folklife photographs 1968, 1973
 Festival of American Folklife records 1967, 1968, 1973

MISCELLANEOUS

The following private individuals generously supplied information from their
personal libraries and files:

Rick Bell, Cortez, Colo.
Marian Broadus, Lexington, Ky.
Mary Dunn, Campton, Ky.
Ken Fadeley, Royal Oak, Mich.
Mary Tolson Gilbert, Campton, Ky.

Larry Hackley, North Middletown, Ky.
Dwight Haddix, Lost Creek, Ky.
Michael D. Hall, Hamtramck, Mich.
Lynda Roscoe Hartigan, Washington,
 D.C.

Dr. Paul and Patricia Maddox, Campton, Ky.
Guy Mendes, Lexington, Ky.
Eugene W. Metcalf Jr., Oxford, Ohio

Clay Morrison, Chicago
Monnie Profitt, Campton, Ky.
Ellsworth Taylor, Lexington, Ky.
John Tuska, Lexington, Ky.

INTERVIEWS

Interviews by the Author

The following personal interviews were conducted with generous assistance from the Kentucky Oral History Commission. Tapes and transcripts are archived at the University of Kentucky Oral History Collection, King Library, Lexington, Kentucky.

Abercrombie, Wanda Tolson. July 19, 1993. Winchester, Ky.

Adkins, Minnie. May 18, 1993. Isonville, Ky.

Bell, Rick. August 3, 1993, August 4, 1993. Cortez, Colo.

Bellando, Richard. April 13, 1993. Berea, Ky.

Bowman, Russell. April 18, 1993, Milwaukee, Wis.

Broadus, James. April 22, 1993. Lexington, Ky.

Broadus, Marian. April 22, 1993. Lexington, Ky.

Brown, Roger. June 22, 1993. Chicago.

Cable, Monna. July 21, 1993. Rogers, Ky.

Colt, Priscilla. January 29, 1993. New York.

Druckman, Nancy. February 4, 1993. New York.

Dunn, Mary. February 22, 1993. Campton, Ky.

Fadeley, Ken. March 17, 1993. Royal Oak, Mich.

Gilbert, Mary Tolson. (See Tolson, Mary)

Glenn, Anne Toepker. March 15, 1993. Cincinnati, Ohio.

Hackley, Larry. January 27, 1993, March 10, 1993. Lexington, Ky.

Haddix, Dwight. April 5, 1993. Lost Creek, Ky.

Hall, Julie. March 16, 1993. Birmingham, Mich.

Hall, Michael D. March 27, 1993, April 3, 1993, April 10, 1993. Columbus, Ohio;
 August 14, 1993. Hamtramck, Mich.

Hammer, Carl. June 23, 1993. Chicago.

Hemlepp, Travis. February 3, 1993. Brooklyn, N.Y.

Hemphill, Herbert W., Jr. February 1, 1993. New York.

Holwerk, David. June 8, 1993. Lexington, Ky.

Kerrigan, Caroline. February 4, 1993. New York.

Laffal, Florence and Julius. January 31, 1993. New York.

Lopez, George. (See Ortiz, Savinita)

Maddox, Dr. Paul and Patricia. February 11, 1993. Campton, Ky.

McKenzie, Carl. June 17, 1993. West Liberty, Ky.

Mendes, Guy. May 29, 1993, Lexington, Ky.

Morrison, Clay. June 23, 1993. Chicago.

Ollman, John. February 2, 1993. Philadelphia, Pa.

Ortiz, Savinita, and George López. August 2, 1993. Córdova, N.Mex.

Profitt, Monnie. February 11, 1993. Rogers, Ky.

Rosenak, Chuck. August 2, 1993. Tesuque, N.Mex.

Rosenak, Jan. August 2, 1993. Tesuque, N.Mex.

Scalora, Sal. January 30, 1993. New York.

Smith, Colin. February 4, 1993. New York.

Swain, Adrian. June 10, 1993. Morehead, Ky.

Taylor, Ellsworth "Skip." May 27, 1993. Lexington, Ky.

Tolson, Donny. March 24, 1993, June 9, 1993. Rogers, Ky.

Tolson, Elvin, and Sally Tolson. January 11, 1993. Clay City, Ky.

Tolson, Mary. August 18, 1993. Campton, Ky.

Tuska, John. June 16, 1993. Lexington, Ky.

Tuska, Miriam. February 19, 1993. Lexington, Ky.

Watts, Flossie Tolson. May 21, 1993. Campton, Ky.

Williams, Roberta. February 23, 1993. Louisville, Ky.

Additional Interviews by the Author

Ahlborn, Richard. Telephone interview. May 17, 1993.

Bickel, Gary. Telephone interview. October 11, 1993.

Bickel, Sharron. Telephone interview. October 10, 1993.

Conti, Eugene. Telephone interview. April 26, 1993.

Friedman, Estelle. Personal interview. August 19, 1992. Washington, D.C.

Gundersheimer, Karen and Werner. Personal interview. August 28, 1992.
 Washington, D.C.

Horwitz, Elinor. Personal interview. August 18, 1992. Washington, D.C.

Jabbour, Alan. Personal interview. August 28, 1992. Washington, D.C.

Kerrigan, Caroline. Telephone interview. March 20, 1997.

Long, Woodie. Personal interview. January 30, 1993. New York.

Meyer, George. Personal interview. March 16, 1993. Birmingham, Mich.

Percito, Trish. Telephone interview. October 12, 1993.

Rinzler, Ralph. Telephone interview. May 7, 1993.

Royce, Michael. Telephone interview. May 31, 1993.

Sheffel, Fern. Personal interview. April 5, 1993. Little, Ky.

Smith, Judy. Personal interview. August 1, 1993. Santa Fe, N.Mex.

Swigert, Sonya. Telephone interview. October 12, 1993.

Taulbee, Graydon. Personal interview. February 23, 1994. Bethany, Ky.

Personal Interviews by Others

Arient, Jim and Beth. Interview with Betty Blum, April 27–29, 1988. Washington,
 D.C., Archives of American Art.

Hall, Michael D. Interview with Dennis Barrie. July 19–26, 1976. Washington, D.C.,
 Archives of American Art.

Ollman, John. Interview with Lynda Hartigan. August 10, 1989. Washington, D.C.,
 Archives of American Art.

Ollman, John. Interview with Liza Kirwin. March 15, 1990. Washington, D.C.,
 Archives of American Art.

Tolson, Edgar. Interview with Roderick Moore and Michael D. Hall. 1971.
 Campton, Ky.

Tolson, Edgar. Interview with Michael D. Hall. 1972. Campton, Ky.

Tolson, Edgar. Interview with Ellsworth Taylor. January 17, 1973. Campton, Ky.

Tolson, Edgar. Interview with Michael D. Hall, Ken Fadeley, and Chris Hayman. September 1973. Campton, Ky.

Tolson, Edgar. Interview with Marian and James Broadus.

Tolson, Edgar. Interview with Michael D. Hall. July 1978. Campton, Ky.

Tolson, Edgar. Interview with Ellsworth Taylor. May 16, 1979.

Tolson, Edgar. Interview with M. Watt. April 15, 1980. Campton, Ky.

Tolson, Edgar. Interview with Estill Curtis Pennington. July 30, 1981. Campton, Ky. Washington, D.C., Archives of American Art.

Tolson, Edgar. Interview with Sandra Profitt, 1983. Jackson, Ky., Lees College Oral History Collection.

BOOKS, ARTICLES, CATALOGS, LETTERS

Abby Aldrich Rockefeller Folk Art Center. *Folk Art USA since 1900, from the Collection of Herbert Waide Hemphill Jr.* Williamsburg: Abby Aldrich Rockefeller Folk Art Center, 1980.

Abernathy, Frank Edward, ed. *Folk Art in Texas.* Dallas: Southern Methodist University Press, 1985.

Abrahams, Roger D. "The American Folklore Society: The First Hundred Years." *Clarion* 13 (Fall 1988): 54–57.

Addams, Jane. *Twenty Years at Hull House.* New York: Macmillan, 1910.

Adler, Elizabeth Moseby. "Home Grown and Fotched-On: Whittling and Carving Traditions in the Southern Highlands." In *The Art of Carl McKenzie,* 14–26. Milwaukee: UWM Art Museum, 1994.

Adorno, Theodor W. *The Jargon of Authenticity.* Translated by Knut Tarnowski and Frederic Will. Evanston, Ill.: Northwestern University Press, 1973.

American Art Directory, 1993–1994. 54th ed. New Providence, N.J.: R. R. Bowker, 1993.

American Folk Art: The Herbert Waide Hemphill Jr. Collection. Milwaukee: Milwaukee Art Museum, 1981.

American Folk Sculpture from the Hall Collection. Lexington: University of Kentucky Art Gallery, 1974.

American Sampler: Folk Art from the Shelburne Museum. Washington, D.C.: National Gallery of Art, 1987.

Ames, Kenneth. *Beyond Necessity: Art in the Folk Tradition.* Winterthur, Del.: Henry Francis du Pont Winterthur Museum, 1977.

———. "Folk Art: The Challenge and the Promise." In *Perspectives on American Folk Art,* edited by Ian Quimby and Scott Swank, 293–324. New York: W. W. Norton, 1980.

———. "Folk Art and Cultural Values." In *Common Ground/Uncommon Vision: The Michael and Julie Hall Collection of American Folk Art,* 83–93. Milwaukee: Milwaukee Art Museum, 1993.

Ardery, Julie. "A Bitter Paradox: M.F.A. Confers a Degree of Contradiction." *New Art Examiner* 17, no. 1 (September 1989): 27–29.

————. "Charley Kinney." *Lexington Herald-Leader*, April 19, 1991, A9.

————. "Crafts Book Recalls Browns' Consumer Legacy." *ACE Magazine* (Autumn 1990): 20–21.

————. "The Designation of Difference." *New Art Examiner* 19, no. 1 (September 1991), special folk art edition: 29–32.

————. "Folk Art Mishandled." *Texas Observer*, February 6, 1987, 16–19.

————. "From the Well: Eight Families of Eastern Kentucky Artists." In *Generations of Kentucky: An Exhibition of Folk Art with Photographs by Guy Mendes*, 3–9. Louisville: Kentucky Art and Craft Foundation, 1994.

————. "How Edgar Tolson Made It: Oral Sources and Folk Art's Success." *Oral History Review* 23, no. 2 (Winter 1997): 1–18.

————. "'Loser Wins': Outsider Art the Salvaging of Disinterestedness." *Poetics* 24, no. 5 (February 1997): 327–346.

————. "Past and Presence: The Art of Evan Decker." In *When, The, Skies, Not, Cloudy, All, Day: The Art of Evan Decker*, 9–26. Berea, Ky.: Appalachian Museum, 1992.

————. "The Temptation: Edgar Tolson and the Sociology of Twentieth Century Folk Art." Ph.D. diss., University of Kentucky, 1995.

————, ed. "Steps, Mis-Steps on the Road to Defining Folk Art." *New Art Examiner* 19, no. 1 (September 1991), special issue.

Arnold, Carroll. "Appalachian Cooperatives: Economies of the Third Kind." *Appalachia, Journal of the Appalachian Regional Commission* 11, no. 3 (December 1977–January 1978): 21.

Arnow, Harriette Simpson. *The Dollmaker*. New York: Macmillan, 1954. Reprint, Lexington: University Press of Kentucky, 1985.

Baker, Kenneth. "Folk Art Displays Temptation in Eden." *San Francisco Chronicle*, August 4, 1990, C7.

Barker, Garry G. *The Handcraft Revival in Southern Appalachia, 1930–1990*. Knoxville: University of Tennessee Press, 1991.

Barrett, Didi. *Muffled Voices: Folk Artists in Contemporary America*. New York: Museum of American Folk Art, 1986.

Batteau, Allen W. *The Invention of Appalachia*. Tucson: University of Arizona Press, 1990.

Baxendall, Michael. *Painting and Experience in Fifteenth Century Italy*. Oxford: Oxford University Press, 1972.

Becker, Howard S. *Art Worlds*. Berkeley and Los Angeles: University of California Press, 1982.

Becker, Jane Stewart. "Selling Tradition: The Domestication of Southern Appalachian Culture in 1930s America." Ph.D. diss., Boston University, 1993.

Bell, Rick. "Edgar Tolson." *Mountain Review* 5, no. 2 (October 1979): 21–24, front and back covers.

Benjamin, Jessica. *The Bonds of Love: Psychoanalysis, Feminism, and the Problem of Domination*. New York: Pantheon Books, 1988.

Benjamin, Walter. "The Work of Art in the Age of Mechanical Reproduction." In *Illuminations*, 217–52. New York: Schocken Books, 1968.

Berger, John. *About Looking*. New York: Pantheon Books, 1980.

————. *Ways of Seeing*. London: British Broadcasting Corporation, 1972.

Best, Bill. "Stripping Appalachian Soul: The New Left's Ace in the Hole." *Mountain Review*, January 3, 1979, 14–16.

Bickel, Gary W. "The Story of the Grassroots Craftsmen." In file 47-7, "GCCA 1967–69." Records of the Appalachian Volunteers. Berea College, Berea, Ky.

Bigart, Homer. "Kentucky Miners: A Grim Winter." *New York Times*, October 20, 1963, 1, 79.

Bishop, Bill, and Julie Ardery. "Four Kentucky Wood-Carvers." *Beaux-Arts* (Summer 1981): 10–15.

Bishop, Robert. *American Folk Sculpture*. New York: E. P. Dutton, 1974.

Bishop, Robert, Judith Reiter Weissman, Michael McManus, and Henry Niemann. *Folk Art: Paintings, Sculpture, and Country Objects*. New York: Alfred A. Knopf, 1983.

Black, Mary. "American Folk Sculpture." *Craft Horizons* 26, no. 4, (July–August 1966): 18–21, 40.

Blasdel, Gregg. "The Grass-Roots Artist." *Art in America* 56, no. 5 (September–October 1968): 20–41.

Bly, Sally. "Mountain Handicrafts Find Market." *Louisville Courier-Journal*, September 1, 1970, B3.

Boehn, Max von. *Dolls*. Translated by Josephine Nicoll. New York: Dover Publications, 1972.

Bonesteel, Michael. "Chicago Originals." *Art in America* 73, no. 2 (February 1985): 128–35.

Booth, Hazel. "Campton Man Launches New Career as Carver of Elephants, Adam and Eve." *Lexington Leader*. n.d. Wolfe County Library.

———. "Edgar Tolson Whittles Out New Career." *Wolfe County News*, July 26, 1968, 1.

———. "Wolfe County Quilts Make Hit with Washington, D.C. Groups." *Lexington Leader*, November 22, 1967, 5.

Borum, Jennifer Penrose. "Term Warfare." *Raw Vision* 8 (Winter 1993): 24–31.

———, ed. "Self-Taught Art: The New Contender in the Post-Mainstream Arena." *New Art Examiner* 22, no. 5 (September/October 1994), special issue.

Bourdieu, Pierre. *Distinction: A Social Critique of the Judgement of Taste*. Translated by Richard Nice. Cambridge: Harvard University Press, 1984.

———. *The Field of Cultural Production: Essays on Art and Literature*. Edited by Randal Johnson. New York: Columbia University Press, 1993.

Bourdon, David. "Folk Art Flowers in Brooklyn." *Village Voice*, March 22, 1976, 91.

Bowman, Russell. "Introduction: A Synthetic Approach to Folk Art." In *Common Ground/Uncommon Vision: The Michael and Julie Hall Collection of American Folk Art*, 13–21. Milwaukee: Milwaukee Art Museum, 1993.

———. "Looking to the Outside: Art in Chicago, 1945–1975." In *Parallel Visions: Modern Artists and Outsider Art*, edited by Maurice Tuchman and Carol Eliel, 150–173. Princeton, N.J.: Princeton University Press, 1992.

———. "Varieties of Folk Expression: The Hemphill Collection." In *American Folk Art: The Herbert Waide Hemphill Jr. Collection*, 19–32. Milwaukee: Milwaukee Art Museum, 1981.

Braun, Lillian Jackson. "From Grass Roots to the Big City." *Detroit Free Press*, June 14, 1972, 1C.

Briggs, Charles L. *The Wood Carvers of Córdova, New Mexico: Social Dimensions of an Artistic "Revival."* Knoxville: University of Tennessee Press, 1980.

Brody, J. J. "The Creative Consumer: Survival, Revival, and Invention in Southwest Indian Arts." In *Ethnic and Tourist Arts: Cultural Expressions from the Fourth World*, edited by Nelson H. H. Graburn, 70–84. Berkeley and Los Angeles: University of California Press, 1976.

Bronner, Simon J. "Cane Making as Symbol and Tradition." In *American Folk Art Canes: Personal Sculpture*, edited by George H. Meyer, 218–221. Bloomfield Hills, Mich.: Sandringham Press, 1992.

———. *Chain Carvers: Old Men Crafting Meaning*. Lexington: University Press of Kentucky, 1985.

Bullard, Helen. *Crafts and Craftsmen of the Tennessee Mountains*. Falls Church, Va.: Summit Press, 1976.

Cahill, Holger. *American Primitives*. Newark, N.J.: Newark Museum, 1930.

"Campton Carver of Wood Causes Stir in Washington." *Wolfe County News*, April 12, 1968, 1.

Cantwell, Robert. *Ethnomimesis: Folklife and the Representation of Culture*. Chapel Hill: University of North Carolina Press, 1993.

Cardinal, Roger. "Towards an Outsider Aesthetic." In *The Artist Outsider: Creativity and the Boundaries of Culture*, edited by Michael D. Hall and Eugene W. Metcalf Jr., 20–43. Washington, D.C.: Smithsonian Institution Press, 1994.

Casey, Phil. "Kentuckian Produces Penknife Art." *Washington Post*, March 28, 1968, C12.

Caudill, Harry M. *Night Comes to the Cumberlands: A Biography of a Depressed Area*. Boston: Little, Brown and Co., 1963.

Celebrate! Santa Fe, N.Mex.: Museum of International Folk Art, 1979.

Center for African Art. *ART/artifact: African Art in Anthropology Collections*. New York: Center for African Art, 1988.

Children's Museum. *America Expresses Herself: Eighteenth, Nineteenth, and Twentieth Century Folk Art from the Herbert W. Hemphill Jr. Collection*. Introduction by Mildred S. Compton. Indianapolis: Children's Museum, 1976.

Clark, T. J. *The Painting of Modern Life: Paris in the Art of Manet and His Followers*. Princeton, N.J.: Princeton University Press, 1984.

Clarke, Kenneth W. *Kentucky's Age of Wood*. Lexington: University Press of Kentucky, 1976.

Clifford, James. *The Predicament of Culture*. Cambridge: Harvard University Press, 1988.

Clifford, James, and George E. Marcus, ed. *Writing Culture: The Poetics and Politics of Ethnography*. Berkeley and Los Angeles: University of California Press, 1986.

Cobb, Ann. *Kinfolks*. Boston: Houghton-Mifflin, 1922.

Coleman, A. L., et al. "Rural Development and the Quality of Life in Harlan, Perry, Whitley, and Wolfe Counties: Summaries of Data from Surveys of Households in 1961 and 1973." University of Kentucky Department of Sociology, University of Kentucky Agricultural Experiment Station, Lexington, December 1973.

College Art Association. *MFA Programs in the Visual Arts: A Directory*. New York: College Art Association, 1987.

Colt, Priscilla. *Edgar Tolson: Kentucky Gothic*. Lexington: University of Kentucky Art Museum, 1981.

Columbus Museum of Art. *Elijah Pierce, Woodcarver*. Columbus, Ohio: Columbus Museum of Art, 1992.

"Committee for Miners Presents Folk Music for Hazard" (flier for performance
February 28, 1968, at Polytechnic Auditorium, Baltimore). In "Kentucky" file.
Washington, D.C., American Folklife Center Library, Library of Congress.

*Common Ground/Uncommon Vision: The Michael and Julie Hall Collection of American Folk
Art.* Milwaukee: Milwaukee Art Museum, 1993.

Conti, Eugene A., Jr. "Mountain Metamorphoses: Culture and Development in East
Kentucky." Ph.D. diss., Duke University, 1978.

Cook, Scott. "Crafts, Capitalist Development, and Cultural Property in Oaxaca,
Mexico." *Inter-American Economic Affairs* 35, no. 3 (Winter 1981): 53–68.

Copetas, Karen G. "The 1965 Appalachian Volunteer Summer Project: A Plunge into
Reality." Paper, Union College, Barbourville, Ky. Special Collections, University
of Kentucky, Lexington, Ky.

Counts, Charles. *Encouraging American Handcrafts: What Role in Economic Development?*
Washington, D.C.: U.S. Department of Commerce, 1966.

Cranbrook Academy of Art Galleries. *American Folk Sculpture: The Personal and the
Eccentric.* Bloomfield Hills, Mich.: Cranbrook Academy of Art, 1972.

Crane, Diana. *The Transformation of the Avant-Garde: The New York Art World,
1940–1985.* Chicago: University of Chicago Press, 1987.

Crawford, Byron. "Scholar Chronicles Traditional Fiddling." *Louisville Courier-
Journal,* April 13, 1992, B1.

Crow, Thomas. "Modernism and Mass Culture in the Visual Arts." In *Modernism and
Modernity,* edited by Benjamin H. D. Buchloh et al., 215–64. Halifax: Press of the
Nova Scotia College of Art and Design, 1983.

Crumm, David. "Portrait of a Folk Craftsman." *Lexington Herald-Leader,* July 25, 1982,
G1, G3.

Csikszentmihalyi, Mihaly, and Eugene Rochberg-Halton. *The Meaning of Things:
Domestic Symbols and the Self.* Cambridge, Eng.: Cambridge University Press, 1981.

Cubbs, Joanne. "Rebels, Mystics, and Outcasts: The Romantic Artist Outsider." In
The Artist Outsider: Creativity and the Boundaries of Culture, edited by Michael D. Hall
and Eugene W. Metcalf Jr., 76–93. Washington, D.C.: Smithsonian Institution
Press, 1994.

Cunningham, Rodger. *Apples on the Flood: The Southern Mountain Experience.* Knoxville:
University of Tennessee Press, 1987.

Curry, David Park. "Rose Colored Glasses: Looking for 'Good Design' in American
Folk Art." In *An American Sampler: Folk Art from the Shelburne Museum,* 24–67.
Washington, D.C.: National Gallery of Art, 1987.

Daniels, Ellen Stodolsky, ed. *Community Arts Agencies: A Handbook and Guide.* New
York: American Council for the Arts, 1978.

Daniels, Mary. "In or Out?" *Chicago Tribune,* October 10, 1993, sec. 15, p. 8.

Danto, Arthur. "The Artworld." *Journal of Philosophy* 61 (1964): 571–84.

———. *Beyond the Brillo Box: The Visual Arts in Post-Historical Perspective.* New York:
Farrar, Straus, Giroux, 1992.

Davis, Fred. "Nostalgia, Identity, and the Current Nostalgia Wave." *Journal of Popular
Culture* 11, no. 2 (Fall 1977): 414–24.

"Death Claims Edgar Tolson, Famed Carver." *Wolfe County News,* September 14, 1984, 1.

Dewhurst, Kurt, Betty MacDowell, and Marsha MacDowell. *Religious Folk Art in
America: Reflections of Faith.* New York: E. P. Dutton, 1983.

DiMaggio, Paul. "Cultural Aspects of Economic Action and Organization." In *Beyond the Market Place: Rethinking Economy and Society*, edited by Roger Friedland and A. F. Robertson, 113–36. New York: Aldine de Gruyter, 1990.

———. "Cultural Boundaries and Structural Change: The Extension of the High Culture Model to Theater, Opera, and the Dance, 1900–1940." In *Cultivating Differences: Symbolic Boundaries and the Making of Inequality*, edited by Michèle Lamont and Marcel Fournier, 21–57. Chicago: University of Chicago Press, 1992.

DiMaggio, Paul, and Michael Useem. "Cultural Democracy in a Period of Cultural Expansion: The Social Composition of Arts Audiences in the United States." In *Performers and Performances: The Social Organization of Artistic Work*, edited by Jack B. Kamerman and Rosanne Martorella, 199–226. New York: Praeger, 1983.

Dubuffet, Jean. *Asphyxiating Culture and Other Writings*. Translated by Carol Volk. New York: Four Walls Eight Windows, 1986.

———. *Dubuffet and the Anti-Culture*. New York: Richard C. Feigen and Co., 1986.

Early and Modern History of Wolfe County. Campton, Ky: Wolfe County Women's Club, n.d.

Eaton, Allen H. *Handicrafts of the Southern Highlands*. New York: Russell Sage Foundation, 1937.

"Edgar Tolson." *Contemporary Art Southeast* 2, no. 1 (1978): n.p.

"Edgar Tolson Whittles Out New Career." *Wolfe County News*, July 26, 1968, 1.

Ehrenreich, Barbara. *Fear of Falling: The Inner Life of the Middle Class*. New York: Pantheon Books, 1989.

Ellis, Sue. "Vanishing Grass Roots Crafts Return." *Louisville Courier-Journal*, November 19, 1967, D12.

Ennis, Philip H. "Back to Basics: The Diamond, the Stream, and the Parade." *Culture*, Newsletter of the Sociology of Culture Section of the American Sociological Association, 8, no. 1 (Fall 1993): 10–14.

Evans, William J., and Lawrence K. Lynch. *The Development of Kentucky's Handicraft Industry*. Lexington, Ky.: Spindletop Research Center, 1963.

Flower, Milton E. *Wilhelm Schimmel and Aaron Mountz: Wood Carvers*. Williamsburg: Abby Aldrich Rockefeller Folk Art Collection, 1965.

"Focus on Galleries." *Folk Art Finder* 3, no. 1 (March–April 1982): 4.

"Folk Art Summer Show Features Contemporary Works." *Antiques and the Arts Weekly*, May 2, 1980, 96.

Ford, the Honorable Wendell H. Letter to the author. May 5, 1993.

Foucault, Michel. *Discipline and Punish: The Birth of the Prison*. New York: Vintage Books, 1979.

———. *Madness and Civilization*. New York: Random House, 1965.

———. *The Order of Things: An Archaeology of the Human Sciences*. New York: Random House, 1970.

———. "What Is an Author?" In *Textual Strategies: Perspectives in Post-Structuralist Criticism*, edited by Josué V. Harari, 141–60. Ithaca, N.Y.: Cornell University Press, 1979.

"Founding of Kentucky Arts Commission." *Wolfe County News*, February 24, 1967, 1.

Fox, Carl. Letter to the author. May 7, 1993.

Fudge, James. "Mountain Craftsman Exhibits Primitive Art." *Kentucky Kernel*, January 19, 1970, 2.

Gablik. Suzi. *Has Modernism Failed?* New York: Thames and Hudson, 1984.

Gans, Herbert J. *Popular Culture and High Culture.* New York: Basic Books, 1974.

Garland, Jim. *Welcome the Traveler Home: Jim Garland's Story of the Kentucky Mountains,* edited by Julia S. Ardery. Lexington: University Press of Kentucky, 1983.

Garrow, David J. *Bearing the Cross: Martin Luther King Jr. and the Southern Christian Leadership Conference.* New York: William Morrow and Co., 1986.

Gaver, Eleanor E. "Inside the Outsiders." *Art and Antiques* 7 (Summer 1990): 72–86, 15–163.

Geertz, Clifford. "The Cerebral Savage: On the Work of Lévi-Strauss." In *The Interpretation of Cultures,* 351–55. New York: Basic Books, 1973.

———. "The Impact of the Concept of Culture on the Concept of Man." In *The Interpretation of Cultures,* 33–54. New York: Basic Books, 1973.

Generations of Kentucky: An Exhibition of Folk Art with Photographs by Guy Mendes. Louisville: Kentucky Art and Craft Foundation, 1994.

Georgia Forum on Folk Art. "Missing Pieces or Missing the Point?" In *ArtPapers,* "On Folk, Self-Taught, Outsider Artists" (special issue), 18, no. 5 (September/October 1994): 8–19.

Gitlin, Todd. *The Sixties: Years of Hope, Days of Rage.* Rev. ed. New York: Bantam Books, 1993.

———. *The Whole World Is Watching: Mass Media and the Making and Unmaking of the New Left.* Berkeley and Los Angeles: University of California Press, 1980.

Glassie, Henry. "The Idea of Folk Art." In *Folk Art and Art Worlds,* edited by John Michael Vlach and Simon J. Bronner, 269–74. Ann Arbor: UMI Research Press, 1986.

Goffman, Erving. *The Presentation of Self in Everyday Life.* Garden City, N.Y.: Doubleday, 1959.

Goings, Kenneth W. *Mammy and Uncle Mose: Black Collectibles and American Stereotyping.* Bloomington: Indiana University Press, 1994.

Goldin, Amy. "Problems in Folk Art." *Artforum* 14, no. 6 (June 1976): 48–52.

Goldwater, Robert. *Primitivism in Modern Art.* Enlarged ed. Cambridge: Harvard University Press, Belknap Press, 1986.

"A Good and a Bad Way to Fight Poverty." Editorial. *Louisville Courier-Journal,* November 18, 1964, 8.

Goodman, Paul. *Growing Up Absurd.* New York: Vintage Books, 1956.

Graburn, Nelson H. H. "Art and the Acculturative Process." *International Social Science Journal* 21, no. 3 (1969): 457–68.

———. "Eskimo Art: The Eastern Canadian Arctic." In *Ethnic and Tourist Arts: Cultural Expressions from the Fourth World,* 39–55. Berkeley and Los Angeles: University of California Press, 1976.

———. *Ethnic and Tourist Arts: Cultural Expressions from the Fourth World.* Berkeley and Los Angeles: University of California Press, 1976.

———. "'I Like Things to Look More Different Than That Stuff Did': An Experiment in Cross-Cultural Art Appreciation." In *Art in Society: Studies in Style, Culture, and Aesthetics,* edited by Michael Greenhalgh and Vincent Megaw, 51–70. New York: St. Martin's Press, 1978.

Gramsci, Antonio. *Selections from Cultural Writings.* Edited by David Forgacs and Geoffrey Nowell-Smith. Translated by William Boelhower. Cambridge: Harvard University Press, 1985.

"Grassroots Craftsmen of the Appalachian Mountains, Long Range Plan." Berea, Ky., Marketing Appalachia's Traditional Community Handicrafts (MATCH), June 1983.

Hackley, Larry. *Remembrances: Recent Memory Art by Kentucky Folk Artists.* Louisville: Kentucky Art and Craft Foundation, 1986.

———. *Sticks: Historical and Contemporary Kentucky Canes.* Louisville: Kentucky Art and Craft Foundation, 1988.

———. "Twenty-five Years of Growth: Notes on the History of the Guild." In *Kentucky Guild of Artists and Craftsmen Twenty-fifth Anniversary Celebration,* 11–15. Louisville: Water Tower Association and Kentucky Guild of Artists and Craftsmen, 1986.

Hakanson, Joy. "Tolson Sculptures Top Folk Art's 'Honesty and Beauty.'" *Detroit News,* June 18, 1972, 4E.

Hall, Julie. *Tradition and Change: The New American Craftsman.* New York: E. P. Dutton, 1977.

Hall, Julie, and Russell Bowman. "Interview with Julie Hall, by Russell Bowman." In *Common Ground/Uncommon Vision: The Michael and Julie Hall Collection of American Folk Art,* 41–53. Milwaukee: Milwaukee Art Museum, 1993.

Hall, Julie, and Michael Hall. "Conversation with the Halls." Interview with Mary Orrin. *Antique Review Preview* (February 1990): 18–19.

Hall, Michael D. "American Folk Sculpture." *Cranbrook Magazine* (Winter 1972): 5–10.

———. *American Folk Sculpture: The Personal and the Eccentric.* Bloomfield Hills, Mich.: Cranbrook Academy of Art Galleries, 1972.

———. "The Bridesmaid Bride Stripped Bare." In *The Ties That Bind: Folk Art in Contemporary American Culture,* edited by Michael D. Hall and Eugene W. Metcalf Jr., 33–54. Cincinnati: Contemporary Arts Center, 1986.

———. "Hands-On Work: Style as Meaning in the Carvings of Elijah Pierce." In Columbus Museum of Art, *Elijah Pierce, Woodcarver,* 26–36. Columbus, Ohio: Columbus Museum of Art, 1992.

———. "Jahan Maka: Symbolist on the Precambrian Shield." In *The Artist Outsider: Creativity and the Boundaries of Culture.* Edited by Michael D. Hall and Eugene W. Metcalf Jr., 124–42. Washington, D.C.: Smithsonian Institution Press, 1994.

———. "The Mythic Outsider: Handmaiden to the Modern Muse." *New Art Examiner* 19, no. 1 (September 1991): 16–21.

———. "The Problem of Martin Ramirez." In *Stereoscopic Perspective,* 227–36. Ann Arbor: UMI Research Press, 1988.

———. *Six Naives: An Exhibition of Living Contemporary Naive Artists.* Akron: Akron Art Institute, 1973.

———. *Stereoscopic Perspective: Reflections on American Fine and Folk Art.* Ann Arbor: UMI Research Press, 1988.

———. "You Make It with Your Mind." *Clarion* 12 (Spring–Summer 1987): 36–43.

Hall, Michael D., and Rick Bell. *The Work of Edgar Tolson.* Lexington: University of Kentucky Student Center Gallery, 1970.

Hall, Michael D., and Russell Bowman. "Interview with Michael D. Hall, by Russell Bowman." In *Common Ground/Uncommon Vision: The Michael and Julie Hall Collection of American Folk Art*, 23–39. Milwaukee: Milwaukee Art Museum, 1993.

Hall, Michael D., and Sarah Faunce. "A Sorting Process: The Artist as Collector." In *Folk Sculpture U.S.A.*, 33–53. Brooklyn, N.Y.: Brooklyn Museum, 1976.

Hall, Michael D., and Herbert W. Hemphill Jr. "The Hemphill Perspective—A View from a Bridge." In *American Folk Art: The Herbert Waide Hemphill Jr. Collection*, 7–17. Milwaukee: Milwaukee Art Museum, 1981.

Hall, Michael D., and Eugene W. Metcalf Jr. *The Ties That Bind: Folk Art in Contemporary American Culture*. Cincinnati: Contemporary Arts Center, 1986.

———, eds. *The Artist Outsider: Creativity and the Boundaries of Culture*. Washington, D.C.: Smithsonian Institution Press, 1994.

Halle, David. *Inside Culture: Art and Class in the American Home*. Chicago: University of Chicago Press, 1993.

Harrington, Michael. *The Other America: Poverty in the United States*. New York: Macmillan, 1962.

Hartigan, Lynda Roscoe. "Collected with Passion." *Clarion* 15 (Summer 1990): 34–41.

———. *Made with Passion: The Hemphill Folk Art Collection*. Washington, D.C.: Smithsonian Institution Press, 1990.

Hauser, Arnold. "Folk Art." In *The Sociology of Art*, translated by Kenneth J. Northcott, 562–69. Chicago: University of Chicago Press, 1982.

Hayes, Jeffrey R., Elizabeth Mosby Adler, and Larry Hackley. *The Art of Carl McKenzie*. Milwaukee: UWM Art Museum, University of Wisconsin, Milwaukee, 1994.

Heard Museum. *Chispas! Cultural Warriors of New Mexico*. Phoenix: Heard Museum, 1992.

Hemphill, Herbert W., Jr., ed. *Folk Sculpture U.S.A.* Brooklyn: Brooklyn Museum, 1976.

Hemphill, Herbert W., Jr., and Julia Weissman. *Twentieth Century American Folk Art and Artists*. New York: E. P. Dutton, 1974.

Herzig, Doris. "The People Speak in Folk Art Exhibit." *Newsday*, September 14, 1970, design 2, 17A.

Hitt, Jack. "The Selling of Howard Finster." *Southern Magazine* 2, no. 2 (November 1987): 52–59, 91.

Hobsbawm, Eric, and Terrence Ranger, ed. *The Invention of Tradition*. Cambridge, Eng.: Cambridge University Press, 1983.

Hoffberger, Rebecca, Roger Manley, and Colin Wilson. *Tree of Life: The Inaugural Exhibition of the American Visionary Art Museum*. Baltimore: American Visionary Art Museum, 1996.

Hoffman, Alice J. "The History of the Museum of American Folk Art: An Illustrated Timeline." *Clarion* 14 (Winter 1989): 36–63.

Holwerk, David. "Whittlin' Man." *Louisville Courier-Journal Magazine*, March 14, 1971, E7–10.

hooks, bell. "Spending Culture: Marketing the Black Underclass." In *Outlaw Culture: Resisting Representations*, 145–53. New York: Routledge, 1994.

Horwitz, Elinor Lander. *The Bird, the Banner, and Uncle Sam*. Philadelphia: J. B. Lippincott, 1976.

————. *Contemporary American Folk Artists*. Philadelphia: J. B. Lippincott, 1975.

————. *Mountain People, Mountain Crafts*. Philadelphia: J. B. Lippincott, 1974.

Houghton, Donald M. "Building-Boom Sidelight: Business Bullish on Art." *Louisville Courier-Journal*, December 26, 1971, E6.

Howard, Leslie. "Urban Art." *Folk Art Finder* 13, no. 4 (October–December 1992): 6.

J. B. Speed Art Museum. *An Exhibition of Art to Be Used in Citizens Plaza*. Louisville: J. B. Speed Art Museum, 1971.

Johnson, Anne Lewis, dir. *Roving Pickets*. Appalshop Films, 1990.

Johnson, Jay, and William C. Ketchum. *American Folk Art of the Twentieth Century*. New York: Rizolli Press, 1983.

Jones, Michael Owen. *Craftsman of the Cumberlands: Tradition and Creativity*. Lexington: University Press of Kentucky, 1989.

Jones, Suzi. "Art by Fiat, and Other Dilemmas of Cross-Cultural Collecting." In *Folk Art and Art Worlds*, edited by John Michael Vlach and Simon J. Bronner, 243–266. Ann Arbor: UMI Research Press, 1986.

Joyce, Rosemary O. "'Fame Don't Make the Sun Any Cooler': Folk Artists and the Marketplace." In *Folk Art and Art Worlds*, edited by John Michael Vlach and Simon J. Bronner, 225–41. Ann Arbor: UMI Research Press, 1986.

Jules-Rosette, Bennetta. "Aesthetics and Market Demand: The Structure of the Tourist Art Market in Three African Settings." *African Studies Review* 29, no. 1 (March 1986): 41–59.

Kamerman, Jack B., and Rosanne Martorella, ed. *Performers and Performances: The Social Organization of Artistic Work*. New York: Praeger, 1983.

Kant, Immanuel. "Analytic of the Beautiful." In *The Critique of Judgement*, translated by Walter Cerf, 3–128. New York: Bobbs-Merrill, 1963.

Kapelke, Steven. "Enter Folk Art: The Hall Collection at the Milwaukee Art Museum." *New Art Examiner* 21, no. 6 (February 1994): 12–16 (cover art, Edgar Tolson's *Barring the Gates of Paradise*).

Karlins, N. F. "American Folk Art in Corporate Collections." *Clarion* 13 (Spring 1988): 33–47.

Kaufman, Barbara Wahl, and Didi Barrett. *A Time to Reap: Late Blooming Folk Artists*. South Orange, N.J.: Seaton Hall University and the Museum of American Folk Art, 1985.

Kentucky Guild of Artists and Craftsmen Twenty-fifth Anniversary Celebration. Louisville: Water Tower Association and Kentucky Guild of Artists and Craftsmen, 1986.

Kind, Phyllis. "Book Review: *The Artist Outsider*." *Folk Art Messenger* 8, no. 2 (Winter 1995): 9.

Kirwin, Liza. "Documenting Contemporary Southern Self-Taught Artists." *Southern Quarterly* 26, no. 1 (Fall 1987): 57–75.

Klamkin, Marian, and Charles Klamkin. *Wood Carvings/North American Folk Sculpture*. New York: Hawthorne Books, 1974.

Koch, Kenneth. *Wishes, Lies, and Dreams: Teaching Children to Write Poetry*. New York: Random House, 1971.

Kramer, Hilton. "American Art since 1945: Who Will Write Its History?" *New Criterion* (Summer 1985): 1–9.

————. "An Expert Folk Sculpture Show in Brooklyn." *New York Times*, March 13, 1976, 17.

Kubler, George. *The Shape of Time: Remarks on the History of Things*. New Haven: Yale University Press, 1962.

Kuspit, Donald. "The Appropriation of Marginal Art in the 1980s." *American Art* 5, nos. 1–2 (1991): 132–41.

———. "Art in an Age of Mass Mediation." In *The Critic Is Artist: The Intentionality of Art*, 387–94. Ann Arbor: UMI Research Press, 1984.

———. "'Suffer the Little Children to Come Unto Me': Twentieth Century Folk Art." In *The New Subjectivism: Art in the 1980s*, 454–65. Ann Arbor: UMI Research Press, 1988.

Laffal, Florence, "Adam and Eve in Folk Art." *Folk Art Finder* 2, no. 5 (November–December 1981): 4–5.

———. "Auction in Connecticut—A Review." *Folk Art Finder* 13, no. 4 (January–March 1993): 11.

Laffal, Jules, and Florence Laffal. "Demographic Perspectives on Twentieth Century American Folk Art." *Folk Art Finder* 15, no. 2 (April–June 1994): 6–7.

Lansdell, Sarah. "Artist and Idea or Getting Perfect." *Louisville Courier-Journal*, April 25, 1976, H12–13.

———. "Edgar Tolson: Kentucky Gothic." *Louisville Courier-Journal Magazine*, September 13, 1981, 26–29.

———. "Folk Art: Label It If You Must, but Enjoy." *Louisville Courier-Journal*, July 15, 1979, E7.

———. "A Proud Lot of Kentucky Art to Stay for Keeps." *Louisville Courier-Journal*, December 19, 1971, F20.

———. "Tolson Carvings Whittle Their Own Spells." *Louisville Courier-Journal*, October 18, 1981, H10.

La Plante, Eva. "In the Temporal Lobes, Seizures and Creativity." *New York Times*, October 12, 1993, B6.

Lasch, Christopher. *The True and Only Heaven: Progress and Its Critics*. New York: W. W. Norton, 1991.

Lavitt, Wendy. *American Folk Dolls*. New York: Alfred A. Knopf, 1982.

Lears, T. J. Jackson. "The Concept of Cultural Hegemony: Problems and Possibilities." *American Historical Review* 90, no. 3 (June 1985): 567–93.

———. *No Place of Grace: Antimodernism and the Transformation of American Culture, 1880–1920*. New York: Pantheon Books, 1981.

"Limberjack or Dancing Doll." In *Foxfire 6*, edited by Eliot Wigginton, 208–13. New York: Doubleday, 1975.

Lipman, Jean. "American Folk Art, Six Decades of Discovery." In *American Folk Painters of Three Centuries*, edited by Jean Lipman and Tom Armstrong, 220–22. New York: Arch Cape Press and the Whitney Museum of American Art, 1980.

———. *American Folk Art in Wood, Metal, and Stone*. New York: Pantheon Books, 1948. Reprint, New York: Dover Publications, 1972.

———. *American Primitive Painting*. New York: Oxford University Press, 1942. Reprint, New York: Dover Publications, 1972.

———. "A Critical Definition of the American Primitive." *Art in America* 26 (October 1938): 171–77.

———. *Provocative Parallels: Naive Early Americans/International Sophisticates*. New York: E. P. Dutton, 1975.

————, ed. "American Primitive Painting: Collection of Edgar William and Bernice Chrysler Garbisch." *Art in America* 42 (May 1954), special issue.

Lippard, Lucy R. *Get the Message? A Decade of Art for Social Change.* New York: E. P. Dutton, 1984.

————. "The Pink Glass Swan: Upward and Downward Mobility in the Art World." *Heresies* 1 (January 1977): 82–87.

Livingston, Jane, and John Beardsley. *Black Folk Art in America, 1930–1980.* Jackson: University Press of Mississippi, 1982.

Lockwood, David M. "Identification of Characteristics of Art Work by Beginning Art Students of Liberal Arts Colleges in the Appalachian Region." Ph.D. diss., University of Tulsa, 1972.

Lowry, W. McNeil, ed. *The Arts and Public Policy in the United States.* New York: American Assembly and Prentice-Hall, 1984.

Lyne, Jack. "Edgar Tolson, Sculptor." *Blue-Tail Fly* 1, no. 4, (January 1970): 5–6.

MacCannell, Dean. "Cannibalism Today." In *Empty Meeting Grounds: The Tourist Papers,* 17–73. London: Routledge, 1992.

————. *The Tourist: A New Theory of the Leisure Class.* New York: Schocken Books, 1976.

MacDowell, Marsha. "Folk Art Study in Higher Education." *Kentucky Folklore Record* 30, nos. 1–2 (January–June 1984): 26–33.

MacGregor, John M. *The Discovery of the Art of the Insane.* Princeton, N.J.: Princeton University Press, 1989.

Mainardi, Patricia. "Quilts: The Great American Art." In *Feminism and Art History,* edited by Norma Broude and Mary D. Garrard, 330–46. New York: Harper and Row, 1982.

Mallarmé, Stéphane. "The Impressionists and Edouard Manet." In *The New Painting: Impressionism, 1874–1886,* 27–35. San Francisco: Fine Arts Museum of San Francisco, 1986.

Malraux, André. *The Museum without Walls.* Translated by Stuart Gilbert and Francis Price. Garden City, N.Y.: Doubleday, 1967.

Manley, Roger. "Robbing the Garden." *Folk Art Messenger* 7, no. 2 (Winter 1994): 4–7, 9.

————. "Separating the Folk from Their Art." *New Art Examiner* 19, no. 1 (September 1991): 25–28.

————. *Signs and Wonders: Outsider Art inside North Carolina.* Raleigh: North Carolina Museum of Art, 1989.

Maquet, Jacques. *Introduction to Aesthetic Anthropology.* Malibu, Calif.: Undena Publications, 1979.

Mark, Norman. "My Dreams Are a Spiritual Enfoldment." *Chicago Daily News,* November 11, 1967.

"Marketing Folk Art." *New York Folklore* 12, nos. 1–2 (Winter–Spring 1986), special issue.

Martin, Charles. "Kentucky's Traditional Arts and Crafts: A Bibliography." *Kentucky Folklore Record* 31, nos. 1–4 (January–December 1985).

Martorella, Rosanne. "Art and Public Policy: Ideologies for Aesthetic Warfare." In *Performers and Performances: The Social Organization of Artistic Work,* edited by Jack B. Kamerman and Rosanne Martorella, 281–88. New York: Praeger, 1983.

Marxsen, Patrisha. "Tolson's Art Doesn't Look Real; It Feels Real." *Lexington Herald-Leader*, September 13, 1981, H1, H4.

Mendes, Guy. "Appalachia Revisited." *Craft Horizons* 37, no. 3 (June 1977): 28–40, 71–76.

————. "Found People: Some Figures on My Urn." *Place Magazine* 2, no. 2 (December 1972): 44–48.

————. *Light at Hand: Photographs, 1970–1985*. Frankfort, Ky.: Gnomon Press, 1986.

Merin-Bihalji, Otto, and Tomasevic Nebojsa-Bato. *World Encyclopedia of Naive Art*. Scranton, Pa.: Harper and Row, 1985.

Metcalf, Eugene W., Jr. "Artifacts and Cultural Meaning: The Ritual of Collecting American Folk Art." In *Living in a Material World: Canadian and American Approaches to Material Culture*, edited by Gerald Pocius. St. Johns, Canada: Institute for Social and Economic Research, 1990.

————. "Black Folk Art and the Politics of Art." In *Art, Ideology, and Politics*, edited by Judith H. Balfe and Margaret Jane Wyszomirsk, 169–92. New York: Praeger, 1983.

————. "From Domination to Desire: Insiders and Outsider Art." In *The Artist Outsider: Creativity and the Boundaries of Culture*, edited by Michael D. Hall and Eugene W. Metcalf Jr., 212–27. Washington, D.C.: Smithsonian Institution Press, 1994.

————. "From the Mundane to the Miraculous: The Meaning of Folk Art Collecting in America." *Clarion* 12 (Winter 1987): 56–60.

————. "The Politics of the Past in American Folk Art History." In *Folk Art and Art Worlds*, edited by John Michael Vlach and Simon J. Bronner, 27–50. Ann Arbor: UMI Research Press, 1986.

————. "Public Art, Folk Art, and the Social Consequences of Aesthetics." In *Public Art Dialogue = Southeast* (conference proceedings), 129–42. Durham, N.C.: Durham Arts Council, 1989.

Miller, Jim Wayne. *The Mountains Have Come Closer*. Boone, N.C.: Appalachian Consortium Press, 1980.

"Milwaukee Art Museum Acquires Major Folk Art Collection." *Antique Review Preview* (February 1990): 1, 16.

Morris, William. *Hopes and Fears for Art*. New York: Garland, 1979.

Muchnic, Suzanne. "What's Fueling the Astonishing Boom in Prices Paid for Contemporary Art?" *Louisville Courier-Journal*, June 25, 1989, I1, I6.

Mueller, Lee. "Son of Famous Woodcarver Followed Legacy of Art, Temper." *Lexington Herald-Leader*, February 9, 1997, B1, B7.

National Endowment for the Arts. "Artists Increase 81% in the 1970s." Research Division Note #3—April 27, 1983. Washington, D.C., 1983.

————. *National Endowment for the Arts, 1965–1995: A Brief Chronology of Federal Involvement in the Arts*. Washington, D.C.: National Endowment for the Arts, 1995.

————. *Toward Civilization: A Report on Arts Education*. Washington, D.C.: National Endowment for the Arts, 1988.

Naylor, Gillian. *The Arts and Crafts Movement*. Cambridge: MIT Press, 1971.

Niebuhr, Reinhold. *Moral Man and Immoral Society*. New York: Charles Scribner's Sons, 1932.

1973 Biennial Exhibition, Contemporary American Art. New York: Whitney Museum of American Art, 1973.

1973 Festival of American Folklife. Washington, D.C.: Smithsonian Institution, 1973.

Norman, Gurney. *Divine Right's Trip: A Novel of the Counterculture*. Frankfort, Ky.: Gnomon Press, 1990.

Ogden, Anne. "Edgar Tolson, 1904–1984." *American Craft* 44, no. 6 (December 1984– January 1985): 94.

Old Friends, New Friends. Produced by Fred Rogers. Family Communications, Inc. Pittsburgh. PBS, August 15, 1980.

Oppenhimer, Ann. "A Message from the President." *Folk Art Messenger* 1, no. 1 (Fall 1987): n.p.

Parsons, Pat. "Primal Portraits: Adam and Eve Imagery as Seen by Twentieth Century Self-Taught Artists." In *A Report from the San Francisco Craft and Folk Art Museum* 8, no. 2 (1990): n.p.

Patterson, James T. *America's Struggle against Poverty, 1900–1985*. Cambridge: Harvard University Press, 1986.

Patterson, Tom. "Ingrained Images and Outside Influences: Recent and Current Family Art Traditions in Appalachian Kentucky." In *Generations of Kentucky: An Exhibition of Folk Art with Photographs by Guy Mendes*, 11–20. Louisville: Kentucky Art and Craft Foundation, 1994.

————. "Ten Years in the Life of Contemporary Art's Parallel Universe: A Personal View." *Art Papers* 18, no. 5 (September–October 1994): 2–7.

Pierce, James Smith. *God, Man, and the Devil: Religion in Recent Kentucky Folk Art*. Lexington: Folk Art Society of Kentucky, 1984.

Plattner, Stuart. *High Art, Down Home: An Economic Ethnography of a Local Art Market*. Chicago: University of Chicago Press, 1996.

Price, Sally. *Primitive Art in Civilized Places*. Chicago: University of Chicago Press, 1989.

Proeller, Marie Luise. "Looking Back, Looking Forward: Ten Years of Folk Art Studies at New York University." *Folk Art* 18, no. 2 (Summer 1983): 50–54.

Quimby, Ian M. G., and Scott T. Swank. *Perspectives on American Folk Art*. New York: W. W. Norton, 1980.

Rabkin, Dorothy. "New World Freedom." *Clarion* 5 (Summer–Fall 1980): 29.

Rankin, Allen. "He Lost Ten Thousand Years" (Bill Traylor). *Collier's*, June 22, 1946.

Reif, Rita. "Spotlight on Appalachian Craftsmen." *New York Times*, April 12, 1967, 50.

Reitlinger, Gerald. *The Economics of Taste*. Vol. 3, *The Art Market of the 1960s*. London: Barrie and Jenkins, 1970.

Reuss, Margaret Magrath. Letter to the author. May 13, 1993.

Rhodes, Lynette I. *American Folk Art: From the Traditional to the Naive*. Cleveland: Cleveland Museum of Art, 1978.

Ricco, Roger, Frank Maresca, and Julia Weissman. *American Primitive: Discoveries in Folk Sculpture*. New York: Alfred A. Knopf, 1988.

Rieff, Philip. *The Triumph of the Therapeutic: Uses of Faith after Freud*. New York: Harper and Row, 1966.

Rinzler, Ralph. "Preface to the Dover Edition." In Allen H. Eaton, *Handicrafts of the Southern Highlands*, vii–ix. New York: Dover Publications, 1973.

Robbins, Daniel. "Folk Sculpture without Folk." In *Folk Sculpture U.S.A.*, 11–30. Brooklyn: Brooklyn Museum, 1976.

Robins, Corinne. *The Pluralist Era: American Art, 1968–1981*. New York: Harper and Row, 1984.

Robinson, Aminah. "A Holy Place: A Tribute to Elijah Pierce." In *Elijah Pierce, Woodcarver*, 65–68. Columbus, Ohio: Columbus Museum of Art, 1992.

Rosenak, Chuck. "Folk Art Is Alien to Cultural Aesthetics." *Folk Art Messenger* 5, no. 3 (Spring 1992): 8–9.

Rosenak, Chuck, and Jan Rosenak. *Museum of American Folk Art Encyclopedia of Twentieth Century American Folk Art and Artists*. New York: Abbeville Press, 1990.

Rumford, Beatrix T. "Uncommon Art of the Common People: A Review of Trends in the Collecting and Exhibiting of American Folk Art." In *Perspectives on American Folk Art*, edited by Ian M. G. Quimby and Scott T. Swank, 13–53. New York: W. W. Norton, 1980.

Ryerson, Scott, H. "Seri Ironwood Carving: An Economic View." In *Ethnic and Tourist Arts: Cultural Expressions from the Fourth World*, edited by Nelson H. H. Graburn, 119–36. Berkeley and Los Angeles: University of California Press, 1976.

Sale, Kirkpatrick. *SDS*. New York: Random House, 1973.

"Sam D. Cecil, Five Years a Whittler, Carves to a Purpose." *Wolfe County News*, February 2, 1968, 1.

Sapir, Edward. "Culture Genuine and Spurious." In *Selected Writings of Edward Sapir in Language, Culture, and Personality*, 308–31. Berkeley and Los Angeles: University of California Press, 1949.

Scalora, Sal. *"Over-Loaded with Wisdom": A Selection of Contemporary American Folk Art*. Hartford: Aetna Institute Gallery, 1985.

Schadler, Karl-Ferdinand. "African Arts and Crafts in a World of Changing Values." In *Tourism: Passport to Development?*, edited by Emmanuel de Kadt, 146–56. London: Oxford University Press, 1979.

Schapiro, Meyer. "On Perfection, Coherence, and Unity of Form and Content." In *Theory and Philosophy of Art: Style Artist and Society*, 33–49. New York: George Braziller, 1994.

Schlereth, Thomas J. "Material Culture Studies in America, 1876–1976." In *Material Culture Studies in America*, edited by Thomas J. Schlereth, 1–75. Nashville: American Association for State and Local History, 1982.

Scott, James C. *Domination and the Arts of Resistance*. New Haven: Yale University Press, 1990.

———. *Weapons of the Weak: Everyday Forms of Peasant Resistance*. New Haven: Yale University Press, 1985.

"Selections from the American Folk Art Collection of Mr. and Mrs. Robert P. Marcus." Sotheby's (auction catalog), New York, October 14, 1989, n.p.

Sellen, Betty-Carol. *Twentieth Century American Folk, Self Taught, and Outsider Art*. New York: Neal-Schuman Publishers, 1993.

Seriff, Suzanne Katherine. "'Este Soy Yo': The Politics of Representation of a Texas-Mexican Folk Artist." Ph.D. diss., University of Texas, 1989.

Seymour, William R. "New Hope Springs from Grass Roots Crafts." Reprint 366, Farmers Cooperative Service, U.S. Department of Agriculture; originally published in *News for Farmers Cooperatives* (August 1969).

Shapiro, Henry D. *Appalachia on Our Mind: The Southern Mountains and Mountaineers in the American Consciousness, 1870–1920*. Chapel Hill: University of North Carolina Press, 1978.

Sherlock, Maureen P. "The Rhetoric of Rusticophilia." *Art Papers* 18, no. 5, (September–October 1994): 34–37.

Simmel, Georg. *The Conflict in Modern Culture and Other Essays*. Translated by K. Peter Etzkorn. New York: Teachers College Press, 1968.

———. *On Individuality and Social Forms*. Edited by Donald N. Levine. Chicago: University of Chicago Press, 1971.

Siporin, Steve. *American Folk Masters: The National Heritage Fellows*. New York: Harry N. Abrams, 1992.

Smith, Herb E., dir. *Strangers and Kin*. Appalshop Films, 1984.

Smith, Richard Cándida. "Exquisite Corpse: The Sense of the Past in Oral Histories with California Artists." *Oral History Review* 17, no. 1 (Spring 1989): 1–38.

———. "Modern Art and Oral History in the United States: A Revolution Remembered." *Journal of American History* 78, no. 2 (September 1991): 598–606.

Smith, Roberta. "Pondering the Nature of Twentieth Century American Crafts." *New York Times*, January 22, 1990, B3.

Sondheim, Alan. "Unnerving Questions Concerning the Critique and Presentation of Folk/Outsider Arts." *ArtPapers* (July–August 1989): 33–35.

Sontag, Susan. "The Artist as Exemplary Sufferer." In *Against Interpretation*, 39–48. New York: Dell, 1966.

Spielberg, Steven, dir. *Indiana Jones and the Last Crusade*, 1989.

Stacy, Helen Price. "Self-Taught Sculptor Has an Inimitable Way of Creating with Wood." *Lexington Leader*, April 20, 1970, 2.

"Statewide and Regional Folk Art Exhibitions (1974–1988)." *Folk Art Finder* 10, no. 1 (January–March 1989): 7–13.

Stephen, Lynn. "Culture as a Resource: Four Cases of Self-Managed Indigenous Craft Production in Latin America." *Economic Development and Cultural Change* 40, no. 1 (October 1991): 101–29.

Stewart, Susan. *On Longing: Narratives of the Miniature, the Gigantic, the Souvenir, the Collection*. Baltimore: Johns Hopkins University Press, 1984.

Stocking, George W., Jr., ed. *Objects and Others: Essays on Museums and Material Culture*. Madison: University of Wisconsin Press, 1985.

Stonitsch, Lonnette M. "Reverend Howard Finster." *New Art Examiner* 18, no. 3 (November 1990): 45.

Svenson, Arthur. "State and Local Arts Agencies." In *Public Policy and the Arts*, edited by Kevin V. Mulcahy and C. Richard Swaim, 195–211. Boulder: Westview Press, 1982.

Swaim, C. Richard. "The National Endowment for the Arts, 1965–1985." In *Public Policy and the Arts*, edited by Kevin V. Mulcahy and C. Richard Swaim, 169–94. Boulder: Westview Press, 1982.

Swain, Adrian. *Local Visions: Folk Art from Northeast Kentucky*. Morehead, Ky.: Morehead State University, 1990.

Swank, Scott T. Introduction to *Perspectives on American Folk Art*, edited by Ian M. G. Quimby and Scott T. Swank, 1–12. New York: W. W. Norton, 1980.

Tangerman, E. J. *Carving Faces and Figures in Wood*. New York: Sterling, 1980.

Taylor, Ellsworth. "Edgar Tolson, Kentucky Woodcarver." In *Unschooled Talent*, n.p. Owensboro, Ky.: Owensboro Museum of Fine Art, 1979.

Taylor, Ellsworth, and James Smith Pierce. *Folk Art of Kentucky*. Lexington: University of Kentucky Fine Arts Gallery, 1975.

Thévoz, Michel. "An Anti-Museum: The Collection de l'Art Brut in Lausanne." In *The Artist Outsider: Creativity and the Boundaries of Culture*, edited by Michael D. Hall and Eugene W. Metcalf Jr., 62–75. Washington, D.C.: Smithsonian Institution Press, 1994.

"Tolson Exhibition." *Lexington Herald-Leader*, January 1, 1970, 50.

Tolstoy, Leo. "What Is Art?" In *I Cannot Be Silent: Writings on Politics, Art, and Religion*, 143–45. Bristol: Bristol Press, 1989.

Tower, Ann. "Woodcarver Left Mark on Art World." *Lexington Herald-Leader*, September 13, 1984, D1.

Transmitters: The Isolate Artist in America. Philadelphia: Philadelphia College of Art, 1981.

Trillin, Calvin. "I Know I Want to Do Something." *New Yorker*, May 29, 1965, 72–120.

Tromble, Meredith, and John Turner. "Striding Out on Their Own: Folk Art and Northern California Artists." *Clarion* 13 (Summer 1988): 40–47.

Trotter, Robert. "The Vitality of Folk Artists' Personal Vision." *Art Voices/South* (December 1980): 39.

Truco, Terry. "Contemporary Painting: The Audience Is Broadening in a Volatile Field." *ARTnews* 80, no. 4 (April 1981): 78–82.

Tuchman, Maurice, and Carol Eliel, eds. *Parallel Visions: Modern Artists and Outsider Art*. Princeton, N.J.: Princeton University Press, 1992.

Tucker, Paul Hayes. *Monet in the '90s: The Series Paintings*. Boston: Museum of Fine Arts, 1989.

Tully, Judd. "Outside, Inside, or Somewhere in Between?" *ARTnews* 95, no. 5 (May 1996): 118–21.

Twentieth Century American Folk Art: The Herbert W. Hemphill Collection. Introduction by Phyllis Kind. Chicago: Renaissance Society, 1975.

"Twentieth Century Folk Art." *Maine Antiques Digest*, March 1990, 9-E.

Two Centuries of American Folk Art: Nineteenth and Twentieth Century Masterworks from the Collection of Mr. and Mrs. Robert P. Marcus. Boca Raton, Fla.: Ritter Art Gallery, Florida Atlantic University, 1984.

U.S. Bureau of the Census. *Historical Statistics of the United States: Colonial Times to 1970, Part 1*. Washington, D.C.: U.S. Department of Commerce, Bureau of the Census, 1975.

Useem, Michael, and Paul DiMaggio. "A Critical Review of Research of the Content, Quality, and Use of Audience Studies." In *Research in the Arts*, edited by David Cwi (Proceedings of the Conference on Policy Related Studies of the National Endowment for the Arts, December 7–9). Baltimore: Walters Art Gallery, 1977.

Vance, Kyle. "Federal Study Team Praises Appalachian Volunteers' Efforts." *Louisville Courier-Journal* (state edition), September 9, 1968, B1.

Veblen, Thorstein. *The Theory of the Leisure Class*. New York: Penguin Books, 1979.

Vesey, Susannah. "Drawn into Controversy." *Atlanta Journal/Atlanta Constitution*, January 3, 1993, A1, A10.

VISTA. Washington: ACTION, Volunteers in Service to America, 1980.

Vitanyi, Ivan, and Maria Sagi. "Rediscovery and Re-animation of Folk-Art in Modern Industrial Societies." *International Social Science Journal* 35, no. 1 (1983): 201–11.

Vlach, John Michael. *Plain Painters: Making Sense of American Folk Art.* Washington, D.C.: Smithsonian Institution Press, 1988.

———. "The Wrong Stuff." *New Art Examiner* 19, no. 1 (September 1991): 22–24.

Vlach, John Michael, and Simon J. Bronner. *Folk Art and Art Worlds.* Ann Arbor: UMI Research Press, 1986.

Volkersz, Willem. "Mixed Baggage: A Decade of State Folk Art Surveys." *Folk Art Finder* 10, no. 1 (January–March 1989): 4–13.

Wade, Edwin L. "The Ethnic Art Market in the American Southwest, 1880–1980." In *Objects and Others: Essays on Museums and Material Culture,* edited by George W. Stocking Jr., 167–91. Madison: University of Wisconsin Press, 1985.

Wadsworth, Anna, ed. *Missing Pieces: Georgia Folk Art, 1770–1976.* Atlanta: Georgia Council for the Arts and Humanities, 1976.

Wagner, Arlo T. "Kentucky Woodcarver's 'Stroke' of Luck." *(Covington) Kentucky Post Times Star,* April 2, 1968, 6K.

Wakefield, Dan. "In Hazard." In *Appalachia in the Sixties: Decade of Reawakening,* edited by David S. Walls and John B. Stephenson, 10–25. Lexington: University Press of Kentucky, 1972.

Walle, A. H. "Mitigating Marketing: A Window of Opportunity for Applied Folklorists." *New York Folklore* 12, nos. 1–2 (1986): 91–112.

Wayne, June. "The Male Artist as a Stereotypical Female." In *Feminist Collage: Educating Women in the Visual Arts,* edited by Judy Loeb, 128–37. New York: Teachers College Press, Columbia University, 1979.

Weaver, Emma. *Artisans of the Appalachians.* Asheville, N.C.: Miller Printing Co., 1967.

Weber, Max. "Religious Rejections of the World and Their Directions." In *From Max Weber: Essays in Sociology,* edited by H. H. Gerth and C. Wright Mills, 323–59. New York: Oxford University Press, 1946.

———. "Science as a Vocation." In *From Max Weber: Essays in Sociology,* edited by H. H. Gerth and C. Wright Mills, 129–56. New York: Oxford University Press, 1946.

Weissman, Julia. Letter to the editor. *Folk Art Finder* 5, no. 5 (January–February 1985): 2.

Wells, Ken. "'Outsider Art' Is Suddenly the Rage among Art Insiders." *Wall Street Journal,* February 25, 1992, A1, A10.

Wertkin, Gerald C. "Dr. Robert Bishop (1938–1991): A Personal Memoir." *Clarion* 16 (Winter 1991–92): 35–40.

West, Don. "Romantic Appalachia." In *Appalachia in the Sixties: Decade of Reawakening,* edited by David S. Walls and John B. Stephenson, 210–16. Lexington: University Press of Kentucky, 1972.

Whisnant, David E. *All That Is Native and Fine: The Politics of Culture in an American Region.* Chapel Hill: University of North Carolina Press, 1983.

———. *Modernizing the Mountaineer: People, Power, and Planning in Appalachia.* Boone, N.C.: Appalachian Consortium Press, 1980.

———. "Public Sector Folklore as Intervention: Lessons from the Past, Prospects for the Future." In *The Conservation of Culture: Folklorists & the Public Sector,* edited by Burt Feintuch, 233–47. Lexington: University Press of Kentucky, 1988.

White, Harrison C., and Cynthia A. *Canvases and Careers: Institutional Change in the French Painting World*. Chicago: University of Chicago Press, 1965. Reprint, Chicago: University of Chicago Press, 1993.

Winchester, Alice, ed. "What Is American Folk Art? A Symposium." *Antiques* 57 (May 1950): 335–62.

Wolfe, Cheri L. "Position Paper on the Effect of MAC Programs on Other Governmental Assistance Programs." Mississippi Arts Commission, Jackson, 1987.

Wolfe, Tom. *Radical Chic and Mau-Mauing the Flak Catchers*. New York: Farrar, Straus, Giroux, 1970.

"A Woodchopper's Ball at 'Folk Sculpture U.S.A.'" *Los Angeles Times*, July 18, 1976, 68.

Yanagi, Muneyoshi. *The Unknown Craftsman: A Japanese Insight into Beauty*. Rev. ed. Tokyo: Kodansha International, 1985.

Yelen, Alice Rae, William Ferris, Jane Livingston, Lowery Stokes Sims, Susan Larsen, and Kimberly Nichols. *Passionate Visions of the American South: Self-Taught Artists from 1940 to the Present*. New Orleans: New Orleans Museum of Art, 1993.

Zolberg, Vera. "Barrier or Leveler? The Case of the Art Museum." In *Cultivating Differences: Symbolic Boundaries and the Making of Inequality*, edited by Michèle Lamont and Marcel Fournier, 187–209. Chicago: University of Chicago Press, 1992.

INDEX

Page numbers in italics refer to illustrations.